The First World Festival of Negro Arts, Dakar 1966

Postcolonialism across the Disciplines 20

Postcolonialism across the Disciplines

Series Editors
Graham Huggan, University of Leeds
Andrew Thompson, University of Exeter

Postcolonialism across the Disciplines showcases alternative directions for postcolonial studies. It is in part an attempt to counteract the dominance in colonial and postcolonial studies of one particular discipline – English literary/cultural studies – and to make the case for a combination of disciplinary knowledges as the basis for contemporary postcolonial critique. Edited by leading scholars, the series aims to be a seminal contribution to the field, spanning the traditional range of disciplines represented in postcolonial studies but also those less acknowledged. It will also embrace new critical paradigms and examine the relationship between the transnational/cultural, the global and the postcolonial.

The First World Festival of Negro Arts, Dakar 1966

Contexts and Legacies

David Murphy

Liverpool University Press

First published 2016 by
Liverpool University Press
4 Cambridge Street
Liverpool L69 7ZU

This paperback edition first published 2021

British Library Cataloguing-in-Publication data
A British Library CIP record is available

ISBN 978-1-78138-316-2 cased
ISBN 978-1-80034-924-7 paperback

Typeset in Amerigo by Carnegie Book Production, Lancaster
Printed and bound by CPI Group (UK) Ltd, Croydon CR0 4YY

Contents

II Legacies

Acknowledgements

This project has been long in the making. In the process of writing a book chapter on Léopold Sédar Senghor almost a decade ago, I kept encountering references to the First World Festival of Negro Arts, which was cited as the 'apotheosis' of Negritude but it seemed impossible to find any in-depth analysis of the event. As I began to explore the topic further, I encountered the work of Elizabeth Harney, Tobias Wofford, Tracy Snipe and others who had already conducted research on the visual arts strands of festival. I then discovered the pioneering work of Andrew Apter, whose monograph on FESTAC '77 confirmed what I had begun to suspect: that Dakar 1966 and the other major Pan-African festivals of the 1960s and 1970s were so rich and so diverse that even a book-length study would struggle to engage with them in their entirety. I realised that there was a real need for a volume that would offer a sustained engagement with the contexts and legacies of the 1966 festival: then, as time passed and the 50th anniversary of the festival grew closer, it began to dawn on me that if I did not try and pull such a volume together, then perhaps no one else would.

A project such as this is impossible without archival research and I am greatly indebted to those bodies whose funding allowed me to visit various far-flung archives. I would like to recognize the support of the British Academy who awarded me two separate grants which permitted me to attend FESMAN 2010 and also to consult the official 1966 festival archive at the Senegalese national archives. A University of Stirling–Santander staff mobility grant made it possible to consult the Marian Anderson papers at the University of Pennsylvania in Philadelphia, as well as the official US festival organizing committee papers held at the Schomburg Center for Research in Black Culture in New York. Finally, funding from the Division of Literature and Languages at the University of Stirling facilitated a trip to consult the

Mercer Cook papers at the Moorland-Springarn Research Center at Howard University in Washington, DC.

Over the past six years, I have benefited from various opportunities to share my research on the 1966 and 2010 Dakar festivals, and I am very grateful to the following colleagues for invitations to speak on this topic at their respective universities: Sam Coombes (University of Edinburgh), Pierre-Philippe Fraiture (University of Warwick) and Lydie Moudileno (University of Pennsylvania). In addition, I was able to deliver papers to the French Media Studies Research Group Study Day on 'Sport and the Media' at the University of Newcastle (September 2011), an AHRC Workshop on 'Utopian Archives' at the University of East Anglia (May 2013), a conference on 'Pan-Africanism and Negritude' at Howard University (November 2015) and a study day on Francophone West Africa at the British Library (January 2016).

I offer my sincere thanks to Alison Welsby and Anthony Cond at Liverpool University Press for accepting to publish this volume. As always, they have been extremely supportive, demonstrating once again why Liverpool University Press is head and shoulders above most other academic publishers. I am also very grateful to the Press's anonymous reader who provided incredibly insightful feedback on a draft manuscript. I thank Aedín Ní Loingisgh for her brilliant translation of Cédric Vincent's chapter and for her typically astute comments on a draft of my introduction (any remaining flaws are, of course, my own).

In the process of researching this topic, I encountered numerous researchers who were simultaneously exploring various aspects of the 1966 festival, and some encounters have proven particularly fruitful: Tsitsi Jaji has been an amazingly generous source of information, leads and ideas on the 1966 festival and on Pan-Africanism, more generally; Sarah Frioux-Salgas, a curator at the Quai Branly Museum in Paris introduced me to some fascinating archival material on Dakar 1966 through her exhibition on Présence Africaine (2009–10); Sarah was also kind enough to introduce me to Dominique Malaquais and Cédric Vincent who were then just beginning their ground-breaking work on what would become the *PANAFEST Archive*. I am delighted that Tsitsi, Dominique and Cédric as well as so many other scholars and friends whose work I admire have contributed to this volume. Indeed, I am deeply grateful to all the contributors to this collection, who were a pleasure to work with not only in practical terms but also in thinking through the intellectual parameters of the project. And I hope this book will inspire others to take its ideas forward in new and unexpected directions.

Figures

between pages 42 and 43

Contributors

Samuel D. Anderson is a PhD candidate in African History at the University of California, Los Angeles. His work focuses on Muslim societies, education and law in north-west Africa in the colonial and postcolonial periods.

Andrew Apter is Professor of History and Anthropology at the University of California, Los Angeles. His monograph, *The Pan-African Nation: Oil and the Spectacle of Culture in Nigeria* (2005) is the sole full-length study of any of the major Pan-African festivals of the 1960s and 1970s.

Ruth Bush is Lecturer in French at the University of Bristol where her research interests include African literature, book history, and cultural studies. Her first book is *Publishing Africa in French* (Liverpool University Press, 2016). She has also recently published a web history of New Beacon Books, the UK's first radical black bookshop and publishing house, as part of the Heritage Lottery-funded 'Dream to Change the World' project.

Ferdinand de Jong is Senior Lecturer in Anthropology at the University of East Anglia. His publications include *Masquerades of Modernity* (2007) and *Reclaiming Heritage* (2007, co-edited with Michael Rowlands). He is currently completing a monograph on the heritage of Pan-Africanism in Senegal.

Elizabeth Harney teaches in the Art History Department of the University of Toronto. Her research focuses on global modernisms, contemporary art practices in Africa and its diasporas, postcolonial theory, and the politics of exhibition. Her first book, *In Senghor's Shadow* (2004) investigated the contours of Senegalese modernism and Negritude philosophy and received the prestigious Arnold Rubin Book Award.

Tsitsi Jaji teaches in the English Department at Duke University. Her first book, *Africa in Stereo: Modernism, Music and Pan-African Solidarity* (2014), traces Ghanaian, Senegalese and South African responses to African American music in print and film. One chapter is devoted to the role of jazz at FESMAN 1966 and in Senghor's thought more broadly.

Hélène Neveu Kringelbach is Lecturer in African Studies at University College London. Her monograph, *Dance Circles: Movement, Morality and Self-fashioning in Urban Senegal* (2013) explores various genres and contexts from women's dances during neighbourhood events and family ceremonies to 'contemporary' choreography, through popular dance videos and neo-traditional musical theatre.

Dominique Malaquais is a senior researcher at the Institut des Mondes Africains, CNRS (Centre national de la recherche scientifique, Paris). She is co-director of the *PANAFEST Archive*, a multidisciplinary research endeavour focusing on Pan-African arts and culture festivals of the 1960s and 1970s.

David Murphy is Professor of French and Postcolonial Studies at the University of Stirling. He has published widely on various aspects of modern and contemporary Francophone West African culture, including the monographs, *Sembene: Imagining Alternatives in Film and Fiction* (2000) and (with Patrick Williams), *Postcolonial African Cinema* (2007). Alongside his ongoing research on Pan-African cultural festivals, he is also currently preparing a biography of the interwar Senegalese anti-colonial militant, Lamine Senghor.

Brian Quinn is Assistant Professor of French at the University of Colorado, Boulder, where he teaches Francophone African literature. His research addresses performance practices in the former French colonies, and especially theatre and cultural heritage in urban Senegal.

Cédric Vincent trained as an anthropologist and is currently a researcher within the 'Anthropology of Writing' research group based at the École des hautes études en sciences sociales in Paris. He is co-director of the project, *PANAFEST Archive*, funded by the Fondation de France.

The Performance of Pan-Africanism: Staging the African Renaissance at the First World Festival of Negro Arts

David Murphy

We deeply appreciate the honor that devolves upon us at the First World Festival of Negro Arts to welcome so many talents from the four continents, from the four horizons of the spirit. But what honors us most of all and what constitutes your greatest merit is the fact that you will have participated in an undertaking much more revolutionary than the exploration of the cosmos: the elaboration of a new humanism which this time will include the totality of humanity on the totality of our planet Earth.

President Léopold Sédar Senghor, opening address at the festival colloquium, 30 March 1966, 'The Function and Meaning of the First World Festival of Negro Arts' (1966b): 5

There had never been anything quite like it...

On 30 March 1966, the Senegalese poet-president Léopold Sédar Senghor ascended the steps of the National Assembly in Dakar, which stands at the heart of the *Plateau*, the gleaming white city built by the French colonial authorities at the start of the twentieth century to act as the administrative centre of its vast West African Empire. Senegal had freed itself from French colonial rule in 1960, and here it was, just six years later, proclaiming itself temporary capital of black civilization at the launch of the First World Festival of Negro Arts. The festival proper would not begin for two days. Senghor was in fact at the National Assembly to launch a colloquium on 'The Function of Negro Art in the Life of and for the People', which would run from 30 March to 8 April. That Senegal should hand over its legislative chamber for more than a week to writers, performers, artists and scholars to discuss the significance of art in the emerging post-imperial world was entirely in keeping with the central role that Senghor attributed to culture and the

arts.[1] Culture was not merely rhetorically significant, for Senghor apparently backed up his words with hard cash: various sources estimate that up to 25 per cent of the national budget was devoted to the arts in the early years after independence (see Harney 2004: 49).

Organized against the backdrop of African decolonization and the push for civil rights in the USA, the Dakar festival was indelibly marked by the euphoria and idealism of the times. It emphasized Senghor's conception of the significance of culture and the arts in defining a global role for Africa in the aftermath of empire, and, in a complex mix of pragmatic achievements and utopian objectives, it sought to forge greater links between Africans and people of African descent. Above all, the festival was underpinned by Senghor's emphasis on culture as central to the development of Africa. In his speech to the delegates gathered in the National Assembly (cited in the epigraph above), Senghor hailed the 'revolutionary' nature of the festival which had no less a goal than the 'elaboration of a new humanism which this time will include the totality of humanity on the totality of our planet Earth'. New political structures were all well and good but they would serve no purpose without a new conception of humanity. His speech further assumed that all of the delegates present had bought into this agenda, as he told his audience, in an expression that flattered both him and them, that 'your greatest merit is the fact that you will have participated in an undertaking much more revolutionary than the exploration of the cosmos'. While the Soviets and the Americans raced to conquer space, the 'black world' was gathered together to find its soul. In essence, the festival sought to situate culture at the heart of the post-imperial world. Leaders of these emerging postcolonial countries had famously gathered in Bandung in 1955 and Senghor's close ally, Alioune Diop, founder of the Présence Africaine journal and publishing house, dreamed of 'un Bandung intellectuel pour l'Afrique' [an intellectual Bandung for Africa] (Verdin 2010: 234): the political revolution would now be accompanied by a philosophical and cultural revolution.

Senghor's status as political and cultural figurehead was both a boon and an obstacle for the festival. The French government's highest-ranking representative in Dakar, Minister for Culture, André Malraux, took the floor after the President, and, using typically exalted rhetoric, was unstinting in his praise for Senghor's vision, declaring in his much-cited speech: 'Nous voici donc dans l'Histoire. Pour la première fois un chef d'état prend entre ses mains périssables le destin d'un continent' [Here we are at a great moment in History. For the first time, a head of state has taken into his mortal hands the destiny of a continent] (Malraux 1966b).[2] Malraux's elevation of Senghor

1 This was not the only occasion that saw Senghor use the National Assembly in this way. For example, in 1971, international delegates gathered there to discuss the ongoing significance of Negritude as a cultural philosophy and set of values.

2 The full text of Malraux's speech is available from various online sources and is also reprinted in the festival's 'livre d'or': *Premier Festival mondial des arts*

to the status of sole creative mind behind the festival was unsurprising, given that he devoted the latter part of his career to the service of France's own providential leader, General Charles de Gaulle. For Senghor's friends, such praise from the French authorities constituted proof of his constructive and pragmatic approach to relations with Senegal's former imperial's masters; for his enemies, it constituted further evidence that Senghor was a neo-colonialist whose aim was to maintain French dominance after the formal end of empire.

The First World Festival of Negro Arts was a modern cultural event on an unprecedented scale in Africa and, as its official title suggests, the organizers were keenly aware of its pioneering status. The festival may not have been the first transnational black cultural gathering—the preceding decade had witnessed the celebrated Congresses of Black Writers in Paris (1956) and in Rome (1959); African writers gathered together for a congress at Makerere University (Uganda) in 1962, while that same year an International Congress of African Culture was held in Salisbury (in what was then Southern Rhodesia)—but it was the first time that a festival on this scale celebrating black culture had been organized. That such a grandiose event should take place in an Africa gradually liberating itself from a century of colonial rule was symbolic of the growing sense of a new dawn for the continent. On a more pragmatic level, the festival would also allow Africans to discover more about each other, as well as forging greater links with the diaspora.[3]

The festival ran from 1 to 24 April 1966 (although, as we have seen, the festival colloquium began on 30 March), dates chosen to coincide with the major religious festivals of Easter and Tabaski, as well as Senegalese national independence (4 April). Over the course of three and a half weeks, more than 2,500 artists, musicians, performers and writers, including Senghor and Aimé Césaire (two of the three founding figures of Negritude), as well as Langston Hughes, Duke Ellington, Josephine Baker and Wole Soyinka gathered in Dakar: indeed, the list of participants reads like a 'who's who' of some of the greatest black cultural figures of the early and mid-twentieth century. However, it did not go unnoticed at the time that the choice of participants largely favoured an older generation of artists, viewed as more politically and aesthetically conservative by many of the younger generation. Some of the most prominent invitees represented an era that had begun with the celebration of the New Negro, the Harlem Renaissance, the jazz age and Negritude. By 1966, however,

nègres (1967). The most widely available printed source is the second volume of Malraux's memoirs, *Le Miroir des Limbes*, in a section that contains a wider account of his trip to Senegal (1976: 11–48). The opening ceremony was formally opened by Lamine Guèye as President of the National Assembly. Next to speak was Alioune Diop, as President of the Association du Festival, who then handed over to Senghor, followed finally by Malraux (Huchard 2012: 123).

3 Interviewed in 2008, internationally renowned arts curator Simon Njami stated that one of the benefits of African visual arts exhibitions/biennales is that they allow Africans to know more about each other as 'les Africains ne connaissent pas l'Afrique' [Africans don't know Africa] (Vincent 2008c: 108).

the ideas, values and politics that had been central to the transnational black politics of the mid-century were increasingly being challenged. The festival was also quite categorically a celebration of the 'high arts' and not a more generic celebration of 'culture' (another clear sign of Senghor's influence on its underlying philosophy): it would celebrate Africa's cultural renaissance by primarily celebrating the continent's 'Classical' tradition.

Representatives from 30 independent African countries gathered in Dakar, and six countries with significant African diasporic populations were also represented: the USA, Brazil, Haiti, Trinidad and Tobago, the United Kingdom and France. At the Congresses of Black Writers in 1956 and 1959, the desirability of holding a similar event in Africa, drawing together writers and intellectuals, had been discussed. At the latter event in Rome, a formal resolution was taken that the recently created Société africaine de culture should make this happen.[4] However, by 1966, the scale of the festival had developed far beyond these original plans to become a sprawling event spanning literature, theatre, music, dance, film, as well as the visual and plastic arts.

The participation of the US delegation was of particular importance to Senghor. In 1930s Paris, he and a group of fellow black students from Africa and the Caribbean had been inspired by the Harlem Renaissance and its self-confident celebration of black culture to launch the Negritude movement, which sought to promote black pride among France's colonial subjects. In turn, the festival's significance as a historical event was not lost on African American visitors as disparate as the legendary jazzman, Duke Ellington, and the streetwise, radical journalist Hoyt Fuller:

> The 1966 World Festival of Negro Arts in Dakar, Senegal, is a really great accomplishment. [...] Never before or since has the Black Artist been so magnificently represented and displayed. (Ellington 1973: 337)

> There had never been anything quite like it. From four continents and the islands of the Caribbean, thousands of people with some claim to an African heritage converged on Dakar, Senegal, the glittering little cosmopolitan city on the western-most bulge of Africa, and there they witnessed— or took part in—a series of exhibitions, performances and conferences designed to illustrate the genius, the culture and the glory of Africa. (Fuller 1966d: 91)

The poet, Langston Hughes, the elder statesman of African American literature, was one of the most eagerly anticipated guests. He was received at the presidential palace where Senghor recited one of the visiting American's

4 The Société africaine de culture had been founded in the aftermath of the 1956 Paris Congress at the Sorbonne. It was created by Alioune Diop as a response to the racism he encountered within the Société européenne de culture and it had the practical benefit that, as a non-commercial enterprise (unlike Présence Africaine), it could receive funding from bodies such as UNESCO (Verdin 2010: 272–73).

poems, which he had himself translated for the occasion (Figure 1). As Arnold Rampersad states in his biography of Hughes, the African American poet enjoyed a semi-official role as a presiding spiritual father during the festival (1988: 400–03). For Senghor, Hughes embodied the cultural bond between Africa and people of African descent; bringing him to Dakar for the festival meant closing the circle between Africa and the diaspora that had begun to be traced during the interwar period.

In its aim to give concrete cultural expression to the ties that would bind the African 'homeland' to its diaspora, the festival sought, I would argue, to *perform* an emerging Pan-African culture. Judith Butler's work on identity as performance has marked scholarship across various fields in the last few decades. It is now a given for most scholars that identity is not fixed; rather, it is constantly played out and negotiated in a range of complex ways. Similar ideas have been prevalent in influential scholarship on identity in African contexts. For example, in the field of anthropology, influential work by Jean and John Comaroff (2009; see also De Jong 2007) has explored how 'authentic' African national and ethnic identities are performed and brokered in complex political, social and economic contexts. My own conception of Pan-Africanism as performance owes a particular intellectual debt to similar notions about black identity/community that have been articulated by Brent Hayes Edwards and Tobias Wofford. For Edwards, there is no pre-existing transnational blackness; rather it is something that is constantly reworked through the 'practice' of diaspora (Hayes Edwards 2003); while, in a persuasive essay on the Dakar festival, Wofford follows Stuart Hall in examining identity as a 'process' or form of 'production': 'The First World Festival of Negro Arts [...] can be seen as an attempt to *produce* a global community through a shared blackness' (2009: 181; my emphasis).

The participants and audiences at the Dakar festival all brought with them their own, sometimes complementary, sometimes conflicting, notions of what black and/or (Pan-)African identity actually meant. In this sense, the 1966 event reflects Simon Njami's conception of the arts biennale, which he prefers to the curated arts exhibition: 'Avec une exposition, on défend une thèse, avec une biennale, on en ouvre 150, et en s'autorisant des pistes contra-dictoires' [With an exhibition, one defends a thesis, with a biennale, one opens up 150 of them, and authorizes contradictory understandings] (Vincent 2008c: 102). Analysis of the First World Festival of Negro Arts does not reveal a single vision of Pan-Africanism, for by its very nature, the festival involved the creation of a space in which multiple versions of Pan-Africanism and the African Renaissance could be performed.

Tsitsi Jaji writes in *Africa in Stereo*, her innovative exploration of trans-Atlantic musical encounters, that 'the Afromodern experience is collaboratively, coevally, and continually forged' (2014: 4), and the First World Festival of Negro Arts is a striking example of that very process at work. For just short of a month, the festival's daily performances provided a forum in which Pan-Africanism was given a series of material but ephemeral forms: as with

5

all performances, it was never quite the same from day to day, but in the shared, collective space of the festival, audiences could explore cultural and emotional connections spanning the black world. The African Renaissance had been announced in countless speeches and essays and now here it was leaping off the page in a living illustration of black culture and identity.

Researching Pan-African Festivals

The present volume seeks to explore the multiple ways in which the Dakar festival performed this African Renaissance, providing the reader with an overview of the festival's main strands, its aims and objectives, and also its many legacies, not least the series of mega-festivals that would follow over the ensuing decade. It seems remarkable that no single volume has previously attempted to do justice to the scale and ambition of the festival. Indeed, in the decades immediately following the event, it was habitually relegated to passing (albeit often glowing) references in biographies of Senghor as the high water mark of Negritude. However, beyond the enumeration of its main partic-ipants and the use of quotations from Senghor's key speeches at, or in advance of, the event, the festival itself was rarely the subject of in-depth analysis.[5] It was as though the simple fact of the festival having taken place was enough to illustrate what it had meant. Equally, for critics of Senghor, of whom there were many from the mid-1960s onwards, the festival was assumed to have been the straightforward celebration of Negritude that its proponents said it was. This critical reaction to the idealism of the festival can at times seem like a response to the euphoria expressed during an exuberant and drunken party: on the one hand, a vague, warm glow at the memory of the elation felt during the event while details are lost in a drunken haze; on the other, these high hopes evaporate in the cold light of day when all that remains is a financial hole in the party goer's pocket and an unpleasant hangover. As Cédric Vincent has written of the memory of all the Pan-African festivals of this era: 'leur héritage demeure flottant et stéréotypé, lié à la prégnance de leur aura plus qu'à la qualité mémorielle. Curieusement, leur histoire reste à écrire' [their legacy remains fluid and stereotyped, linked more to the extent of their renown than to the richness of public memory about them. Curiously, their history remains to be written] (Vincent 2008d: 17).

Over the past two decades, however, a growing number of scholars have begun to explore the archival traces of the 1966 festival and to assess its significance in greater detail. Given the sheer scale of the event, their

5 A striking but by no means exceptional example of this is Jacques Louis Hymans' biography of Senghor, which does not discuss the Dakar festival at all in the main body of the text. However, in an appendix featuring a chronology of Senghor's career, he writes 'Festival of Negro Arts in Dakar: apotheosis of négritude' (Hymans 1971: 262).

analyses, rather than attempting an overview of the entire festival, have quite understandably focused on providing sustained examination of specific aspects: the art exhibitions (Snipe 1998; Harney 2004; Ficquet and Gillimardet 2009; Wofford 2009), dance performances (Castaldi 2006; Neveu Kringelbach 2013a); theatre (McMahon 2014); musical performances (Jaji 2014); the literature/cinema programme (Murphy 2012b; 2015); the participation of the US delegation (Ratcliff 2014). Their research has typically involved the careful excavation of various archival sources: the Senegalese national archives hold 48 box files of material from the overall festival organizing committee (yet another sign of the desire on the part of the Senghorian state structures to ensure the legacy of the festival). Other major archival sources include the Schomburg Center for Research in Black Culture (New York), which holds the papers of the US organizing committee; the University of Pennsylvania holds the personal papers of the great classical singer, Marian Anderson, honorary chairman of the US committee; while the Moorland-Springarn Research Center at Howard University in Washington holds the papers of Mercer Cook, the US ambassador to Senegal from 1964 to 1966.[6] In addition, the festival organizers produced a range of material to mark the event—including several books, at least three LP records (Figure 2) and even a set of commemorative stamps— that sought in part to act as an interpretive framework in which it was to be understood.[7] The festival also spawned several documentary films—including

6 Cédric Vincent's contribution to this volume (Chapter 1) lists a further series of important archival sources in relation to the *Negro Art* Exhibition, which was a central component of the Dakar festival. See also Chapter 10 on the value and limitations of official archives.

7 Five 'official' texts were published either shortly before or shortly after the festival, although somewhat confusingly two of them, published in 1966 and 1967 respectively, appeared under precisely the same title: *Premier Festival mondial des arts nègres*. The 1966 text, produced in advance of the event, is the festival programme, which features a series of essays on black and African culture (by the likes of Senghor, Engelbert Mveng and Lamine Diakhaté), as well as tourist information for visitors. The 1967 text, often referred to as the 'livre d'or du festival' is a very handsome coffee table book with very little text but lots of photographs from the festival and a full list of prize winners in the event's various categories. *L'Art nègre: sources, évolution, expansion* (1966) is the official catalogue for the exhibition held initially at the Musée Dynamique and subsequently at the Grand Palais in Paris. The text of the *Spectacle féerique de Gorée* was produced in a slim volume in 1966. Finally, the colloquium proceedings were published by Présence Africaine in 1967 under the somewhat cumbersome title, *1er Festival mondial des arts nègres, Dakar 1er–24 avril 1966. Colloque Fonction et signification de l'art nègre dans la vie du peuple et pour le peuple, 30 mars–8 avril, 1966*. As for the festival recordings, the LP, *1er Festival mondial des arts nègres, Dakar 1966* was released by Philips in Paris and contains material from the *Spectacle féerique de Gorée*, traditional West African court music and choral arrangements sung by the Leonard de Paur choir; *Premier Festival Mondial des Arts Nègres: Contributions Musicales des Nations Africaines*, also released by Philips, contains (as its title suggests), songs by artists from 12 different African nations; finally, another LP,

The First World Festival of Negro Arts by the celebrated African American filmmaker William Greaves, *African Rhythms*, shot by a Soviet film team and *Le Sénégal au Festival mondial des arts nègres* by Paulin Soumanou Vieyra (although this last film appears to have been 'lost').[8] Greaves' film is without doubt the best known of the three and, for many, it constitutes the primary (perhaps sole) visual record of the festival that they have encountered;[9] however, as we shall see below, it offered a somewhat partial vision of the event.

The 1966 Dakar festival was followed by a series of major Pan-African cultural festivals: the First Pan-African Cultural Festival held in Algiers (Algeria) in 1969; Zaïre '74, a music festival held in conjunction with the Muhammad Ali–George Foreman fight, the *Rumble in the Jungle*, that took place in Kinshasa (then Zaïre, now Democratic Republic of the Congo) in 1974;[10] and the Second World Festival of Black Arts and Culture, better known as FESTAC, the belated successor to the 1966 Dakar festival, held in Lagos (Nigeria) in 1977. (See Chapter 10 for a discussion of a research project attempting to archive these events.) These other major Pan-African festivals of the 1960s and 1970s have been marked by a similar absence of sustained critical analysis, with the signal exception of Andrew Apter's ground-breaking monograph, *The Pan-African Nation: Oil and the Spectacle of Culture in Nigeria* (2005), which examines the politics of FESTAC '77.[11] Apter explores how the postcolonial Nigerian state, flush with oil revenues, attempted to project a Pan-African culture that was truly global but that positioned Nigeria as the centre of this culture: 'Nigeria's black and African world was clearly an imagined community, national in idiom yet Pan-African in proportion, with a racialized sense of shared history, blood and culture' (6). Apter had embarked on his project

also entitled *1ᵉʳ Festival mondial des arts nègres, Dakar 1966*, was released by Barclay and featured songs performed by the Ensemble Instrumental Traditionnel du Sénégal.

8 Greaves' film can be obtained from his website: www.williamgreaves.com/catalog. htm (consulted 21 December 2015). The Soviet film exists in two versions, one longer than the other and each featuring different material. It is sometimes found under the title *African Rhythmus* (see, for instance, the copy held by the New York African Film Festival), but this may simply be the result of a typographical error that has slipped into the records. Details of Vieyra's filmography can be found at: www.psv-films.fr (consulted 21 December 2015). In the course of their research, the PANAFEST Archive team also discovered two further documentary films about the festival, one Italian, the other Romanian: *Il Festival di Dakar*, by Sergio Borelli (1966 Italy, 50 mins) and *Rythmes et Images: Impressions du Premier festival mondial des arts nègres*, by V. Calotescu and C. Ionescu-Tonciu (1968, Romania, 20 mins).

9 For an overview of Greaves' career, see Knee and Musser (1992).

10 See Dominique Malaquais' incisive analysis of *Zaïre '74* for one of the few in-depth scholarly engagements with the festival (Malaquais 2008).

11 Mériem Khellas' short book (2014) on the 1969 Algiers festival contains fascinating information on the event. Despite the ongoing lack of monographs, there is a growing number of edited publications, articles and book chapters on these major Pan-African festivals: see Vincent (2008a); Coquery-Vidrovitch (2013).

assuming that FESTAC would constitute the antithesis of the great colonial exhibitions but soon found a more complex set of relationships between the exhibitionary practices of the colonial and postcolonial periods: '[FESTAC's] [a]rtistic directors and cultural officers invented traditions with pre-colonial pedigrees [...] [I]n a fundamental sense, the customary culture which FESTAC resurrected was always already mediated by the colonial encounter, and in some degree was produced by it' (6).

My approach to the First World Festival of Negro Arts is greatly indebted to Apter's work. Although the context in Dakar in 1966 was in several respects rather different from mid-1970s Nigeria—Senegal was a small country, with no oil boom to boost its economy or self-esteem—it witnessed similar attempts to perform a Pan-African culture that was predicated upon problematic colonial-era notions of racial and ethnic identity. This volume also builds on the work of Tsitsi Jaji and Cédric Vincent who have revisited the Pan-African festivals of the 1960s and 1970s and explored the cultural and political energies that they managed to harness. For, despite their very real differences, each of the four major Pan-African festivals of this era shared the fact that they were driven by a vision of the providential nation state as the source of all legitimacy, even as the events themselves promoted a dissolution of the national within the transnational vision of Pan-Africanism.

The aim of this introduction, and of the volume more widely, is to trace the problematic aspects of the Dakar festival's *performance*, as well as the ways in which the event mobilized a set of utopian energies that still have resonance today. In so doing, the volume seeks to move beyond the type of dichotomous responses to the festival that were outlined above, which sought to short-circuit analysis by deeming the event to be either a success or a failure. In addition, the current publication is the first sustained attempt to provide not only an overview of the festival itself but also of its multiple legacies: from the subsequent mega-festivals in Algiers (1969), Kinshasa (1974) and Lagos (1977) to the 'festivalization' of Africa from the early 1990s onwards, which has seen culture become more explicitly tied into a discourse of economic development through the promotion of cultural tourism, although, as will be argued below, the temptation to read this evolution as a shift from the idealism of the 1960s and early 1970s to a greater political and economic pragmatism should be resisted. The remainder of the introduction will provide an overview of the festival organization and situate the event within the very specific political climate of the period. It will give a taste of the full range of arts that were showcased during the festival and examine the involvement of the important US delegation, which was so central to Senghor's vision for the event. In addition, it begins the exploration of some of the major questions that are at the heart of subsequent chapters: what is the role of culture in a post-imperial world? How exactly does culture contribute to 'development'? Does any of the utopianism of the 1960s survive in the contemporary world in which festivals have become central to the culture industry?

The volume is divided into two sections, 'Contexts' and 'Legacies'. In the first section, Chapters 1–5 engage with different aspects of the festival: the 'traditional' art exhibition (Vincent), dance (Neveu Kringelbach), theatrical and other performances (Quinn and Bush), and the way the festival was mediated for various audiences via the contemporary black press (Jaji). (Vincent's chapter is the first in this section precisely because of the importance of the exhibition on *L'Art nègre*.) The intention is not to provide exhaustive coverage of the event as a whole (which would have been an encyclopaedic undertaking). Instead, these chapters offer in-depth analysis of the debates surrounding different artistic forms, and explore the ways in which the postcolonial nation state mobilized culture as part of an attempt to imagine post-imperial forms of belonging and identity. Together, the different contributions reveal the tensions and continuities between different artists and works of art enlisted to act as expressions of Pan-Africanism and Negritude; they also reveal the clear hierarchies involved in the selection of these 'negro arts'.[12]

The second section analyses the festival's legacies: in the first instance, this involves analysis of the 1969 Algiers festival (Anderson) which was specifically conceived as a radical response to the Dakar event, and the 1977 Lagos festival (Apter) which, although explicitly billed as the successor to the First World Festival of Negro Arts, sought to distance itself from many aspects of its predecessor, an event it read in large part through the critical lens of the 1969 Algiers colloquium at which Negritude was loudly denounced. The focus then expands to a wider consideration of the 'festivalization' of African culture that has occurred in recent decades (also referred to as 'festivalism'), with detailed analysis of a specific local cultural festival held in Senegal (De Jong) and a wide-ranging discussion of contemporary black and African arts festivals both in Africa and the West (Harney). The final chapter seeks to draw conclusions regarding the significance and legacy of the four major Pan-African festivals mentioned above in light of the findings of the French-led research project, *PANAFEST Archive* (Malaquais/Vincent), based at the École des hautes études en sciences sociales in Paris.[13] This concluding chapter reflects on questions central to each of the chapters in this volume: what is the archive of ephemeral events such as the First World Festival of Negro Arts and how should scholars confront the challenge of tracing their legacy?

12 From the 1980s onwards, Negritude largely fell out of fashion as a topic of academic exploration but there has been a resurgence of interest in the subject over the past decade, which has led to some highly innovative new approaches to the subject (see, for example, Wilder 2005 and 2015; Thiam 2014).
13 The project website can be found at: www.iiac.cnrs.fr/article477.html (consulted 21 December 2015).

Culture and the Festivalization of Africa

The emergence of a body of scholarship on African cultural festivals must be seen within the context of the 'festivalization' of Africa (and much of the rest of the world)—part of what has been termed a general 'spectacularization' of culture (Vincent 2008d: 12)—as festivals have become key elements in continent-wide policies of cultural and touristic development. The great transnational festivals held in Africa in the 1960s and 1970s often appeared exciting, radical and utopian, seeking in their own different ways to imagine new communities/identities and to challenge the global order. Can that utopianism survive when festivals are seen as part of a set of leisure, tourism and development agendas?

As has been the case elsewhere in the world, the rise of a festival industry has not met with unanimous approval. The Ghanaian writer, Ayi Kwei Armah, long resident in Senegal, wryly commented on the (eventually aborted) plans to host a Third World Festival of Negro Arts in the country in the mid-1980s:

> This is the kind of news that raises the hope that some day Africa's creative and productive artists will see through the festival game and leave the parasites alias bureaucrats to organize, to participate in, and finally to make their petty personal profits from such wasteful demonstrations of intellectual bankruptcy—on their own. In short, such news is bad news. (Armah 2010 [1985]: 133)

Armah here takes aim at what he views as the African nation state's inability to foster genuine artistic creativity. However, the festivals of the past two decades are just as likely to have been either commercial endeavours or to have been driven by NGOs, for whom cultural diversity emerged as a key element of international programmes combating poverty from the 1990s onwards (Andrieu 2013: 123).[14] These events also tend for the most part to be organized on a far smaller scale than the mega-events of the 1960s and 1970s, which allows them to engage more with local communities rather than acting as top-down initiatives of a remote state (see Douxami 2008: 81–82). Ferdinand de Jong (Chapter 8) refers to the cultural performances at local festivals as 'masquerades of modernity', which demonstrate that 'the independent Senegalese state and its subjects have reclaimed the format of the colonial exhibition for a modernist agenda by deliberately forgetting the colonial origins of its cultural archive'. The cultural festival is now simply a part of the modern Senegalese/African landscape.

The decision finally to host a Third World Festival of Negro Arts in Dakar in December 2010—following just over a year after a fortieth anniversary staging of the Algiers Pan-African Cultural Festival—illustrates the hybrid form taken by the contemporary 'mega-festival'. A certain critical and artistic

14 One of the most important critics of 'festivalization' or 'festivalism' is Peter Schjeldahl (1999).

faith in Pan-Africanism has endured but, equally, these events can, and have, been interpreted as exercises in nostalgia, which attempt to incorporate the idealism of the past into the contemporary global cultural market. The 2010 festival was branded as 'FESMAN 2010', taking its name from the initials of the French title, 'Festival mondial des arts nègres'; and this abbreviation was probably modelled on FESTAC, acronym of the 1977 Lagos festival. It seems highly likely that the FESMAN title was part of a marketing exercise designed to create an easily recognizable brand name. (FESMAN was not a term used at the time in conjunction with the 1966 festival, either in the festival documentation or in responses to it, but the effect of the 'FESMAN' label post-2010 has been for it to be deployed retrospectively in relation to 1966.[15])

The rapid development of the global culture industry has been the subject of powerful analyses by various commentators over the past decade and more, and the role of cultural festivals within this framework of culture as commodity has been increasingly examined.[16] Africa is gradually finding a place within the scholarship that has come to constitute the emerging field of festival studies: for example, Lindiwe Dovey's *Curating Africa in the Age of Film Festivals* (2015) explores the evolving role and status of African film festivals; a major research project, *PANAFEST Archive* (mentioned above and discussed in Chapter 10), seeks to excavate a new archive for the First World Festival of Negro Arts, alongside the other three great Pan-African festivals of the 1960s and 1970s; while Akin Adesokan and the team around the South African-based magazine and online platform *Chimurenga* have done outstanding work in making visible the archive of FESTAC '77.[17]

It would be a mistake, however, to read the evolution of African cultural festivals as a straightforward shift from idealism to consumerism. Festivalization does not merely present culture as a commodity. As Sarah Andrieu has argued, all African festivals tend to view culture and development as inextricably linked, and they continue to play a key role in the construction of local, regional and national identities (Andrieu 2013; see also Doquet 2008 and Djebbari 2013). Also, despite the retrospective idealization of the 1966 festival in particular, the Pan-African festivals of the 1960s and 1970s all had one eye firmly fixed on the emerging culture industry as an important

15 Several of the contributors to this volume have used the term 'FESMAN 1966' to refer to the First World Festival of Negro Arts. This is not something that needs to be 'corrected', for, although the terminology is, strictly speaking, anachronistic, the use of the FESMAN label for the 1966 event is now common usage and is likely to remain so.

16 See, in particular, Amirou (2000); Yúdice (2004); Picard and Robinson (2006); Giorgi et al. (2011); Fléchet et al. (2013).

17 For the project website, see: www.chimurengalibrary.co.za/festac-77 (consulted 19 February 2016). The team has also worked closely with the Tate Modern in London on a project entitled *Across the Board*, examining artistic practices in Africa and the diaspora: www.tate.org.uk/download/file/fid/37959 (consulted 19 February 2016).

source of revenue, and, indeed, cultural tourism has been one of the main legacies of these events. Many of the official publications produced by the 1966 Dakar festival organizers emphasized the opportunities for performers, delegates and visitors to enjoy the sights and sounds of Senegal during the event or perhaps to enjoy a holiday afterwards. This emphasis was not lost on attendees. Hoyt Fuller wrote that 'the Festival was also a gamble at stimulating tourism' (1966d: 102), although he was sceptical about its likely success: 'Dakar was thrilling during the Festival but what it is like when there are no celebrations is what will make all the difference to tourists' (102).[18]

Recognition of the festival organizers' desire to promote tourism is not to deny that they also had their other eye firmly placed on the larger historical picture: after centuries of Western domination, through slavery and colonialism, Africa was now free, with figures of all political stripes proudly proclaiming that an African Renaissance was at hand, and these festivals constituted self-conscious performances of that renaissance. As Aedín Ní Loingsigh's work demonstrates, we should not view the festival's idealism and its pragmatism as dichotomous: 'the development of a viable Senegalese tourist industry capable of catering to the transnational market of FESMAN was seen as a powerful means of representing the nation as a modern economy' (2015: 80). Moreover, Senegal's ability to host a major international event was seen in itself as proof of the renaissance the festival was seeking to stage. By the same token, later festivals from the 1990s onwards, although bound up in a discourse that promotes the culture industry as central to economic development, still serve as complex sites for the expression of multiple identities (local, national, transnational).

Culture and Development

On one level, then, the discourse on development surrounding the Dakar festival envisaged the growth of what we would today refer to as the culture industry. At a more profound level, however, the major Pan-African festivals of the 1960s and 1970s also gave culture a utopian status that posited it as central to the identity and unity of the former colonies, and crucial to their evolution as independent nations.[19] The persistence of the perceived link

18 A central plank of the festival's tourism strategy appears to have been the promotion of the southern region of Casamance as a site in which an 'authentic' African culture could still be found. Festival organizers held cultural events and organized tourist excursions in Casamance before and during the main festival in Dakar, and produced a small brochure to accompany these events. See Archives Nationales du Sénégal, FMA016. Malraux was the most famous festival invitee to avail himself of the opportunity to engage in cultural tourism in Casamance, an experience he wrote about in his autobiography (1976).

19 This does not mean, however, that there has been unanimity either around the significance of festivals (see Armah 2010 [1985]) or the notion of development: as

between culture and development reveals some of the underlying similarities between events as seemingly opposed as the Dakar and Algiers festivals (as is also argued in Chapter 10). The ideological language may have been different but, as I have argued elsewhere (Murphy 2015), there was also a fundamental continuity in terms of the core vision that the post-imperial world should be as concerned with the cultural elevation of Africa as it was with its industrial and scientific development.

For Senghor, culture should be placed at the heart of any attempt to consider progress or development. At the National Congress of his Union Progressiste Sénégalaise (UPS) political party in late 1966, Senghor's speech dealt with various budgetary matters and justified the expenditure that had been set aside for the festival in the following terms: 'Les sacrifices financiers que le Festival nous a coûtés, nous ne devons pas le regretter parce qu'il s'agit de culture et qu'encore une fois, la culture est au commencement et à la fin du développement' [The financial sacrifices that the Festival has cost us should not be a source of regret because this is a question of culture, and, let me repeat it again, culture is the source and the conclusion of development] (cited in Rous 1967: 81). What did it mean to position culture as 'the source and the conclusion of development'? Was Senghor arguing that cultural development was more important than the industrial and technological development of his homeland? If so, does the logic of this argument not lead to a situation in which culture is posited as a form of compensation for the absence of material development? In a country entering a vicious cycle of drought and famine that would devastate large sections of the rural population, some would argue that expenditure on the festival was merely a frivolous and irrelevant extravagance. But, for Senghor, there was a deeper political and ideological agenda at work. If the festival's work could be deemed more important than the exploration of space, then it was also more important than the economic and infrastructural development of his homeland: for what price could be placed on the cultural renaissance of the black world?

This is why Senghor's staging through the festival (as he had previously done through his writing) of an African Renaissance was so significant. His writings had worked for decades to define an African 'classical' age that might act as an inspiration for the future, and, in particular (as will be seen below), the exhibition at the Musée Dynamique 'reunited' many of Africa's 'classic' works of art under one roof for the first time. In speeches prior to the festival, Senghor underlined this 'classical' theme, making remarkable comparisons between contemporary Senegal and ancient Greece:[20]

Congolese writer Sony Labou Tansi famously declared 'Je ne suis pas à développer. Je suis à prendre ou à laisser' [I am not someone to be developed. I am someone to take or leave as you find me] (cited in Mensah 2007: 6).

20 Ali Mazrui provides a striking analysis of the influence of the Classical tradition on African nationalists in his short text, *Ancient Greece in African Political Thought* (1967).

[Le peuple grec] habitait un pays pauvre, fait de plaines étroites et de collines caillouteuses. Mais, comme le peuple sénégalais, il avait la mer en face de lui et des céréales sur ses plaines et de l'huile sur ses collines, et du marbre dans son sol [...] C'est pourquoi, si longtemps que vivront des hommes sur notre planète, ils parleront de la civilisation grecque comme d'un monde de lumière et de beauté.] (Speech to UPS in January 1966; Rous 1967: 76–77)

[The Greeks lived in a poor country of narrow plains and rocky hills. But, like the Senegalese people, they had the sea beside them, cereals on the plains, oil in the hills and marble in the soil [...] That is why, as long as Men are alive on this planet, they will speak of Greek civilization as a world of light and beauty.]

This is, in many ways, a typical piece of exalted Senghor prose, far removed from the day-to-day concerns of many of his people, although it was also a canny piece of political stage-management, announcing for his homeland a vocation that belied its size. The Rome to Senegal's Greece was Nigeria, which, as the rest of the speech makes clear, wins hands down in terms of quantity; however, the smaller country has nothing to envy it in terms of quality. Also, despite Senghor's love of abstraction and *la longue durée*, the festival and not least the exhibition at the Musée Dynamique were built on hugely impressive diplomatic and practical achievements. In its complex mix of the utopian and the pragmatic, the First World Festival of Negro Arts was thus a striking example of the approach that Gary Wilder has identified as central to the post-war thought of both Senghor and Aimé Césaire in his remarkable study, *Freedom Time: Negritude, Decolonization, and the Future of the World* (2015). Although Wilder focuses on the period from 1945 to 1960, and the ultimately failed attempt to construct a federal solution that would tie France to its former colonial possessions—in what he calls 'pragmatic-utopian visions of self-determination without state sovereignty' (7)—his analysis is applicable to their (equally fraught) attempt through the festival to construct a transnational black community:

[Césaire and Senghor's] projects were at once strategic and principled, gradualist and revolutionary, realist and visionary, timely and untimely. They pursued the seemingly impossible through small deliberate acts. As if alternative futures were already at hand, they explored the fine line between actual and imagined, seeking to invent sociopolitical forms that did not yet exist for a world that had not yet arrived. (Wilder 2015: 2–3)

Wilder's reading of Senghor's and Césaire's transnational political imagination in the post-war period invites us to look beyond the 'failures' of their project and its perceived lack of realism. Their willingness to imagine a post-imperial world outside the confines of the nation state or the hegemony of Western imperialism may ultimately have been unsuccessful but it offered models and ideas—a commitment to transnational forms of community, and a focus on culture as the best way to forge that community—that continue to inspire many black people both in Africa and the diaspora.

Negritude, Pan-Africanism and the Search for Black Unity

The reader has probably realised by this point that this introduction is working on the assumption that both Negritude and the First World Festival of Negro Arts constituted very specific expressions of Pan-Africanism. Negritude and Pan-Africanism are, of course, not wholly interchangeable terms: the former concept implies a racial understanding of Africanness that is absent from some of the broader geopolitical constructions of a Pan-African identity. Indeed, the 1966 Dakar festival revealed some of the tensions between Negritude and these broader understandings of Pan-Africanism, as North African nations were given observer status and excluded from official festival competitions, although some North African art works were exhibited at the Musée Dynamique (see Chapter 1 for further details) and there were performances of music and dance (including a concert by the Tunisian singer and writer, Taos Amrouche). However, such tensions do not make Negritude and Pan-Africanism opposing concepts, for the latter term has always been malleable, available to those keen to give it a racial or a geopolitical meaning.

The concept of Pan-Africanism had been born in the nineteenth century, as a way of attempting to forge a common bond between Africans and those of African descent (primarily) in the Americas, one that might transcend the historical catastrophe of the Atlantic slave trade and growing European domination of what it viewed as the 'dark continent'. In the first half of the twentieth century, Pan-Africanism inspired the writings of key black intellectuals such as W.E.B. DuBois and George Padmore who sought to 'reunite' the black world through a series of major congresses (London, Paris, Brussels, Manchester). Then, in the era of decolonization, figures such as Ghanaian president Kwame Nkrumah aimed to give tangible political form to the Pan-African ideal through the attempted creation of a United States of Africa.[21] Paradoxically, the European empires had reinforced Pan-Africanism by bringing colonized peoples together: as was mentioned above, Negritude was born in Paris, while, as is noted by several contributors to this volume, the William Ponty School in Senegal would play a foundational role in the emergence of a Pan-African performing culture.

The First World Festival of Negro Arts was organized in the middle of a period extending from the late 1950s to the mid-1970s during which a wide range of organizations and events—cultural, sporting and political—informed by Pan-Africanist ideals were created: from the footballing African Cup of Nations in 1957, through the launch of the Organization of African Unity (OAU) in 1963 to the first of the now biennial festivals of African cinema (FESPACO) in Burkina Faso in 1969. As was mentioned above, the 1966 festival

21 Nkrumah's brainchild, the Organization of African Unity, proved unable to drive greater African integration and, in a rather grim irony, the Ghanaian was overthrown in a *coup d'état* in early 1966, shortly before the Dakar festival.

was also followed by a series of other major Pan-African cultural festivals. During this period, the cultural domain arguably became the privileged forum for the expression of Pan-Africanist sentiment, at the very moment when political independence for Africa and civil rights (if not actual equality) for African Americans became a reality. It may seem ironic that what had long been a primarily political idea should take on more of a cultural character at precisely the moment at which Africans and African-descent peoples were finally gaining greater autonomy. However, Pan-Africanism has always been in part an expression of what Raymond Williams (1977) termed a 'structure of feeling': it constitutes the lived experience of a given historical moment, what it means for different people around the world to 'feel' African.

Indeed, the series of major cultural festivals in the era of decolonization might be seen to have constituted some of the most meaningful articulations of Pan-Africanism. In essence, as was argued above, these festivals staged the 'performance' of a Pan-African culture, and they formed a crucible in which the African Renaissance could be forged. They facilitated concrete encounters between Africans and members of the diaspora that fashioned a new and profound sense of cultural belonging. For instance, in his autobiography, *Music is my Mistress* (1973), Duke Ellington described his trip to Dakar as a return home—'After writing African music for thirty-five years, here I am at last in Africa!' (1973: 337)—and he wrote of the warm response to his performances (Figure 3): 'It is acceptance of the highest level and it gives us a once-in-a-lifetime feeling of having broken through to our brothers' (338).[22] Furthermore, the festival's commitment to bilingualism—almost all of the official publications were in both French and English—was a central plank in the attempt to reach out to black people around the world beyond the limits of old colonial boundaries (although, of course, these two languages could not hope to speak to all black people).[23]

In statements he made about the Dakar festival, Senghor expressed a desire for Senegal to be perceived as the 'deuxième patrie' [second homeland] for all black visitors (1977: 63). As Andrew Apter discusses in his contribution to this volume (Chapter 7), the Algiers and Lagos festivals of 1969 and 1977 respectively would push this sense of Pan-African belonging still further, leading to the (temporary) positing of Pan-African citizenship as something that superseded one's belonging to any particular nation state. In this vision, one's current national citizenship was deemed an accident of history, whereas one's Pan-African citizenship was the result of a profound cultural identity. Nonetheless, the festival was also a source of Senegalese national pride. As Brian Quinn and Ruth Bush (Chapters 3 and 4) demonstrate in their analysis of the Senegalese play *Les Derniers Jours de Lat Dior*, its story of the recent past

22 For an overview of Ellington's trip to Dakar, see Cohen (2010: 500–04).
23 Edwards (2003) has charted the importance of translation to black internationalism from the 1920s to the mid-century. For instance, in its early years, the journal *Présence Africaine* was published in both French and English.

had greater resonance for local audiences than some of the more celebrated transnational, Pan-African works performed in Dakar.

The 1960s and 1970s was a period when the destinies of Africa and black America seemed inextricably intertwined, a belief shared across very different shades of political opinion. For instance, in *Journey to Africa*, a collection of his writings on various trips to the continent, the radical journalist Hoyt Fuller wrote (regarding his first trip to Guinea, in 1959) that:

> The African emergence is a significant development for all the world, but it has a very special importance for those of African blood who are rooted in the American culture. For, with all respect to the moral intent of desegregation, only Africa will set the Black American free. (Fuller 1971: 68–69)

From an early twenty-first-century perspective, such vaunted hopes that Africa might play a major part in the progress of black America, just like Nkrumah's dream of a United States of Africa, no doubt appear outmoded or excessively utopian to many.[24] Even Fuller, by 1971, was writing despondently that: 'The reality of Africa can be enough to drive a Black man to despair, if that man believes that genuine freedom for Black people all over the world will only come when the Black African holds genuine power' (1971: 71). Pan-African political unity is a distant prospect today but that does not mean that attempts to achieve unity or to imagine a transnational black culture are somehow misguided. One of the main aims of this volume is precisely to try to understand better the cultural and political energy of the Pan-Africanism of the 1960s and 1970s by fostering an analysis that refuses to be bound solely by considerations of the movement's apparent 'success' or 'failure':

> The recognition that practicing solidarity is hard work offers us an opportunity to consider pan-Africanism not so much as a movement that has or has not succeeded, but as a continuum of achievements and apparent failures that can only be understood in toto. (Jaji 2014: 18)

In addition, Tsitsi Jaji's work has provided a timely reminder of the distinction that George Shepperson drew over 50 years ago between 'Pan-Africanism' and 'pan-Africanism': the former refers to the formal international gatherings and organizations of the 'Pan-Africanist' movement since 1900 while '[s]mall "p" pan-Africanism designates an eclectic set of ephemeral cultural movements and currents throughout the twentieth century ranging from popular to elite forms' (2014: 3). The 1966 Dakar festival was a Pan-Africanist

24 The Chair of the American Society of African Culture (AMSAC), John A. Davis, a white academic, wrote in the inaugural issue of AMSAC's journal, *African Forum*, that 'The American Negro has always seen the Africans' struggle for freedom and equality as an integral part of his own, for he always believed that freedom for one is not possible without freedom for the other' (Davis 1965: 4).

event but it was also one at which the performance of pan-Africanism, in terms of personal encounters and exchange around cultural forms, was able to flourish.[25]

Organization of the Festival

As mentioned above, the idea of organizing a festival of African culture in Africa had been formerly adopted by the Société africaine de culture, at the Second Congress of Black Writers in 1959. However, it was not until 4 February 1963 that Senghor formally announced his plan to host the festival in a radio address to the nation, shortly after he had emerged victorious from a power struggle with his former ally, the more politically and economically radical Mamadou Dia (see Ficquet and Gallimardet 2009: 138). Had Senghor been obliged to delay his long-cherished and costly dream of hosting the festival while Dia held the reins of government as prime minister? The historical record does not allow us to make a categorical judgement on the matter but, at the very least, it seems plausible. Financial justification of the festival's cost would become a constant refrain in comments from Senghor and some of his ministers before and after the event, indicating a pronounced sensitivity to questioning of their priorities for an impoverished nation.

Although Senghor's presiding spirit informed planning for the festival, from the outset, the practical organization fell to others. With the creation of the Association du Festival Mondial des Arts Nègres, formally launched on 21 September 1963, to act as the overall organizing committee at one remove from the Senegalese government, Senghor handed oversight of the festival to two of his closest allies: Alioune Diop, president of the Société africaine de culture and chair of the Association du Festival, and Aimé Césaire, vice-chair of the Association and Senghor's longstanding literary ally (see Huchard 2012: 121–22).[26] Much of the heavy lifting at the local level was done by the Senegalese organizing committee, led by a succession of government officials with Souleymane Sidibé finally bringing the project to fruition (two previous incumbents had been ousted from their posts as their organizational skills struggled to match the sheer scale of the event, which had grown exponentially since the 1959 proposal to organize an expanded writers' congress in Africa).

25 I do not propose to maintain the 'p'/'P' distinction in spelling in the remainder of this volume—academic usage tends to be too unruly for such policing—but the reader is invited to remain alert to the presence of both concepts throughout this introduction and the chapters that follow.

26 As one of Diop's biographers has underlined, Diop and Césaire were close friends as well as intellectual collaborators, and Césaire worked far more closely with Présence Africaine than Senghor (Verdin 2010: 235–40). For an overview of Diop's contribution to the festival, see Verdin (2010: 299–336) and Grah Mel (1995: 99–218).

It takes many hands to organize the different strands of such a mammoth festival, and, although it is beyond the scope of this chapter to detail all of those involved, it is important to note the contribution of several key figures. As Cédric Vincent demonstrates (Chapter 1), the organizers of the 'traditional' art exhibition, *L'Art nègre* [Negro Art], played a particularly important role, with their committee enjoying autonomy from the wider festival organizational structures. The Swiss museum director Jean Gabus and a young Cameroonian priest Father Engelbert Mveng (together with the French curator Pierre Meauzé) were central in gathering together the items that would form the basis of this exhibition. After a number of missions across Africa, Europe and North America, they had managed the remarkable feat of securing the loan of 600 items for the exhibition from over 50 museums as well as a number of private collections.[27]

As Tobias Wofford has underlined, the decision of the festival organizers solely to engage with national delegations effectively prioritized international cultural relations over the promotion of the work of individual artists (Wofford 2009: 182). Indeed, much of the official festival paperwork, including the programme, makes reference primarily (and sometimes exclusively) to the nation due to perform on a given date. The need for the artist to play a representative role on behalf of his/her nation and race would lead to some ambiguous moments. For instance, the Grand Prize for printmaking and illustration in the modern art section of the festival was won by William Majors, an abstract artist who claimed to be uninterested in his African heritage: 'I don't care about going to Africa … I just work' (cited in Wofford 2009: 184). The other modern art prize (for painting) went to the British Guyanan Frank Bowling, yet another abstract artist who did not travel to Dakar.

The participation of the US delegation was facilitated by the fact that diplomatic relations between Senegal and the USA had been entrusted to two 'men of culture': the US ambassador to Senegal, Mercer Cook, was a trained musician (son of the celebrated maestro Will Marion Cook) and respected scholar of French literature, while the Senegalese ambassador to the USA was the novelist Ousmane Socé Diop, one of whose novels, *Mirages de Paris* (1937), had centred on a very different type of 'festival', the 1931 Colonial Exhibition in Paris. Cook had grown up as part of the black bourgeoisie in Washington, DC, where he had been friends with a young jazz prodigy, Edward Kennedy Ellington, later known as Duke (Figure 4).[28] In 1934, Cook had met Senghor and the Nardal sisters at the Paris apartment of Louis Achille and he became

27 To give some sense of the scale of the 1966 exhibition, at the time of writing in February 2016, the Musée Dapper in Paris is holding a major exhibition (30 September 2015–17 July 2016) of African 'traditional' art, entitled *Chefs-d'œuvre d'Afrique* [African masterpieces], which draws together 'just' 130 pieces.

28 Cook and Ellington remained close and the musician would name his own son Mercer in honour of his friend. Mercer Ellington became a trumpeter in his father's band and played at the Dakar festival in 1966.

a close friend of the future Senegalese leader as well as other leading black Francophone writers (in particular, René Maran) with whom he remained in regular correspondence. Cook was also a scholar of Haiti where he studied in the 1940s, and he collaborated with Langston Hughes on the English translation of Jacques Roumain's landmark novel, *Masters of the Dew*. Cook was, therefore, an important *passeur* figure, facilitating the communication of ideas between Anglophone and Francophone contexts. It also seems quite likely that he shared Senghor's vision of the make-up of the American delegation, prioritizing those artists who had made their name prior to the increased radicalism of the civil rights era (as will be shown below, the choice of participants would be queried and contested during and after the festival).

The American scholar, dancer and choreographer, Katherine Dunham, was another major figure overseeing preparations for the festival (see Figure 5). She was in the unique position of having been appointed by Senghor to act as an advisor to the festival, as well as being nominated by the US State Department officially to represent the USA in Dakar (see Harnan 1974: 201; Aschenbrenner 2002: 175; Jaji 2014: 96–100). She also occupied a distinctive role as one of the few prominent women within this 'inclusive' Pan-Africanist initiative. She served on the prize committee for Anglophone literature and chaired the performing arts committee, which was given the task of analysing performances at the festival. A close friend of Senghor, even though she disagreed fundamentally with what she perceived to be Negritude's promotion of a 'fixed' notion of blackness, she had been invited prior to the festival to spend several months in Dakar training the members of the national ballet. In advance of this trip, she drew up a 'Plan for an Academy of West African Cultural Arts' to be housed on the island of Gorée, just off the coast of Dakar (see Clark and Johnson 2005: 407–10). This plan never came to fruition, but Dunham's role before and during the festival, and her general commitment to forging links with newly independent Africa, illustrate the strength of Pan-African ties at this moment in history.

The organization of the festival not only entailed bringing artists and exhibitions to Dakar but also involved the physical transformation of the city itself. An early assessment of the infrastructural improvements required in order for Dakar to be in a position successfully to host a festival on this scale had identified the need both for new artistic spaces to be constructed and for the city's hotel capacity to be greatly increased. This led to major infrastructural projects (such projects are often the most visible legacies of festivals): shantytowns were cleared; brand new roads were carved through the city; a new terminal was built at the airport, complete with a mural entitled *The Sun Bird* by Senegalese painter Iba N'diaye; two major cultural venues were built, the Théâtre National Daniel Sorano in the city centre (which in fact was ready by early 1965) and the Musée Dynamique on the western corniche, which would house one of the art exhibitions; while nearby an existing artisans' village next to the fishing harbour at Soumbedioune Bay was redeveloped. The Senegalese government had originally planned to build a Cité des Arts around

the Musée Dynamique, which would have included a 500-seat auditorium, a concert hall, smaller exhibition spaces for fashion and artisanal work, administrative buildings and a shop.[29] Financial constraints meant that none of these plans beyond the construction of the Musée Dynamique was ever realized and, ironically, the area around the museum is today occupied by a fun fair.

Participating nations were asked to make a financial contribution to the cost of the festival, while UNESCO funded construction of the Musée Dynamique and the colloquium held at the National Assembly; UNESCO had earlier hosted a 'pre-colloquium' gathering at its Paris headquarters on 5–6 December 1964 (Huchard 2012: 122). The vast majority of funding came, though, from the Senegalese state, while the French poured vast resources into the 'traditional' art exhibition at the Musée Dynamique: once the festival closed, the exhibition was transferred in the summer of 1966 to a brand new exhibition space at the Grand Palais in Paris, before touring major Western museums. The French also provided much of the technical support for the *son et lumière* show on Gorée island and installed state-of-the-art production equipment in the Daniel Sorano Theatre.

Various commentators have underlined that it would be no exaggeration to view the festival as a largely Franco-Senegalese initiative (see Ficquet and Gallimardet 2009: 139–41; see also Cédric Vincent's contribution in Chapter 1). A quick perusal of official festival publications reveals the participation of many French officials on festival committees: and, at the top of the organizational pyramid, President Charles de Gaulle shared the status of honorary patron with Senghor. Indeed, it could justifiably be argued that the festival marked the emergence of France's policy of 'cultural cooperation' with its former African colonies, which would eventually lead to the creation of *la Francophonie*. As Catherine Coquio (2012) has argued, Malraux's speech in Dakar presented precisely this model of cultural relations: France and Africa should be partners, although France should remain the paternal figure for its wayward African offspring. De Gaulle largely deployed his Minister for Culture's eloquence to present the idealistic case for France's continued presence in Africa. Meanwhile, behind the scenes, De Gaulle's African 'fixer' Jacques Foccart was putting in place the networks and mechanisms that would become known as *la françafrique*, the system of corruption and support for autocratic regimes that operated in the name of France's 'interests'. French cultural cooperation was not simply the camouflage to hide French neo-colonialism; it was the flip side of that neo-colonialism, the expression of a 'desire for Africa' that had developed during the colonial period. Before and after independence, France celebrated African culture while systematically exploiting Africa economically and politically.[30]

29 Ousmane Sow Huchard, who would later act as director of the Musée Dynamique, gives a detailed account of the plans for the Cité des Arts and the later history of the museum after the festival (Huchard 2012).

30 In a speech delivered in Dakar in 2007, the then French president Nicolas Sarkozy

In the decades since the festival, a certain degree of nostalgia has tended to cloud memories of the very real administrative difficulties encountered by the organizers. The relative lack of cultural interest on the part of Senghor's successor, Abdou Diouf, as well as the monumental logistical dysfunction of FESMAN 2010, have understandably shaped a retrospective vision of the 1966 festival as an organizational triumph. However, its practical deficiencies were not lost on contemporary observers, even those inherently favourable to the event: Hoyt Fuller writes of 'incredible blunders in planning and goofs unworthy even of children', including 'hundreds of people [being] turned away from theater box-offices time and again because no tickets were available' only for the very same plays to be performed later that day before half-empty venues (Fuller 1966d: 101).[31] According to another American festival attendee, Fred O'Neal, 'several of the performances at the Sorano were interrupted because the Senegalese running the theater had not yet learned how to operate the complex lighting and sound systems' (cited in McMahon 2014: 298). The festival was postponed on a number of occasions,[32] and some of the new hotels required to house the thousands of participants and visitors never materialized. In the end, the Soviet government stepped in and gave the Senegalese use of a cruise ship, which was moored in the port of Dakar, to provide extra bed space (another was loaned to Senegal by Italy).

Trouble was not limited to infrastructural issues, for, in the months preceding the festival, Dakar had been subjected to an unusually high level of social disruption. The ever-radical university students had once again been brought on to the streets in a series of student strikes in February and March 1966 in an angry response (that escalated into rioting) to the overthrow of Ghana's independence hero Kwame Nkrumah, who, as we saw above, was one of the most vocal advocates of political Pan-Africanism: the irony of the apparent death of Nkrumah's dream of a United States of Africa just as Senghor's dream of black cultural unity was about to be realized was probably not lost on the protestors.[33] In a press conference a month before the festival, the Senegalese Minister for Information warned students who

infamously asserted that 'the tragedy of Africa is that the African has not fully entered into history'. Forty years after Malraux's words, the African entrance into modernity announced by the Minister of Culture was deemed not to have even begun. For a discussion of Sarkozy's speech, see Thomas (2013: ch. 4).

31 Fuller's account is corroborated by a short article tucked away on the back page of Senegal's daily newspaper *Dakar-Matin* on Tuesday, 5 April 1966, which laments the number of empty seats in the Daniel Sorano Theatre over the opening weekend of the festival.

32 A firm set of dates spanning the Christmas/New Year period December 1965 to January 1966 was announced before organizers noted a series of clashes leading it to be postponed until its eventual date in April 1966.

33 Neighbouring Guinea, under the radical and temperamental leadership of Sékou Touré, would eventually boycott the Dakar festival, which it perceived as a neo-colonialist venture.

had been involved in anti-government demonstrations that 'le Gouvernement se montrera à leur égard d'une fermeté inébranlable' [the Government will display an unshakeable firmness towards them] ('Le Sénégal ne se laissera pas imposer' 1966: 1).[34] The alleged ringleaders were expelled from the university, while a number of foreign students were expelled from the country altogether. In response, a full student strike was called and the government's 'unshakeable firmness' finally gave way, just over a week before the festival, to a desire to bring an end to social unrest that would reflect badly on the country. A deal was struck allowing all students who had been expelled to resume their studies but the university remained closed until after the beginning of the festival, with classes eventually resuming on 13 April (Bathily 1992: 51–52; de Benoist 1998: 146).

The local political context in Senegal was also highly charged in early 1966. The newly independent nation was gradually becoming a one-party state as opposition groupings were subsumed into Senghor's ruling UPS party. Just a few weeks before the beginning of the festival, the police arrested many of the leaders of the radical Parti Africain de l'Indépendance (PAI) (Bathily 1992: 30), no doubt with an eye on limiting potential protest during the event. The police had also sought to 'clean up' central Dakar by rounding up the numerous beggars who populated the downtown area and pushing them to the outskirts of the city, a move closely linked to the desire to provide visitors to Dakar with an improved (tourist) experience of Senegal's 'front region' (see Ní Loingsigh 2015: 89). Clearing the city of beggars was deemed by the government to be part of a more general 'assainissement de la ville' [cleansing of the city]:

> Si la lutte déclenchée depuis le 25 août 1965 par la police contre les mendiants, les lépreux, les vagabonds et les aliénés qui pullulent dans notre capitale a déjà eu des résultats spectaculaires, il importe de la poursuivre avec des moyens renforcés, afin d'aboutir à un assainissement définitif. ('Le Sénégal ne se laissera pas imposer' 1966: 1)

> [Although the fight that was launched by the police on 25 August 1965 against the beggars, the lepers, the vagrants and the alienated who swarm in our capital has already enjoyed spectacular results, it is important that it be continued with greater means at its disposal so as to achieve a definitive cleansing of the city.]

In addition, the *New York Times'* reporter in Dakar noted that a tall aluminium screen had been erected to fence off parts of the Medina so that the slum dwellings there would not be visible to international visitors (Garrison 1966c). Clearly, not all of the Senegalese population was welcome at this gathering of the black world. However, despite this troubled build-up to the festival, it would eventually unfold in a relative calm.

34 For an account of the political tensions in Senegal (and in particular student unrest) in this period, see Ndiaye (1971).

The Festival: 1–24 April 1966

With the formal opening of the festival on Friday, 1 April, Senegal headed into a long weekend of celebration, as Monday, 4 April was a national holiday marking the sixth anniversary of independence. Over those first four days, festival audiences were treated to a wide array of events: a gala performance of Wole Soyinka's play *Kongi's Harvest* at the Daniel Sorano Theatre; the hugely popular Congolese rumba band OK Jazz played gigs at the Sorano and the national stadium; and the weekend culminated on independence day with a grandiose production of the epic play *Les Derniers Jours de Lat Dior*, by Senegalese government minister Amadou Cissé Dia, which featured a cast of hundreds, and met with great popular patriotic fervour. (For a discussion of this and other theatrical performances, see Chapters 3 and 4, below.) Over the next three weeks, the festival programme was packed full of official and unofficial events—'The intensity of the festival itself was evidenced by the simple fact that there were many more things to do each day than was humanly possible' (Flather 1966: 58)—and, as one might imagine with an event on this scale, it contained material and performances of varying quality—'The Festival [...] proved sometimes banal, frequently engrossing, and occasionally brilliant' (Fuller 1966d: 100).

The festival was held in a series of locations around the city. Some of the most high-profile events were held in the newly built venues: in addition to Soyinka's play, the Daniel Sorano Theatre hosted performances of Césaire's *La Tragédie du roi Christophe*,[35] as well as nightly performances of music and dance; the Musée Dynamique was home to the major exhibition of *Negro Art*; the refurbished Centre culturel Daniel Brottier hosted theatre, music and dance; while the Palace Cinema was the venue for the somewhat margin-alized film strand. Other parts of the festival saw non-arts venues pressed into service: as was indicated above, the event was formally launched at the National Assembly where the official festival colloquium took place; there was a modern art exhibition at the Palais de Justice (the law courts); both musical and theatrical performances were held at the National Stadium; the African American gospel singer Marion Williams performed in the Cathedral; and Dakar town hall was the venue for a modest exhibition on the festival's 'Star Country', Nigeria (indeed, the entire town hall had been handed over as a base for the Nigerian delegation); the *son et lumière* show on the beachfront at Gorée, entitled the *Spectacle féerique de Gorée*, brought the festival out on to the city streets. A highlight of the festival, the *Spectacle féerique* was produced by a Frenchman, Jean Mazel, and written by Haitian author Jean Brierre, who was living in Senegal as a refugee from the Duvalier regime, yet another striking example of Pan-Africanism in operation (for analysis of this show, see Chapter 4). The *Spectacle féerique* presented a series of tableaux recounting the

35 Visiting USA-based academic, Thomas Cassirer, hailed Césaire's play as the 'hit of the festival' (cited in McMahon 2014: 302).

history of Senegal, through the slave trade and colonialism, culminating in the nation's very recent independence from France. It took place nightly during the festival (apart from 4 April) and reports indicate that it was seen by over 20,000 people, which suggests a more than respectable audience of around 1,000 each night.[36]

The festival may have featured a wide array of cultural forms but, for Senghor, its centrepiece was, without question, the exhibition of Africa's 'classical' art at the Musée Dynamique. By contrast, an exhibition of art works by young African artists left him slightly disappointed. As was explained above, Mveng, Gabus and the other members of the exhibition committee played key practical roles in bringing these artistic treasures to Dakar. But, more than any other aspect of the festival, the exhibition embodied Senghor's vision of Negritude and the role of African culture in a post-imperial landscape; and, as Cédric Vincent clearly demonstrates (Chapter 1), Senghor's willingness to deploy his political and cultural capital was central in persuading the owners of the material to loan their works for the exhibition. The *Negro Art* exhibition managed to assemble some of the finest examples of 'traditional' African art. These were exhibited alongside a selection of works by Picasso, Léger, Modigliani (amongst others), borrowed from the Museum of Modern Art in Paris, in what must have been a fascinating contrapuntal play between traditional sources and the modern masterpieces inspired by them.

This juxtaposition of so-called traditional African arts and European high modernist art was designed to illustrate both difference and complementarity, which was central to Senghor's cultural philosophy. Negritude was often perceived as turned towards the past, and, in the context of decolonization, some interpreted the break with European imperial control as signalling the re-emergence of a previously oppressed culture. As I have argued elsewhere (Murphy 2012b), Senghor's vision of post-independence African culture is more complex than such critical views allow. To paraphrase Senghor's vast output on the topic, Negritude was designed to locate and define the black soul: once a new, positive black identity had displaced the old, racist imaginary of the colonial era, Africa could enter confidently and on equal terms into the Universal Civilization of the future in which the entire world would be subject to a process of *métissage* (or mixing). Senghor thus used the festival and, in particular, the *Negro Art* exhibition to reiterate his fundamental belief in both a deep sense of black identity (Negritude) and the need for dialogue and exchange (the emerging 'Universal Civilization').

If Senghor was clear on where he perceived the heart of the festival to reside, he was less forthcoming about (and arguably less interested in) whom he envisaged as the potential audience for the best art that the black world had to offer. Who were the audiences that the festival managed to reach?

36 One contemporary newspaper report claimed that the *Spectacle féerique* had attracted a total audience of 23,500 during its three-week run (as Ruth Bush notes in Chapter 4).

Was it solely the French-educated cultural elite? As we saw above, the performances on Gorée drew large audiences, but can we conclude that this was one of those moments where the festival reached a wide popular audience? The island is sparsely populated and, in addition to the cost of the ticket to see the performance (400 CFA, the equivalent of roughly $1.60 at the time), the average *Dakarois* would have needed the funds to pay the shuttle fare for the boat ride from the mainland. It is difficult to imagine anyone except the well-to-do middle classes or foreign visitors making up the audience.

One 'event' that did draw a huge crowd was the arrival of Ethiopian Emperor Haile Selassie who was driven through the streets of the city in a motorcade preceded by the presidential mounted cavalry: in Greaves' documentary film, we see thousands of cheering locals lining the streets to greet him. In addition, most contemporary reports indicate that there was a general air of celebration in Dakar throughout the festival, with impromptu musical and other performances taking place in the streets across the city. Duke Ellington describes listening to bands rehearsing every night from the balcony of his hotel (1973: 337), while Hoyt Fuller writes of 'local groups in gay—and sometimes outrageous—costumes [who] enlivened the streets and the *médinas* with explosions of song and dance' (1966d: 100).[37] Dance parties were held across the city, which, as Hélène Neveu Kringelbach argues (Chapter 2), were moments when popular (often urban) cultural forms excluded from the festival proper could find a home. The national newspaper *Dakar-Matin* (as well as the UPS newspaper *L'Unité Africaine*) ran stories on the festival on its front cover virtually every day in the three months leading up to the event and, of course, each day of its duration. It may have been impossible for many ordinary Senegalese to attend festival performances/exhibitions, but there is little doubt that the event caught the attention of the local populace, and even generated genuine enthusiasm among a considerable number of them.

Despite these 'popular' elements, however, the festival was neither a festival of 'popular culture' nor a 'popular' festival in terms of the audience it reached (or largely sought to reach). This was no broad celebration of 'culture' in which anything goes; it was a celebration of the arts as understood by Senghor (and, by extension, cultural figures of his generation). He was a lover of the 'high' arts and they informed his conception of the entire festival, which meant that sculpture, visual art and theatre were in, while most popular arts were largely left out. The festival was to be a showcase for the best the black world could offer and this quality would be judged in formal competitions, grouped into specific formal categories, with panels of experts awarding prizes to those whom the festival deemed to be the cream of the 'negro' arts world.

The most noticeable absentee was perhaps contemporary pop music: for

37 Christina McMahon charts a series of impromptu events that took place during the festival (2014: 302). One of the best-remembered of these was the concert given by Duke Ellington's orchestra at the party hosted by Mercer Cook at the US ambassador's residence.

example, while 'classic' big band jazz (which had enjoyed its heyday in the interwar period) was included, none of the hugely popular soul artists from the Motown label, which had made its major commercial breakthrough three years earlier, was invited to take part. The gap between the emerging popular youth culture and the middle-class, middle-aged tastes of the organizers is clearly visible in a letter of March 1966 to the US festival organizing committee from Motown's lawyer patiently explaining that 'Motown Record Corporation is the world's largest Negro-owned record company', and going on to elucidate what soul music is and who its greatest stars are.[38] Some popular music did make it into the festival, as many of the national 'orchestres' were in fact among the most commercially successful African musicians of the mid-sixties (not least the eagerly anticipated OK Jazz, cited above), and there was a competition for the best popular music record, although the adjudication of this prize was farmed out to the cultural attachés of various embassies in Dakar.[39]

Various other factors, in addition to the choice of art forms selected for the festival, are likely to have influenced attendance: the decision to charge an entry fee for performances,[40] as well as the fact that they were held in what would surely have seemed intimidatingly formal venues to many ordinary Senegalese, are all likely to have dissuaded many locals from attending. It is difficult to give precise figures but it seems probable that the total audience for the festival's performances was around 50,000—various sources cite attendance figures of 20,000 for the festival (Ficquet 2008: 22) plus a further 20,000 to 25,000 for the *son et lumière* show on Gorée. These are more than respectable audience figures, not least because in the mid-1960s Dakar's population stood at fewer than 500,000 (far fewer than the current estimate of over three million for the greater Dakar region). However, if one considers that there were at least two to three shows taking place every day over more than three weeks, it can be seen that each one gathered an audience of perhaps several hundred only. Although an event on a massive scale, it did not reach a massive audience. But, then, Senghor's claims regarding the significance of the festival were always centred on the work it set out to do rather than the number of people it might reach.

38 Schomburg Centre for Research in Black Culture, Archives of the US organizing committee for the First World Festival of Negro Arts, SCM84-32 MG220, Box 1.

39 Many of the score cards used by the cultural attachés to assess these records have been preserved in the festival files in Dakar. Archives Nationales du Sénégal, FMA013.

40 The full range of ticket prices was as follows: Daniel Sorano Theatre (300–1,000 CFA; 1,000–1,500 CFA for gala performances); Stadium (150–300 CFA); Cathedral (500 CFA). The lower prices at the stadium may well explain the healthy popular audience at the 4 April performance of *Lat Dior*. Prices listed on 'Performing Arts Schedule', Schomburg Centre for Research in Black Culture, Archives of the US organizing committee for the First World Festival of Negro Arts, SCM84-32 MG220, Box 1.

The festival made a significant financial loss of over $500,000 dollars, which would be more than $4.5 million in today's money, largely due to lower than expected income from ticket sales. At the closing press conference for the festival, though, the Senegalese commissioner, Souleymane Sidibé, declared (in Senghorian terms): 'Il n'y a pas de déficit en matière culturelle. Les résultats de ce premier Festival ont plus de valeur que tous les milliards du monde' [There is no deficit in cultural terms. The results of this first Festival are worth more than all of the billions in the world] (Ficquet 2008: 23).

The US Delegation, the Cold War and Civil Rights

As was discussed above, the participation of the US delegation was central to Senghor's vision of the festival. The cultural flowering of the Harlem Renaissance and the big band jazz age had played a formative role in shaping Senghor's conception of Negritude in the 1930s: it was thus no great surprise that Langston Hughes and Duke Ellington, two heavyweight representatives of these cultural moments should figure so prominently in Dakar.[41] Not everyone shared this favourable view of the composition of the American delegation, however. For instance, Hoyt Fuller, one of the most astute commentators on the festival, noted general puzzlement at 'the absence of the most exciting of America's black intellectuals' (Fuller 1966d: 102), such as Amiri Baraka (then still known as LeRoi Jones), Ossie Davis and James Baldwin, and equal bemusement at the choice of musical artists: 'Painter Amadou Yoro Ba, a jazz *aficionado*, asked why musicians like Miles Davis and Thelonious Monk did not come to Dakar, and half of Senegal seemed to have assumed that Harry Belafonte should have been present' (102). Such artists were absent for a complex range of reasons. Some related to the aesthetic preferences of Senghor and, it seems likely, his close friend, the US ambassador to Senegal, Mercer Cook. However, there were also more political reasons: the US State Department placed a white socialite Mrs Virginia Inness-Brown at the head of the US organizing committee and, through her, exercised a hidden but vice-like grip on the choice of US participants: no US delegates to Dakar were to drag politics into the cultural sphere by talking about civil rights and the scourge of American racism. Simultaneously, on the other side of the political spectrum, there was a perception among more radical black figures (like Belafonte) that Senghor's Senegal was a politically conservative regime that should be shunned in favour of more revolutionary states, not least Sekou

41 In September 1966, Senghor travelled to the USA on an official visit, during which he presented prizes to those African American artists who had received awards from the festival juries. Mercer Cook provides a detailed account of this triumphal visit, which included the awarding of an honorary degree to Senghor at Howard University where Cook returned as Professor of French after his time as an ambassador (Cook 1966).

Touré's Guinea. As Dominique Malaquais and Cédric Vincent reveal (Chapter 10), it is now clear that the US delegation had in part been funded by the CIA who wanted to use the festival to promote a positive image of the USA in Africa. Many of those within and around the US delegation were conscious of a CIA presence in Dakar, although fears were silenced to preserve a sense of unity. However, several years later, as black politics on both sides of the Atlantic became more radicalized, Hoyt Fuller would denounce the 1966 festival, and in particular the US delegation, for allowing itself to fall foul of the US State Department's Cold War machinations:

> One of these days, the full awful story of the American secret service's role in the First World Festival of Negro Arts in Dakar in 1966 will be told, stripping of honor certain esteemed Black Americans who lent their prestige to the effort to hold to the barest minimum the political impact of that unprecedented event. (Fuller 1971: 92)

As well as its accusations of duplicity, the implication of Fuller's critique was that Negritude was so devoid of radicalism that it could be safely backed by the State Department as lacking any potential threat to the USA's global and domestic status quo.

One of the most powerful records of the Dakar festival is the documentary (simply entitled *First World Festival of Negro Arts*) by African American filmmaker William Greaves. A director for the United States Information Agency (USIA), Greaves had been sent to Dakar by his employers to film footage for a newsreel. However, quickly realizing the scale, ambition and importance of the festival, Greaves instructed his team to shoot as much footage as possible so that a full-length documentary film could be pieced together upon his return to the USA (as the footage was filmed in 'snatched' moments, the finished documentary is obliged to make widespread use of post-synchronous sound). The film opens with images of Langston Hughes strolling along the fisherman's beach at Soumbedioune Bay, chatting and joking with the locals, while in the narrative voiceover we hear Greaves reciting Hughes' famous poem, 'The Negro Speaks of Rivers', its references to the Congo, the Nile and the Mississippi evoking a deep historical connection between Africa and the Americas. The implications of beginning a film in this fashion about a festival held in, and primarily organized by, an African country, are teased out by Tsitsi Jaji:

> The film's narration is remarkable for its prophetic tone, in part an effect of the off-screen, stage-perfect enunciation of Greaves's Actor's Studio-trained voice, but also because of the diction and rhetorical structure of the narration. The poem so aptly captures the agenda of the film that we might not immediately recognize how remarkable it is that a text about Négritude's most important historical event begins not with a poem by Senghor, nor for that matter, with a reading from Césaire or Damas. Instead Hughes is the focus. This reads two ways: first, as an extension of black international literary connections beyond Négritude proper to include

the New Negro movement and beyond [...] and, second, as an indication that the film was designed to present an American and specifically State Department perspective. (Jaji 2014: 94)

This American focus is reinforced when the film gradually segues from the images of Hughes, via an image of a Benin bronze, to shots of Duke Ellington's band in concert at the national stadium. The film was edited by the USIA in a manner that clearly emphasized the role of American participants in the festival, and also ensured that the slave trade was never directly evoked (the film contains no footage of the *son et lumière* show on Gorée). The USIA would tour Greaves' film around Anglophone Africa for the next decade and it was, reportedly, its most popular film. By contrast, it remained pretty much unseen in the USA for several decades. This example clearly illustrates that the Dakar festival's dialogue between Africa and people of African descent was mediated by powerful forces that a post-imperial world would struggle to overturn.

The festival, somewhat inevitably, also found itself bound up in the complex political wrangling of the Cold War, as both the USA and the Soviet Union sought potential allies among the newly independent African nations. As was shown above, the US State Department used the festival to demonstrate America's commitment to racial equality, the nation's global reputation having suffered during the protracted Civil Rights struggle back home. The Kennedy administration's decision to appoint a small number of black ambassadors to African nations, not least Mercer Cook, had been an early illustration of this desire to 'win over' black Africa (although, as Cook revealed much later in an interview, such was his disillusionment at the lack of concrete US support for developing African countries that he had in fact sought to resign from his position in late 1965 but had been persuaded to stay on until after the festival).[42] In particular, the participation of Duke Ellington's orchestra had been facilitated by funding from the US State Department which had, by the mid-1960s, been deploying its Jazz Ambassadors programme for a decade as part of its Cold War diplomacy, sending black artists around the world to represent the USA while, back home, they did not enjoy even the most basic civil rights (see von Eschen 2004).

For its part, the Soviet Union, which consistently underlined US racism in its pitch to newly independent black countries, was keen to use the festival to increase its influence in Africa. Without a black diaspora of its own, it could not play a formal role in the festival itself but, as was mentioned above, it did help the beleaguered hosts in their desperate attempts to secure sufficient hotel accommodation by lending them a cruise ship: as a

42 Cook reveals his disappointment at the lack of State Department support for US diplomatic and developmental initiatives in Africa in a fascinating 1981 interview conducted as part of the Phelps-Stokes oral history project looking at the role of former Black Chiefs of Mission. A copy of the interview is held in the Mercer Cook Papers at the Moorland-Springarn Research Centre, Howard University, Washington, DC, Box 157-5.

New York Times journalist wryly reported, the Soviets had prepared a small exhibition to entertain the festival goers housed on the ship (including some Americans): 'As the guests sip their vodka on the main deck, they are also treated to an exhibit extolling Russian–Negro brotherhood. Several display boards highlight the fact that the Russians never engaged in the slave trade while guess-who did' (cited in Wofford 2009: 185). The Soviets also sent their distinguished and charismatic poet Yevgeny Yevtushenko, a critic of Stalinism who benefited from the relative openness of the Khrushchev regime and enjoyed rock star status in the mid-1960s. Senghor was always happy to meet a fellow poet but asked Yevtushenko to wait until the conclusion of the festival proper to conduct a public reading of his work: this was a festival of 'negro art' after all.

The Soviets had sent journalists to cover the festival and newsreel footage shot in Dakar was later pulled together to create the documentary film, *African Rhythms* (which includes footage of a meeting between Yevtushenko and Senghor). Whereas the use of black-and-white film stock and the solemn voiceover in Greaves' film had given his documentary an epic and somewhat nostalgic feel, the Soviet film was shot in colour and it captures more of the spontaneity and excitement of the performances. Given that the Soviets did not share American qualms about representations of slavery, the film also captures footage of the *son et lumière* show on Gorée. Finally, the film also shows us the street scenes that are largely absent from the Greaves film: 'The Russian narration guides viewers through numerous Dakar neighborhoods into which the festival's events spilled over in outdoor performances, and emphasizes the event's significance as a "reunification" of peoples severed by colonization' (Jaji 2014: 96). This street-level 'reunification' of Africans and those of African descent reminds us that the festival unfolded as a living performance of the African Renaissance, one that extended far beyond the museums, theatres and concert halls of the official festival venues.

One of the unexpected encounters facilitated by the festival involved Langston Hughes and Yevgeny Yevtushenko. The Russian, prevented from performing during the festival, had a lot of time on his hands, and Hughes later recalled:

> 'We had dinner on the ship, with an endless supply of Georgian champagne. After that, for about a week, we went out drinking every night.' One companion in their revels was the Harlem-born filmmaker William Greaves, who [...] was making a documentary movie about the festival. 'We used to ride around in Yevtushenko's limousine', Bill Greaves recalled, 'drinking pretty heavily and having a lot of fun'. (Rampersad 1988: 401)

As with Senghor's poetic encounter with Yevtushenko (captured in *African Rhythms*), this anecdote suggests 'that shared poetic interests overrode national and geopolitical differences' (Jaji 2014: 105). So much then for Hoyt Fuller's vision of the US delegation as Cold War patsies serving a State Department agenda. Hughes' account of US–Soviet 'fraternization' reminds us

to be wary of excessively ideological readings of complex personal encounters. The complexity of such personal interaction must also be traced in relation to the role of Negritude within the festival. What might a wider examination of some of the many personal encounters generated by the festival reveal to us about the performance of pan-Africanism (to cite Shepperson's non-capitalized sense of the term) as lived by individuals rather than as imagined by the festival organizers?

'Pan-Africanism' and 'pan-Africanism': Tracing Personal Encounters at Dakar 1966

While the 1966 festival (like the other mega-festivals of the 1960s and 1970s that followed) was in large part driven by a national government keen to promote the officially sanctioned account of its relevance and significance, various cultural actors, performances and works of art refused to conform to the dominant ideological narrative, despite careful attempts to police festival programming. Bringing together thousands of participants and audience members inevitably gave rise to a series of personal encounters the narrative of which simply could not be regulated by the Senegalese state or other supporters of Negritude who wished to preserve a specific archive of the festival. As is demonstrated by various contributions to this volume, the encounters generated when thousands of cultural actors are brought together in one city can often take highly unexpected forms. For example, Hélène Neveu Kringelbach (Chapter 2) charts the 'popular cosmopolitanism' of the dance parties and street events in Dakar, while Tsitsi Jaji (Chapter 5) traces non-elite accounts of the festival in popular magazines. In the process, both authors recover the voices of female participants (mainly dancers) in the festival, whose stories are often occluded. Neveu Kringelbach also notes the impact on individual Senegalese dancers of witnessing the modernity of the Alvin Ailey dance troupe's performances, which would influence their vision of African dance. The story of the vast Pan-African festivals of the 1960s and 1970s will thus remain incomplete if it does not include the experiences of a wide range of individual actors alongside the overarching national/transnational narratives promoted by the organizing nation state. To return to Shepperson's terms, we must attempt to capture the story of pan-Africanism alongside that of Pan-Africanism.

Given that William Greaves appears from the Hughes-Yevtushenko encounter cited above to have enjoyed the social aspects of his stay in Dakar, it is ironic that his documentary deploys throughout a solemn, epic tone from which such spontaneous and potentially subversive 'fun' is conspicuously absent. The film does, however, provide us with a glimpse of some of the many human encounters that must have occurred at the festival, including its opening scene (discussed above) in which Langston Hughes speaks with the fishermen on Soumbedioune Beach. Duke Ellington later wrote in his memoirs

33

about the desire for direct human contact that had been prompted by his performances: 'the cats in the bleachers really dig it. You can see them rocking back there while we play. When we are finished, they shout approval and dash for backstage where they hug and embrace us, some of them with tears in their eyes' (Ellington 1973: 338). Ellington's memoir also reveals that, while in Senegal, he became good friends with the Senegalese artist Pape Ibra Tall, some of whose tapestries he brought back to the USA with him. The festival elicited in Ellington a desire to communicate on a personal and cultural level with Africans: in preparation for the event, he had even composed a new song, 'La Plus belle Africaine' and, as his son (a trumpeter in his father's band), told the *Los Angeles Times*, 'Sam Woodyard, our drummer, was a big hit [...] He's spent a lot of time studying African rhythms, so the natives got a big kick out of hearing their own licks come back home.'[43] In addition to these individual examples, the American Society of African Culture (AMSAC) had chartered a plane taking over 200 visitors to Dakar for the festival and one can only guess at the numerous personal encounters to which this gave rise.[44] At the dawning of the jet age, Africa was now for the first time within easy reach for an emerging African American middle class.

The *PANAFEST Archive* project, cited above, has been guided by principles that chime with Shepperson's ideas on the coexistence of pan-Africanism/ Pan-Africanism. The project has consulted the 'official', institutional archives of the four major Pan-African festivals of the 1960s and 1970s (where these exist) and then, in a second phase, shifted from macro to micro history via the stories of individual participants from each of the four festivals. Filmed interviews with participants feature on the project website, which allow us to gain a better sense of many of the diverse, personal and cultural encounters that were facilitated by such events. As Dominique Malaquais and Cédric Vincent, the co-directors of the project, state (Chapter 10), their work is 'grounded in a definition of archives as labile entities fixed neither in space nor time—a definition that accords with the complex, multifaceted and changing nature of Pan-Africanism itself'.

For Léopold Senghor, the festival was designed to act as a living 'illustration of Negritude' (Senghor 1977: 58), the moment when the theory about which he had written at such great length would come alive. The examples above demonstrate, however, that this living illustration, this 'performance of Pan-Africanism', did not result in a monolithic assertion of Negritude as a unifying black identity. The selection for the US delegation of abstract artists,

43 This information is taken from a press clipping contained in the Mercer Cook Papers, Box 157-18, File 5. The article, 'Duke's Triple Play: Africa, Hollywood, Japan', by Leonard Feather, is taken from the *Los Angeles Times*, and is undated, although from the context it would appear to be from the summer of 1966.

44 A glimpse of this 'personal' encounter with Africa can be seem in the many notes of thanks sent to Mercer Cook, not least for the party he hosted at the ambassador's residence. See Mercer Cook Papers, Boxes 157-1, 157-2, 157-3.

who refused to see themselves as 'black' artists, is a classic case in point. Discussing the issues surrounding their selection, Tobias Wofford has argued that:

> Rather than being situated outside the rhetoric of racial unity put forward by Negritude, the diversity of works in the US delegation mirrored the larger space of the festival as a site for a dialogue about the possibility of creating a global blackness. (Wofford 2009: 186)

The festival was an occasion to question, challenge, debate, explore rather than simply to assert or passively accept various conceptions of a global black identity/community. There was no consensus about what Pan-Africanism meant or what role culture should play in the period after empire: rather the festival was a site in which various actors could come together to perform their own understanding of black culture and identity in complex and often contradictory ways.

Was Dakar 1966 Really a Festival of Negritude?

Despite the multifaceted nature of the First World Festival of Negro Arts, it has nonetheless largely been remembered as 'Senghor's festival' and a celebration of Negritude. Indeed, a perusal of the festival colloquium proceedings reveals that Senghor had gathered together in Dakar a group of cultural actors who were, at the very least, broadly supportive of Negritude as a project, although (as we have seen at various points already in this introduction) closer examination reveals it did not enjoy hegemonic status either in the colloquium or in the festival more widely. To what extent, then, was the Dakar event a festival of Negritude?

That an international cultural festival as complex and diverse as Dakar 1966 has regularly been perceived as having espoused a hegemonic political–cultural ideology is a shorthand interpretation that stems not only from the accounts of Senghor's 'friends' (see, for example, Malraux's speech cited above) but also from those of his 'enemies'. In particular, the juxtaposition of the 1966 Dakar festival with the Algiers festival of 1969, at which Senghor and Negritude were loudly denounced by delegates at its colloquium as outdated and reactionary, has led to polarized understandings of both events. Samuel D. Anderson and Andrew Apter (Chapters 6 and 7) closely examine the very real ideological opposition between the 1966 and 1969 festivals. At the same time, we must remain conscious of the continuities that might be concealed by these ideological differences. As we saw above, underlying all of the major Pan-African festivals of the 1960s and 1970s was a development discourse that placed culture at the heart of the modernization of post-imperial Africa.

Far from the hegemonic espousal of Negritude, the 1966 festival witnessed many different performances of black identity and culture. For instance, US

speakers at the festival colloquium, including Langston Hughes and Katherine Dunham, did not actively endorse Negritude, a concept about which they continued to harbour strong reservations.[45] Indeed, Hughes' celebration of African American 'soul' as the American equivalent of Negritude constitutes a striking example of the 'décalage' that Brent Hayes Edwards has identified in communication between Africa and its diaspora: strongly similar ideas but understood and expressed in often quite different ways. Even Aimé Césaire, the man who coined the term 'Negritude', spent part of his speech to the festival colloquium expressing just how tired he was of both the word and the constant requirement to define and/or defend it.

Elizabeth Harney's work on the arts scene in post-independence Senegal underlines the fact that, although Negritude was official state cultural policy, Senghor's fostering of the arts in fact led to the development of a cultural scene in which oppositional voices were able to emerge:

> [P]erhaps the aptest model for understanding the field of production during the postindependence period is one that emphasizes the intersection of histories and zones of practice wherein those working under government patronage shared physical space and a cultural climate with those seeking to subvert the system's premises. [...] The avant-gardist and anti-Négritude movement was thus enabled by Senghor's commitment to Négritude arts. (Harney 2004: 12–13)

Similarly, the 1966 festival provided a platform for artists with political and cultural visions that clashed with those of Senghor. Not only did they gain a platform, but some of them won official festival prizes. In particular, his compatriot, the Marxist novelist and filmmaker Ousmane Sembene won prizes for literature and cinema (see Murphy 2015). The success of Sembene's work at the festival created something of a problem for those critics, scholars and journalists who wished for the event to be perceived as the apotheosis of Negritude. In the June 1966 edition of the monthly cultural magazine *Bingo*, Paulin Joachim engaged in a less than subtle process of recuperation in his ambiguously entitled editorial, 'La Négritude, connais pas' [Negritude, never heard of it] (1966b). Joachim claims that Wole Soyinka, Tchicaya U'Tamsi and Sembene, all of whom had previously signalled their disapproval of Negritude but who had now won prizes at the festival, have been forced to see the error of their ways, as though winning prizes at what he explicitly views as a festival of Negritude is clear evidence of their false consciousness.

The tenuous nature of Joachim's argument is revealed in a profile of Sembene later in the same issue (Joachim 1966d). Although Sembene is more charitable in this interview than he is in many of his other statements about Negritude, his remarks are consistent with his usual Fanonian reading of

45 The exiled South African poet, Keorapetse Kgositsile, who attended the festival with the US delegation, was scathing in his critique of the festival's refusal to engage with burning political issues (see Ratcliff 2014: 178–79).

Negritude as a historically contingent concept whose time had passed with the achievement of independence. What is perhaps most remarkable is that Joachim appears to share Sembene's reading of Negritude, for in an article earlier in the same issue, tellingly entitled 'Où va la culture négro-africaine?' [Where is Black African Culture Heading?], Joachim positions the Dakar Festival both as a celebration and the culmination of Negritude. Having outlined the nature of 'classical' black civilization, Africa can now look to the future:

> Ce Festival des Arts est un tournant. La nuit tombe [...] sur une étape [dans notre développement] qui fut certes douloureuse, mais exaltante. Le jour se lève sur une nouvelle ère où il ne sera plus question d'encenser éperdument le Nègre [...] ni de chanter l'Afrique comme la terre préservée ou comme le berceau de l'humanité. (Joachim 1966c: 13)

> This Festival of the Arts is a turning point. Night is now falling [...] on a stage [in our development] that was painful but exhilarating. The dawn of a new era is upon us, one in which it will no longer be a question of mindlessly praising the Black man [...] nor will we constantly be obliged to praise Africa as the promised land or the cradle of humanity.

Essentially, for Joachim, the festival was the real enactment of the metaphorical process that Senghor had often evoked in relation to Negritude, that of storing Africa's soul in a safe place in order to meet the challenges of a future globalized world. This is what Senghor viewed in the Musée Dynamique exhibition as the celebration of Africa's 'Classical' age: what shape the future of African culture would take and how it might lead to the development of the continent was at the heart of a more rancorous debate that would rage all through the subsequent Pan-African festivals of the 1960s and 1970s.

The Legacy of 1966: from Dakar 1966 to FESMAN 2010

The First World Festival of Negro Arts clearly announced its pioneering status in its title but it also implied that its aim was to inaugurate a regular gathering to celebrate black arts and culture. The Second Festival of Black Arts and Culture finally took place in Lagos in 1977 but, as Andrew Apter demonstrates (Chapter 7), it did so more in a spirit of rupture than continuity with the cultural agenda identified by Senghor 11 years earlier. Hostility towards Negritude had been expressed, largely from a Marxist perspective, by many at the Algiers colloquium; in Lagos, this hostility took a somewhat different form and was based on a desire for the festival to provide a platform for all of Africa, as well as a more widely understood 'black world', encompassing the dark-skinned people of Papua New Guinea, amongst others. As the discussions grew more rancorous, Alioune Diop, who was there to represent continuity with the First World Festival, found himself unceremoniously removed from the organizing committee.

In the mid-1980s, the respected Senegalese academic Pathé Diagne was charged by President Abdou Diouf with exploring the feasibility of Senegal hosting another edition of the festival but, in the era of Structural Adjustment Programmes and IMF-imposed budget cuts, the project finally ran into the sands (see Ficquet 2008: 24; Vincent 2008b: 159).[46] In the same period, the Musée Dynamique, which constituted the most tangible legacy of the 1966 festival, became the most visible symbol of the decline of Senghor's cultural programme and the apparent demise of his vision of culture as the motor of development at the heart of the African Renaissance. After functioning for over a decade as one of Africa's most respected art galleries (hosting exhibitions of work by Picasso and Chagall, amongst others), the museum was suddenly and inexplicably transformed by Senghor into a dance school. Then, in the late 1980s, it lost its artistic vocation entirely, when Diouf's government turned it into a law court: it today houses Senegal's Supreme Court.

But is Senghor's vision of culture really dead? Senegal hosted the Third World Festival of Negro Arts (FESMAN) in December 2010, defiantly announcing the arrival of the African Renaissance more than four decades after Senghor had made almost identical claims.[47] Can we conclude from this that FESMAN 2010 was an inherently belated gesture, a nostalgic rerun of an event that made sense in the context of post-independence utopianism but that seemed outdated in the early twenty-first century? Or should we interpret President Abdoulaye Wade's organization of the festival and his construction of the monumental (and highly controversial) *Monument de la Renaissance Africaine* in Dakar as evidence that Pan-Africanism is still alive and kicking or perhaps in ruder health than ever given that FESMAN attracted 6,000 participants from over 50 countries (Pool 2011)? Certainly, many Senegalese commentators in particular have opted for the former interpretation, viewing FESMAN 2010 as an opportunistic attempt by Wade to recuperate some of the cultural capital of his predecessor: by many accounts, a man with a gargantuan ego, Wade had reputedly long envied Senghor's status as a man of learning.[48] Certain critics of FESMAN have decried the event as embodying the 'politics of self-aggrandizement' (Niang 2012: 32) of a new, neoliberal elite who have replaced the patrician leaders of the independence era: '[FESMAN 2010] provided a metaphor for the hypnotic capacity of mega-events to breed a sense of achievement in a ruling

46 Such are the difficulties in organizing festivals and biennales that one critic has argued for the creation of a history of these 'absent' or 'incomplete' events (Vincent 2008b).

47 In a sign of the evolving terminological debates, the full title in French of FESMAN 2010 was *Festival mondial des arts nègres*, while its English title was Festival of Black and African Culture, which saw the adoption of the terms that had been used at FESTAC '77.

48 See, for example, the two strident critiques of FESMAN 2010 in a special issue of *African Theatre* on festivals (Dieye 2012; Niang 2012).

elite resolutely turned outward and collectively obsessed with wealth and power' (36). In addition, critics often cite the lack of a coherent intellectual framework for the festival and, indeed, its colloquium gave a prominent place to the strident Afrocentrism of Molefi Kete Asante, Théophile Obenga and Runiko Rashidi and their essentialist views about a transnational black culture. Furthermore, much of the organization of FESMAN was catastrophic with many events simply cancelled at the last minute, while the government of new president Macky Sall (who defeated Wade in elections in Spring 2012) uncovered major discrepancies in the festival's accounts which appeared to indicate that there had been widespread embezzling of funds.[49]

FESMAN 2010 may have lacked a single, guiding philosophy but, in many ways, this is a reflection of the contemporary fragmentation or diversity (depending on one's point of view) of thought on black culture and identity. In addition, as was argued above, the 1966 festival only appears in retrospect to have been a unanimous celebration of Negritude, whereas in fact a conscious process of recuperation had been required to defuse the critiques of the likes of Soyinka and Sembene. FESMAN 2010 was a flawed but rich and diverse performance of Pan-Africanism, which was responding to the changed landscape of the early twenty-first century. As I have argued elsewhere (Murphy 2014), the 2010 festival might charitably be interpreted as an attempt to democratize the understanding of black art and culture. While the 1966 festival was marked by its explicitly selective approach to the arts, FESMAN 2010 showcased a highly eclectic mix of African cultural forms with a strong emphasis on popular arts, especially pop music, as well as elements of African culture defined far more broadly. Over the three weeks of the festival (it ran from 10 December to 31 December), a wide array of events took place, and, unlike the 1966 event, absolutely everything was free to the public. There was an impressive exhibition of contemporary art at the Biscuiterie de la Médina (featuring works by the renowned British-Nigerian artist Yinka Shonibare); a low-key exhibition of 'traditional' art at the newly renovated IFAN Museum (a major contrast to the richness of the *Negro Art* exhibition in 1966); dance shows at the Maison de la Culture Douta Seck, which also housed Mondomix's outstanding, high-tech interactive exhibition on black music. Every night, there was a free, open-air concert at the independence monument in Colobane, and huge crowds turned up to see the likes of Youssou N'dour, Salif Keïta, Akon and Diam's. (These concerts were broadcast live by the state television channel, RTS.) There were also theatre, architecture and literature programmes. Football matches at the national stadium, featuring Brazilian and Senegalese club and national (junior) teams drew crowds of over 20,000, while the magnificent opening ceremony in the same arena drew a huge audience of at least 30,000. By any standards, this was a big and incredibly eclectic festival that sought to engage with a wide range of audiences.

49 For a first-hand account of my own experiences at the festival, see Murphy (2011).

What is more, in drawing thousands of participants and festival audiences to Dakar, the event permitted more of the personal encounters that facilitate the performance of pan-Africanism (in Shepperson's terms). FESMAN 2010 may have been marked by a recuperative and nostalgic approach to the archive but this did not foreclose the possibility of reigniting some of the utopian energies central to earlier manifestations of the Pan-Africanist project. Shortly after the conclusion of FESMAN, its British artistic director Kwame Kwei-Armah claimed of his experience in Dakar that:

> It was like the UN in the artists' village [...] You sit in the cafeteria and Mauritanians are jamming, the Guadeloupeans are giving impromptu readings—it's artistic heaven. Being able to take in the great art, and then being able to chill out with world-class artists with my children has probably been the highlight of my life so far. (Kwei-Armah, cited in Pool 2011)

It is reported that 'Kwei-Armah was asked to curate on the recommendation of the legendary Senegalese musician Baaba Maal, who had seen several of his plays' (Pool 2011): a Senegalese musician appreciating the work of a British playwright of Caribbean descent is very much p/Pan-Africanism in action. Although the success of FESMAN 2010 as a well-oiled mega-event may be questioned, it appears evident that it still managed to provide a forum in which p/Pan-Africanist energies were tapped into by Kwei-Armah and many others present.

We must recall though that the main legacy of Dakar 1966 has not been the proliferation of mega-festivals but rather the proliferation of smaller cultural events. Senegal alone now holds roughly 100 cultural festivals each year, although they all tend to follow a model whose foundations were laid by the Dakar event. As Ferdinand de Jong argues in his contribution to this volume (Chapter 8), 'the cultural festival as a genre of cultural performance has been appropriated to claim global membership by serving as both channel of modernity as well as "archive" of tradition'. As was the case with the 1966 event, the modern African cultural festival is simultaneously past- and future-oriented. For her part, Elizabeth Harney (Chapter 9) explores 'the persistent engagement with and appeal of refashioning African modernist and vanguardist discourses of FESMAN '66 to suit the workings of the local and global art worlds of today'. The pull of the local and the global, the modern and the traditional, still echoes through African cultural festivals. The First World Festival of Negro Arts constituted a key moment of transition from the colonial to the postcolonial exhibition, and it is one that continues to inspire and challenge cultural actors in highly varied ways.

Conclusion

From an early-twenty-first century perspective, the Pan-African political and cultural initiatives of the 1960s and 1970s often appear strikingly utopian.

However, the Pan-African ideal has continued to inspire various cultural and political actors on both sides of the Atlantic and there has been a renewed academic interest in Pan-Africanism over recent years. As Tsitsi Jaji argues: 'to speak of pan-Africanism as an ongoing project now seems outmoded. Yet it is precisely because the challenges of new forms of exploitation are so acute and pervasive that renewed perspectives on liberation movements and solidarity are so urgently needed' (Jaji 2014: 8). It is thus important for us to revisit the First World Festival of Negro Arts not solely to explore what it tells us about the past but also in terms of the lessons we might learn for our present and our future. This chimes with ideas that Gary Wilder has outlined in another context:

> I am not primarily concerned with futures whose promise faded after imperfect implementation nor with those that corresponded to a world, or to hopes, that no longer exist but instead with futures that were once imagined but never came to be, alternatives that might have been and whose unrealized emancipatory potential may now be recognized and reawakened as durable and vital legacies. (Wilder 2015: 16)

The series of cultural festivals in the era of decolonization, of which the Dakar event was the first, marked some of the most profound articulations of Pan-Africanism. As has been argued throughout this introduction, the 1966 festival constituted a hugely significant *performance* of Pan-Africanism, acting as a living illustration of shared values and facilitating concrete encounters between Africans and members of the diaspora in which a profound sense of cultural belonging was performed. What is so significant about the First World Festival of Negro Arts (and each of the Pan-African festivals that has taken place since then) is that it provided a context in which Pan-Africanism could be performed in ways meaningful to a wide range of people. Even those doubtful about the value of Negritude, such as Ousmane Sembene, Wole Soyinka and Langston Hughes, were willing to attend because of the historic cultural and political possibilities opened up by the simple fact of being there. This left them open to processes of recuperation but they thought it worth the risk so that they too could play their part in a global dialogue about the black world. Ultimately, though, perhaps what is most important about the festival is that it took place at all:

> The Festival became a success by the mere fact that it opened, that it was held at all—for here were all but a few of the independent nations of Africa and the Caribbean, most of them desperately poor and with monumental problems, implicitly admitting that they nevertheless are bound together by certain historical and cultural imperatives, and that they wish to affirm and to strengthen those bonds. (Fuller 1966d: 101)

Over the past 50 years, it has sometimes appeared as though the significance of the First World Festival of Negro Arts has been entirely lost from view. However, the past decade has seen a revival in scholarly as well as public

awareness of this landmark event.[50] This volume seeks to consolidate that resurgence in interest and to restore Dakar 1966 to its rightful place at the heart of our understanding of a transnational black culture and identity in the second half of the twentieth century.

50 At the time of writing, the project team behind the PANAFEST Archive have just launched an exhibition at the Quai Branly Museum in Paris, *Dakar 66: Chronicle of a Pan-African Festival* (16 February–15 May 2016), to coincide with the 50th anniversary. For an outline of the exhibition, see www.quaibranly.fr/en/exhibitions-and-events/at-the-museum/exhibitions/event-details/e/dakar-66-36335 (consulted 8 February 2016). On 23 January 2016, a screening of the Soviet film, *African Rhythms* (billed as *African Rhythmus*), was held at the Daniel Sorano Theatre in Dakar. At the time this volume was going to press, planning was underway to organize a conference and an exhibition in Dakar in November 2016 as part of an official commemoration of the festival.

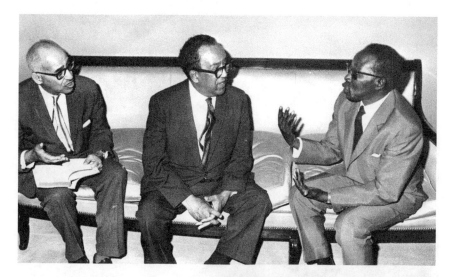

1 (*left to right*) Mercer Cook, Langston Hughes, Léopold Sédar Senghor. Official meeting at the presidential palace Mercer Cook Archive; Moorland-Springarn Research Center, Howard University, Washington, DC

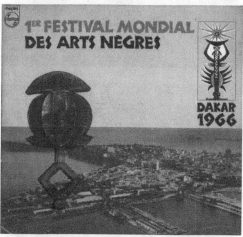

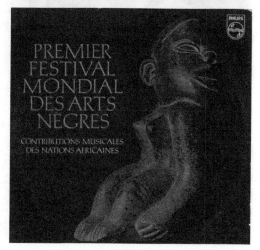

2 Sleeves of two official festival music LP records

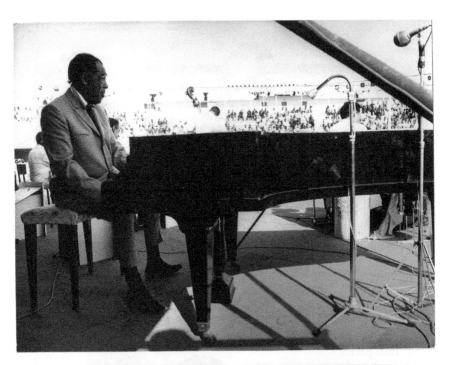

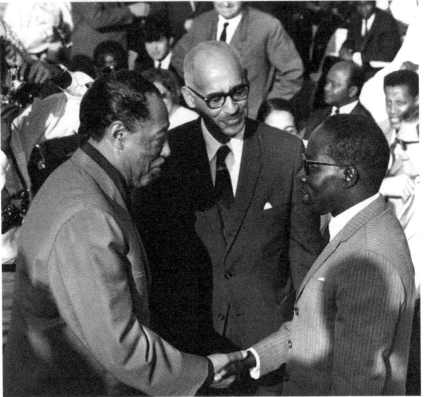

3 *opposite* Duke Ellington on stage at the national stadium
Fonds Jean Mazel; Collection PANAFEST Archive

4 *opposite* (*left to right*) Duke Ellington, Mercer Cook, Léopold Sédar
Senghor. A formal handshake at Ellington's concert at the national stadium
Mercer Cook Archive; Moorland-Springarn Research Center, Howard
University, Washington, DC

5 *above* (*left to right*) Langston Hughes, Katherine Dunham, St Clair Drake at
the festival colloquium
Mercer Cook Archive; Moorland-Springarn Research Center, Howard
University, Washington, DC

6 *above* A view of the Musée Dynamique from the Corniche ouest in Dakar
Fonds Jean Mazel; Collection PANAFEST Archive

7 *opposite* Mounting the exhibition of *Negro Art* at the Musée Dynamique
Fonds Jean Mazel; Collection PANAFEST Archive

8 *below* The *Negro Art* exhibition at the Musée Dynamique
Fonds Roland Kaehr; Collection PANAFEST Archive

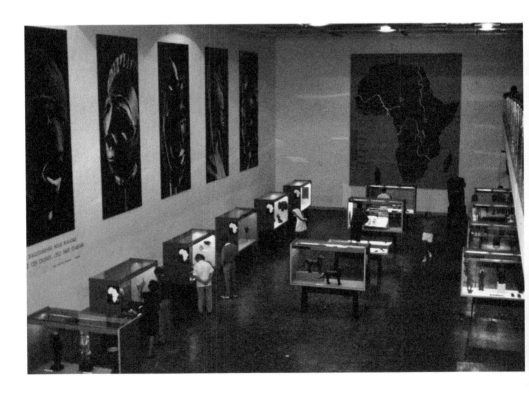

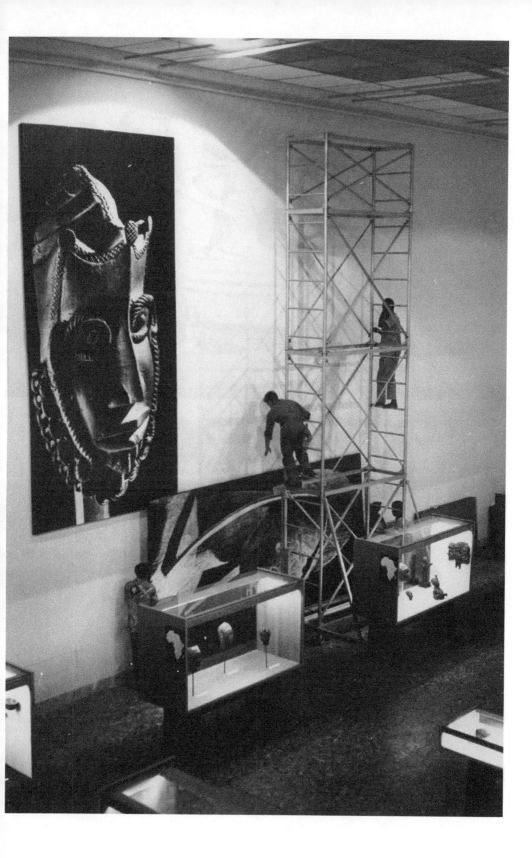

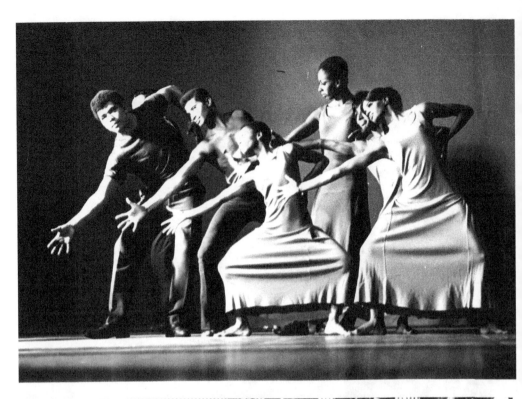

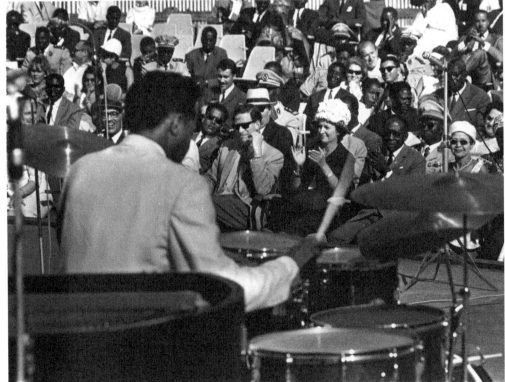

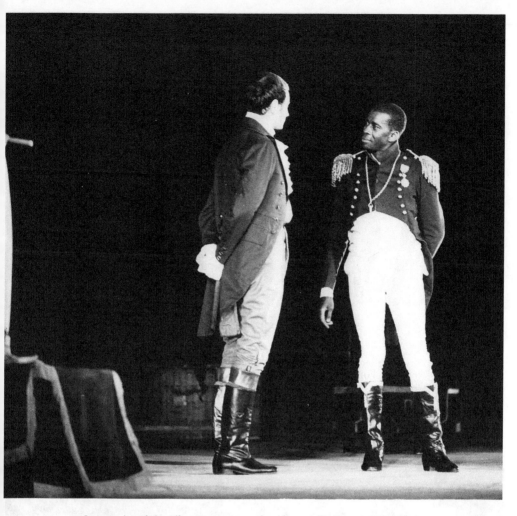

9 *opposite* Alvin Ailey Dancers performing at the Sorano Theatre
Mercer Cook Archive; Moorland-Springarn Research Center, Howard
University, Washington, DC

10 *opposite* Duke Ellington orchestra performing at the national stadium.
Drummer Sam Woodyard is visible in the foreground; President Senghor,
US ambassador Mercer Cook and their spouses are visible in the front row
of the audience
Mercer Cook Archive; Moorland-Springarn Research Center, Howard
University, Washington, DC

11 *above* Performance of Césaire's *La Tragédie du roi Christophe* at the Sorano
Theatre
Fonds Jean Mazel; Collection PANAFEST Archive

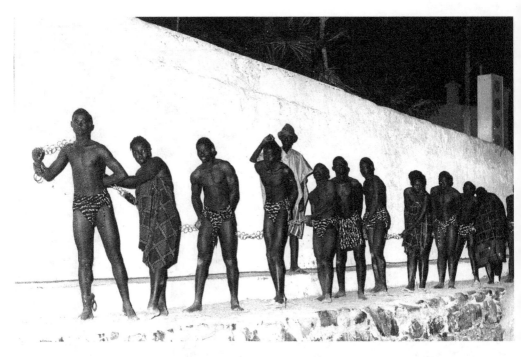

12 Performance of the *Spectacle féerique de Gorée*
Fonds Jean Mazel; Collection PANAFEST Archive

13 Performance of the *Spectacle féerique de Gorée*; the camera tripod of the
Soviet documentary film crew is visible in the edge of the frame
Fonds Jean Mazel; Collection PANAFEST Archive

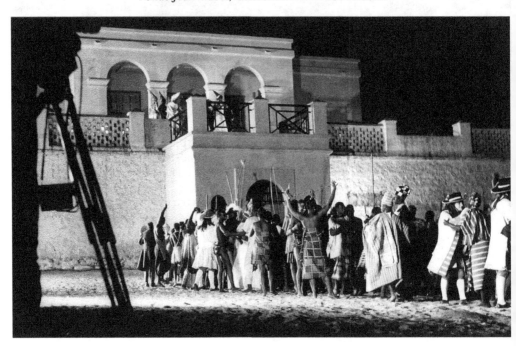

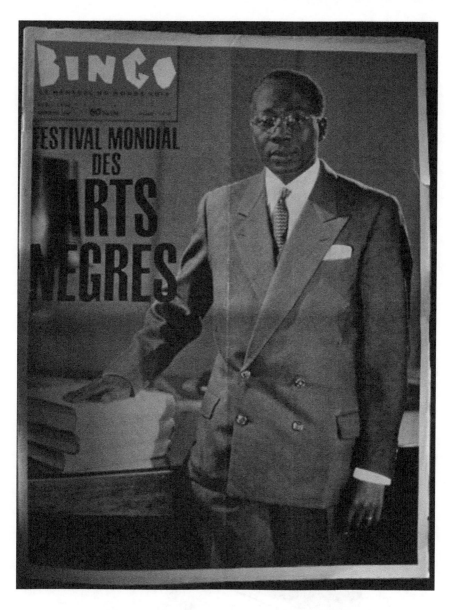

14 Léopold Sédar Senghor on the cover of the April 1966 issue of
French West African cultural magazine, *Bingo*

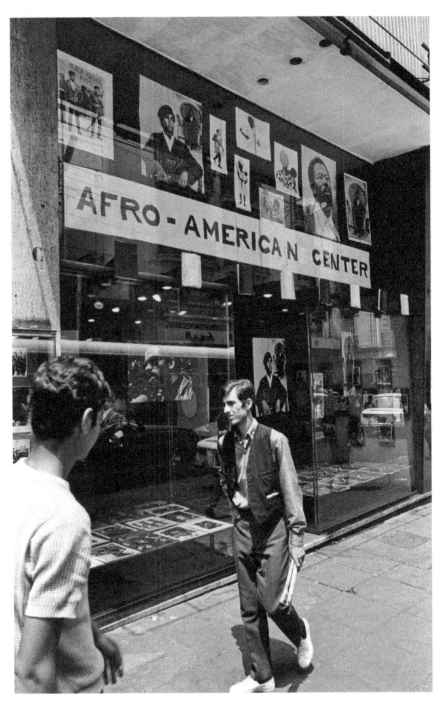

15 Afro-American Information Center, Algiers, 1969
Photograph: Robert Wade

I
Contexts

CHAPTER ONE

'The Real Heart of the Festival': The Exhibition of *L'Art nègre* at the Musée Dynamique[1]

Cédric Vincent

The exhibition, *L'Art nègre/Negro Art: Sources, Evolution, Expansion*, was (alongside the similarly themed colloquium), the major highlight of the *Premier Festival mondial des arts nègres*. It was also the event that attracted by far the most attention from the world's press. For instance, the USA-based scholar John Povey categorically affirmed that: 'The traditional museum pieces were remarkable. A single visit to this exhibition made the trip to Dakar already worthwhile' (1966: 26). In the build-up to the festival, the Senegalese newspaper, *Dakar-Matin*, published regular progress reports on preparations for the exhibition, as well as updates on the construction of the event's purpose-built home, the Musée Dynamique (Figure 6). This was the first time that the 'masterpieces' of African art had been gathered together under one roof in Africa: this involved not only art works held in museums and private collections in Europe and America but also pieces that remained in Africa as part of the continent's still vibrant cultural heritage. After Dakar, the exhibition transferred to Paris that summer for a show that inaugurated a brand new exhibition space within the Grand Palais.

On 30 March, the day before the exhibition opened, the festival was launched by a colloquium held in Senegal's National Assembly. Over the course of a week, speakers debated 'The Function and significance of negro art in the lives of and for the people', a theme that echoed earlier discussions at the Congrès des artistes et écrivains noirs held in Paris (1956) and Rome (1959). The debates centred on establishing an inventory of African cultural riches, identifying new cultural forms and exploring the notion of cultural unity. The festival had been charged with affirming the global recognition of 'black culture' through a comprehensive demonstration of its key cultural and artistic achievements. In light of this, the exhibition can be seen to have

1 Translated from the French by Aedín Ní Loingsigh.

provided aesthetic support for the colloquium, as well as giving expression, through the representative sample of works exhibited, to the desire to provide a synoptic history of African art.[2] However, the attention that the exhibition drew risked diverting observers from the other main preoccupation of the colloquium, namely to lay the foundations for Africa's cultural future.

This chapter will focus less on the exhibition as a representational and finite enterprise than on tracing the remarkable work that went into curating and organizing an exhibition on this scale. For this reason, the exhibition space itself will be less central to the chapter than the broader notion of 'negro art', which constitutes both a framework for the production of art and a form of cultural development that is articulated across several different sites.

Although the overall direction of the exhibition was determined by the festival's broader Pan-African project, the French state enjoyed a significant practical influence through its financial and logistical contributions. Indeed, French involvement provided an easy target for opponents of the festival who could argue that the first major cultural event organized by a nation 'freed' from the yoke of colonialism in fact witnessed the perpetuation of French domination of Senegal (see Boukman 1966; Stouky 1966). However, this type of criticism obscures the context of co-production that this chapter considers to be central to the festival's organization.

The Exhibition's 'Mixed Committee'

In its accompanying catalogue, the *Negro Art* Exhibition is presented by Georges-Henri Rivière as the culmination of a shared Franco-Senegalese project: 'Mr André Malraux has been intending to hold an exhibition of negro arts in Paris; President Senghor wished to hold an exhibition of the same kind in Dakar.' He then goes on to cite a third partner: 'UNESCO, with its interest in developing cultural institutions in Africa, wanted to set up a pilot museum in the Senegalese capital' (*L'Art nègre* 1966: xxxvi). The exhibition was clearly announced as the product of an unprecedented international cultural collaboration.

In 1963, a team of seven commissioners was brought together to form the Exhibition's 'mixed committee' with the aim of giving equal representation to European and African experts. The French director of the Musée des arts et des traditions populaires, Georges-Henri Rivière, shared the role of committee director with Dahomey's (now Benin) Minister for Justice, Alexandre Adandé, who, more importantly, had previously served as right-hand man to Théodore

2 This chapter owes a great deal to Eloi Ficquet and Lorraine Gallimardet (2009) who conducted a pioneering, in-depth analysis of the exhibition on *L'Art nègre*. Their study focuses on the intricate relationship between the exhibition and the colloquium.

Monod, founding director of the Institut Français d'Afrique noire (IFAN) in Dakar. The French commission was led by Pierre Meauzé, head of 'Black Africa' collections at the Musée des arts d'Afrique et d'Océanie, while his deputy was Jacqueline Delange, who held the same role at the Musée de l'Homme. The African commission included the youngest member of the team, the Cameroonian Jesuit cleric and University of Yaoundé academic Engelbert Mveng (born in 1930). His deputy, the Senegalese Salif Diop, was also appointed to liaise with the festival organizers. Finally, the Swiss curator and director of Neuchâtel's Musée d'ethnographie, Jean Gabus, was appointed by UNESCO to serve as a consultant for the African representatives. Alioune Diop, director of Présence Africaine and President of the Société africaine de culture, attended meetings and was called upon to use his diplomatic skills when it came to negotiating the thorny question of securing loans from Western museums.

The work of the exhibition committee was centred in Paris, and it operated independently of the overall festival organizing committee. The sheer volume of archival collections generated over the three years leading up to the exhibition provides some insight into the administrative headache involved in its organization. These archives are now divided between the Musée du Quai Branly (deposited there by the Musée de l'Homme and the Musée des Arts d'Afrique et d'Océanie), the Réunion des musées nationaux (RMN), UNESCO and the Musée d'ethnographie in Neuchâtel (Switzerland). It is significant that there is very little documentation on *Negro Art* in the Senegalese National Archives (just some staff records and reports on overseas trips).[3]

In an effort to ensure an equal relationship between the main parties, an agreement was signed between the Festival Association, represented by Alioune Diop, and the Réunion des musées nationaux, represented by Jean Chatelain, overall director of French museums. This document provides an insight into the financial agreement that had been reached and its precise objective: 'Dispositions financières: de façon à apporter une aide technique et financière efficace à l'association' [Financial arrangements: to lend an efficient technical and financial assistance to the association].[4] In line with this thinking, all takings from the Dakar exhibition would go the Festival Association. Moreover, the RMN agreed to pay the Association any profit generated by the Paris exhibition, and if the latter were to make a loss, the RMN would cover this amount.

Beyond these arrangements designed to even out the power relations between the various partners, minutes from committee meetings do not provide us with a full picture of exchanges between committee members. However, an incident from 1965, catalogued in a file entitled 'Mveng Dispute',

3 The collection devoted to 'Festival des arts nègres' at the Senegalese National Archives was made available in 2001.
4 See Archives des Musées Nationaux, file 4 CC67, 'divers transports et assurance', pochette 'contrats signés'.

does provide certain clues.[5] Claiming that he had been authorized to do so by Adandé, Mveng wrote the introduction to the exhibition catalogue and submitted it to the other members of the organizing committee. However, this triggered a series of protests. For example, in a letter addressed to Georges-Henri Rivière, the French General Secretary for Cultural Affairs Jacques Jaujard declared:

J'ai l'honneur de vous faire savoir que le projet d'introduction au catalogue qui vient de me parvenir sous la signature du père Engelbert M'Veng, ne saurait rencontrer mon approbation [...] Il n'est pas admissible que, pour une exposition organisée et subventionnée par le ministère des affaires culturelles, celui-ci ne soit pas mentionné. Si ce texte reflétait bien les sentiments réels de certains de nos interlocuteurs africains, il démontrerait qu'un malentendu profond existe entre nous. Ce ne sont pas quelques paroles courtoises à l'égard de personnalités individuelles qui suffiraient à reconnaître l'effort de sympathie agissante et d'amitié concrète réalisé en l'occurrence par le gouvernement français pour favoriser la manifestation, sur un plan international, des expressions les plus précieuses et les plus authentiques de l'âme des arts africains.

[I must inform you that I cannot approve the proposed introduction to the catalogue signed by Father Engelbert M'Veng, which I have just received [...] It is inadmissible that the Ministry of Culture, which is organizing and subsidizing the exhibition, should not even be mentioned. If this introduction genuinely reflected the feelings of some of our African interlocutors, it would reveal that there is significant misunderstanding between us. A few polite words about a small number of individuals could not hope to provide sufficient recognition for the active gestures of kindness and genuine friendship shown in this instance by the French government through its international support for an event that constitutes a most precious and authentic expression of the soul of African art.]

In the rejected version, Mveng had written: 'il nous eût été impossible de mener ce travail à bien sans la présence, l'appui et les conseils de nos amis de France et de l'étranger. MM. Jaujard et Vésinet des Fesles, représentant respectivement les ministères des affaires culturelles et de la coopérations' [it would not have been possible to complete this work without the involvement, support and advice of our friends in France and abroad, Misters Jaujard and Vésinet des Fesles, respectively representatives of the Ministries of Cultural Affairs and of Cooperation].[6]

The incident may appear anecdotal, relating as it does to the particular

5 Archives des Musées Nationaux, file 4 CC68, 'catalogue', pochette 'litige Mveng'; see also the letter from Engelbert Mveng to Alioune Diop, 8 December 1965, Archives des Musées Nationaux.

6 Manuscript with the introduction penned by Engelbert Mveng, together with his correspondence addressed to Alioune Diop, Archives des Musées Nationaux, file 4 CC68, 'catalogue', pochette 'litige Mveng'.

wording of acknowledgments used by Mveng in the conclusion of his text. Diplomatic protocol required the efforts of the French State to be acknowledged, not those of individual civil servants. However, there is more to the story than questions of diplomacy, for this dispute appears to have occurred against the backdrop of an existing set of tensions between Rivière and Mveng. According to Rivière, not only had the young Jesuit, a protégé of Alioune Diop and Léopold Senghor, taken it upon himself to pen the introduction to the catalogue, but he had also attempted to usurp the title of the exhibition's General Curator. Rivière was exasperated by the stream of criticism from Mveng, who accused the Frenchman of regularly failing to consult the African members of the committee, and suggested that he was altering the programme without committee approval. Rivière threatened to resign on three occasions and informed Chatelain that: 'On ne peut m'imposer plus longtemps de subir les attaques à mon honneur de conservateur français et à ma réputation d'ancien directeur de l'ICOM conseiller permanent de cette institution' [I cannot be expected to endure for much longer the attacks on my honour as a French curator and on my reputation as former director of ICOM [International Council of Museums] and permanent advisor to this organization]. At the same time, he accused Mveng of 'dresser les membres africains' [pitting the African members] against 'les membres français de la commission' [the French members of the committee].[7] This troubled situation of opposing forces and struggles for power and influence allows us to glimpse a sort of division, some might say a hierarchy, of roles within the commission that Mveng was attempting to undermine. What is interesting is that nowhere is the content of Mveng's introduction—his own area of expertise after all— discussed or questioned. Rather, the dispute related to formal matters of cultural diplomacy, which were of concern to higher authorities. In the end, an edited version of Mveng's text was published in the Exhibition catalogue. It was left to Senghor to write the acknowledgments.

Panning for Gold

The establishment of the exhibition committee coincided with a change in direction regarding the structure and content of the overall festival, which had begun to expand in new directions as ideas and invitations proliferated.[8]

7 Undated letter from Georges-Henri Rivière to Jean Chatelain, Archives des Musées Nationaux, file 4CC68.
8 Preparations for the festival had officially begun in 1963. However, this date obscures an earlier, more adventurous period of planning. Following a resolution agreed at the Congress of Rome (1959), the First World Festival of Negro Arts was originally scheduled to take place in Modibo Keita's Mali in January 1961 to coincide with independence celebrations. Later, the project was rescheduled for April 1961 in Senegal. Finally, after several delays and growing interest in the event, the festival took place in April 1966. The date coincided with Senegal's

For this reason, the original proposal to hold an exhibition at the IFAN museum, based on a 'modern presentation of its collections', was abandoned. In its place, there would be an exhibition of 'a different nature, whose quality and meaning would be justified by its place in the *Premier Festival des arts nègres*' and would be housed in a purpose-built museum.[9]

From the outset, the Committee established 'the principles guiding the exhibition'. These would remain unchanged until 1966. In the press release distributed to Festival guests, these principles were listed as follows:

(1) L'exposition aura à Dakar et à Paris la même composition [...]

(2) L'exposition sera monumentale, elle ne sera pas géante. Hypothèse de travail huit cents objets.

(3) Elle n'est pas d'ethnologie. Son plan ne reflétera pas, fondamentalement, les structures de cette discipline: économie, techniques, structures sociales, vie religieuse et culturelle etc.

(4) Elle n'est pas didactique. L'appareil d'interprétation sera réduit à un petit nombre de documents clés, exposés en place discrète. La photographie jouera son rôle d'explication et d'animation: très limité au travers d'un critère très exigeant de valeur artistique des clichés. Le témoin majeur restera l'objet, dont la signification sera dégagée par le choix et le groupement.

(5) L'exposition sera d'art [...] L'exposition ne retiendra que de beaux objets.

(6) [...] Présentée à Dakar, elle doit aider le visiteur africain à penser un art qu'il agit et qu'il vit. Présentée à Paris, elle a mission de révéler au visiteur occidental l'essence de l'art africain. À Dakar comme à Paris, son rôle est de mettre en lumière la participation de l'art africain à l'art universel.

(1) The Dakar and Paris exhibitions will be comprised of exactly the same pieces.

(2) The exhibition will be monumental in scale, not gigantic. Working estimate of 800 objects.

(3) It is not a piece of ethnology. Its organization will not fundamentally reflect this discipline's structuring principles: economics, technical, social structures, religious and cultural life, etc.

(4) It is not didactic. The interpretative framework will be limited to a small number of key documents, discretely displayed. Photography will play its role in explaining and illustrating: but this will be very limited due to rigorous criteria regarding the artistic quality of the images. The primary

commemoration of independence as well as the religious feasts of Easter and Tabaski.

9 Jean Gabus, *Rapport musée d'ethnologie de Neuchâtel année 1966*, Archives du Musée d'ethnographie, Neuchâtel, p.129.

reference will remain the work of art whose meaning will be conveyed through its selection and its relationship to surrounding objects.

(5) It will be an art exhibition [...] It will only contain objects of beauty.

(6) [...] In Dakar, [the exhibition] must help the African visitor to imagine an art that is both animated and lived by him. In Paris, its task is to reveal the essence of African art to the Western visitor. In both Dakar and Paris, its role is to highlight African art's participation in universal art.

In other words, the project was envisioned as an exhibition of 'masterpieces' that would gather together an exceptional African heritage scattered across the globe, and, that would, therefore, involve a series of meticulous searches through different collections. These searches were conducted by Meauzé, Mveng and Gabus who travelled to Africa (Mveng and Gabus), Europe (Meauzé) and the USA (Gabus).[10] On paper, the project emerges as a breathtaking and colossal endeavour, involving as it did visiting private and public collections across three continents, meeting with curators, collectors and historians in order to identify appropriate works and persuade relevant actors to loan the best pieces for the exhibition. These missions, favoured from the beginning by Alioune Diop, were the result of Mveng and Gabus' shared desire to collaborate more closely than the organizing committee had initially imagined, with the aim of harmonizing the colloquium and the exhibition.[11]

Mveng's first mission, from 17 July to 5 September 1964, took in Senegal, Ivory Coast, Ghana, Cameroon, Nigeria and Dahomey (Benin). In the company of government officials, religious leaders and local dignitaries, he visited museums as well as sites of worship, craft markets, research centres and universities. Mveng's report notes the 'contacts multiples et fructueux en vue de la préparation du festival aussi bien dans les milieux officiels que dans le peuple et jusque dans les campagnes' [many fruitful contacts made with regard to festival preparation in official centres but also among the people and even in the countryside]. He provides a detailed account of these encounters, as he does of the receptions and conferences to which he was invited. He gives his opinions on local life, and in particular his impressions of expectations regarding the festival, as well as activities undertaken to support it. For, as well as searching for hidden masterpieces, Mveng also played the role of festival ambassador and advocate to those he met. These missions were opportunities for Mveng to assess national delegations' level of preparation and to communicate their criticisms and worries back to the

10 Each of them benefited from these missions in order to deepen their own respective areas of knowledge and they published critical works reflecting upon their discoveries: see Mveng (1964; 1967); Gabus (1967); Meauzé (1967). The Meauzé text is a coffee table book that includes reproductions of these 'masterpieces'.

11 Father Mveng was also one of the main colloquium organizers. For more information on this issue, see Ficquet and Gallimardet (2009).

organizing committee. Certain governments expressed their reservations: Ghana, for example, believed that the festival should have been organized by the Organization for African Unity.[12] Others, as Mveng notes, disapproved of French involvement: 'Il y a des suspicions sur les intentions du Festival et son véritable contenu, beaucoup se demandent s'il est vraiment africain, et pourquoi cette préparation à Paris, mais une fois éclairés tous manifestent un enthousiasme sans réserve' [Suspicions exist regarding the festival's intentions and its true content. Many are wondering if it is really African and why it is being organized from Paris. But once the situation is explained all show unreserved enthusiasm]. He plays down these reservations by highlighting the popular enthusiasm generally shown for the festival: 'On peut dire que l'homme du peuple, même là où les pouvoirs hésitent, ne manifeste aucune réserve. Il y a au contraire une prise de conscience mêlée de fierté devant les valeurs de notre culture' [It is clear that even where the powers-that-be hesitate the ordinary man in the street shows no such reservations. On the contrary, there is a form of awareness mixed with pride in the values of our culture]. In 1965, Mveng also went to Central and East Africa, including Ethiopia.

Mveng's trips had been preceded by two short missions assumed by Jean Gabus: between 26 August and 14 September 1963 he travelled to Ivory Coast, Niger, Cameroun, Nigeria, Ghana and Senegal; between 21 March and 11 April 1964 he returned to Cameroun and also visited Dahomey (Benin). A comparison of the reports of both men is insightful. Gabus' perspective reveals a greater concern with issues of museology and curation than with the questions of diplomacy and festival promotion that seem to preoccupy Mveng.[13] Gabus wanted to give the exhibition an innovative angle by presenting works from Cameroon's traditional kingdoms that until then had rarely been seen in a museum context. Gabus' museological project emerges in particular in his 1964 report: it is necessary to 'faire connaître des œuvres africaines prélevées directement dans le patrimoine traditionnel, restées dans leur fonction' [make available to the public African works taken directly from their traditional cultural contexts, objects that have retained their practical function]. In addition, the Swiss curator was acting in his role as a UNESCO representative, and he envisaged that the exhibition could be used as a form of leverage to make political progress on the protection of Africa's artistic heritage. Following visits to the Foumban Royal Palace in Cameroon and the royal palaces of Abomey in Dahomey (Benin), during the second part of his 1964 mission, he presented recommendations for their restoration to UNESCO. In January 1965, he travelled to the USA in order to select works from private and

12 The organization of the First Pan-African Cultural Festival in Algiers in 1969 was a decision of the OAU.

13 The form of Mveng's reports is particularly helpful for the researcher: taking the form of a travel journal, they often provide an hour-by-hour account of his activities.

public collections. It was following this mission that he requested that Robert Goldwater, director of New York's (now defunct) Museum of Primitive Art, be appointed to chair the exhibition committee and arrange all of the loans from the USA.

These reports allow us to understand the on-the-ground organization of the exhibition and the hopes, especially African, invested in the event. However, they also go beyond that in providing an insight into the contemporary cultural and political context of the countries involved, as well as the cultural and artistic policies to which the festival itself would give rise. Gabus' assessment regarding the worrying state of African museum collections no doubt prompted him to focus his search on the treasures held in traditional kingdoms. He argued for a balance between works sourced on the African continent and those loaned by foreign collections. While the ethnographic nature of collections in the Niamey Museum were judged largely irrelevant to the exhibition's objectives, the Abidjan Museum was a major contributor with 25 pieces chosen for their artistic qualities, including gold jewellery, gold weights, musical instruments, masks and statues. The importance of the Abidjan Museum was unsurprising, as it was the only institution affiliated with the Institut Français d'Afrique noire to have been conceived as an art museum by its founders. Its collections, informed by aesthetic criteria, had initially been built up in the 1940s by Pierre Meauzé, himself an artist and creator of sculptures in the colonial style.

Senghor had established strict criteria for North African material: 'choisir un petit nombre d'œuvres destinées à représenter l'art des communautés noires vivant en Afrique du Nord—et non l'art berbère ou arabe' [choose a small number of works representing the art of North Africa's black communities—and not Berber or Arab art][14] and in February 1966 missions were undertaken in Morocco, Tunisia and Algeria by French specialists on this region. However, the festival's general exclusion of North Africa from its remit was to be a recurring criticism. The response of curators from these countries was both unanimous and unambiguous: while they were willing to recognize that certain forms of music and dance revealed black African influences, their visual and plastic arts belonged to Mediterranean culture and owed nothing to Sub-Saharan Africa. In the end, only the United Arab Republic (what is now Egypt) made a contribution to the *Art nègre* exhibition. The unexpected and belated expansion of the geographical remit signalled by this contribution was also received with suspicion by Rivière who saw it as a manoeuvre undertaken by Mveng to please Senghor.[15]

14 'Suggestions pour la mission de Madame Olanier-Riottot', Archives des Musées Nationaux, file 4CC68, 'Missions Tunisie, Maroc'.
15 Undated letter from George-Henri Rivière to Jean Chatelain, Archives des Musées Nationaux.

Borrowing and Lending

According to the provisional organizational schedule, missions for sourcing the exhibition's art works were to have been completed by May 1965 to allow for subsequent negotiations with the owners about loaning them out for the exhibition. The rules were clear: 'les pays prêteurs prennent en charge l'emballage, le transport, l'assurance des objets pour l'exposition de Dakar. La France assumera le transfert de l'exposition à Paris' [countries lending works of art to the Dakar exhibition are financially responsible for their packaging, transport and insurance. France will be responsible for their onward transport to the French exhibition] and their repatriation.[16] Almost 50 museums were involved, as well as a number of private collectors. In approximate terms,[17] Europe (notably French, Belgian and British museums) contributed half of the works concerned; a third came from Africa (mostly from traditional kingdoms in Cameroon and Dahomey (Benin), as well as Nigerian museums, amongst others); 46 works were sourced in the USA. However, this unquestionable success was not achieved without the emergence of tensions between the former imperial centres and their former colonies over the issue of ownership and the circulation of objects. If the objective of the Dakar festival was to celebrate an African cultural renaissance and the reappropriation of their culture by the people, the meaning of this reappropriation varied depending on the actors involved.

The primary directive guiding the organizing committee—'Any loan refused to one of the cities will not be accepted by the other'—was tested when Kenneth C. Murray, director of antiquities at the Lagos Museum, proved reluctant to loan Nok art works, as well as pieces from Ife and the Kingdom of Benin, to Paris on the basis that Europeans rarely reciprocated when it came to organizing exhibitions in Africa. 'Classical' Nigerian art work was due to occupy a central place in the exhibition and the festival more widely, for Nigeria had been allocated the status of Guest of Honour by Senghor. He supported this decision through historical and aesthetic arguments and by making ever more numerous and effusive declarations about Nigeria's status as 'the Ancient Greece of Africa' (Nzekwu 1966).[18]

A letter from Murray to Rivière sheds some light on the dispute: 'The number of Benin plaques in Lagos is twenty-five on exhibition and twelve

16 'Convention concernant l'exposition', Archives du Musée d'ethnographie de Neuchâtel, file 1386.
17 On this point, we need to be wary of the catalogue, as not all of the works exhibited are listed. For example, two intersecting arch-crowns from the chiefdom of Rey Bouba (Northern Cameroun) are not mentioned, but we know they were exhibited (see Biebuyck 1969: 143).
18 Senghor variously wrote about Nigeria as both the Ancient Rome and the Ancient Greece of Africa (see Senghor's speech from January 1966, cited in Rous 1967: 76–77). Dakar's City Hall was made available for Nigeria to organize an exhibition promoting its own artistic and cultural traditions.

in the store. The British Museum, which Mr Fagg says is "a little richer" in Benin material than Nigeria, has sixty on loan.'[19] Sold at auction in London following a British punitive expedition to the Kingdom of Benin in 1897, these commemorative bronze plaques were, by 1966, held in significantly greater numbers in European collections than they were in Nigeria. Ultimately, it was André Malraux's insistence and the persuasive conviction shown by Rivière— he offered reassurance by heralding the efforts of the International Council of Museums (of which he had previously been director) to safeguard Africa's cultural heritage—that convinced Murray to relent and agree to the loan of these art works. A year later, the outbreak of the Biafran War would lead to works of this type flooding the world's art markets. The asymmetries of power underpinning relations between cultural and artistic institutions based in the former colonial centres and those in their former colonies were to resurface in 1975. During preparations for FESTAC, the Second World Festival of Negro Arts in Lagos, the British Museum refused to loan its organizers the famous sixteenth-century ivory pendant of Idia, the queen mother of the Kingdom of Benin, which had been chosen as the festival's emblem.[20]

Elsewhere, it emerged that the authorities in certain African countries had taken the initiative in choosing the objects they wished to be exhibited. A report by the organizing committee reveals disquiet regarding this development: 'Il est à craindre que cette exposition ne prenne un caractère plus politique qu'artistique, car ce sont les pays qui proposent les œuvres, alors que le choix des objets devraient être uniquement le fait des experts du Comité' [It is a source of concern that this exhibition may take on a political rather than an artistic character, as it is the countries themselves that are proposing works of art whereas the choice of objects should be entirely the responsibility of the Committee's experts].[21] However, rather than seeing this as a political choice, it may well have been a misunderstanding caused by a contrast between the more tightly controlled and autonomous curation of the exhibition and the looser organization of the wider festival, where each participating delegation was free to choose the cultural forms they wished to present.

No doubt, the most awkward incident to resolve arose from an editorial published in January 1965 by Paulin Joachim in the West African magazine *Bingo*. Entitled 'Rendez-nous l'art nègre' [Give us back our negro art], the text concluded by insisting on the restitution to Africa of the objects loaned to the festival by Western museums. Joachim's demand provoked a fear among the

19 Letter from Kenneth C. Murray to Georges-Henri Rivière dated 13 July 1965, Archives des Musées Nationaux, file 4CC65.

20 It is interesting to note that the ivory pendant of Idia features on the cover of the issue of *Nigeria Today* that documents Nigeria's participation in the 1966 festival: the image used is identical to the one that would later appear on the official FESTAC posters.

21 'Commission—séance du 7 mai 1965', Archives des Musées Nationaux, file 4CC68, pochette 'Rapports de Missions'.

directors of institutional and private collections that the works of art they had loaned would remain in Africa. The organizing committee was thus faced, on the one hand, with the threat of potential demands for restitution of objects by African countries, at the same time as it had to deal with the concerns expressed by the lenders of these art works.

In the end, a letter in which President Senghor gave his personal commitment to protect these art works proved the only way to reassure worried lenders. The letter insisted that no demands regarding ownership would be tolerated and that the objective remained the organization of an art exhibition 'placée sous le signe de la coopération internationale et de la compréhension interraciale, au service de l'amitié humaine et du prestige de la Négritude' [in the name of international cooperation and interracial understanding, working in the service of human friendship and for the prestige of Negritude].[22] Concerns outlined in correspondence from Robert Goldwater to Rivière indicate that agreement regarding loan requests was only secured once this guarantee had been provided: 'You will understand without some such assurance, it is impossible for me to request anyone—museum or individual collector—for the loan of his object.'[23]

It seems unlikely, however, that Senghor's intervention fully assuaged fears about the fate of objects to be loaned for the exhibition. Indeed, this possibility may explain the Soviet Union's decision to send photographs of art works rather than the actual objects. The Museum of Primitive Art in New York also hesitated for a long time before finally agreeing to participate. In correspondence with Nelson A. Rockefeller, the museum's founder, Goldwater can be seen offering some reassurance:

> Monsieur Chatelain, director of the Musées de France and administrator of the Réunion de musées nationaux personally assured me at the ICOM meetings that there was no danger either of a change of government in Senegal (which is under French supervision) or of outside expropriation. Both Senegal's National Commissioner and President Senghor have stated privately and written publically that 'no revendications' of any sort will be tolerated by their government.[24]

Between the lines, we can see here the ambiguous nature of French involvement in the organization of the exhibition: it reassured certain institutions located outside Africa, but it also acted as a brake on the participation of others within the continent.

22 Letter from the Senegalese Embassy to Georges-Henri Rivière dated 4 August 1965, file 4CC68, 'Rapports de mission'.

23 Letter from Robert Goldwater to Georges-Henri Rivière dated 28 April 1965.

24 Letter from Robert Goldwater to Nelson A. Rockfeller dated 9 February 1966, folder 1675, box 163, series 'Projects Rockfeller Foundation Archives', Rockfeller Archive Centre, North Tarrytown, New York.

Design of the Exhibition

On 31 March 1966, President Senghor arrived ahead of schedule for the official opening of the Musée Dynamique. Inside the building the exhibition was still in the process of being installed. A succession of delays related to the construction of the museum and the late arrival of exhibits had upset the timetable. An understanding poet-president agreed to postpone the official opening for a few minutes so that the final technical issues could be resolved. At 4 p.m., the exhibition could at least give the illusion of being ready in time for a preview before invited guests.

In the early stages of planning, it had been envisioned that the exhibition would comprise up to 1,000 objects. In the end, the final number was closer to 600. Photographs documenting the installation of the exhibition reveal the 'story' that the principal designer, Jean Gabus, wished to tell (Figure 7).[25] The importance of the 'staging' is accentuated by the space itself: a vast hall with high ceilings, the alignment of the display cases, all the same size and spaced out in symmetrical fashion, each containing a group of objects and, above, on the mezzanine level, a more selective group of art works. It is significant that most photographs of the exhibition are taken from this mezzanine level, as this enabled the capture of dramatic high-angle shots of the main exhibition room below. This view also makes the most of a facing wall that was hung with five impressively large photographs (2.5 m × 5 m) in which close-up shots of the heads of statues served to accentuate the sense of monumentality. At the end of the exhibition space hung a huge map of Africa.[26]

The overall feel of the presentation was airy. Works were presented in glass display cases with the largest pieces on plinths or selectively hung on white picture rails beneath the mezzanine (Figure 8). The room was lit by spotlights on ceiling tracks and, in addition, each glass case had its own individual lighting system. Maps of the African continent placed on the sides of the display cases indicated the geographic origin of the pieces. In line with the exhibition's focus on aesthetic quality, the explanatory labels provided minimal information on the objects' 'social function'. In other words, it was intended that the objects on display should be appreciated according to their formal properties and in relation to the other objects.

If, as certain reports suggest, the design of the exhibition encouraged visitors to move through its displays in a haphazard manner, the organizers had envisaged a more structured experience as early as 1964. The proposed route through the exhibition was divided into five parts, preceded by a preamble designed to catch visitors' attention from the very entrance by immediately introducing them to a 'selection of objects of great beauty' (*L'Art nègre* 1966:

25 For more on the Swiss curator's concept of exhibition design, see Gabus (1965).
26 Original exhibition plans included background music for certain sections but it appears that the final, hasty preparations did not allow for this to happen. Background music did feature in the Paris Exhibition.

xxiv). These objects, about 30 in all, were said to '[represent] the major styles of Tropical Africa', and they included ivory combs from Ivory Coast, gold Akan pendants, the above-mentioned bronze commemorative plaques from the Kingdom of Benin, and other objects made of wood, clay and terracotta. At the entrance of the museum, Senghor had the following words inscribed on the wall in embossed lettering placed between two Bamum drums:

> Seul l'homme peut rêver et exprimer son rêve
> En des œuvres qui le dépassent
> Et dans ce domaine le Nègre est roi
> D'où la valeur exemplaire de la civilisation négro-africaine
> Et la nécessité de la décrypter
> Pour fonder sur elle un nouvel humanisme.

> [Only man can dream and express his dream
> In works that are greater than him
> And in this domain the Negro is king
> Which gives Negro-African civilization its value
> And the need to decipher it
> To use it as a base on which to build a new humanism.]

The first part of the route through the exhibition was devoted to the 'historical dimension' and was designed to bear witness to the historical depth of black civilization through a display that included terracotta from the Nok culture, Chad and Ethiopia, as well as references to the cave art of Tassili and Zimbabwe. Next came the most substantial section, emphasizing the 'geographic dimension', which was designed to showcase Africa's artistic diversity and its global influence, especially in the Americas, through a selection of objects from across the continent. Objects chosen for the third section explored different 'aspects of life'. These included religion (for example, through the reconstruction of Vodun altars), political and military life (illustrated, for example, by panels from Benin and Abomey), economic life (through Akan gold weights). The 'message of Negro art' and its significance were at the heart of the fourth section. Religion and death were illustrated using pieces with a funereal, liturgical or maternal function.

For Gabus, the overall challenge was to 'suggérer des preuves d'après lesquelles la culture et les arts africains n'ont pas seulement subi des influences mais qu'ils ont également marqué les cultures et les arts européens' [suggest proof that showed African arts and culture had not only absorbed influences but had also influenced European arts and cultures].[27] In this respect, the final section, 'Dialogue with the World', on the mezzanine level, highlighted a more complex and problematic set of ideas by displaying pieces that represented processes of exchange between African art and practices from other continents: for example, objects from Madagascar, which was at the

27 Gabus, *Rapport Musée d'ethnographie de Neuchâtel année 1966*, Archives du Musée d'ethnographie, Neuchâtel, p. 140.

crossroads of Africa and South East Asian cultures, or Afro-Portuguese pieces, such as a brass crucifix, a traditional ruler's chair and a finely sculpted ivory horn. It was in this section, and not in the historical section, that 30 Ancient Egyptian objects, largely from the Egyptian Museum of Antiquity in Cairo and the Museum of the Pyramids, were displayed. Significantly, objects from Pharaonic Egypt were excluded from this selection in favour of pieces, many quite pedestrian, from Nubia, Egypt's most southerly region, often considered its most 'African'. What this indicates, of course, is the rejection of Afrocentric theories of a 'black' Ancient Egypt which had been popularized most notably in *Nations nègres et cultures* (1954) by historian Cheikh Anta Diop, a well-known opponent of both the Senegalese President and Negritude thought.[28] Finally, a display of works loaned by the Museum of Modern Art in Paris—including pieces by Léger, Picasso, Atlan, Zadkine and Modigliani—formed part of this last section of the Exhibition and was intended to highlight the influence of African arts on the development of modern art in Europe.

The official route through the exhibition continued on to the Palais de Justice where the contemporary art exhibition, *Tendances et Confrontations* [Tendencies and Confrontations], curated by Senegalese artist Iba N'Diaye, was being held.[29] From Senghor's historical perspective, as outlined in his speech at the opening of the *Negro Art* exhibition, there should be a marked continuity between the creative practices of the past and the contemporary era (Senghor 1977: 60). It was thus significant that the exhibition at the Palais de Justice was officially opened after the exhibition at the Musée Dynamique. However, instead of the complementarity between the two exhibitions that organizers hoped for, there developed a sharp sense of competition. Critics were quick to express their preference for *Negro Art* over a contemporary art judged to be a weak, pale imitation of European modern art.

The Musée Dynamique

It is important to include a discussion of the Musée Dynamique, as the *Negro Art* exhibition is inextricably linked to the building that housed it. Modelled on a columned Greek temple, set in a dramatic location overlooking Soumbedioune Bay, the museum could not but impress the visitor. Although the museum is today used to house Senegal's Supreme Court, at its opening, Senghor presented it as the 'vrai centre du Festival' [the real heart of the Festival] and predicted that it 'sera, dans l'avenir, le témoignage le plus signifiant' [will be,

28 Interestingly, Diop was singled out in the festival as the 'writer who had the most influence on twentieth-century black thought' (Huchard 2001: 229). However, it is noteworthy that he was absent from the festival colloquium.
29 Before becoming the title of this art exhibition, 'Tendances et Confrontations' was to have been the heading for the section of the larger 'Negro Art' exhibition that would subsequently be devoted to 'Dialogue with the World'.

in the future, its most significant legacy] (Senghor 1977: 64). This enduring significance can be understood by the building's embodiment of two key characteristics of the post-war museum: the 'museum as monument' and the 'museum as instrument', with a readily identifiable architecture associated with the flexible and neutral use of space that became known as 'white cube' (see Giebelheusen 2006).

For this reason, the museum was not just designed to meet the functional requirements of the exhibition it would house. Its construction also constituted a guarantee that the exhibition's aims would be achieved. Gabus first suggested building the museum after the exhibition organizers had given up on the idea of reconceptualizing the display of the existing IFAN collections.[30] For it was realized that, without a new museum, the artistic ambitions of *Negro Art* could not be fulfilled. At a purely practical level, for example, the guarantee it provided of an air-conditioned exhibition space meeting strict conservation and security requirements was an essential negotiating point in discussions with public and private lenders of art works. (The IFAN museum could meet none of these requirements.)

Construction of the Musée Dynamique was financed by UNESCO and its design was overseen by Gabus himself. The project was managed by the Dakar-based architects Michel Chesneau and Jean Vérola. Their practice had been actively involved in the Senegalese capital's post-war urban development and the pair had previously designed a number of prestigious buildings in the city that included hotels (The N'Gor and La Croix du Sud), the French, Belgian and Italian embassies, as well as the Daniel Sorano Theatre (see Culot and Thiveaud 1992). The architects submitted their preliminary designs for the museum in 1964, and thereafter they remained in constant contact with the Swiss curator in order to adjust and refine the project as the need arose. For Gabus, as we saw above, the 'museum is conceived as a stage set with all the possibilities that provides of changing the décor/backdrop'.[31] From then on, the design and construction of the museum were bound up with the overseas missions and other vagaries of the planning process. It was finally handed over to the curators in February 1966.

The building's 40 square columns supported the overall structure across three levels. The basement housed technical spaces, maintenance workshops and also machinery. The middle ground level was designated as an administrative space with a curator's office and a photography laboratory. The ground floor and mezzanine constituted the exhibition space, with its total surface area of 1,450 square metres designed to be 'the temporary museum for other museums'.

The museum's name had not been decided upon at the beginning of the process. In June 1964, Jean Gabus wrote to the architects: 'Une question me

30 For a history of IFAN's curatorial policies, see De Suremain (2007).
31 Gabus, *Rapport Musée d'ethnographie de Neuchâtel année 1966*, Archives du Musée d'ethnographie, Neuchâtel, p. 140.

préoccupe, question de détail; c'est le titre du bâtiment: "galerie d'expositions" ou "Musée dynamique"' [One question keeps bothering me, just a detail: it is the name of the building: 'Galerie d'expositions' or 'Musée dynamique?'].[32] The space was not designed to house a permanent exhibition or to store a reserve collection. Other documents again describe it as a 'new museum for temporary exhibitions'. The aim, clearly, was to provide a multi-use space that could accommodate all kinds of exhibitions. This most likely explains why Gabus finally opts, in the same letter, for 'Musée dynamique', a museum with no collection of its own but that 'is in a constant state of readiness'.

'Just a detail'? The name that was eventually chosen bears Gabus' imprint and establishes a link with Neuchâtel's Musée d'ethnographie. Gabus was not only the director of this institution, but had also been the prime mover behind the construction of a new section of the museum (built 1954–55) envisaged as a 'musée dynamique' that would stand alongside the 'static museum' housing the permanent collection. This temporary exhibition building—known today as the Black Box—is recognizable for its distinctive closed structure. The plans for the Dakar exhibition space were modelled directly on the Neuchâtel wing, with a similar gallery–mezzanine arrangement creating huge wall spaces for display. One of the Dakar-based architects, Verola, travelled to Neuchâtel to see the new museum wing's fittings for himself, in particular the display cases. The cases were eventually designed in Switzerland following Gabus' instructions and transported to Dakar. It is also worth noting that Salif Diop, the Musée Dynamique's first director, spent a period of time gaining practical experience in Neuchâtel.

The *Premier Festival mondial des arts nègres* was built in part on a Paris–Dakar axis, but it becomes clear that there was also an important detour via Neuchâtel. Indeed, one of the projects developed by the museum in the aftermath of the festival was entitled 'Switzerland presents Switzerland' (1971), and it sought to answer the question 'What makes Switzerland Swiss?' The exhibition extended from pre-history to the works of Giacometti, Paul Klee and Le Corbusier, as well as the craft of the clockmaker: a history of the Swiss nation that provoked a certain exotic appetite for the specific social and cultural structures of this small, multilingual country. While on paper these choices signalled a diplomatic endeavour, they also marked the continued relationship between Gabus and Salif Diop.

Afterword

The transfer of *L'Art nègre* to the Grand Palais in Paris, outside the context of the festival, necessarily entailed new cultural challenges and expectations.

32 Letter from Jean Gabus to Michel Chesneau dated 1 June 1964. Archives du Musée d'ethnographie, Neuchâtel, file 1422, 'Musée dynamique: correspondance des architects Michel Chesneau and Jean Vérola'.

The festival was envisioned as a way of accelerating the reappropriation of Africa by Africans, and the exhibition was intended to play a central role in that project. The sharing of the exhibition between Dakar and Paris had been identified as a founding principle by the organizing committee, and both events had the same goal of valorizing the 'participation of African art in universal art'. However, the differences between the two sites meant that the material could not be displayed in the same way in the Grand Palais. Although both exhibitions gathered together exactly the same objects, the layout of the Paris display designed by Reynould Arnould, which privileged corridors and closed rooms, could not hope to create the same sense of scenography as the Senegalese museum.

The Musée Dynamique would go on to play an important role in the development of the Senegalese arts scene. It was one of the few exhibition spaces in Africa able to mount major exhibitions of European artists: *Kandinsky and Miro* (1970); *Drawings by Leonardo da Vinci* (1970); *Chagall* (1971); *Picasso* (1972); and *Soulages* (1974), of whom Senghor was a great admirer. Only two Senegalese artists (Iba N'Diaye and El Hadj Sy) had their work exhibited there. From 1973 onwards, the museum hosted the annual stagings of the *Salon des Arts Plastiques Sénégalais*, and it organized the travelling exhibition, *Contemporary Art of Senegal*, which would itself go on to be shown at the Grand Palais in Paris in 1974.[33]

In a short piece on the museum, written in 1989 by Ousmane Sow Huchard, one of its former directors, one can clearly see that the institution veered away from the initial ideas that had been central to Gabus' plans. In addition to a permanent collection (on the mezzanine), Huchard mentions an arts library and a centre for the arts. The use of the word 'dynamique' in the museum's name had become associated with a reaction against colonial museum policies. The Musée Dynamique was thus envisaged in the aftermath of the festival as a living institution, looking towards the future.[34] The relationship with the Neuchâtel museum and with Gabus was obscured and the Musée Dynamique came to be seen solely as a creation of the Senegalese state.

In 1977, the museum was suddenly and without explanation designated as

33 The Musée Dynamique was initially conceived as the first stage in the creation of a Cité des arts, a vast project that was designed to occupy the entire promontory overlooking Soumbedioune Bay. The Cité des arts was envisaged as a teaching establishment that would cover all of the major arts. Beyond the museum, there were plans for a fine arts building, a centre for dramatic arts and music, an administrative building and artists' residences.

34 It should also be noted that there has been some dispute regarding the originality of the Musée Dynamique in the African context. Following his visit to the 1966 festival, Frank McEwen claimed that the National Gallery in Harare (at the time Salisbury, Southern Rhodesia), of which he had served as director from its inception in 1957, was the first 'Musée dynamique' in Africa (McEwen 1967). He was referring to the multiple activities that he had initiated in the museum, from the workshop school to the ICAC festival of 1962.

the home for a dance school (*École Mudra*), which was a project conceived by French-born dancer and choreographer, Maurice Béjart, although the school would be run by the Ivorian Germaine Acogny (also a dancer and choreographer). It reopened as a museum in 1985 but three years later its activities were once again suspended. According to Senegalese art historian Abdou Sylla (2007), major structural damage had been discovered in the building housing the capital's main law court and the Musée Dynamique was identified as a temporary home. However, this transitory solution would in fact prove to be long term: the building now houses Senegal's Supreme Court and the Musée Dynamique has never since reopened its doors as a museum.

Dance at the 1966 World Festival of Negro Arts: Of 'Fabulous Dancers' and Negritude Undermined

Hélène Neveu Kringelbach

Introduction

This chapter examines the dance programme at the 1966 Dakar festival, thereby addressing a curious gap in the legacy of this important event.[1] Little is known about the fact that in addition to the visual arts exhibition, the colloquium and the major plays, the festival was also about people performing, and about audiences enjoying dance and music. There were national troupes from a broad range of African nations (which included Senegal, of course, but also Mali, Chad, Ivory Coast, Niger, Sierra Leone, Togo, Cameroon, Gabon, Zaïre, Congo, Zambia, Burundi and Ethiopia). Like much choreographic and musical production throughout Africa in the 1950s and 1960s, these troupes reimagined rural African life and performed ethnic identities while also projecting images of national unity (Askew 2002; Castaldi 2006; Edmonson 2007; White 2008; Djebbari 2011).

In dance and musical performance as in other art forms, Senghor's explicit objective was to showcase the fundamental connections between all black expressive forms, and to celebrate Africa's contribution to world culture. As with all major events, however, the choices made were as much about exclusion as they were about inclusion. At the heart of the festival was a purposeful juxtaposition of 'traditional' African arts and European modernist art (Murphy 2015). But what exactly was being juxtaposed? And what choreographic forms were excluded?

In this sense, the festival was very much an extension of colonial ideologies into the postcolonial period. Apter makes a similar point in his monograph on

1 This chapter considers dance as an integrated element in genres of performance, which include other expressive forms such as drama, music and song, since choreographic movement is rarely performed on its own.

FESTAC 1977, held in Lagos, when he writes that 'the customary culture which FESTAC resurrected was always already mediated by the colonial encounter, and in some degree was produced by it' (2005: 6). As Mamdani (1996) has argued, European colonial rule in Africa was structured as a dual legal system (a 'bifurcated state'), one centred around civil law for the colonizer and a privileged urban minority, and the other centred around customary law for the rural populations. The 'customary', however, was not simply a survival of pre-colonial social organization made to work for the benefit of the colonial state. As Mamdani suggests, in the rural areas a despotic mode of government ('decentralized despotism') was made to replace pre-colonial forms of 'distributed authority'. But this was couched in the language of 'culture', 'tradition' or 'custom' so as to legitimize the exclusion of rural populations from full citizenship. For Mamdani, the failure of many postcolonial states to ensure the wellbeing of their citizens is a direct legacy of this history. As I will elaborate in the section on antecedents to the festival, the presentation of African culture in musical and choreographic performance, as it emerged from the 1930s onwards, was indeed shaped by this colonial ideology. What does not always come across in Mamdani's work, however, is a sense of African agency: more than a single model of indirect rule, the colonial experience was diverse, and this is largely due to the differentiated ways in which African citizens appropriated or rejected colonial structures. Although Mamdani discusses this differentiation early on in his study, what ultimately comes across is a top-down, violent mode of governance which largely gets carried over into the postcolonial period.

Focusing on cultural production, and on events like the 1966 festival, I argue, sheds a different light on the continuity between the colonial and the postcolonial. This kind of focus enables us to bring to the fore the differentiated ways in which post-independence leaders sought to redress the violence of colonialism, as well as the aspirations of African citizens during the same period. Although the festival was explicitly designed to promote Léopold Sédar Senghor's philosophy of Negritude and Alioune Diop's version of Pan-Africanism, their traditionalism was only marginally embraced by the performers and the audiences. Senghor made no secret of his conception of art as 'high culture' (Murphy 2015), and his disdain for popular culture was already noticeable during his Parisian days as a student (Vaillant 2006). To him, the African masks and sculptures borrowed from the collections of European museums were 'high art', whereas modern African paintings were unfinished experiments. In dance, the dichotomy was even more noticeable since all the African troupes programmed at the festival were viewed as restaging the folklore of particular ethnic groups, as if their work contained nothing modern, choreographed or experimental. Moreover, the classification of all dance performed by black artists as 'Negro art' did not do justice to the multiplicity of sources involved in choreographic processes.

But expressive performance has a tendency to defeat ideologies, and in the end the organizers' traditionalist discourse was not what captured the

imagination of audiences and performers. What did capture their imagination were, rather, the elements of novelty, the cosmopolitan character of the festival, the combination of the familiar and the never-seen-before, like the Alvin Ailey Dance Company, and the dance parties held in the interstices of the official programme. The festival was a turning point in the circulation of performing styles, artistic ideas and individuals within Africa, as well as between Senegal and other parts of the African Diaspora. If anything, then, the dancing that went on at the 1966 World Festival of Negro Arts demonstrates the limits of attempts by state-led ideologies to control people's bodily and creative engagement with the world. As the gap between Senghor's imagination of an African past and people's aspiration to cosmopolitan cultural forms was laid bare, did the festival mark the beginning of Negritude's quiet demise?

Choreographic Antecedents:
Musical Theatre during the Colonial Period

The 1966 festival was in many ways a juxtaposition of dance events, but this did not happen in a choreographic vacuum. Indeed, as the capital of French West Africa since 1902, Dakar had long attracted artists from all over the region, particularly after the end of the Second World War. In addition, the presence of the William Ponty School to train African schoolteachers and colonial administrators helped to turn Senegal into a space of experimentation in the performing arts from the 1930s onwards. These developments form the historical backdrop to the festival, and the context in which local audiences and artists experienced both familiarity and novelty in dance.

The William Ponty School was set up by the French authorities in Gorée in 1915, and moved to Sébikotane, east of Dakar, in 1938. It attracted students from all over French West Africa. In 1935, Charles Béart, a Frenchman who had taught in Bingerville in Ivory Coast, introduced theatre to the curriculum, and was soon appointed director.[2] The students were asked to spend their holidays writing plays that would illustrate their 'native' traditions, with the aim of encouraging them to preserve a connection with rural life. Indeed, while these students epitomized the successful *évolués*,[3] there was also a fear that they might lose touch with the populations they would have to teach or administer on behalf of the French. This concern was evident in Béart's writings:

> Des élèves ont demandé au Directeur de l'école William-Ponty de leur prêter les costumes exécutés pour la fête afin qu'ils puissent 'jouer' pendant les

2 For an excellent study of the role of the William Ponty School theatre in the formation of an elite urban culture in Francophone West Africa, see Jézéquel (1999).

3 The term designated African individuals who were literate, educated in the French system, wore European dress and displayed modern lifestyles.

vacances. Demain, fonctionnaires, ils iront avec sympathie vers leurs frères des villages, ils étudieront les formes d'art trop longtemps négligées et les remettront à la place d'honneur. Ce sera précieux pour nous, qui aimons l'Afrique et qui la connaîtrons mieux; ce sera précieux pour ceux qui se consoleront des menus tracas du métier grâce à cette activité désintéressée et généreuse,—l'instituteur qui aura trouvé une nouvelle et gracieuse légende ou qui aura noté un vieux chant héroïque, oubliera vite qu'il s'est chamaillé avec l'interprète du commandant. (1937: 14)

[Some pupils have asked the Director of the William Ponty School to lend them the costumes made for the [end-of-year] party so that they may 'play' during the holidays. Tomorrow, as civil servants, they will meet their village brothers with sympathy, they will study the art forms neglected for so long and they will restore them to their rightful place. It will be precious for those of us who care about Africa, because we will know it better; it will be precious for those who will find comfort from the minor worries of the profession in this unselfish and generous activity—the schoolteacher who will have discovered a new and enchanting legend or who will have transcribed an old epic song will soon forget that he has quarrelled with the major's interpreter.]

If the Ponty training was successful in producing several generations of *évolués*, as far as the theatre was concerned things did not turn out according to the French plan. Indeed, a significant number of Ponty-trained schoolteachers played a crucial role in the emergence of nationalist politics in Senegal and in other parts of French West Africa after the Second World War (Foucher 2002a; Ly 2009).

If it is difficult to assess the role theatre played in this political awakening, it certainly provided the Ponty students with opportunities to express anti-colonial sentiments in subtle ways, by imagining and staging the lives of resistance heroes. *Bigolo*, for example, was written by a group of Ponty students and staged in the late 1930s by Casamançais student Assane Seck (Foucher 2002a; Ly 2009), who was to become a politician and a minister in Senghor's regime. In the play, Bigolo is a soldier who has defeated the French in the Casamance region in the late nineteenth century. While the Casamançais dance and sing to celebrate their victory, word comes that the French retreat was just a ploy, and that they are preparing a new attack. In a fit of rage, Bigolo destroys his fetish, which he believes to have betrayed him. He returns to war and is eventually defeated and killed. The plot leaves sufficient room for various interpretations: the villain may be the French army or it may be Bigolo himself, who is not sufficiently cool-headed to control his anger, and eventually betrays the traditional spirits who have protected him thus far.

We do not know much about the dances and songs in *Bigolo*, but plays like this one often contained their most subversive elements in the musical interludes, which seemed like innocuous folklore to the French authorities. Mbaye (2004) notes that the Ponty staff censored the plays at times, but this rarely affected the musical and choreographic elements. French actor Henri

Vidal, who had witnessed the play *Téli Soma Oulé* by Lompolo Koné from Burkina Faso, echoed this perception of dance as innocuous folklore in a commentary written for colonial magazine *Traits d'Union*:

> C'est une pièce exclusivement folklorique, permettant d'incorporer les danseurs et danseuses qui, héritiers directs des personnages de la légende, danseront ce que leurs grands-parents ont dansé devant les chefs célèbres de cette époque-là. (Vidal 1955: 66)

> [This is an exclusively folkloric play, which allows the incorporation of men and women dancers who, as direct descendants of these legendary characters, will dance what their grandparents danced in front of the famous chiefs of the time.]

As elsewhere in colonial Africa, the students were divided in their attitudes towards the colonial enterprise, and musical theatre provided a creative space where they could momentarily set aside their political differences. But modern theatre, involving acting, music and choreography, also became popular because it drew on regional performing traditions of a similar kind.[4] Before the arrival of Charles Béart at Ponty, the students were already staging plays with dances and songs, but for entertainment rather than as a formal part of the curriculum. In Bingerville, it was after being impressed by pupils putting together a short play about villagers announcing the arrival of a colonial officer that Béart developed the idea of promoting theatre in school (Mouralis 1986). Thus the emergence of a modern theatrical genre combining regional performing traditions with European ones was the outcome of mutual inspiration rather than a top-down French imposition.

As this theatre spread over time and space with the appointment of Ponty-trained schoolteachers across Francophone West Africa, the genre became reconfigured in every location. During research I carried out previously on the choreographic world in Dakar, I interviewed men who had moved to Dakar from rural Casamance in the 1950s and 1960s, and who had set up theatre and dance troupes in the capital city. They all had memories of putting together plays in primary schools in Casamance, and from their testimonies it seems that dance and song gradually replaced dialogue because this meant that language was less of an issue for diverse audiences. Moreover, the first Ponty plays had been in French because the students there were fluent in French and the teachers probably found it a useful language to communicate with educated youths from all over French West Africa. But schoolteachers appointed in the rural areas would later find it difficult to motivate rural schoolchildren to perform in a language which, in this context, was associated with the violence of colonialism rather than social mobility and Pan-African politics.

From the very first days of its emergence in the 1930s, this musical theatre contained a contradiction: on the one hand, it had a modernist outlook since

4 See, for example, Labouret and Travélé (1928) on Koteba comedy theatre in Mali, and Diop (1990) on traditional theatre in Senegal.

its creators were French-educated young men with aspirations to become modern African citizens; on the other hand, it had a traditionalist outlook since its raison d'être was to act as a mediator for indirect rule. This, of course, illustrates the contradictions which formed part of the colonial project. Over time, however, African nationalist elites co-opted the genre for its traditionalist rather than its modernist dimension. By the time the genre was promoted in its diverse national and regional variations at the 1966 festival, it was framed as a re-enactment of tradition on stage. For this reason, I use the term 'neo-traditional performance' to describe the choreographic genre which emerged from the circulation and codification of musical and choreographic school theatre in Francophone Africa.

Fodéba Keita and the Emergence of Neo-traditional Performance in West Africa

A Guinean student and poet, Fodéba Keita, played a central role in simultaneously popularizing and politicizing the genre. As one of Alioune Diop's friends, he would later be a member of the 1966 festival's performing arts committee, even though Guinea, under Sékou Touré's leadership, refused to participate. Born in 1921 in the Maninka district of Siguiri in Guinea, Keita was a student at Ponty between 1940 and 1943. A keen performer and writer, he soon distinguished himself through his multi-faceted talent and his ability to integrate various elements of performance. He had already played banjo in a school orchestra in Conakry before attending the William Ponty School, and while in Senegal he also developed an interest in poetry, theatre and song writing ('Fodéba Keita, ambassadeur itinérant' 1957; Cohen 2012). In subsequent years he taught briefly in Tambacounda, then for four years in Saint-Louis, at that time capital of the French colony of Senegal. There he formed a jazz band, Sud Jazz, and played in a small theatre troupe aptly named *Le Progrès*. He returned to Guinea, where he worked as a schoolteacher and youth leader for a short period, and probably resumed a friendship with Guinea's future president Sékou Touré, whom he had met in secondary school (then named *École Primaire Supérieure*) in Conakry ('Fodéba Keita, ambassadeur itinérant' 1957). But the young Keita was ambitious, and he soon made his way to Paris to study law. There he socialized with other African students and artists, among whom were Léopold Sédar Senghor, the latter's nephew and future leader of the Senegalese National Theatre Maurice Sonar Senghor, Alioune Diop and other founders of the Negritude movement. Senegalese students who had engaged with theatre, such as Assane Seck, Henriette Bathily, Annette Mbaye d'Erneville, and the older and already well-established dancer Féral Benga, socialized in the same circles. Benga had been successful in the Parisian music-hall scene in previous decades after being one of Josephine Baker's lead dancers at the Folies Bergères in 1926 (Coutelet 2012). By the time Keita arrived in Paris, Benga was choreographing

shows at the cabaret-restaurant he had opened in 1938, 'La Rose Rouge' (Sonar Senghor 2004; Coutelet 2012). Léopold Sédar Senghor had arrived in Paris in 1928, at a time of excitement and experimentation in the performing world. Following the Russian revolution, Diaghilev had brought his *Ballets Russes* to Paris, where they produced modernist choreographies with decor from avant-garde painters like Picasso, Bakst and Matisse.

Parisian musical theatre, then, formed part of the intellectual milieu in which Léopold Sédar Senghor, his nephew Sonar Senghor and Alioune Diop forged their ideas on the intimate link between art and politics. In the 1950s, these ideas would lead them to create the Société africaine de culture, modelled on the Société européenne de culture. The African intellectual milieu in Paris would also compel them to view events like the 1966 festival as cornerstones in the rehabilitation of African cultures and the development of the newly independent African nations.

It was in this highly politicized, cosmopolitan environment that Fodéba Keita set up his first theatre troupe, *Le Théâtre Africain*, in 1949 ('De Ziguinchor' 1965; Straker 2009). The first performances took place at the Cité Universitaire in Paris, and students from Guinea, Senegal, Mali, Ivory Coast and Cameroon made up the initial troupe ('Fodéba Keita, ambassadeur itinérant' 1957). Keita joined forces with musician Facelli Kanté, whom he had probably met in Saint-Louis (Cohen 2012), and with Senegalese actor Bachir Touré ('De Ziguinchor' 1965). Keita's subtly anti-colonial scripts, his poems and his skills as a stage director and choreographer, combined with Kanté's modern music, produced immediate success. His most famous drama, *Minuit* (Keita 1952), was banned in French West Africa because of its explicit anti-colonial stance, but others were less openly political. At the height of its successful trajectory in Paris, Keita's troupe, now renamed Les Ballets Africains de Fodéba Keita, restaged Assane Seck's *Bigolo* at the prestigious Théâtre des Champs Élysées in March 1954 ('Dans le monde' 1954; Straker 2009). In the early 1950s, as the troupe began to tour around Europe and North America, the choreographic and musical dimension gradually displaced spoken dialogue, probably because this was more appealing to international audiences (Straker 2009). The repertoire featured choreographed versions of ceremonial practices from various parts of West Africa, with 'special emphasis on the Mandinka folklore of Guinea and Casamance' (Kaba 1976: 102), combined with movement styles the dancers had picked up during their travels. Then steeped in the Negritude movement, Keita conceptualized his artistic production as a project of cultural revival, modernization and moral salvation all at once (Keita 1955).

The success of these first years led to a tour of West Africa in 1955 and 1956, at the invitation of the Governor of French West Africa. During the tour Keita's troupe recruited a new generation of young, lesser-educated performers to replace the first Paris-based students (Straker 2009: 97–98). At Guinea's independence in 1958, the group was renamed Ballets Africains de la République de Guinée and toured the world as the nation's 'cultural

ambassadors' under Kanté's leadership. Keita was appointed Interior Minister in Sékou Touré's first government, and although Touré later turned against him and had him executed in 1971, he was highly influential in Guinean politics up to the 'cultural revolution' of 1968. The generational shift that took place in the late 1950s not only marked the end of textual plays in favour of musical and choreographic performance, it also ensured that the new generation would be politically malleable. In addition, it offered the cultural material from which Touré's regime would sculpt a national identity that reified and marginalized the populations he considered most likely to oppose his modernization project: people from the forest areas, the *forestiers* (McGovern 2013). In retrospect, one might say that this generational shift prefigured Touré's descent into despotism in the 1960s. At any rate, the genre, which had initially been developed by revolutionary intellectuals, was already being co-opted to serve authoritarian state agendas. Had the neo-traditional performing genre been restricted to Guinea, this would not have concerned the 1966 festival. But this is relevant to the history of the festival because the success of the Ballets Africains on stages worldwide meant that they served as a template for many national dance troupes across West and Central Africa.

In the first half of the 1960s there was growing animosity between Touré and Senghor, for a range of political reasons as well as a degree of personal rivalry. Despite this animosity, or perhaps because of it, Senegal, alongside Mali, would go the furthest in emulating the model of the Ballets Africains. It also mattered that Mali and Guinea shared very similar musical repertoires, an important factor in the imagination of a wider Mande area (Charry 2000; Djebbari 2011).

Following the success of the West African tour in 1955 and 1956 and a new performance in Dakar in 1959, the Guinean troupe returned to Senegal in 1961 ('Les Ballets Guinéens' 1961). By then Dakar already featured a significant number of neo-traditional troupes of different kinds, from the offshoots of rural migrant associations to youth clubs and the family-based troupes headed by the talented members of *griot* lineages.

Maurice Sonar Senghor had established his own dance troupe upon his return from Paris, but it was only in 1961 that it formally became the National Ballet of Senegal, one of three components of the new National Theatre.[5] As several interviewees who performed with the National Ballet in the 1960s and 1970s have confirmed, the Ballets Africains were the Senghors' main source of inspiration in creating a Senegalese equivalent to the Guinean troupe. They served as the primary inspiration for the performers too, who all dreamt of being acclaimed the world over, just like Keita's troupe. Throughout the 1950s, Francophone African magazine *Bingo* regularly featured articles on the success of the Ballets Africains abroad, and in Dakar this success was the talk of the town. Having attended the 1959 Dakar performance by the Ballets

5 The other two were the National Drama Troupe and the Traditional Instrumental Ensemble.

Africains, Léopold Sédar Senghor himself felt compelled to write a review in *L'Unité Africaine*, the magazine of his Socialist party, the UPS. This performance had been an opportunity to articulate his ideas on 'Black African dance', which he saw as embodying the 'emotional' nature of African cultures:

> Les danses négro-africaines restent très près des sources. Elles expriment des drames. La danse est, pour le Négro-africain, le moyen le plus naturel d'exprimer une idée, une émotion. Que l'émotion le saisisse—joie ou tristesse, gratitude ou indignation—, le négro-africain danse. Danse si différente du ballet européen. Rien d'intellectuel. Ni pointes, ni lignes droites, ni savantes arabesques ou entrechats. Ce sont des danses telluriques, les pieds nus posés à plat sur le sol, martelant le sol sans fatigue ni répit. (cited in Sonar Senghor 2004: 66)

> [Black African dances stay very close to their sources. They express drama. For the black African, dance is the most natural way of expressing an idea, an emotion. When taken by an emotion—joy or sadness, gratitude or indignation—the black African dances. Dance so different from European ballet. Nothing intellectual. Neither pointe shoes nor straight lines nor elaborate arabesques or entrechats. These are earth-bound dances, bare feet flat on the ground, pounding the ground without either tiredness or rest.]

Though he was not much of a dancer himself (Vaillant 2006: 124), it is evident in Senghor's writings that he regarded dance as a quintessential African art. His poem, 'Prières aux Masques Africains' (Senghor 1956) ended with an allusion to Africans as 'people of the dance': 'Nous sommes les hommes de la danse, dont les pieds reprennent vigueur en frappant le sol dur' [We are the people of the dance, whose feet regain strength by pounding on the hard ground]. Further in the Ballets Africains review, however, Senghor was also critical of the Guinean production, and there is little doubt that the National Ballet of Senegal was tasked, from the beginning, with outshining the Guinean troupe. In this context, the absence of the Ballets Africains from the festival in 1966 was a political statement. There were Cold War and postcolonial politics at play, of course, since Sékou Touré's Guinea had elected to leave the French Federation in 1958 and initiated a rapprochement with the Soviet Union. Senghor, on the other hand, had no communist leanings, and was probably no revolutionary at heart, even though his government ended up renting a Soviet cruise ship to accommodate some of the festival's foreign delegations. Senghor saw to it that Senegal remained closely associated with France, and he openly courted the USA in the run-up to the festival; France and the USA were also the event's biggest financial contributors.[6]

6 In addition to official contributions to help finance the construction of several new buildings ahead of the festival (the new Parliament building and the Daniel Sorano Theatre), France probably covered the substantial deficit left in its wake (Verdin 2010).

In official discourse, the work of the National Ballet of Senegal aimed at recovering rural ceremonial practices from the past, celebrating the nation's diversity and showcasing Senegalese culture abroad (Castaldi 2006).[7] The juxtaposition at the festival of similar cultural projects from a variety of African nations would help to create a link between the past and the present in the imagination of audiences. In practice, the National Ballet staged tableaux combining music, dance and drama drawn from Sonar Senghor's Parisian days, the troupe's creative work and the dance styles the young performers knew, either from contemporary practices or from their experience of musical school theatre. Some of the young performers had even performed abroad already, with Dakar's existing troupes ('Les Ballets Sénégalais' 1961). There were also recruits among migrants from the Casamance region, from the Sereer-speaking Siin-Saalum south of Dakar and from towns like Louga and Coki in northern Senegal, all areas where school theatre had been particularly successful (for a discussion of Coki, see Niang 1961). Finally, there were students from the School of Arts and youths from the long-established Cape Verdean community in Dakar, who often shone on the dance floors of Dakarois nightclubs pulsating with Cuban music. Young as these recruits were, they would have had limited knowledge of regional histories. Behind the discourse of historical recovery, therefore, the work of the National Ballet consisted mainly in the further codification of the neo-traditional genre.

As far as celebrating the nation's diversity was concerned, the National Ballet followed both French colonial policy and the Guinean troupe in introducing an implicit hierarchy between the urban and the rural, and between different linguistic groups. Urban life was never represented since it was associated with the present (mistakenly, given the long-standing existence of cities in West Africa), and therefore in no need of cultural preservation. In continuity with the Ballets Africains, as well as a French tendency to regard the forest areas as the repositories of 'authentic' African cultures, and therefore as backwards, a substantial proportion of the performance drew on the rhythms, movement styles and instruments from Casamance. The work of the National Ballet was in effect making manifest the peripheries of the nation as Senghor conceived them.

Outside Senegal, the Senegalese troupe had some success from the beginning. The first European tour in 1961, for example, gained very good reviews in the printed press in the UK, Germany and France, and the tour was extended by several weeks ('La Presse allemande' 1961). But the most challenging test for the National Ballet would be its juxtaposition with other troupes at the 1966 festival. By then, the genre imagined by Fodéba Keita had lost much of its modernist edge, and lost all ambition to act as a mediator in the liberation of African populations.

7 See Djebbari (2011) for an excellent analysis of a similar political project with the National Ballet of Mali.

Neo-traditional Performance at the Festival:
The Making of a Conservative Tradition?

The dance programme at the festival seemed to capture perfectly Diop's Pan-Africanist ambitions and Senghor's vision of Negritude as a philosophy of shared black creativity, rhythm and emotion. There was a juxtaposition of the new and the old, modern dance and neo-traditional performance, the work of diaspora artists and that of Africans from the continent. The printed press coverage celebrated the diversity of African cultures as expressed in the 'live spectacle' (spectacle vivant) programme. There was genuine diversity, but as far as the dance displays by various African nations were concerned I suggest that what was shared was the aspiration to emulate the Ballets Africains, and their attempt to reimagine a rural African past. Interestingly, in his colloquium speech, French Minister of Culture and writer André Malraux warned against the temptation to use contemporary ceremonial practices to recover the past:

> Puissiez-vous ne pas vous tromper sur les esprits anciens. Ils sont vraiment les esprits de l'Afrique. Ils ont beaucoup changé; pourtant ils seront là pour vous quand vous les interrogerez. Mais vous ne retrouverez pas la communion en étudiant les cérémonies de la brousse. Il s'agit certainement pour l'Afrique de revendiquer son passé; mais il s'agit davantage d'être assez libre pour concevoir un passé du monde qui lui appartient. (*Premier Festival mondial des arts nègres* 1967: 47)

> [May you avoid misunderstanding the ancient spirits. They really are the spirits of Africa. They have changed a great deal; and yet they will be there for you when you call upon them. But you will not find communion by studying rural ceremonies. Certainly, Africa must claim her past; but it is even more important to conceive a past of the world that belongs to her.]

What Malraux did not say was that the way in which the past was being reimagined in neo-traditional performance, through the selection and standardization of a limited number of performing practices and elements of material culture from the young nations' perceived peripheries, served a contemporary political purpose: it was about co-opting these peripheries into state agendas, while at the same time neutralizing them by representing their heritage as backwards (McGovern 2013).

The choice of troupes, the press coverage and the assessment by the festival's performing arts committee at the end of the programme all indicate that the festival organizers sought to promote traditionalism and that they rejected the elements of experimentation and innovation in the work of these troupes. Little was left, by then, of a sense in which the performing arts could embody a diversity of ideologies, including open-ended ones, and ones that did not fit with the nation-building agendas at hand.

The element of standardization was evident, for example, in the costumes: in several of the dance troupes (Ivory Coast, Liberia, Togo, Chad, Cameroon,

Niger, Congo) the performers wore raffia skirts and criss-crossing chest bands made of beads or cowrie shells, similar to those favoured by the Ballets Africains. In several troupes the dancers wore high fringe hats typical of the Mande area, and particularly of the Siguiri region from which Keita originated.[8] These elements did feature in ceremonial practices in some of the forest regions, but forest regions only form part of these countries. Although these regions' status in the new nations varied (they were not, in all cases, regarded as marginal or as minorities), all seemed to have adopted the Guinean model of an implicit opposition between the tradition-bound forest people and the modern coastal cities or Savannah areas. The young female dancers of several countries (Senegal, Mali, Chad, Congo) performed with bare breasts, even though many communities were uneasy with this kind of display (see Apter 2005 for Nigeria). This echoes McGovern's observation that, in Sékou Touré's Guinea in the 1960s and 1970s, populations from the Savannah-forest frontier feared the forced recruitment of young women into ballet troupes, where they would be forced to perform bare-breasted for all audiences (2013: 215).

There were also strong similarities with the selective process described by Apter (2005) for FESTAC '77 and the Nigerian Festival of the Arts (Nafest) in 1974, which had served as an important step in the preparation of FESTAC. Like the Nigerian festivals in the 1970s, though perhaps less explicitly so, the selection of dance troupes and genres at the 1966 festival followed 'ideal types' seen to embody Pan-Africanism and Negritude. In other words, the work of the African dance troupes did not so much showcase the cultural diversity of the new nations as it involved a careful process of selecting and editing that diversity. African authenticity, as it was conceived of in the performances selected for the festival, was a rather standardized affair which bore the mark of the Ballets Africains and the colonial ideology from which it had emerged.

The festival's concern with traditionalism and authenticity also came across in the organizers' and the media's insistence that true African dance is spontaneous, rather than the outcome of lengthy training and choreographic work. In this sense, organizers and media alike had internalized stereotypes on Africans dancing which can be traced back to the nineteenth century, if not earlier (Neveu Kringelbach 2013a). This perception was reflected in the press coverage, such as the following portrait, entitled 'Dance, a traditional mode of expression', of a Gabonese woman dancer in *Bingo*, whose editor-in-chief at the time, Beninese poet and journalist Paulin Joachim, was one of Alioune Diop's protégés:

Micheline Sofoum du Gabon est une toute jeune fille, très intimidée, qui a répondu à nos questions. Elle danse depuis l'âge de 6 ans et, aujourd'hui, à 15 ans, bien qu'elle fasse partie de la troupe nationale du Gabon, elle ne

8 Djebbari (2011) also describes these hats as a recurring feature of the National Ballet of Mali's favourite costumes.

pense pas que sa promotion soit extraordinaire et n'envisage même pas de faire un métier de ce qui n'est, pour elle, qu'un moyen d'expression traditionnel dans son pays. Elle vit simplement dans son village, au milieu de ses onze frères et sœurs, dansant non pour gagner sa vie ou pour devenir une vedette, mais parce que c'est un délassement sain et mystique et le festival n'est qu'une occasion de plus de danser et d'apporter le message intact de la brousse. ('Elles ont dansé' 1966: 17)

[Micheline Sofoum, from Gabon, is a shy young woman, who has accepted to answer our questions. She has been dancing since the age of six. Today, aged 15, although she is a member of the national troupe of Gabon she does not think of her promotion as extraordinary. She is not even considering making a profession of what is just, for her, a traditional mode of expression in her home country. She lives simply in her village among her eleven brothers and sisters. She does not dance to earn a living or to become famous, but because dancing is a healthy and mystical pastime, and because the festival is yet another opportunity to deliver the true message of the bush.]

The festival committee gave prizes which followed the classification of different art forms which emerged in Europe in the nineteenth century: there were prizes for the best literary works, films, records and contemporary visual arts. In the performing arts, however, it was decided that comparison across the different genres would be too difficult, and that there would be no prizes. Rather, the performing arts committee would assess the quality of each of the performances according to the following criteria: staging, music, decor, costumes and quality of the performance. Probably in an attempt to avoid causing offence, the performances by established non-African artists like Duke Ellington, Josephine Baker or Marpessa Dawn, the American-born French actress who had starred in the film *Black Orpheus* by Marcel Camus, would not be reviewed. The committee was headed by African American choreographer Katherine Dunham, Marpessa Dawn, French filmmaker and anthropologist Jean Rouch, Senegalese theatre producer Mr Crespin, and committee secretary Ibrahim Samb. The assessments, which were published in some of the festival's official publications (e.g., *Premier Festival mondial* 1967) and in the state-controlled Senegalese daily *Dakar-Matin*, reflected a similar kind of traditionalism and lack of recognition of the experimental nature of the African choreographic work presented at the festival. The National Ballet of Mali, for example, was praised for its capacity to 'interpret the traditional dances of Mali, regardless of the origin of the dancers and musicians' (*Premier Festival mondial* 1967: 117). But the committee also expressed a fear that the dancers' training might, one day, 'destroy their spontaneity'.

For the Togolese troupe, the committee found particular interest in 'traditional dances from the "Krikri" Voodoo sect', and did not seem to acknowledge the fact that many Voodoo dances would not be performed outside this religious context without significant transformations. The National Ensemble of Ivory Coast was said to have shown an 'interesting

transfer of traditional wrestling and showcasing of spontaneous dance schools', but it is unlikely that there was anything spontaneous in the work of a troupe that became a major point of reference in West African neo-traditional performance in the 1970s. The Ethiopian troupe was said to have presented 'interesting archaic dances, interpreted by a fresh and naïve troupe' (*Premier Festival mondial* 1967: 118), and yet the Ethiopian dancers wore white outfits very reminiscent of Ethiopia's Christian heritage. Niger's National Ensemble was deemed to have displayed a 'flagrant authenticity of all the dances, both naïve and charming' (120).

There was a tendency among the festival organizers, then, to reify African choreographic performance as timeless, immutable and open to a single exegesis. In this sense, they chose to play down the complexity of many African expressive genres, the thrill of which often comes precisely from the contextual nature and the open-endedness of interpretation. This was demonstrated masterfully by Karin Barber (1991) in her work on the Yoruba *oriki* genre of oral performance. But these qualities, which extend far beyond Yoruba society, were not recognized in the creations of the festival invitees.

Among the non-African troupes, Haiti and Brazil received a fairly negative assessment. It was as if, having praised many of the African performances, the committee wished to demonstrate that the review was also a critical exercise. The Brazilian show, in particular, was deemed to have been 'a disappointment, despite the individual talent of the artists. The Brazilian fever, exuberance and elegance, much admired worldwide, were lacking' (*Premier Festival mondial* 1967: 120).

But there were also contradictions, which probably reflected the ideological tensions within the festival's organization. Whereas it was feared that the dancers of the Mali ensemble might become too well trained and not sufficiently spontaneous, for example, the dancers of the National Ballet of Senegal were deemed to lack training. This may explain why Katherine Dunham was charged with recruiting new dancers and raising the level of the National Ballet of Senegal as soon as the festival was over. Ousmane Noël Cissé, one of the National Ballet's lead dancers in the 1970s, said Dunham had recruited him into the troupe shortly after the festival.[9]

Oddly, too, Alioune Diop turned to the USA for academic expertise on 'traditional' African dances, a request that seemed to assume a lack of institutional knowledge about dance among the African invitees. Diop sent a late telegram, dated 18 March 1966, to Gray Cowan of the African Studies Association, asking him to recommend a speaker on the subject: 'Connaîtriez-vous experts signification danse traditionnelle—Si oui donner adresses—Amitiés. Président Alioune Diop' [Do you know any experts in the meaning of traditional dance—if so, please send addresses—yours truly].[10] Cowan must have suggested dance scholar Judith L. Hanna at the University

9 Personal interview with Ousmane Noël Cissé, Dakar (April 2011).
10 Archives Nationales du Sénégal (ANS), st928/FMAN/Pl.

of Wisconsin, for the festival archive I accessed at the National Archives in Dakar includes a telegram addressed to her by Diop a few days later (dated 23 March 1966), this time in English: 'Could you write a paper on the significance of the dance on a given tribe or ensemble of tribes for colloque—Could you also participate in eventual jury for dance prize. Président Alioune Diop'.[11] The archive contains a copy of a typed paper on dance in Africa, based on Hanna's earlier fieldwork in Nigeria, but, unsurprisingly given that she received the invitation only a week before the festival began, she did not attend.

Consistent with Senghor's traditionalism, other performing genres that were popular in African cities at the time were excluded. The 21 Senegalese dance troupes selected to perform all worked within the neo-traditional genre ('21 troupes artistiques' 1966), even though the 1960s were also the heyday of Cuban music and dance, when Senegalese salsa bands filled the dance floors of Dakar, Saint-Louis or Ziguinchor with Cuban rhythms and songs in Spanish or Wolof (Shain 2002). Many of my older informants in the dance world remembered the Cuban nights of their youth with enchanted nostalgia (Neveu Kringelbach 2013b). Ousmane Noël Cissé's Cuban dancing skills were what had distinguished him from other candidates when he auditioned to join the National Ballet. Saliou Sambou, a prominent Senegalese politician and an early playwright for the Dakar-based Casamançais troupe Bakalama, remembered the Cuban dance parties of his youth so vividly that he performed an entire Johnny Pacheco song when I interviewed him in Dakar in April 2011. Cuban rhythms were indeed popular throughout the coastal cities of West and Central Africa (White 2002). Yet, no Cuban rhythms featured in the festival's dance programme.

What the festival did achieve, on the other hand, was to help codify the neo-traditional genre initially developed between Senegal, Guinea, Mali and France by working as a large-scale 'contact zone'. For many young artists, this was the first opportunity to see a wide range of choreographic practices, to meet performers from other parts of the continent and beyond, to be confronted with cosmopolitan audiences, and to receive worldwide press coverage, however uninformed. It is likely that WoDaaBe dancers from Niger had performed in France in previous years, for example, but this was undoubtedly the first time that their dances were reviewed in US newspapers and magazines like the *New York Times*, the *Washington Post* or *Ebony*, in which African American writer Hoyt Fuller wrote that they 'enchanted the sophisticated audiences with their astonishing charm and innocence and their strange, bird-like songs and movements' and that they 'wore feathers, painted their faces, and chirped like birds' (Fuller 1966d: 102). It is evident from the festival's visual archive that the WoDaaBe performed a young men's dance, the *geerewol*. Understandably for someone unlikely to have known much about the social context of WoDaaBe performance, the reviewer struggled to make sense of what he saw. There was no drumming, no speed and no

11 ANS st1033/FMAN/Pl.

athletic feats, for, as Lassibile (2004) has shown, the WoDaaBe value elevation, slowness and precision in the movements, as well as a skilful display of different facial expressions, which form part of the choreography. The *geerewol* simply celebrates the beauty of individual performers, according to WoDaaBe aesthetic criteria. As noted by Apter (2005), there was some continuity between colonial fairs and pan-African festivals. It is thus no accident that the *Ebony* review echoed the press coverage of African performances during the major 1931 colonial exhibition in Paris, for example, where animal imagery was also abundant. In a similar exoticizing style, the *New York Times* wrote that:

> lance-wielding tribal dancers in leopard skins lent a roaring welcome [...] to the World Festival of Negro Arts, Africa's largest such event. The leopard men presented traditional dances from the Republic of Chad, and the National Dance Troupe of Mali, wearing ferocious symbolic masks, presented a century-old ritual devil dance. ('Tribal dance' 1966: 16)

There was no sense that performance might have been choreographed for this specific context, and old stereotypes about Africans dancing reverberated in the international press throughout the festival.

American Dance: A Game of Absence and the Legacy of Alvin Ailey

The most imposing delegation was that of the USA, where, at the height of the Civil Rights movement, there was intense interest in African diaspora connections. Moreover, it did help that Senghor's old friend Mercer Cook was now the US ambassador in Senegal. However, the American committee suffered from a lack of funds. There was also hostility from a number of prominent African American artists, some of whom were appalled to see the presidency in the hands a white woman, Virginia Inness-Brown. The head of the American delegation to the World Festival of Negro Arts carried great symbolic value, and the presence of a white person in this post implied that no black individual was good enough for the job. Although officially chosen by Senegal, in reality it is likely that Inness-Brown had been appointed at the suggestion of the State Department in an attempt to raise the $600,000 budgeted for the American delegation's participation. But the fundraising campaign was a (possibly engineered) failure, and the State Department was forced to give out a substantial sum to avoid a complete debacle. The failure unleashed a flood of criticism towards Inness-Brown's presidency, and the much-reduced American delegation was marred by tension. Other African American artists openly criticized Senghor's philosophy and his politics. Harry Belafonte, for example, refused to attend and declared, speaking from Paris, that Senghor was 'too soft on Rhodesia' (Garrison 1966a). But it is also likely that the State Department made sure that no black radical artist would attend the festival, for fear that the wind of independence in Africa would provide further ammunition to the Civil Rights movement (Kelley 2012; Jaji 2014).

In this context, the only American dance group that made it to Dakar was the Alvin Ailey Dance Company (Figure 9). Flown in from Rome during a European tour, the company enthralled the audience at the national stadium with Ailey's 1960 piece, *Revelations*. The performance was a last-ditch attempt by the State Department to include black dance in the programme after the initial plan to have a major show involving six choreographers led by New York City Ballet dancer Arthur Mitchell, named the American Negro Dance Company, was cancelled at the last minute due to lack of funds. As late as 2 April, the *New York Times* wrote that 'the participation of an American Negro dance group [was] unlikely' ('Tribal dance' 1966: 16).

The festival, and the sojourn in Senegal, must have left their mark on the performers at a time when many African American artists dreamt of travelling to a continent they regarded as a mythic motherland. Jazz pianist and civil rights activist Randy Weston, who travelled to West Africa the following year on a tour supported by the State Department, recalled the pain of being excluded from the festival delegation at a fairly late stage (Weston and Jenkins 2010). Star Ailey dancer Judith Jamison did make the trip with the company, and later wrote in her memoir that it had been her first voyage to Africa (Jamison 1993: 82).

Likewise, the Ailey show had a tremendous impact on the Senegalese—and probably other African—choreographic scenes for many years to come. After all, this was the first time most participants saw a (mainly) black dance group of such a high standard, and the combination of modern choreography and American spirituals captivated the audience. Ousmane Noël Cissé told me that watching the performance had been one of the turning points in his career, and that it had compelled him to carry out his own choreographic experiments in the 1970s and 1980s, when he led various dance groups and combined West African dances with American modern jazz. He did not so much attempt to copy the Ailey style as to develop his own choreographic 'language', but it was the thrill of watching the American company that inspired him to look for a style more modern, and more cosmopolitan than what the National Ballet was producing in the 1960s. According to Cissé, Senghor too was deeply impressed with the Ailey show, and this may have been one of the reasons he chose to support the modernist, Pan-African Mudra Afrique dance school, which opened in Dakar in 1977.[12] But the impact of the Ailey visit extended further into the Dakarois choreographic world, and probably also into the dance scenes of other African nations who had sent participants to the festival. Dakarois choreographer Jean Tamba, for example, has fond memories of performing sections of *Revelations* with one of the dance studios

12 Mudra Afrique was established at the initiative of French choreographer Maurice Béjart, Senegalese-Beninese choreographer Germaine Acogny—the school's director on a daily basis—and President Senghor. The school was housed in the building of the Musée Dynamique, a choice that seemed to stress the continuity with the festival. A unique experiment in Africa, Mudra Afrique was forced to close in 1983 due to lack of funding (see Neveu Kringelbach 2013a).

he attended in Dakar in the 1980s. In dance the biggest popular success at the festival, then, did not come from one of the Pan-African troupes cherished by Senghor, but from the work of an African American choreographer steeped in the modern dance techniques of Martha Graham and Lester Horton, and in African American Church music.

Dance Parties and Street Events: Popular Cosmopolitanism?

Did audiences, too, dance at the festival? Concentrated in Dakar, the festival remained largely an elitist event with paid entry the norm for most performances. But in the interstices of the official programme, dance parties were organized in abandoned army barracks, cinema halls and other large spaces, and there people threw themselves into the cosmopolitan dance crazes of the moment:

> At the flag-bedecked Place de l'Indépendance, and at less imposing spots throughout the city, local groups in gay—and sometimes outrageous—costumes enlivened the streets and the Medinas with spontaneous explosions of song and dance. Long after the theatres had dimmed their lights, merry-makers crowded the floors of the nightclubs of the city and along the sea-cooled corniche, doing the frug and the Watusi until near-dawn. At Camp Mangin, a mid-city outpost recently abandoned by the French army, a Nigerian band played riotous Pied Piper to devotees of the High Life, that free-wheeling ancestor of the dance crazes currently sweeping the Western world. (Fuller 1966d: 100)

Duke Ellington's performance at the stadium was a resounding success, and the genuine enthusiasm of the large audience is almost palpable in Greaves' and Borelli's documentary films about the festival (Figure 10). The *bal populaire* held at the El Mansour cinema, in one of Dakar's old African quarters, with music by Senegalese band Harlem Jazz, took the dancing crowds by storm. The dance parties must have been the organizers' compromise to address the abundant critiques of elitism Senghor faced both within and outside Senegal, and to give the festival the air of a popular event. Even Senghor's guest, Katherine Dunham, criticized his ideology in thinly veiled terms, saying that she saw no reason 'for putting any particular label in front of what we are doing that requires an elaborate explanation. The Negroness that we are is there. There is no way to get out of it' (Garrison 1966b).

Away from the clubs and the bands, people also danced in the city centre's streets, alongside the lesser-known Senegalese troupes selected to provide the festival's *animation* [government-led entertainment]. These included the amateur troupes established by hometown associations, mainly from the Sereer-speaking Siin Saalum region south of Dakar and from Casamance. The choice of the nation's perceived cultural peripheries to represent Negritude, then, was carried all the way into the participative dances that set ordinary city dwellers in motion throughout the festival.

Conclusion

In this chapter I have attempted to give a sense of the 1966 World Festival of Negro Arts as a crucial moment in the development of choreographic scenes in postcolonial Africa, and as a turning point in Pan-African politics. In many ways, the emphasis on reimagining rural practices for the stage, on timelessness and on the selection of particular ethnicities to stand in for emerging national identities was in continuity with the late colonial politics that followed the Second World War. These were very much about the confrontation between the artistic experiments of an emerging class of African intellectuals and French (and British) attempts to maintain their empires for as long as possible through indirect rule. Indirect rule as it had evolved during the first half of the twentieth century involved the reification of 'traditional' practices and the construction of rural Africans as stuck in the past, as radically different from Europeans and European-educated urban Africans, and therefore as undeserving of full citizenship. Given the legacy of nineteenth-century stereotypes about African dances, dance played an important role in this construction of rural Africans as modernity's 'other'. When Fodéba Keita and his peers experimented with bringing West African (mainly Mande) dances to the stage in the 1940s and 1950s, they attempted to develop a modern genre that would recover the glorious African past while also providing a sideways critique of colonialism. By the time this neo-traditional genre had been elevated to the status of national heritage through national ballets and their offshoots, however, there was little left of the original radical edge. By then, the troupes selected by Alioune Diop and other members of the festival committee during travels through Africa in the run-up to the festival were charged with serving the political agendas at hand—nation-building internally, and projecting their nation's image abroad. In the process, the colonial construction of certain regions as the cultural peripheries were reproduced, and nowhere was this as visible as during the 1966 festival.

The dance programme at the festival also magnified the dissonance between Senghor's version of Negritude and the Senegalese audiences' appetite for cosmopolitanism: while Senghor and the festival organizers focused on the neo-traditional genre, people moved to Cuban rhythms and high life, educated youths organized ballroom dances, and the performers who attended the festival were enthralled by Alvin Ailey's *Revelations*. Over time, however, the neo-traditional genre fostered by Keita's experiments and by the Dakarois performing scene after the Second World War established its legitimacy through the worldwide touring of such troupes as Guinea's Ballets Africains, the National Ballet of Senegal and the National Ballet of Mali. What Keita, and later Senghor and others, conceived of as a project of cultural salvation became a project of cultural 'extraversion' (Bayart 1999). The 1966 festival, it turns out, was a milestone in Senegal's postcolonial history of extraversion.

Staging Culture:
Senghor, Malraux and the
Theatre Programme at the First
World Festival of Negro Arts

Brian Quinn

The theatrical work presented at the 1966 *Festival mondial des arts nègres* in Dakar (now commonly referred to as FESMAN) played a pivotal role in helping the event to navigate the political and artistic stakes of a new postcolonial era. Three works made up the Francophone theatrical programme: a production of *La Tragédie du Roi Christophe*, written by Martinican playwright Aimé Césaire and staged by French director Jean-Marie Serreau (Figure 11); *La Mort de Guykafi*, by the Gabonese writer and politician Paul de Vincent Nyonda; and *Les Derniers Jours de Lat Dior*, by Amadou Cissé Dia, then Senegalese Interior Minister. The programme included the same number of Anglophone works: *Hannibal*, by Ethiopian socialist writer Kebbede; *The Savant*, by Lady Diawara, wife of the Gambian Prime Minister; and *The Passion Play*, performed by the Panafrican Players of Great Britain. Also central to the event's theatrical line-up were the nightly performances of the *Spectacle féerique* on nearby Gorée Island. This large-scale performance was billed as 'deriv[ing] from the newest methods employed in live "Son et lumières" entertainment' (*Spectacle féerique* 1966: 22) and presented a commemoration, through a series of tableaux, of the island's history, beginning with the sixteenth century, moving through the era of the slave trade, and ending with a celebration of Senegalese independence.

Weaving the performance of text with multiple musical and dance interludes, each of the theatrical productions at FESMAN appealed to multivalent understandings of a new pan-African citizenship that included dialogical, visual and auditory forms of participation. The multidisciplinary approach of these works fits within the tenets of *théâtre total*, a term that in the French West African context had emerged to describe a work whose combined use of text, music and dance not only reflected a sense of dramaturgical balance but also evinced what could be considered an authentic familiarity with the repertoires of local folklore and tradition. Works of *théâtre total* were thus seen as representative of the customs and artistic practices of the

population from which they hailed. Furthermore, they frequently echoed the ethnographic works of earlier anthropological writings that were coeval with this theatre's emergence in the colonial context. A commonly staged theme was that of kingly authority, its means of enforcement and transmission, as well as its role in maintaining order within the community. Through these works questions of politics and hegemonic order were at the foreground of the FESMAN stage, showing that, if chief among the event's goals was the instantiation of 'l'ensemble des valeurs de la civilisation noire' [the whole of black civilization's values] (1988: 136)—Léopold Sédar Senghor's shorthand definition of Negritude—it was still far from certain what political shape such an ensemble should take.

The festival's theatrical productions pointed towards the complex cultural and political heritage left by former European colonies. Historian Gary Wilder, in his discussion of post-independence approaches to 'the problem of freedom', points out that nation-state structures and nationalism were not necessarily ingrained in Senghor's Negritude ideology. Instead, the Senegalese president's political practice reflects a desire to suspend demands for national sovereignty in favour of a relationship of connectivity with the European powers. In his reading of Senghor's poetry, Wilder states that:

> his belief in forgiveness was entwined with his view that despite the boundaries created by sovereign states and recognized by international law, former imperial powers and former colonized peoples had no choice but to create a new set of arrangements *together* since they would remain entangled on this shared earth. (Wilder 2015: 59)

Such concerns come through clearly in the stagings presented at Senghor's festival. The historical context of FESMAN may have been marked by the rise of political independence and new nationalist narratives, but the event's framing reveals an impulse to foster a deepened sense of connectivity with the former colonizer, rather than a rupture.

This connectivity played out in the recalibrations of the place and meaning of 'Culture'—a term often capitalized both by Senghor and André Malraux, the French Minister of Cultural Affairs—as a community-forming agent. In the case of FESMAN, new notions of culture operated within a global context and in dialogue with, most notably, the creation of the Ministry of Cultural Affairs in France. This early initiative of De Gaulle's Fifth Republic would see the nomination, in 1959, of Malraux as the first holder of this position. Malraux, for whom the new Ministry was purportedly 'taillé sur mesure' [tailor-made] (Fumaroli 1991: 84), used his ministerial role to originate and deploy a new set of cultural policies intended to extend access to cultural works to a broader French public. At stake for both Senghor and Malraux in their reworking of the relationship between culture and the State was the presentation of a new cultural space that allowed for shared imaginings of ways of being together within and among the postcolonial nations and Fifth-Republic France. These questions were explicitly placed at the heart

of FESMAN's theatrical programme, as will be illustrated below in a reading of one of the event's locally produced works, *Les Derniers Jours de Lat Dior*, a production that highlights the dramaturgical tools at creators' disposal in their presentation of a new, multifaceted code of citizenship in the postcolonial era.

Reshaping the Contours of Culture

Malraux and his new vision of culture provide helpful keys for contextualizing a similar vision at work at the Dakar festival, at which he was the guest of honour. In France, Malraux's new ministry would in fact take on a double task in its mission to democratize culture: first, that of establishing which works were to be given the privileged status of belonging to a universal human heritage, and, secondly, that of facilitating a more democratic interaction between such a heritage and the greater public (Poirrier 2013: 305). At the inaugural speech of one of his new *maisons de la culture*, in Amiens, Malraux declared a historic victory on behalf of his new institution: 'ce que nous avions tenté ensemble est exécuté et nous pouvons dire que ce qui se passera ce soir se passera dans le domaine de l'Histoire' [what we have attempted together has been accomplished, and we can say that what is taking place tonight will go down in the annals of History] (Malraux 1966a). Malraux's Amiens speech conveys a cultural message steeped in a sense of a historic present, illuminated by a long cultural heritage, and defined by the passing of Culture into the hands of the masses, for, as Malraux states: 'Une maison de la culture se définit par l'audience qui la constitue. Hors de cela, on crée des paternalismes parfaitement inutiles' [A house of culture is defined by its audience. Otherwise, one creates perfectly useless forms of paternalism] (Malraux 1966a).

Part of the historic nature of this new notion of Culture included a commitment to envisioning cultural works as not simply handed down to the greater public but placed in active dialogue with it. The foil for such a model was the *beaux arts* system of patronage of the Third Republic. The Director General of Arts and Letters, Gaëtan Picon, argued that the new ministry's work was a much-needed extension of the democratizing reforms of the French Third Republic in the field of education. Whereas, he states, the Third Republic was justified in rallying around the notion of education for all, it also showed itself negligent in matters of the nation's cultural production: 'Laissant mourir Verlaine et Gauguin misérables, l'État n'avait aucune mauvaise conscience: c'était même respecter la création que de ne pas intervenir' [In allowing Verlaine and Gauguin to die in destitution, the State showed no sense of guilt: not intervening was even considered a sign of respect for artistic creation] (Picon 2013: 53). Malraux's mission was thus to sponsor a new cultural model driven by the adage 'la culture pour chacun' [culture for each individual], which differed subtly, he would explain, from 'la

culture pour tous' [culture for all], in that the latter was reflective of a Soviet system that inevitably led to intellectual totalitarianism (Malraux 1966b). The new minister's role was thus envisioned as nothing less than to serve as a Jules Ferry of the Fifth Republic, or, in his own words, 'faire pour la culture ce que la IIIème République a fait pour l'enseignement; il s'agit de faire en sorte que chaque enfant de France puisse avoir droit aux tableaux, au théâtre, au cinéma, etc., comme il a droit à l'alphabet [to do for culture what the Third Republic did for education: each French child is entitled to have access to paintings, theatre and cinema, just as he has to the alphabet] (Malraux 1959).

The development of the new French Ministry of Cultural Affairs shares a significant link with France's colonial empire, one that indirectly ties the administration of the new French *maisons de la culture* with the former colonial *centres culturels* once pivotal to the French administration of territories throughout Africa (Bancel 2009). As illustrated by scholarship on the early years of the ministry, as well as by the memoirs of Malraux's former right-hand man and director of theatre, Emile Biasini, former French administrators of the colonies would come to play a central role in carrying out the goals of Malraux's democratization of culture in France (Biasini 1999; Rauch 1998). Just prior to the new Ministry's creation, the imminence of decolonization in Africa had led to the repatriation of a group of young, enterprising and newly unemployed French administrators with skill sets similar to those needed, in Malraux's view, to propagate culture in the neglected provinces of France. Malraux saw in this an opportunity for his fledgling ministry, which had been struggling to attract to its service candidates from the traditional channels of France's prestigious *grandes écoles*. He decided to recruit actively from among the returned colonial administrators, turning his new administration into what one collaborator, Jacques Renard, called 'le rebut des AFOM, les administrateurs de la France d'outre-mer, mis au chômage technique par la décolonisation' [the scraps of the AFOM, the administrators of the French colonies, made redundant by decolonization] (Rauch 1998: 65). It was essentially these former colonial administrators, the 'administrateurs de brousse' [bush administrators] cum cultural technocrats who would carry out the minister's plan to democratize culture within France. The experience is related by Emile Biasini, who before becoming Malraux's right-hand man in establishing the *maisons de la culture* throughout France had spent a combined 11 years in Chad and Dahomey (now Benin) serving as an enterprising and ambitious colonial administrator (inspired by Malraux's early novels). Biasini has recalled Malraux giving him the following ministerial directive: 'Ce que vous avez fait en Afrique, vous allez me le faire en France' [I want you to do for me in France what you have done in Africa] (Biasini 1999: 14; Lebovics 1999: 98). In Biasini's own words, he claims to have used the same 'méthodes de brousse' [bush methods] he acquired in Africa while implementing a plan which, he explains, 'ressemblait fort, dans sa conduite, à ce que j'avais fait en Afrique' [bore a striking resemblance, in its implementation, to what I had done in Africa] (Biasini 1999: 16).

Malraux's participation, at the height of his ministry's activities in France, in Léopold Senghor's festival in celebration of the cultural production of the continent where many of his own cultural foot soldiers had cut their teeth, was imbued with performative meaning. Through his very presence at the festival and in particular through his speech, Malraux engaged in a dual validation of two visions of Culture, which, though not identical, proved highly complementary. Senghor, like Malraux, would adopt a universalist discourse in his notion of culture as a heritage for humanity, both particular in its capacity to reveal the distinctiveness of a given people, and universal in its propensity to foster what was envisioned as a dialogue among equals. It is in this context that Senghor envisioned FESMAN as an originary encounter of civilizations, allowing the art works to speak for themselves, revealing their deeper, inherent meaning, free for the first time of any intermediary (here, the Western colonizer or specialist). In his prefatory remarks in the festival programme (published in French and English), Senghor framed the event by saying:

> To whatever God, to whatever language they belong, the Nations are invited to the colloquy of Dakar, to bridge the gaps, to clear up the misunder-standings, to settle the differences. Partaking at all times, but at a distance and through intermediaries — in the building of the *universal civilization*, united, reunited Africa offers the waiting world, not a gigantic tattoo, but the sense of her artistic creation. (1966a: 14; emphasis in original)

In later writing on what he called the 'fonction et signification' [function and meaning] of FESMAN, Senghor would further expound on the festival's greater purpose, which, for him, was created 'pour nouer les dialogues d'où naissent les civilisations, en tout cas la *Culture*' [to foster the dialogues from which emerge civilizations, or, at least, *Culture*] (1977: 58). Just as Malraux's notion of 'Culture' had not been crafted through a hermetic identitarian process within the Hexagon but through contact with the colonies, Senghor envisioned 'Culture' as coming into focus not through introspection but through a process of continued and continuous dialogue between Europe and the West.

Stepping to the podium at the FESMAN colloquium, Malraux adopted language every bit as steeped in historic importance as that of his inaugural address at the *Maison de la culture* in Amiens earlier that same year. He again emphasized the role of the historic present at the festival, declaring 'Nous voici dans l'histoire' [Here we are in history], before shifting focus to the role of his fellow statesman and African counterpart, Léopold Senghor, stating, 'Pour la première fois un chef d'état prend entre ses mains périssables le destin spirituel d'un continent' [For the first time, a head of state takes into his mortal hands the spiritual destiny of a continent] (Malraux 1966b). Malraux's speech inscribes the historic nature of FESMAN within a geopolitical landscape, further arguing that the historic nature of the Dakar festival lay in Africa's official, staged entry into the realm of Culture. This is what Malraux,

in language that complements that of Senghor, calls 'cette force mystérieuse de choses beaucoup plus anciennes et beaucoup plus profondes que nous' [this mysterious force of things much older and more profound than ourselves] (Malraux 1966b).

From Malraux's perspective FESMAN was historic in that it represented the first of Africa's attempts to create and define its own heritage, and it was also taking place within the framework of the French minister's own vision of a universal culture of humanity. Malraux's language, though solemnly optimistic, is also reflective of a time of great uncertainty, when multiple heads of state were charged with leading the newly independent countries of the continent into the long process of nation-formation. In his later writings on the era of decolonization, published in *Le Miroir des Limbes*, Malraux would reflect upon the task of forging national unity among the newly independent masses of Africa, writing of his experience in Chad: 'De quelle savane surgissait cette foule qui désormais, en Afrique et en Asie, semblait surgir de partout? Avec ses danseurs bleus, ses porteurs de masques, ses cavaliers carolingiens, le président Tombalbaye [...] devait faire un État' [From what savannah emerged this crowd in Africa and Asia that seemed to jump out from all sides? With his blue dancers, his mask-bearers, his Carolingian cavalry, President Tombalbaye [...] was supposed to form a state] (1976: 12). The central argument of FESMAN, ingrained in the very framing of the event, was that the negotiations of such state-formation would take place on the dialogical terrain of the emerging model of culture proposed by Malraux and Senghor. Yet the complexities of such a process were plentiful, and they played out on the FESMAN stage, whose productions were at the heart of the festival's attempts to present and promote the myriad aspects of a new understanding of pan-African citizenship.

Reframing the Colonial Encounter

In the theatre presented at FESMAN, the ideological debates surrounding the event and their implications for notions of culture came to life on stage. For example, the Senegalese contribution to the festival programme, *Les Derniers Jours de Lat Dior* and Césaire's *La Tragédie du Roi Christophe*, illustrate the tensions between local and more global concerns: *Les Derniers Jours de Lat Dior* was a play that would go on to have a considerable impact on later theatrical movements within Senegal, while *La Tragédie du Roi Christophe* was a broader-focused, international production and winner of a festival award. This work, though featuring a number of international performers, including legendary Senegalese stage actor Douta Seck, was presented at FESMAN under the direction of French director Jean-Marie Serreau and billed as representing France in the festival programme. Unlike *Lat Dior*, which has received scant critical attention outside of Senegal, *Christophe* soon became a canonical work of drama and is today part of the repertory of the Comédie

Française. However, it was the performance of *Lat Dior* that proved more in keeping with the festival's symbolic reckoning with colonial and cultural heritage through local interrogations (here, in a Senegalese context), as well as universal ideals. Senegalese stage director and FESMAN attendee Seyba Traoré, attests, in an interview, to the importance of Dia's play to later Senegalese performers and artists:

> On rappelle souvent que lors du Premier Festival Mondial des arts nègres à Dakar, le triomphe c'était *La Tragédie du Roi Christophe*. Ce qu'on oublie, c'est que la pièce populaire par excellence, et celle qui a vraiment mobilisé les Dakarois, ce n'était pas *Christophe*. C'était *Lat Dior!*[1]

> [People often remember that at the First World Festival of Negro Arts in Dakar, the triumph was *La Tragédie du Roi Christophe*. But what people forget is that the most popular play, the one that brought out all the Dakar locals, was not *Christophe*. It was *Lat Dior!*]

The literary and performative impact of this work is also highlighted by the further reworkings of the Lat Dior legend subsequent to Dia's original adaptation (Bâ 1995; Mbengue 1970), and invites us to examine more closely the processes of theatrical heritage and citizenship at work in the play.

Promoted as a tragedy, *Lat Dior* would in fact have been recognizable to informed local audiences at FESMAN as corresponding to the style of the *pièce historique*, or history play. These were works authored by Africans, typically written in French, and characterized by the staging of well-known episodes in the lives and resistance struggles of former African leaders as they confronted, violently or not, the demands of an encroaching colonial regime. The ambiguous nature of such encounters, where the French presence might alternately be seen as a boon or threat, clearly resonated with a group of writers and intellectuals now starting to assess the consequences of France's long-standing colonial presence in Senegal. Much like their historical predecessors, these playwrights felt compelled to suggest a model of interaction with the former colonial empire, beginning with an exploration of how such episodes were to be commemorated, or not, in the context of African independence. They did so by endowing their staged narratives, though based in the historical past, with the same sense of historic present used in the rhetoric of Malraux and Senghor.

On a performative level, history plays in the Francophone West African context were known to integrate musical performance and dance into their story, also staging scripted scenes that, in their content and style, adopted a heroic, Cornellian tone. The link to French classical theatre was not coincidental, since this style of history play originated at the William Ponty School, the most selective of the colonial schools of French West Africa, and one whose goal was to train a new generation of African teachers, translators

1 Personal interview with the author (3 July 2012).

and administrators for the colonies. Aside from its enduring reputation as the training ground for an emerging African elite, the William Ponty School is also remembered today as the birthplace of Francophone African drama. It was at this school, in the 1930s, that students were first encouraged to use their familiarity with French classical playwrights such as Corneille and Racine to stage similarly dramatic renditions of African history and customs, thus producing the first African stage plays in French (De Jong and Quinn 2014; Jézéquel 1999; Sabatier 1980). The pedagogical exercise, which was not mandatory but nonetheless channelled the enthusiasm of an ambitious student body, resulted in a repertory of works whose written texts bore the influence of the students' contact with French literature. The actual stagings, however, reflected attempts to adopt and rework notions of traditional African performance: stages were set in the round, and there was a great sense of freedom in interweaving theatre, song and dance. The Ponty plays soon generated their own annual event, initially on the School's original campus on Gorée Island, where FESMAN would later present its *Spectacle féérique*, and then in performances for the administrative higher-ups of the French West African administration. The productions earned such a reputation among administrators that it was decided to send the students on a tour to Paris in 1937, allowing them to perform at the Théâtre des Champs Elysées, and as part of that year's *Exposition universelle des arts et techniques*. The works met with critical success and prompted lively discussion about the cultural significance of the new educated Africans produced by what was understood to have been the peaceful colonization of French West Africa (Delavignette 1937).

In terms of the plays' content, however, the colonial context had a considerable effect on which stories the students felt they could tell, and how. Although the young writers would often attempt to restore, through their stagings, a sense of dignity to African historical figures they saw as under- or misrepresented by colonial historical narratives, their characters' encounter with French officials inevitably ended on stage with the African chief's acceptance of a European general's authority and apparent good sense. The Ponty plays are remembered to this day as the beginnings of a Francophone African stage aesthetic of which the history play was the most emblematic variation; however, it was not until independence and the later FESMAN event that playwrights felt at liberty to depict the contentious Franco-African encounter and its postcolonial legacy without regard for a ubiquitous and watchful colonial eye.

As a former student of the William Ponty School, Amadou Cissé Dia, the author of *Les Derniers Jours de Lat Dior*, was well aware that his educational pedigree situated him within a significant theatrical performance tradition. At the time of the festival, Dia was the serving Interior Minister of the Senegalese government and he would, like many of his fellow Ponty students, go on to enjoy a life-long career in government and politics. Although part of a revolutionary generation of African leaders, Dia's literary and political focus

was, at this point, on fostering a greater sense of national unity among the populations of Senegal, a move which included a call for continued exchange and connectivity with the former colonial power. Such concerns resonate clearly in Dia's depiction of Lat Dior, or Lat Joor Ngoone Latyr Joop, a major historical figure in Senegal, who is remembered as both a great opponent of colonial rule and the unifier of the two major kingdoms in the region, Cayor and Baol, at the precise moment when the French military conquest of central Senegal was gathering pace. At the Dakar festival, it was Lat Dior the unifier, rather than the dissident, that Dia would present to audiences, choosing to highlight the historical figure as an example around which new models of a complex, multivalent Senegalese identity could form. Lat Dior's image as a foundational figure of an independent nation is based in large part on his role in resisting colonial conquest (Diouf 2001: 157–59). Yet the play refers to him by the unifying title of Damel-Teen ('Damel-Teigne', in French), a contraction of the term for the monarch of the Cayor and Baol regions. But he is far from the only such foundational figure of the Senegalese nation, and Dia's play sets itself the task of placing Lat Dior's resistance narrative within a constellation of fellow founding fathers in such a way as to instantiate a Senegalese nationalist movement forged in the frictional and at times antagonistic contact between these major figures. To achieve this, Dia employs performance as a pedagogical tool—much as had been done in his student days at William Ponty—to allow FESMAN spectators to invest belief in the historical presentation of an always already present sentiment of a collective identity taking shape.

For Dia, one particularly fruitful angle from which to address the complex relationship between the Senegalese and the now former colonizer was Lat Dior's antagonistic relationship with the French general Louis Faidherbe. In this play, Faidherbe acts as a representative of colonial expansion, but Dia is attentive to the fact that this historical figure's contributions are nonetheless commemorated in Senegal as central to and generative of a modern-day Senegalese identity. In contemporary commemorative practices, depictions of and performances featuring the French general have long played a prominent role in popular representations of the nation's history and cultural heritage (De Jong 2009b). Here, the author reckons with this heritage by first reversing the patriarchal relation that once characterized portrayals in the earlier Ponty plays of the colonial encounter, where staged historical interactions between leaders such as Faidherbe and Lat Dior were marked by an intellectual and moral imbalance always favouring the French. Dia thus makes an important modification to what had become a common theme in African history plays— that of the encounter between French and African military leaders—by recasting it as one of mutual respect and a space for dialogue, full of potential for productive collaboration.

In Dia's play, Faidherbe is first presented in conference with his Lieutenant, to whom he describes the fruits and future objectives of his labour in the region: 'Le Djoloff enfin pacifié! Le Sine et le Saloum en paix! Le Walo également pacifié! [...] Partout règne un calme relatif, mais suffisant pour

nous permettre de mener à bien notre dessein, notre grand dessein de créer une Sénégambie hautement développée' [Jolof has finally been pacified and Sine and Saloum are at peace! And Waalo has been pacified! [...] Everywhere there reigns a relative calm, but it is enough for us to bring to fruition our great plans for creating a highly developed Senegambia] (Dia 1978: 26). The general's vision for the future of this region is given in terms that would ring true for the contemporary audience in Dakar, many of whom were charged with bringing about such development in their own respective countries: 'Elle (la région) bénéficierait d'écoles laïques, d'un Service de santé efficace, d'une agriculture et d'un élevage prospères! Elle bénéficierait surtout d'un chemin de fer qui serait l'artère nourricière de ce pays!' [(The region) would benefit from secular schools, an efficient health system, and prosperous agriculture and livestock farming! It would above all benefit from a railway that would serve as the lifeline for this country!] (26). Faidherbe's efforts to connect the major Senegalese cities via newly constructed railways constitute one of the major points of contention between the general and the Senegalese leader, a conflict commemorated to this day in popular narratives of Lat Dior's resistance struggles. By evoking the incident, Dia is foregrounding the conflict between these two historical figures, but not before staging a Faidherbe whose intentions, though colonial in nature, are designed for the benefit of the region and its inhabitants.

Dia's depiction of Faidherbe has the primary purpose of establishing Lat Dior as a decisive figure in the political and economic climate of the region in his day. After enumerating his many plans for Senegambia, Faidherbe expresses a respectful exasperation regarding Lat Dior's continuing influence over the success or failure of his project: 'Et tout cela, encore une fois, tout cela risque d'être anéanti par un seul homme: Lat Dior!' [And all of that, once again, risks being completely ruined by one man alone: Lat Dior!] (26). The general then recalls the ways in which the Damel-Teen has proved a decisive and untameable figure throughout French military operations, forcing the general to conquer regions pre-emptively lest they decide to become allies of Lat Dior, at which point they might become an uncontrollable force. The general states that, although he had been able to establish a peace agreement with the resistance leader, 'Lat Dior est toujours présent, partout présent, utilisant nos propres méthodes de guérilla [...] Il suffit qu'il apparaisse pour que les tiédos, comme l'herbe sèche, s'embrasent; il suffit qu'il leur parle pour qu'ils reprennent le combat' [Lat Dior is always present, everywhere present, using our own guerrilla methods [...] As soon as he appears his ceddos [a local warrior caste] ignite like dry grass; all he has to do is speak and they return to the fight] (26–27).

Yet, despite the frustration that his military counterpart clearly provokes, Faidherbe maintains an unshakeable respect and admiration for Lat Dior's valour and skill, stating 'Et le paradoxe, Lieutenant, le paradoxe, c'est que je ne pourrai jamais haïr cet homme! Je l'estimerai toujours!' [And the paradox, Lieutenant, the paradox is that I will never be able to hate this man! I will always

respect him!] (27). Furthermore, Faidherbe will not allow others to speak of his Senegalese opponent in disparaging terms, not least the lieutenant, whose disrespectful and frankly racist comments, at various moments in the play, are clearly designed to provoke the nationalist sentiments of the audience in Dakar. For the lieutenant, Lat Dior 'est une sorte de paladin donquichottesque […] qui aurait la ridicule ambition de "défendre son sol", le "patrimoine de ses ancêtres", comme si un nègre barbare pouvait nourrir pareils sentiments!' [is a sort of quixotic paladin […] who has the ridiculous ambition of 'defending his homeland', the 'land of his ancestors', as if a barbarous negro could harbour such feelings!] (27). The general reprimands his inferior: 'Je ne puis admettre que tu insultes ces hommes! Je les respecte et les estime comme je respecte et estime tout adversaire valeureux, quelle que soit sa race!' [I will not allow you to insult these men! I respect them and hold them in my esteem as I do any brave adversary, whatever his race!] (27). The scene serves to dissociate Faidherbe symbolically from the racist discourses of the earlier civilizing mission that in fact lay behind justifications and understandings of the colonial conquest.

For the FESMAN audience in 1966, Dia's play stages a version of history that might prove workable for the purposes of nationalist sentiment in the postcolonial era; it does not denounce wholesale European influence and impact, but reframes the historical narrative in a way that might salvage Faidherbe's reputation as one of the foundational historical figures of the Senegalese nation. The nationalist tone of this theatrical narrative, and Faidherbe's place therein, rings clearest when the general explains his purpose by declaring, 'En édifiant la Sénégambie, n'est-ce pas pour Lat Dior, c'est-à-dire pour l'idée qu'il incarne, n'est-ce pas pour réaliser cette idée que je travaille?' [In building up Senegambia, is it not for Lat Dior, that is, for the idea he represents, am I not working to achieve the same goal?] (30)?

A Citizenship of the Senses

Beyond the dialogical staging of national identity the Lat Dior story permits, the playwright also seeks to integrate key sensorial aspects of a new form of local citizenship. One important example is the inclusion of the founder of the Senegalese Sufi order of the Muridiyya, Cheikh Amadou Bamba. Images of this local Sufi saint play a central role in the spiritual lives of Mourid devotees, for whom the reproduction of the single photograph taken of Bamba by colonial authorities in 1913 allows them to disseminate the Islamic figure's *baraka*, or spiritual power, not only for themselves but also for all who lay eyes on the image. Reproductions of the famed image of Bamba are ubiquitous in Senegal and constitute what has been called an instrument of visual citizenship, not only for members of the founder's order, but also for the broader Senegalese community, for which the sanctified personage is above

all a 'mystique pacifique *local*' [peaceful *local* mystic] (Roberts 2013: 210) and thus a foundational element of Senegalese identity.

In his play, Dia depicts these two foundational national heroes at a pivotal moment in Lat Dior's journey as a character. Dia gives us the king in a period of brief retreat from military activities as he consults with Amadou Bamba. Dia's staging recounts what is depicted as a strategic crossroads in Lat Dior's response to French forces, as well as a personal crisis of faith. Lat Dior expresses to the saint a sense of battle fatigue along with doubts regarding the purpose of his resistance, declaring, 'le guerrier en moi est mort. Mon vœu, Bamba, est de faire avec toi la conquête des âmes pour la gloire de l'Islam [...] et de Dieu' [the warrior in me has died. My wish, Bamba, is to embark with you on the conquest of souls for the glory of Islam [...] and of God] (41). Bamba's message to Lat Dior is ultimately one of perseverance in the face of adversity, born out of a sense of belonging to a grander, sacred purpose. Lat Dior responds to Bamba's encouragement, asking: 'Sera-t-il donc donné à d'autres générations—à mon fils, à nos petits-fils—de comprendre ton grand message [...] et de l'exécuter?' [Will it be possible, then, for other generations—for my son, for our grandsons—to understand your great message [...] and to carry it out?] (46).

In the published version of Dia's play, the otherworldly quality that the Bamba character must transmit on stage is expressed by printing the figure's lines, which consist solely of verses of the Koran, in italics. On stage, the performed image of Bamba would enact, for the Muridiyya, the same ocular transmission of *baraka* thought to take place via visual reproductions of the photographed image of Bamba. This practice of staging the Saint, though no longer permitted by the Muridiyya order today, would in fact be continued shortly after the festival in the form of a popular pageant play known as *Bamba Mos Xam* (Babou 2007: 247 n. 120). This later event also took on a highly sacred quality, and drew large crowds from across the country made up of devotees who contributed to the event financially (by buying their ticket), as well as through an act of witnessing and participating in the ocular transmission of the Saint's spirit. Dia's play sought to tap into such processes of visual citizenship in order to instantiate a complex and multisensorial participatory experience that truly resonated with members of the new Senegalese nation.

Given the context of the performance, Dia's depiction of the founding fathers of the Senegalese nation could not omit the individual then presiding over both the state and the festival: Léopold Sédar Senghor. As an homage to the leader known for declaring rhythm to be an essential aspect of Negritude and black identity, Dia situates Senghor's thought within the context of a musical performance. In the staged narrative, when the Almamy, or king, of the neighbouring Tukulor kingdom sends a messenger to propose an alliance against the French, he sends with them a chorus of slaves who use the occasion to perform a song before Lat Dior's court and attendant soldiers. The song has an inebriating effect on the soldiers, and Dia indicates in his stage

directions that they are almost possessed by the sound, and noisily express their admiration. Recognizing the ploy as a ruse of the Almamy, Lat Dior puts a stop to the music, declaring, 'Suffit à présent! [...] Ainsi, Amadou Cheikhou avait l'ambition d'avilir nos âmes, d'amollir nos cœurs et nos bras, pour mieux nous vaincre!' [That's enough! [...] So, Amadou Cheikhou intended to degrade our souls, to weaken our hearts and our arms, in order to defeat us!] (20–21). He dismisses the Tukulor soldiers and calls his own griot, Sakhévar, who takes centre stage to lead the assembly on stage, as well as the audience at the festival, through a didactic rendering of the individual elements of a traditional musical ensemble of Cayor and Baol, described not just as music for its own sake but rather as a source of strength and courage. The *Déguedaw*, he says, is the voice of independence, the *Mbalakh* a source of courage. The progression continues, with each instrument adding its sound in a great crescendo. In a statement to the king, the griot declares: 'Damel-Teigne Lat Dior, quand toutes ces voix ensemble se font entendre [...] quand toutes à la fois rythment nos joies, nos colères, notre Négritude, alors Damel-Teigne Lat Dior, rien, rien ne saurait résister aux Peuples du Cayor et du Baol' [Damel-Teen Lat Dior, when each of these voices resounds together [...] when all at once we hear the rhythm of our joy, our anger, our Negritude, then, Damel-Teen Lat Dior, nothing, nothing can resist the Peoples of Cayor and Baol] (23).

The uttering of the term 'Negritude' by one of Lat Dior's griots is, of course, not a historical claim on the part of Dia, but rather a projection into the past of issues relevant to post-independence Senegal. It served to frame depictions of historic Senegal as having always manifested the cultural and national distinctiveness that Senghor would address throughout his life. It is furthermore significant in this scene that the concept of Negritude is evoked in a cultural context. The cultural expressions of the visiting Tukulor are not innocuous in the world of this staging, but rather come with the power to dilute the resolve of Lat Dior's soldiers, who, subsequent to this encounter, are in need of an immediate return to their own, 'native', music in order to replenish their strength. In the world of Dia's play, culture is therefore a high-stakes affair and proves, moreover, the business of chiefs and, by extension, of heads of state such as those in the audience at FESMAN.

A Canonical Work of Theatrical Heritage

Dia's retelling of Lat Dior's role in Senegalese history and subsequent place in collective commemorations evinces the nationalist efforts at work both in the play and its later staging for the FESMAN audience. On a global level, his play echoed Senghor and Malraux's vision of culture as a universal terrain favouring dialogical potentialities rather than cultural or political conflict. It served to enable the new leaders of the independent continent to negotiate the ambiguous historical landmarks and cultural heritage of centuries of colonial engagement. Dia's literary and theatrical use of the history play, a form that

originated in the colonial educational system, imbued with the language of Negritude, represents an important attempt to save the stage as a Senegalese form of cultural expression in the postcolonial era. This was done by adapting, with significant modifications, the stage practices originally transmitted by the French, but this time as an instrument of dialogical exchange between equals, a didactic tool with implications for both African and non-African attendees at the festival.

As was shown above, *Les Derniers Jours de Lat Dior* left a lasting impression on Senegalese audience members such as stage director Seyba Traoré, for whom the play's complex, multifaceted form of identity and citizenship resonated clearly with the political and cultural uncertainties of independence. The lead performers of the production would go on to become prominent figures in the popular theatre movement that was launched just three years after the FESMAN event, with the publication of a 1969 document called 'Les options fondamentales du théâtre populaire' [The fundamental options for popular theatre]. Referring to *Lat Dior*, Traoré explains: 'Ça, c'est le théâtre populaire! C'était les grands patrons du théâtre populaire qui ont monté cette affaire-là, et qui l'ont fort bien réussi!' [Now that's popular theatre! It was the leaders of popular theatre who organized that production, and they pulled it off beautifully].[2] The pivotal role of *Lat Dior* in the later story of theatrical practice in Senegal indicates the extent of the work's impact. The play served as an example, for later creators in Senegal and elsewhere, of the use of potentially problematic stage forms as tools to highlight the political and cultural ambiguity of what, at the time of FESMAN, was lived as the new and historic postcolonial present.

2 Personal interview with the author (3 July 2012).

Making History:
Performances of the Past at the
1966 World Festival of Negro Arts

Ruth Bush

'Nous voici donc dans l'histoire' [So here we are: part of history], declared French Minister of Culture, André Malraux (1966b) in his speech at the conference that opened the 1966 World Festival of Negro Arts. This was, he claimed, the first time that an African head of state had held the continent's future in his hands. Later at the same conference, Aimé Césaire warned the audience that 'l'histoire est toujours dangereuse. Si l'on n'y prend garde, l'Afrique risque de ne plus se voir que par les yeux des autres' [History is always dangerous. If we are not careful, Africa risks only seeing itself through the eyes of others] (Césaire 2009: 211). From their distinct standpoints, both men conceive of history as an urgent participatory activity, a subjective force for change and, in Césaire's case, a perennial threat in post-independence Africa. Drawing on contemporary press coverage and archival documents, this chapter explores ideas of history and historical change as manifested in three performances in 1966 based on scripts by Amadou Cissé Dia, Jean Brierre and Wole Soyinka. These performances staged frictions between notions of pan-African past(s), present(s) and future(s) in the lived context of Dakar's urban fabric. In doing so, they also generated a tangible, often celebratory, sense of collective belonging and history-making across social strata.

History—the 'accounts of how things change over time' (Hunt 2008: 5)— was a central source of energy and tension in 1966. Did the festival seek primarily to showcase artistic production of the past (as in the museum exhibitions or folkloric dance shows) or to propose a future-oriented, transformative experience? How might these two tasks be intertwined? And how would such apparently abstract questions, long debated in the pages of journals such as *Présence Africaine*, play out in the material contexts of the Dakar festival? In making its own social form of history, the festival marked a decisive shift from the spaces of conference panels and round tables, and the dense columns of intellectual journals, to experiential modes of cultural exchange on an unprecedented scale.

During the period of decolonization certain historical narrative devices, including those of linear, teleological progress and a guiding historical subject, came under increasing pressure. These ideas had informed national projects in Europe and South America in the nineteenth century and concomitantly propped up the colonial civilizing mission in sub-Saharan Africa. The 1950s and 1960s marked the publication of a number of significant works in African history by historians including Cheikh Anta Diop, Joseph Ki-Zerbo and Basil Davidson, together with the UNESCO General History of Africa, a ten-year project launched in 1965. As these new histories were written, others were gradually unmade, or remade in different forms. This work—still in progress today—entailed a general reorientation of history told from the perspective of colonial powers to the viewpoints, lives and activities of African peoples. It also depended on a shift in the readership and audience for that history. As Cheikh Anta Diop suggested, empirical approaches to African history had previously been 'aussi sèches que des comptes d'épicier' [as dry as a grocer's accounts] (1987: 9).

The work of revising and renewing accounts of the past in the postcolonial present found expression in several theatrical productions at the 1966 festival. Some sought to establish a shared sense of the past by representing national and transnational historical events in relatively conventional forms. Amadou Cissé Dia's play *Les Derniers Jours de Lat Dior* recounts the final events in the life of the last Damel (leader) of Cayor, Lat Dior (1842–86), and his opposition to the French colonial forces. The site-specific *Spectacle féerique de Gorée* was performed daily throughout the festival (except for Independence Day on 4 April) and led its audience nimbly through 500 years of history to inaugurate Gorée Island as a key site of pan-African heritage. Other theatrical performances encouraged critical reflection on the process of historical change by dramatizing forms of political power and the passing of time itself. In particular, Wole Soyinka's satire, *Kongi's Harvest*, which was billed as the grand opening of the festival's performance programme, is a provocative example of the divergent ideological currents present in 1966. Praised by Anglophone critics for its radical critique of neo-colonial power and historical inertia, it is largely absent from the Francophone press coverage of the festival.

The festival was intended as a site of cultural dialogue, of critical thought and evaluation; a broad-based expression of pan-African ambition and a landmark in Senghor's state-sponsored cultural policy.[1] In his opening speech at the festival colloquium, Senghor described new artistic production as a salve that would accompany economic and social development in Senegal: 'Qu'ils dansent le Plan de développement ou chantent la diversification des cultures, les artistes négro-africains, les artistes sénégalais d'aujourd'hui nous aident à vivre' [Whether they dance the Development Plan or sing about the diversification of cultures, Negro-African and Senegalese artists of today

1 On the formation and lasting effects of Senghor's cultural policy, see Mbengue (1973) and Benga (2008: 3).

help us to live] (Senghor 1977: 61). Carefully distinguishing between a more abstract, spiritual idea of (human) development and that of economic growth (while maintaining a vital link between the two), Senghor proposed the festival as an essential contribution to the *'civilisation de l'universel'*. More critical voices within and beyond a Francophone context are hard to locate in the 'official' archive of the festival held at the National Archives of Senegal. Some years earlier, Frantz Fanon had of course targeted the work of African 'men of culture', arguing that their efforts 'do little more than compare coins and sarcophagi' (2004: 168). His target here was the Société africaine de culture, an offshoot of the Présence Africaine hub in Paris that was a driving force behind the 1966 festival. For Fanon, as for other vocal critics of Negritude, a cloistered conception of history or culture ran counter to a praxis rooted in everyday lived experience. In the wake of such critiques, the 1966 festival might be seen to mark a symbolic changing of the guard.[2] This shift was further demonstrated at the 1969 Pan-African Festival in Algiers, which was dominated by Marxists affiliated to contemporary revolutionary movements, and in the role attributed to spectators at both events.

As Karin Barber has argued, drawing on Bakhtin, the audience 'has a hand in the constitution of the "meaning" of a performance, text or utterance' (1997: 356). An editorial in *Présence Africaine* shortly after the 1966 festival declared that people should be given the opportunity to 'vivre et exprimer cette "tension féconde" entre la fidélité à la tradition et l'exercice de la responsabilité moderne' [live and express this "fertile tension" between fidelity to tradition and the exercise of modern responsibility] ('Pour une politique de la culture' 1966: 5). Dramatized representations of historical change highlight some of these tensions, signalling the ideological potency of a shared, splintered past performed in a collective present.

Staging the City

While Senghor's plan to forge an African contribution to the *'civilisation de l'universel'* placed its rhetorical emphasis on spiritual aspects of development, there was a significant material dimension to the festival's success. This period witnessed the first steps towards the development of Senegal's tourist industry, launched with the creation of a national tourist office in 1960.[3] Articulations of Negritude and of pan-African solidarity in 1966 were staged against the consciously modern backdrop of the host city for the local and international

2 My thanks to Dr Paulo Fernando de Moraes Farias for this suggestion made following a seminar paper given at the University of Birmingham.
3 A report from 1962 contained in the festival archives called for increased state funding for tourism and outlined the plans for building hotels in Dakar. 'Situation du ministère de l'information et des télécommunications à la fin de 1962': Archives Nationales du Sénégal (ANS) FMA007.

audience.[4] A rigorous programme of urban planning can be traced in the minutes of the organizing committee's meetings.[5] Regular inter-ministerial meetings planned building projects for performance spaces and accommodation, transport infrastructure and the events themselves. High levels of state funding via the separate national committees and specific larger contributions from Senegal, UNESCO, France and the USA guaranteed the smooth running of the many events.[6] The building work was extensive: existing venues such as the Daniel Sorano Theatre, the Centre Culturel Daniel Brottier and the Stade de l'amitié [Stadium of Friendship] were renovated and equipped with electric amplification; a new exhibition hall was built to house the 'musée dynamique'; and the Village artisanal de Soumbedioune was constructed, along with a Village touristique at Ngor to provide further accommodation.[7] Processes of securing housing, organizing transport, cleaning the streets and training guides and hostesses were as carefully planned as many of the performances themselves.[8] Overall, the festival sought to project an image of the Senegalese capital as welcoming, clean and efficient.

The minutes of the organizing committee's meetings note the need to clean the city, repaint buildings, and to remove beggars, the disabled and

4 International guests were, at times, given more attention. Elizabeth Harney argues that in the years following the festival: 'The arts infrastructure remained essentially export-oriented, promoting an image of the nation and its aesthetic abroad and providing a larger Senegalese public with little guidance or incentive to acquire the kind of "cultural capital" needed to serve as an active consumer or patron class for these new arts' (2004: 79).

5 Djibril Dione (Commissaire national), 'Procès-verbal de la Réunion du Comité Interministériel du 20 septembre 1965': ANS FMA007; 'Procès-verbal de la réunion du comité interministériel du 29 novembre 1965': ANS FMA022; 'Conseil interministériel du lundi 21 février 1966. Projet d'ordre du jour': ANS FMA022.

6 The Lebanese community in Senegal also contributed a cheque for 15 million francs gathered from donations ('La Communauté libanaise' 1966).

7 'La salle Daniel Brottier a fait "peau neuve"' (9 March 1966). Newspaper clipping (newspaper title unknown) from Centre de documentation, ANS, file marked 'Festival Mondial des Arts Nègres. Divers'. According to one version of the planned budget, over 45 million CFA was to be invested in this building work: 'Budget remanié du Premier festival mondial des arts nègres (du 1er au 26 avril 1966). Exercices 1963–64/1964–65/1965–66': ANS FMA006.

8 Arrivals of visiting dignitaries and performers were coordinated at the new Yoff airport terminal by teams of hostesses and a 'campagne de courtoisie' [courtesy campaign] launched. Commission du Tourisme 1965: 'Procès verbal, 7 January 1965', p. 2: ANS FMA006; 'Quelques 160 candidates hôtesses et 200 candidats guides sont convoqués pour ce soir au Lycée Technique Delafosse', *Dakar-Matin*, 10 February 1966. Newspaper clipping from Centre de documentation, ANS, file marked 'Festival Mondial des Arts Nègres. Divers'. In total, 300 hostesses were selected via a competitive examination, then trained in history, geography, art, literature and politics in order to offer appropriate hospitality. 'Conseil interministériel du lundi 21 février 1966. Projet d'ordre du jour', p. 6: ANS FMA022.

lepers from sites adjacent to festival venues.[9] Newspapers reported positively on the urban makeover, while one American critic described how 'Dakar was very much "en fête" for the occasion [...] all the buildings were white and clean, looking more like a Mediterranean than a "near North" African city' (cited in Harney 2004: 75).[10] Another more critical report claimed that '40,000 beggars had been driven from the streets of Dakar' (Duerden 1966: 21).[11] From the city's builders, taxi drivers and guides, to the homeless people relocated to the city's outskirts, the social experience of the festival varied widely as its impact was felt across a broad cross-section of Dakar society.

With these material contexts of urban modernity in mind, we now turn to the selected plays. The analysis aims to unpack further the productive tensions between history, performance, and Senghor's politics of development outlined above. While *Kongi's Harvest* sought, via its satire of dictatorial power, to expose fault lines in post-independence leadership, other productions seemed to paper over such incipient cracks, presenting celebratory pageants of Senegalese and pan-African history. Their juxtaposition and reception in the context of the 1966 festival encourages fresh reflection on how African historical narratives could and should play out on the global stage.

Les Derniers Jours de Lat Dior

Amadou Cissé Dia's play celebrates the struggle of Lat Dior against French colonial forces in the late nineteenth century. It was staged twice during the festival, on both occasions at the National Stadium. The first performance took place on 4 April, Senegal's national day, which marked the anniversary of independence, and then as a replacement event after Miriam Makeba pulled out of the festival at short notice ('Les Derniers Jours de Lat Dior' 1966). Dia was a minister in Senghor's government who had revised the play after initially writing it in 1936 while at the William Ponty School, which trained a West African colonized elite (D.B. 1965). As emphasized in a press interview, his script translated oral history into a different setting:

> Ce n'est pas seulement l'expression d'un épisode de notre histoire classique, mais plutôt la physionomie d'une page de la légende locale, telle que la racontent les griots, le soir dans chaque foyer, celui du riche comme celui du pauvre. (D.B. 1965)

9 'Comité interministériel du 29 novembre 1965. Projet d'ordre du jour', p. 4: ANS FMA022. According to minutes of this meeting there were immediate objections on legal grounds to plans to relocate these people to Foundiougne.

10 'Une campagne de propreté et d'assainissement du Grand-Dakar à la veille du Festival'. *Dakar-Matin*. Undated. Newspaper clipping from Centre de documentation, ANS, file marked 'Festival Mondial des Arts Nègres. Divers'.

11 Thanks to James Gibbs for sharing this report, along with other material on Pan-African festivals, from his personal archive.

[It's not only the expression of a classic episode from our history; it has the physiognomy of a page of local legend, as told by the griots every evening in every home, whether rich or poor.]

A collective impulse is foregrounded here with reference to the way in which this story has habitually been told. The paradoxical 'page' from the oral tradition is twinned with an apparently discrete 'classic episode in our history'. Indeed, the play begins by emphasizing the role of the poet-griot in building a collective identity: 'Que deviendraient nos Royaumes si le poète n'existait plus?' [What would become of our Kingdoms if the poet no longer existed?] (Dia 1978: 13). Dia's play communicates the known historical details of Lat Dior's life (albeit with some creative editing) and his approach is consistent with the ways in which the Damel's life had previously been conveyed in Senegal.

In its form, the play is a relatively conventional five-act tragedy showing the complexities of Lat Dior's heroism and the obstacles he faced towards the end of his life. The setting shifts between three locations: Lat Dior's court at Thilmakha-M'Bakol, the military camp of Général Faidherbe just outside Saint-Louis, and Touba, home of Cheikh Amadou Bamba and the Mouride brotherhood in Senegambia. The action shows Lat Dior's unrelenting resistance, the loss of support he suffers as he struggles to prevent the construction of the railway between Dakar and Saint Louis, and his conversion to Islam and the teachings of Cheikh Amadou Bamba.

The play was a major production with a large cast and accompanying music, songs and dance. A set comprising a complete African village was built by the École des Arts and the cast included 250 performers, 50 tam-tam players and 40 horses, including one playing the part of Malaw, Lat Dior's famous steed (Soéllé 1966). The Senegalese organizing committee went to considerable lengths to stage the production for a mass stadium audience, including moving Duke Ellington's much-anticipated performance that day from 9 p.m. to the afternoon slot at the Daniel Sorano Theatre.[12] A laudatory article in the pro-Senghor daily newspaper *Dakar-Matin* noted: 'Nous voilà donc, pour la première fois en Afrique noire, devant ce théâtre de masses, déjà si boudé en Europe et qui reste malgré tout la formule de l'avenir' [Here we are, for the first time in black Africa, watching theatre for the masses, a form already snubbed by Europe and which nonetheless remains the way forward] (Soéllé 1966). Published three days before the first performance and based on the reporter's viewing of rehearsals, this future-oriented rhetoric distances the play from contemporary trends in European theatre, highlighting its popular appeal.

The story of Lat Dior may have seemed an obvious choice for the Senegalese national day in 1966. John Conteh-Morgan suggests that the frequent invocation of history on the Francophone African stage in this period not only provided symbols of unity, but lent legitimacy to new governments by presenting

12 'Procès-verbal de la réunion du comité interministériel du 29 novembre 1965', p. 2 (ANS FMA022).

their leadership 'as continuous with that of a revered ancestor' (2004: 126). A dramatic reconstruction of Lat Dior as hero and anti-colonial martyr sat comfortably within a certain narrative of post-independence Senegalese nationalism oriented around recuperation of a shared past. Mamadou Diouf's study of nineteenth-century Cayor confirms that narratives of this period are never neutral. As the focus of various attempts to establish a lineage of African leaders prior to European colonization, this region and its leaders have regularly been subject to historical and ideological manoeuvres. The story of Lat Dior in particular has become what Diouf terms a 'lieu privilégié d'enracinement' [privileged site of rootedness] (2014: 5) in the construction of the Senegalese nation. Lat Dior's resistance to French colonial incursions offers an alternative foundation stone, a means of diluting the status of the 'parenthèse coloniale' [colonial parenthesis] within collective historical memory.[13] The construction of Dior as national hero takes place in Dia's play at the expense of wider socio-historical complexities.

To give one example, the relationship between Lat Dior and Faidherbe has been reframed by subsequent representations as two sides of 'le couple idéologique senghorien [...] négritude/francophonie' [the Senghorian ideological couple [...] Negritude/Francophonie] (Diouf 2014: 283). Dia's play, as performed in 1966, certainly seems to follow this pattern, depicting Dior as a source of strength and situating him alongside Faidherbe as father figures for a united Senegalese nation. This fictionalized Faidherbe views his task as compatible with Lat Dior's intention to unify Senegambia. The link between the two was emphasized most obviously by the decision of director Ousmane Cissé Madamel to cast a black actor as Faidherbe. The director responded as follows to a journalist's enquiry about this choice:

> Le Festival repose sur la mise en valeur des forces culturelles de la négritude. Il apparaît donc normal que tous les personnages soient joués par les acteurs sénégalais. Cette manière de représenter Faidherbe permet de le projeter également dans la légende comme Lat Dior lui-même. (Soéllé 1966)

> [The Festival is based on the promotion of the cultural forces of Negritude. It therefore seems normal that all the actors be played by Senegalese actors. This way of presenting Faidherbe allows us to project him also into the legend, like Lat Dior himself.]

13 A later play, Mamadou Seyni Mbengue's *Le Procès de Lat Dior* (1970), presents a fictional posthumous trial that assesses Lat Dior's legacy. Its 'tribunal de la postérité' [tribunal for posterity] delivers an overwhelmingly affirmative verdict, calling for Lat Dior to be remembered as hero and martyr, offering him 'en exemple aux générations présentes et à venir, afin que l'Histoire garde son souvenir pour toujours, jusqu'à la fin des temps' [as an example for present and future generations, so that History preserves his memory forever, until the end of time] (85). Championing Lat Dior, Mbengue aims to 'jouer le rôle d'éveilleur de conscience' [take on the task of consciousness-raising] for the Senegalese people (5).

While this may have been a matter of logistics, a black Faidherbe was a further visual cue (particularly significant in a stadium setting with limited amplification) aiming to unify these aspects of Senegal's history under the banner of Negritude.

Lat Dior was elected Damel in June 1862 and died some years after Faidherbe had left Senegal. Though it is not made clear in Dia's play, the main period of conflict between these two figures occurred when Faidherbe returned to Senegal to lead a bloody campaign to restore French influence in 1863 and 1864. A railway project to link Dakar and Saint-Louis (and thereby secure French economic and military influence) was proposed and led by a later governor, Brière de l'Isle, who does not feature in the play. Completed in 1885, the railway was central to developing agriculture in the Cayor region, in particular the production of groundnut for export. Lat Dior's opposition to the project and the strongly implied connection between Lat Dior himself and the threatened land of Cayor, is at the heart of Dia's drama.[14] As Dior declares in the final act: 'ma force, c'est la terre même de Cayor et du Baol, la terre des royaumes frères' [my strength is the very land of Cayor and Baol, the land of brotherly kingdoms] (52).

A more detailed empirical account of Cayor's history is now available, and in particular this highlights the links between the upper echelons of Cayor society and European commerce. It has been argued that Lat Dior's mission was less to defend the people of Cayor than to protect 'les privilégiés de la classe dirigeante et le champ traditionnel où s'exerçait son exploitation' [the privileged members of the ruling class and its traditional area of influence] (Diouf 2014: 283). Similarly, historians have emphasized the extensive violence used by the French in the latter half of the nineteenth century (Diouf 2014: 75), a fact that is somewhat glossed over in Dia's play.[15] Recognition of an embedded history of social hierarchies and conflict in the region and early failed attempts at unification sat awkwardly with the project of the 1966 festival. On closer analysis, the complexities of this performance as a history of African resistance begin to emerge.

While the play's prominence at the festival was in line with the organizing committee's desire to cultivate a national hero figure, closer reading reveals the difficulties involved in forging a stable or singular historical narrative. Dia's play reflected the narrative flexibility of oral traditions and the desire to represent Senegalese and French strands of this history with a degree

14 Subsequent historical accounts suggest the situation was less clear-cut. In September 1879, Lat Dior signed a treaty agreeing to the construction of this railway, a treaty he would later reject. He declared in a letter, 'Je n'avais une alliance avec les Français que dans l'intention de conserver tout le Cayor' [I only had an alliance with the French with the intention of keeping all of Cayor] (cited in Diouf 2014: 269–70).

15 For further accounts of the life of Lat Dior, see Monteil (1963); Samb (1964); Casanova (1976).

of sympathy, in line with the political project of Senghor's government.[16] Traces of the play's reception in 1966 confirm its success with the local audience. In the days immediately following the festival *Dakar-Matin* printed a *vox pop* recording the opinions of members of the Senegalese public. People were asked to name their favourite performance and favourite art work. While many plumped for Aimé Césaire's *La Tragédie du roi Christophe*, several mentioned their enjoyment of Dia's play. This was 'une pièce authentiquement sénégalaise' [an authentically Senegalese play] ('Interview Express' 1966). Another felt it corrected the bias of 'l'histoire de notre pays telle qu'elle était enseignée à ceux de ma génération' [the history of our country as it was taught to members of my generation], constituting 'une réplique aux narrations erronées' [a response to the false accounts] of the life of Lat Dior. A third interviewee, a Dakarois police inspector, asserted: 'Je retiens surtout l'enseignement qui s'en dégage, à savoir qu'on se doit de défendre en toute circonstance l'honneur de son pays' [Above all I remember the lesson it teaches us, that we owe it to ourselves to defend the honour of our country in all circumstances]. Reinforced by the context of its staging and its mass audience, Dia's play successfully catalysed a sense of Senegalese national unity.

Le Spectacle féerique de Gorée

The *Spectacle féerique de Gorée*, by contrast, promoted a much broader vision of African and diasporic history. Situated just off the Cap Vert peninsula, the most westerly point of the African continent, Gorée Island is a 20-minute ferry ride from the port of Dakar and was a strategic seat of Dutch, British and French colonial power from the seventeenth to the early twentieth centuries. It was a key point of departure for the transatlantic slave trade and is now a UNESCO world heritage site whose 'manifest iconicity' has been sustained by numerous historical studies and fictional representations (Forsdick 2015: 134).

This *son et lumière* show was produced by Jean Mazel based on a script by Dakar-based Haitian poet Jean Brierre. Its eight, site-specific, narrated tableaux charted the island's past from the fifteenth century to the present day, interweaving local details with the history of transatlantic slavery (Figures 12 and 13). In scale and logistics alone this was an impressive spectacle. The show used the latest technology in sound and lighting to generate a multisensory experience and featured a cast of over 250 performers. These included former servicemen and residents of the island. It attracted an audience of approximately 700 audience members each night, and by the close of the festival, according to one report, over 23,500 people had seen the performance ('Le Spectacle féerique de Gorée' 1966).

16 For further analysis of the play text, see Brian Quinn's chapter in this volume.

Unlike the national specificity of *Les Derniers Jours de Lat Dior*, this production (quite literally) cast new light on connections across the African diaspora. It also placed Gorée at the heart of the festival as a pan-African heritage site for Senegalese and foreign visitors, consolidating Senghor's decision to designate the island as an official slavery memorial shortly after independence. The printed programme for the *Spectacle* noted that the former government headquarters on Gorée was 'en cours de restauration et deviendra prochainement un centre international de grand tourisme et de pêche sportive' [in the process of being restored and will soon become an international centre for tourism and game fishing] (*Spectacle féerique* 1966: 13). While curating the memory of past trauma, the festival organizers also sought to place a firm stamp on Senegal's modernity for an international audience. The fifth tableau of the *Spectacle* echoed this ambition, describing the founding of Dakar: 'à la pointe du Cap-Vert, les administrateurs et les pêcheurs Lébous posent tour à tour les premières pierres d'une ville appelée à devenir une grande cité moderne, toute blanche: Dakar' [on the point of the Cap-Vert, administrators and Lebou fishermen placed in turn the first stones of a town destined to become a large modern city, all in white: Dakar] (*Spectacle féerique* 1966: 41). The text of this production was reproduced in an illustrated, bilingual French–English souvenir edition including maps, photographs, background information on Gorée and advertisements. The *Spectacle féerique* was carefully packaged as a symbolic meeting point for African and diasporic historical narratives.

In terms of structure, the narrated scenes present a linear chronology progressing from pre-colonial fishermen, encounters with Dutch, French and British traders, to the transatlantic slave trade, the lives of the wealthy Signares (local métis women who played a key role in the slave trade), Gorée Island's privileged status as one of the four Communes in French West Africa, the abolition of the transatlantic slave trade, the island's decline (through yellow fever and the rise of Dakar) and lastly independence from colonial rule. These tableaux were accompanied by recorded music, ranging from eighteenth-century harpsichord (Lully's 'Marche des galères Turcs') to African American spirituals recorded by the 'Back Home' choir of the New York Baptist Church. This medley resulted in what Tsitsi Jaji terms 'a monumentalizing effect [...] emblematic of the festival's approach to representing black history and culture as an overwhelming, monadic, and inescapable whole' (2014: 98). Audiences were invited to make connections and situate themselves in relation to this rapid teleological account of a shared history.

To turn to Brierre's text in more detail, several passages can be seen to locate the production within the context of Senghor's promotion of cultural unity at the festival. The final tableau pays poetic homage to past heroes: 'Que la sonnerie aux morts honore Lat Dior, Cheikhou Omar El Foutiyou, Soundiata, Samory et tous les héros anonymes de nos luttes millénaires' [Let the last post honour Lat Dior, Cheikhou Omar El Foutiyou, Soundiata, Samory and all the anonymous heroes of our ancient struggles] (*Spectacle féerique* 45). Here

the accumulation of West African figures of resistance (and conquest) moves across the region, suspending ideological differences and divisions in the post-independence period, such as the growing animosity between Senghor and the President of Guinea, Sékou Touré. Homage is paid to Soundiata Kéïta, Lat Dior, Cheikhou Omar El Foutiyou (better known as El Hadj Umar Tall, a nineteenth-century Toucouleur leader) and Samory (Samory Touré, founder of the Wassoulou Empire and grandfather of Sékou Touré). The narrator's poetic lens then rapidly pans from the local surroundings to the African diaspora in the Americas:

Ceux qui sont morts à Gorée au cours de rébellions sanglantes;
Ceux qui sont tombés sur la terre ensemencée de cadavres africains;
Ceux que la traite négrière a assassinés, les marrons d'Haïti, de la Jamaïque, de la Guadeloupe, de la Martinique, de Cuba, de la Guyane;
Ceux qui sont morts dans la grande Colombie, au Brésil, en Uruguay et en Argentine pour l'émancipation de l'Amérique espagnole;
Ceux de la guerre de l'indépendance des États-Unis d'Amérique pour les fils de qui John Brown et Lincoln ont été crucifiés. (45)

[Those who died on Gorée in bloody rebellions;
Those who fell on the ground sown with African corpses;
Those assassinated by the slave trade, the maroons of Haiti, of Jamaica, of Guadeloupe, of Martinique, of Cuba, of Guyana;
Those who died in Gran Colombia, in Brazil, in Uruguay and in Argentina for the emancipation of Spanish America;
Those of the American War of Independence, for the sons of whom John Brown and Lincoln were crucified.]

The enumeration of violent deaths builds from the horrific image of a land 'sown with African corpses', shifting to liberation struggles in the Caribbean, Latin America and the USA. The closing lines then turn to praise for Enlightenment philosophers, leading figures of the French abolition movement, and France itself:

Pour les philosophes des lumières, Schoelcher, l'abbé Raynal, la France connue et anonyme,
Solidaire de la cause de l'homme dans le monde.
Nous, de cette génération, ouvrons au monde des bras fraternels:
L'entrée du Sénégal dans le concert des nations libres. (45)

[For the philosophers of the Enlightenment, Schoelcher, Abbé Raynal, known and unknown France,
In its solidarity with man's cause in the world.
Our generation will extend brotherly hands to the world:
The arrival of Senegal in the concert of free nations.]

This neat consolidation of political struggles and French humanism ends with a rhetorical link to Senegal's own present role as a triumphant free nation. Historical complexities are glossed over in the momentum towards

independence. The proposed vision of peace is celebratory, but in the context of the more radical politics of 1960s' *tiers-mondisme*, this grand narrative of Enlightenment values jars with the preceding litany of imperial violence.

Audience response inevitably remains plural: what did it mean to bring people together to witness this constructed narrative? What thoughts were generated and exchanged during the performance, on the boat trip back to the port of Dakar and in the days that followed? Archived newspaper reports applauded the cutting-edge technology used in the production. In one report, an audience member and Gorée resident states that the island 'a effectivement ressurgi des ténèbres du passé, sous la baguette magique des spécialistes de l'électricité et de la stéréophonie' [has indeed re-emerged from the shadowy past, at the wave of the magic wand of specialists in electricity and stereophonics]. Another suggested it was the best *son et lumière* show that she had ever seen, except for Versailles (N'Dir 1966). Katherine Dunham—the American co-chair of the dance committee who was also appointed to an advisory role by the Senegalese authorities—praised the show's 'combined sophistication and primitiveness' (Clark and Johnson 2005: 412). This consolidation of African and diasporic history used the modernity of its performance technology to celebrate and pay homage, while heralding implicitly—and unquestioningly—a shared future.

The *son et lumière* show on Gorée island provided a linear historical narrative with no direct comment on contemporary political affairs in Africa or the diaspora (for example, the Civil Rights movement in the USA). It was didactic and entertaining, expressive, spectacular and yet carefully contained in its island setting. Its selective frame of historical reference reveals the moderate dimensions of the festival's political imagination.

Kongi's Harvest

This is not to say that dissenting voices were absent in 1966. According to British critic Dennis Duerden, writing at the close of the festival, Wole Soyinka's satire of absolute rule in a fictionalized African state was 'the only example of African art [present at the festival] adapted to modern African urban society' (1966: 21). A unified African past performed on Gorée or the shared Senegalese heroic national figures in *Les Derniers Jours de Lat Dior* were perceived, by some, as out of step with consciously new and politically radical forms of artistic expression. In considering how such forms manifested at the festival, we turn now to the performance of power in the festival's opening performance, *Kongi's Harvest*.

In his contribution to the festival colloquium, Soyinka described the role of theatre in contemporary Nigeria. He sketched out, via a summary of recent theatrical productions at the University of Lagos (where he was head of the English department), theatre's capacity to represent individual survival in

the face of tyranny. In contrast to poetry, theatre was not 'un moyen valable de fuite' [a valid means of escape] but rather a way of confronting present realities, whether solely at the surface level, or in greater depth (Soyinka 1967: 539). Accordingly, Soyinka's play explores the organization of time itself and the use of language under a tyrannical regime. Soyinka's opposition to Senghorian Negritude is of course well known. His conviction that the idealization of a shared African past could not be equated with the urgent political tasks confronting postcolonial Africa was articulated during this same period.[17] History had a role to play for Soyinka (as it did for Fanon), but not that of constructing a glorified, immutable past. *Kongi's Harvest* presents historical change as an urgent collective endeavour. As will be shown below, the play had a muted reception in Dakar, yet its central themes encourage renewed reflection on the historical work of the plays discussed above, and of the Dakar festival as a whole.

Soyinka's satire places its archetypal dictator, Kongi, in the fictional African state of Isma. Megalomaniac Kongi is eager to wrest power from the traditional ruler, Oba Danlola. The play is structured around the organization of the annual Harvest festival by Kongi's Secretary, who obediently carries out the President's every whim. It is planned that Kongi, and not Oba Danlola, will receive the symbolic first Yam of the harvest at this event, signalling the latter's abdication from power. Simultaneously, a coup is plotted by the young resistance fighters, Segi and Daodu, and the play concludes with the ambiguous culmination of that uprising.

The drama alludes to contemporary events, in particular the recent coups against Kwame Nkrumah in Ghana and Hastings Kamuzu Banda in Malawi, though Soyinka subsequently denied this was an attack on a particular head of state, arguing that the play takes aim at the machinations of power and political ideology itself: its subject is Kongism, not Kongi (Gibbs 1986: 97). The play's critique of what Soyinka perceives as the neo-colonial politics of 'consciencism', African socialism and economic determinism is apparent throughout. It lampoons both the language of scientific modernity and President Kongi's rejection of traditional customs in his quest for power: yet the way forward, or beyond, is never entirely clear. In the opening scenes, Kongi's advisors (the 'Reformed Aweri Fraternity') seek to establish an appropriate image and slogan for his regime. The series of rapid comic exchanges take place in their mountain retreat in a parody of intellectuals forced to serve the ruling regime:

17 Soyinka's often-quoted quip dismissing Negritude as 'tigritude' was made at the 1962 Conference of African Writers of English Expression held at Makerere University College, Kampala. His critique of Negritude's 'myth of irrational nobility' is developed in various early essays (Soyinka 1968: 18–21). As several critics have argued, Soyinka's relationship with Negritude is more complex and perhaps more sympathetic than this early position-taking suggests: see Irele (2001: 62) and Jeyifo (2003: 42–44).

FOURTH AWERI: We might consider a scientific image. This would be a positive stamp and one very much in tune with our contemporary situation. Our pronouncements should be dominated by positive scientificism.

THIRD AWERI: A brilliant conception. I move we adopt it at once.

SIXTH: What image exactly is positive scientificism?

THIRD: Whatever it is, it is not long-winded proverbs and senile pronouncements. In fact we could say a step has already been taken in that direction. If you've read our Leader's last publication …

FIFTH: Ah yes. Nor proverbs nor verse, only ideograms in algebraic quantums. If the square of XQY(2bc) equals QA into the square root of X, then the progressive forces must prevail over the reactionary in the span of 0.32 of a single generation. (Soyinka 1974: 71–72)

Loosely modelled on the development of Nkrumah's philosophy of consciencism, this scene dramatizes the redundancy of 'long-winded' poetic language as a route to meaningful political action. The characters reject as 'a little old-fashioned' (70) proverbs bearing past wisdom and the symbolism of collective belonging. Instead, quasi-scientific language and absurd algebraic formulae understood by none of the characters present are put forward as pathways towards Kongi's Five-Year Development Plan. The tropes of dictatorial power, from state violence to the symbolic excess of what Achille Mbembe (1992: 1) has called the 'aesthetics of vulgarity', are in play throughout.

Kongi's control extends to the organization of space and time in Isma. In the climactic Harvest Festival scene, the stage direction indicates that images portraying new buildings (a terminus, university, dam, refinery, airport) are to be displayed bearing Kongi's name (Soyinka 1974: 115). This follows an earlier exchange during which the sycophantic Secretary decides to rename the year of the festival as a surprise 'gift' to the President:

SECRETARY: This year shall be known as the year of Kongi's Harvest. Everything shall date from it. [...]

KONGI [*rapt in the idea*]: You mean, things like 200 K.H.

SECRETARY: A.H. my Leader. After the Harvest. In a thousand years, one thousand A.H. And last year shall be referred to as 1 B.H. There will only be the one Harvest worth remembering.

KONGI: No, K.H. is less ambiguous. The year of Kongi's Harvest. Then for the purpose of back-dating, B.K.H. Before Kongi's Harvest. No reason why we should conform to the habit of two initials only. You lack imagination. (Soyinka 1974: 92)

The definition of historical time itself is here in thrall to Kongi's power. The combined absurdity and pettiness of his demands parody a concept of time predicated on the individual. In his eagerness to 'make history', and thereby secure his posterity, Kongi remains oblivious to the collective forces gathering

in opposition to his regime. Struggles over the definition of political power were to the fore in this production and such resonances would not have been lost on audiences. Similarly, it would not have escaped the audience's attention in Dakar that this is also a play about organizing a festival. With hindsight, *Kongi's Harvest* provides a wry commentary on the careful manoeuvring and curation behind such events, and the kinds of posterity they might claim to generate.

These tensions are unresolved by the end of the play. The indications of what might challenge, undo or follow such rhetoric of dictatorial power are suggestive rather than conclusive. A large cast of dissidents is featured, including farmers and women's collectives present through music, dance and spectacle. The climax of the drama occurs when Kongi is presented with the decapitated head of one of the main political dissidents in a covered bowl at the Festival of the Yam. Expecting to be presented instead with the Yam which would seal his power, Kongi's grip on events is thrown into disarray. The women present on stage dance energetically and sing more loudly, suggesting, according to one reading, collective strength in the face of this corrupt regime (Jeyifo 2003: 94). However, the play's final scene, entitled 'Hangover' suggests the apparent failure of the resistance fighters' coup. It has been cut in several productions, including in Dakar, and as a result there is little sense of the aftermath of the uprising (Gugler 1997: 40–44). The audience must decide if Kongi's regime has survived or not.

The very limited traces of *Kongi's Harvest* in the festival archive and press dossiers suggest that the English language remained a barrier for the performance in Dakar. Despite Soyinka's radical ambition, the play used less spectacular staging and reached a limited audience in comparison with *Les Derniers Jours de Lat Dior* and *Le Spectacle féerique de Gorée*. As the gala opening performance in the purpose-built Daniel Sorano Theatre, this was one of the most expensive events to attend. Tickets cost 1,000–1,500 CFA, as opposed to 150–300 CFA for *Les Derniers Jours de Lat Dior*, or 400 CFA for *Le Spectacle féerique de Gorée* ('Programme' 1966: 3). None of the vox pops in *Dakar-Matin* mention Soyinka's production, and there are almost no extant reviews. One exception is Duerden, head of the Transcription Centre in London, who wrote praising Soyinka's aesthetic as inescapably contemporary (1966: 21). He contrasted *Kongi's Harvest* with French-speaking theatrical performances at the festival which 'might be mistaken for imitations of Racine'. The production blended Yoruba folk song, dance and traditional drumming with modern guitars and used 'a fairly solid expressionistic set' (Moore 1978: 69) designed by Soyinka himself. Mythological elements, poetic language and satirical comedy shaped the transformative experience of Soyinka's play and its critique of postcolonial nationalism and the excesses of absolute power. However, these aspects cannot be separated from the context of the performance under the banner of Senghor's ambitions for the festival, and the ironies this evokes on closer enquiry. Where Dia's play and the *Spectacle féerique* choreographed specific historical periods, Soyinka's production encouraged more vigorous

questioning of how power manifests at an individual and collective level, in covert and spectacular forms, and how such power might yet shape African futures.

Conclusion

If, as Césaire suggested in his paper delivered at the festival colloquium, Africans were to avoid seeing African history through another's eyes, then imaginative engagement with the process of making and understanding history would be needed. Contrasting strategies emerged in the shared context of the 1966 festival. Together the three productions analysed in this chapter explored themes of heroism, posterity, unity, tyranny and resistance and they provide a point from which a more critical stance might be taken when faced with the celebratory rhetoric of the festival's official archive. Residual traces of the festival's reception give a glimpse of how Senghor's concepts of Negritude and a '*civilisation de l'universel*' travelled from the realm of ideas and intellectual debate to the diverse social experience of spectators in Dakar's spruced-up performance spaces.

In 2010, Senegalese President Abdoulaye Wade selected the theme of 'African Renaissance' for the Third World Festival of Black Arts held in Dakar. This expression gained currency in the late twentieth century, particularly in the South African context under Thabo Mbeki, building on ideas of regeneration, revival or reawakening found in the speeches and writing of pan-African thinkers since the nineteenth century. In the Francophone context, Cheikh Anta Diop similarly called for future-oriented action in a 1948 article, 'Quand pourra-t-on parler d'une renaissance africaine?'. Critics of Wade's government and of the event's organization in 2010 expressed frustration with the theme's recycled nostalgia for an idealized past. A vocal debate played out in the national press, generating accusations of political complacency and misplaced ambition (Faye 2010; Gaye 2011; Murphy 2011). Elsewhere writer Boubacar Boris Diop (2010) noted more positively in the days leading up to the festival that: 'la meilleure façon de forcer les portes de l'avenir, c'est de faire au moins palabrer nos imaginaires' [the best way of forcing open the doors to the future is at least to make our imaginations speak to each other]. Such tensions are a reminder that state-sponsored cultural production is a highly politicized, often divisive topic in contemporary Senegal. Where some see it as a necessary means for imagining and debating a shared future (as in 1966), the subject now also provokes a far more visible critique of social inequalities and calls for greater artistic autonomy. In both cases, cultural activism is accompanied by a renewed philosophical engagement with ideas of time and historical change generated from within the continent and its diaspora (Diagne 2013: 53–68).

'The Next Best Thing to Being There': Covering the 1966 Dakar Festival and its Legacy in Black Popular Magazines

Tsitsi Jaji

O ne of the ironies of cultural pan-Africanism is that while its broadly leftist discourse of liberation might suggest that non-elite workers would figure prominently in its projects, very few of the participants in its conferences, congresses and festivals came from beyond the ranks of intellectuals, politicians or prominent artists. Indeed, the First World Festival of Negro Arts (FESMAN) of 1966, and the subsequent pan-African festivals of 1969 (Algiers) and 1977 (Lagos), all privileged artists and cultural workers with the means and governmental support to travel. This chapter explores how popular African and African American glossy print magazines allowed less elite participants to follow the festivals from their own homes. The chapter examines selected issues of *Bingo* (based in Paris and Dakar and distributed throughout the Francophone world), the three Johnson Company magazines based in the USA, *Ebony, Jet* and *Negro Digest,* and the Nigerian edition of *Drum* magazine, which covered FESTAC in Lagos in 1977. It focuses specifically on these popular magazines rather than the coverage and responses in more literary publications like *Transition* and *Présence Africaine* in an effort to consider audiences beyond the 'usual suspects' of educated and politically engaged readers.

This discussion of popular magazine coverage seeks to uncover how the digest form of illustrated magazines exposes the way the festival tapped into not only pan-African feeling but also a particular idea of culture as an industry, and by extension cultural events as consumable commodities. These magazines featured stories that wrote back to and against official state agendas, and revealed the rich and sometimes fractious parallel conversations to those in the sanctioned halls of the symposia and colloquia that accompanied each festival. They remind us that the cultural festival is a form that is necessarily messy, noisy, crowded and contentious. Indeed, such live events would seem to offer a forum for the very opposite of unity. However,

113

as the magazine coverage surveyed below shows, such struggles over meaning and accidental encounters were no mere example of 'message creep' but rather opened up to non-elite parties and sceptical commentators those fissures in the stated agendas of official organizers where the real work of solidarity began. Such disjunctures and contradictions showed that, as Lamine Diakhaté would observe at the Algiers festival, unity depended on a recognition of, and respect for, difference. The chapter is structured in two parts, the first on Dakar 1966 and the second on its legacy. Each publication (and often each article within a single publication) highlights a divergent dimension of the events, and reveals how the national contexts of participants also structured the meanings they made from the events. One theme emerges repeatedly— on the margins of official events and in unexpected moments, artists and reporters observed that one of the most valuable elements in the festivals was the opportunity to encounter and exchange with other Africans and diasporans, improvising a common language that did not efface differences so much as translate them into resources for new forms of creativity.

Dakar 1966: The First World Festival of Negro Arts (FESMAN)

Given its editorial connections to Dakar, it is no surprise that *Bingo* covered the 1966 festival in the most detail, with the April issue featuring it as the cover story. The cover's large print title, 'Festival Mondial des Arts Nègres', is superimposed against a green background. The cover image is a three-quarter-length portrait of a bespectacled President Senghor, gazing directly at the camera, wearing a double-breasted, blue suit and resting his hand on three thick, hardback books (Figure 14). The white handkerchief in his top pocket and white cuffs peeking out from his sleeves emphasize the formality of the portrait, a far cry from the interest in traditional African and typically Muslim fashions evinced by American visitors (the more daring adopters being named and finding their bright-coloured new *boubous* highlighted in the US black press). Even at the seemingly mundane level of the sartorial, a set of competing agendas and ideas about *how* to embody or illustrate Negritude would be at the core of the event. The editorial by Paulin Joachim is unusually effusive, and its almost breathless enthusiasm predicted glory for the organizers and a renewal in creativity for the guests in what was termed Africa's 'rendezvous with itself':

> Ce mois d'avril qui éclate dans la joie solaire comme une grenade sur la route de notre destin et nous éclabousse de gloire et de fierté, ce moment que n'attendaient plus nos yeux fatigués de scruter les horizons, nos lèvres lasses de supplier les dieux, toutes les communautés noires éparses dans le monde, le vieux baobab et toutes ses ramifications ultramarines se doivent de le marquer d'une pierre blanche [...] [Le festival] n'est, au fond, que le rendez-vous de l'Afrique avec elle-même dans l'arc-en-ciel fraternel de ses

mille visages et dans la prolifération de son génie [...] Et en regardant vivre, sous le grand soleil, toute nue, une civilisation qui rappelle encore les premiers matins du monde, en baignant dans la vitalité simple et droite de ces peuples africains en marche vers leur destin [...] le vieux monde peut aussi prendre comme un bain de jouvence, puiser des forces nouvelles pour la poursuite de sa route. (Joachim 1966a: 5)

[This month of April, which bursts forth in the joyful sun like a grenade in the path of our destiny and showers us with glory and pride, this moment that our eyes no longer expected to see, tired from scouring the horizon, our lips weary from pleading with the gods, all the scattered black communities around the world, the venerable baobab and all its overseas buds must mark this as a red-letter day [...] Fundamentally, [the festival] is no less than Africa's rendezvous with itself within the fraternal rainbow of its thousand faces and in the proliferation of its genius [...] And, by observing, under the baking sun, in its natural naked state, this civilization that still recalls the dawn of time, by bathing in the simple and upright vitality of these African peoples marching towards their destiny [...] the old world can also use this as a rejuvenating experience and take new strength from it in pursuing its own path.]

Three short articles attempted to give voice to multiple perspectives. Brief interviews with a set of African, European and American intellectuals and readers elicited similar answers to questions about the meaning of African art. An article on Nigeria, the birthplace of black art, included several photographs of rare pieces that would be on display at the festival, including, remarkably, the ivory mask from Benin which later became the symbol for the 1977 FESTAC in Lagos. A third article revisited the history of Fodéba Keita's dance troupe. Not only was Keita involved in planning the festival, the legacy of his dance company was in full evidence in the prominent place and significant stage time devoted to dance troupes from across the continent and diaspora.

The main coverage of the festival in *Bingo* did not appear until June 1966, by which point a more analytical assessment was cohering. The editorial took up the quarrels with Negritude that numerous writers had voiced, particularly in the years since the Makerere Writers' Conference of 1962. Joachim, loyal as ever to Senghor, slyly noted that many of the recent detractors of Negritude among a younger generation of writers and artists had been happy to retract or temper their criticisms, particularly those who won awards for their work at the festival, including Soyinka, Sembene and Tchicaya U'Tamsi. In Joachim's view, the festival was its own vindication:

c'est avec une fierté légitime, la satisfaction naturelle, spontanée, du devoir accompli, que le grand poète sénégalais devait conclure: 'Par l'audience que le Premier Festival mondial des Arts nègres a rencontrée en Afrique et en Amérique, en Europe et en Asie, les militants de la Négritude ont atteint leurs objectifs, dont ils ne voyaient certes pas la réalisation avant la fin du siècle.' (Joachim 1966b: 11)

[it is with legitimate pride, a natural and spontaneous satisfaction at completing a task, that the great Senegalese poet concluded: 'Through the audience that the First World Festival of Negro Arts encountered in Africa and America, in Europe and in Asia, the militants of Negritude reached their objectives, which they had not hoped to achieve before the end of the century.']

Negritude's accomplishment, as he saw it, was to quash the sense of ambiguity and ambivalence that colonial legacies had left lingering:

[La Négritude] nous aura rendus à nous-mêmes dans notre vérité essentielle, et c'est grâce à elle, c'est outillé, armé par elle que nous aurons commencé à cultiver nos valeurs propres qui sont, soulignons-le très fort, des valeurs essentiellement de complémentarité, de dialogue, d'échange, mais non d'opposition systématique, de raidissement ou de je ne sais quel orgueil racial qui sonnerait à nos oreilles comme une démission de l'esprit. (Joachim 1966b: 11)

[Negritude] will have revealed us to ourselves in our essential truth, and it is thanks to it, equipped and armed by it, that we will have begun to cultivate our own values which are, let us emphasize this, essentially values of complementarity, dialogue, exchange, and not of opposition, rigidity or who knows what other racial pride which would signal in our minds a resignation of the spirit.

Returning to the round-robin short interview format, 'Où va la culture négro-africaine' [Where is Black African Culture Going] asked Aimé Césaire, Amadou Samb, Vincent Monteil, Lilyan Kesteloot, R.P. M'veng and Alex Adandé to reflect on the futures whose present the festival performed. More specifically, they were invited to answer three questions regarding the festival's legacy, its most essential contribution to the arts and values of Negritude, and whether and why there ought to be another festival. There was broad consensus on the value of repeating the festival, ideally regularly, but some of the more interesting responses to other questions included Césaire's call for a practice of critique (rather than mere celebration) to be added to the festival, in part to make the process of selecting participants more rigorous: 'Par exemple [...] trop souvent le bon a été noyé dans le médiocre' [For example [...] too often the good was drowned out by the mediocre] (cited in Joachim 1966c: 14). Several commentators commented on the demonstration of unity (even in the midst of such great cultural diversity). Monteil viewed the festival as delivering a decisive shock, a discovery for Europeans of a network of rich and complex cultures. On the other hand, M'veng insisted that it was too soon after the end of the festival to evaluate its significance, a sentiment that may also have motivated the magazines to temper their coverage of the festival post facto—certainly, *Bingo*'s coverage after this June issue was limited to brief references in articles focused on other topics. In some ways, this reflected a lingering sense that those who were in the best position to define and analyse culture were in fact the educated elites—*hommes de culture*—and, to a lesser extent,

artists, rather than viewing the festival as an occasion where the working classes had a voice and role to play in shaping culture. One trace of the sharp critiques Negritude had suffered as being racist (even in its anti-racism) was the emphasis among many commentators at the festival on how it demonstrated what black cultures, and particularly black African cultures, had to contribute to the world at large, often a place-holder for Europe.

As may be clear from the above, much of the coverage of the festival reflected a default emphasis on male artists and intellectuals—figures like Lilyan Kesteloot and Katherine Dunham were notable precisely because they were exceptional. However, one of the few articles focusing on the partici- pation of women in the festival was a feature on dancers and singers: 'Elles ont dansé et chanté au Festival de Dakar' [They danced and sang at the Dakar Festival]. Brief interviews with individual artists from a set of nine performance troupes gave voice to the perspectives of performers (some of the few of any gender presented in the coverage, regardless of publication and location):

> La consécration d'un long effort pour sortir de la masse des danseuses folkloriques anonymes. 'Bingo' a rencontré Georgette Bellow, du Togo, Nina Baden Semper, de Trinidad, Micheline Soloum [elsewhere spelled 'Sofoum'], du Gabon, Victoria Akinyemi, du Nigéria, Ginette Menard, d'Haïti, Pussy El Massey, de la RAU, Jenny Alpha, de Paris, Nilce Correa, du Brésil, et Cucumbra Diarra, du Mali, et s'est entretenu avec elles. ('Elles ont dansé' 1966: 17)

> [The consecration of a long effort to emerge from the mass of anonymous folkloric dancers. 'Bingo' met Georgette Bellow, from Togo, Nina Baden Semper, from Trinidad, Micheline Soloum [elsewhere spelled 'Sofoum'], from Gabon, Victoria Akinyemi, from Nigeria, Ginette Menard, from Haiti, Pussy El Massey, from the United Arab Republic,[1] Jenny Alpha, from Paris, Nilce Correa, from Brazil, and Cucumbra Diarra, from Mali, and spoke with them.]

Their perspectives diverged from each other more markedly than the intellectuals interviewed in the same issue, and while the interviewer's consistent interest in their marital and familial status detracted from the intention to highlight their artistry, the interviews managed to elicit substantive comments on the significance of performance and how the festival had shaped the women's impressions of contemporary arts in Africa. The members of the Malian and Gabonese folkloric dance troupes, among the younger performers interviewed, saw dance primarily as an expression of rhythm and instinct, and a cultural practice rather than a career path. The artists from Haiti, Brazil, Togo and Trinidad, on the other hand, emphasized values closer to the Senghorian agenda of assembling and revealing black cultures to each other— dancer Ginette Menard going so far as to describe the visit as not only a chance to discover a new world but 'surtout un retour aux sources' [principally

1 The United Arab Republic was a state created in 1958 by the union of Egypt and Syria, and, for a short time, the Yemen.

a return to the source] ('Elles ont dansé' 1966: 17). For Victoria Akinyemi, an instructor in initiation, 'cette coutume étant élevée au stade d'institution au Nigéria' [this custom having been elevated to an institution in Nigeria], her cultural expertise was reflected in her impression of the festival 'comme le rendez-vous des traditions de l'Afrique [...] l'art nègre doit donc être avant tout un art traditionnel, la danse restant son expression la plus fidèle' [as the meeting place for Africa's traditions [...] negro art must thus above all else be a traditional art, and dance its most faithful expression] (17).

Among the popular US black magazines covering the 1966 festival, the most comprehensive coverage as well as the most robust engagements with the controversies it generated within the African American community was *Negro Digest*. Both *Ebony* and *Jet* also covered the festival in more 'neutral' journalistic tones, and so a quick review of their features will add context to the *Negro Digest*'s portrayals.

Ebony was the most pictorially oriented of the three Johnson magazines, and its July 1966 issue featured a 13-page article, entitled simply 'World Festival of Negro Arts', which included three pages of full-colour images as well as others in black and white. The aim of the article seemed to be to make the festival as sensorially accessible to readers as possible through sumptuous visual representations and detailed descriptions of accommo-dations and performances alike. The tone in the latter half of the article became more opinionated, and the voice of Hoyt Fuller, which would become more individuated in other publications and with time, emerges vividly in somewhat strident accounts like these:

> The Festival itself proved sometimes banal, frequently engrossing, and occasionally brilliant. Banality was provided by the Brazilians who had been eagerly awaited but who disappointed the expectant international gathering with a sleek, supper club-style revue called 'Nights in Brazil' [...] Appearing in the Catholic cathedral before a capacity audience of a few hundred people [Marion Williams], the big, exuberant singer and her group of six singers, dancers and musicians quickly overcame the very severe handicaps of poor acoustics and awkward staging. Prowling the platform like some great maternal tiger, Miss Williams unleashed her booming voice, at first startling the predominantly-European audience, then captivating it, and finally seducing all into a hand-clapping, foot-stomping accompa-niment that rocked the gothic rafters. (Fuller 1966d: 100)

Descriptions of spontaneous dance and music in the streets and clubs were also included in vivid detail: the colours of outfits were 'gay—and sometimes outrageous'; the nightclubs were located 'in the teeming core of the city and along the sea-cooled *corniche*' (100). Even if readers could not experience the events themselves, Fuller's descriptions sought to make his account visceral.

In 1966, Fuller's appraisal of Negritude was relatively sympathetic, although he found the description by USA-based academic St Clair Drake clearer than that of Senghor:

First, a passion for similar types of music, dance and graphic and plastic art forms which exist in what I call the Pan-African aggregate. Second, a softer and resilient rather than a hard and mechanical approach to life. Third, a deep resentment, whether expressed or unexpressed, over subordination to white people during the 400 years of the slave trade and subsequent structuring of caste relations here (in the U.S.) and in Africa. (Fuller 1966d: 100)

The report mentioned an issue addressed more comprehensively in the editorial and in Johnson's other magazines—the profound disturbance caused to many African American artists by the selection of a wealthy white socialite, Mrs Virginia Inness-Brown, to head the American committee for the festival—and also noted that many Senegalese artists were well informed enough about black cultural production in the USA to have hoped to see some of

the most exciting of America's black intellectuals—people like John O. Killens, LeRoi Jones [later Amiri Baraka], Ossie Davis and James Baldwin [...] 'You sent us Langston Hughes, and we love him', a bi-lingual Senegalese actor complained, 'but where are your younger writers?' (Fuller 1966d: 102)

Similarly, the absence of performers like Miles Davis, Thelonious Monk and Harry Belafonte, disappointed many.

Jet Magazine's style tended more towards gossip column reportage, and coverage featured a 'seen-and-heard about town' style rundown of various celebrities. Its 21 and 28 April issues offered the most contemporaneous coverage of the festival. In the 21 April issue, in the 'Paris Scratchpad' section (an ironic echo of France's prominent role in the planning and funding of the festival), Charles L. Sanders reported: 'Just below Senegal **President** and **Mme. Leopold Senghor** on the Dakar social ladder these days are U.S. **Ambassador** and **Mrs. Mercer Cook**' (Sanders 1966a: 48; emphasis in original). Elsewhere in the issue, a three-page article included seven photographs, one of them showing the kind of impromptu jam session between artists from across the globe that would distinguish the festival tradition in its iterations elsewhere. The caption, 'When Duke's music got good to him, Senegalese drummer Gana M'bow joined band' (48), introduced American readers to one of the heroes of Senegalese percussion. In the 28 April issue, similar attention was paid to personalities, and Sanders informed readers that the festival was drawing the likes of the singer and academic 'Dr. Zelma George (who had to be helped down the plane ramp because of all the packages she was carrying)' and 'fine-shaped Dorothy Cotton, the Atlanta gal who's one of the hardest workers with the SCLC [Southern Christian Leadership Conference]' (Sanders 1966b: 26).

The *Negro Digest* offered a more complex account, and its coverage continued from April to September. The April issue, published before the festival began, was directed largely at visitors to Senegal. Photographs primarily showed the Plateau district's modernist structures, including those constructed for the festival, like the Daniel Sorano Theatre and the art museum (that would later

be transformed into the country's Supreme Court), although there were also two images of women in conversation and a tourist-ready shot of the streets of Gorée. The text drew heavily from the official Senegalese press releases about the festival's aims and the significance of its taking place on African soil. Its description of the city, people and festival facilities introduced a more critical eye, noting the economic and racial segregation of the Plateau including the cramped and insalubrious *medina*, describing each of the ethnic groups represented in Dakar, and warning the magazine's readers of French neo-colonial racism: 'The French in Dakar will be hostile at worst and will feign monumental indifference at best. They should be ignored. However, Festival visitors would insist on courtesy and service, as they certainly will be paying for it' (Fuller 1966a: 81). Interestingly, the feature ends mid-page, and is followed by an extract from *The Wretched of the Earth*. Given Fanon's importance to Black Power thought, and the contrast between his advocacy of armed struggle in Algeria and elsewhere and Senghor's more accommodating stance, the juxtaposition might well be read as an implicit critique of Negritude:

> In order to assimilate and to experience the oppressor's culture, the native has had to leave certain of his intellectual possessions in pawn. These pledges include his adoption of the forms of thought of the colonialist bourgeoisie ... Now the *fellah*, the unemployed man, the starving native do not lay a claim to the truth; they do not *say* that they represent the truth, for they *are* the truth. (Fanon, quoted in Fuller 1966a: 82)

Presumably the editors felt the quote spoke for itself, since no gloss or context was proffered.

While the following month's issue only included brief mentions of particular attendees in the 'Random Notes' social section, a long article by John O. Killens, entitled 'Brotherhood of Blackness', was of obvious relevance to the festival's aims. The article was a response (and a rebuke) to an exchange that had run from January to September of 1965 between a Nigerian student, Thomas O. Echewa, and the African American writer, John A. Williams. Killens opened his article as follows: 'Let us speak with each other for a time about the Brotherhood of Blackness, which might almost just as well be called the Fellowship of the Wretched and the Disinherited. Fanon called us The Damned of the Earth' (Killens 1966: 4). Insisting that such unity was not grounded in biology so much as in a shared struggle against white supremacist racism, Killens urged an engaged pan-Africanism which seems consonant with, although more politically pointed than, Negritude. Not only was a shared history of oppression the grounds for alliance between Africans and African Americans, but so, too, their

> community of objectives is a mutual determination to throw off the black man's burden all over this white-oriented earth. Let us face a few cruel, indisputable facts [...] Africa is not free and independent yet, and Neither is the American Negro [...] Let us, rather emphasize the fundamental things

which keep the Brotherhood together, and forge a unity from Johannesburg, South Africa, to Jackson, Mississippi, to throw off the black man's burden. It is left up to us to make this the Freedom Century. It is up to us to forge a unity of our minds and muscles, dedicated to the proposition that we shall lay this burden down. And free all mankind everywhere. (Killens 1966: 10)

The search for such solidarity remained a key objective and indeed stumbling block for all three of the festivals discussed here.

The most substantive coverage of the festival was in the June 1966 issue. The cover features a collage of authors' faces from the writers' conference held at Fisk University in May 1966. This cover article, along with a report on the Black Arts Convention known as Forum 1966 held in Detroit that month, gives a sense of the vibrant cultural foment of the era, and the context in which Dakar's events were to be interpreted. Photographs from the festival were dotted throughout the volume. The main article, 'Festival Postcripts', began with an alleged account of the selection by the American Committee of the jazz ensemble to represent the USA, and the claim that only after two white band leaders were mentioned did Ellington's name get selected. This 'story—whether apocryphal or true—tells much about the orientation of the American Committee': 'In the first place, only a few thousand American Negroes knew anything about either the American Committee of the Festival of Negro Arts itself. For an event of such importance in the Negro world, this neglect was all but criminal' (Fuller 1966c: 82). The lack of publicity was blamed in large part on the fact *'that a white person [was] the head of a committee for a festival of Negro arts'*, for Mrs Inness-Brown had not thought to inform the black newspapers of the event. Objections were also raised regarding the selection of artists:

Arminta Adams, a 'classical' pianist, and Martina Arroyo, a soprano who recently appeared at the Metropolitan Opera [while fine artists in their own right] were all but wasted at Dakar. There is nothing particularly 'Negro' about a pianist playing Bach preludes and a soprano singing Verdi arias. [*And similar problems applied to the multiracial Leonard De Paur chorus.*] (Fuller 1966c: 83)

However, the critique of the racial and aesthetic values in operation was not limited to the American committee's decisions. One of the most popular performers was the gospel vocalist, Marion Williams, and yet, when

told that it was a pity that the masses of Africans would not have the benefit of Miss Williams' art, one director of the Festival (a Frenchman) replied: 'But what does it matter? Everyone of any importance is here at the cathedral.' *Everyone of importance?* When the audience consisted of only a few hundred people, most of whom were white! (Fuller 1966c: 85)

The report also made clear that some of the most successful moments of the festival had arisen through chance. While the documentary of FESMAN by William Greaves features the Alvin Ailey Dancers prominently, Fuller's

report reveals that they appeared only as a substitute for the Arthur Mitchell group, but nonetheless 'salvaged the sagging prestige of the American representation [...] Mr. Ailey brought some fresh ethnic feeling to the Festival' (Fuller 1966c: 85). Additionally, questions were raised about the role of the State Department (which had provided much-needed additional funding) in selecting (and barring) participants in the festival. Hoyt Fuller asked:

> Would the State Department approve the appearance of jazz musicians or blues singers who have been convicted as narcotics addicts, for example? Or would writers who have consistently opposed the Government's position in Cuba, the Dominican Republic and Vietnam receive State Department approval? (Fuller 1966c: 85)

In addition to the 'Festival Postscript' an editorial reiterated concerns at the failure to appoint a black person to lead the planning committee, and dismissed one of the rationales that had been offered for selecting Mrs Inness-Brown, that of fundraising needs. The editorial closed by calling for the inclusion of regular working people in the festival planning, a call that resonated at multiple points on both sides of the Atlantic as the optics of an elite event became more and more apparent: 'What's wrong with going directly to the black masses, explaining to them what the project is and what the problems are, inviting them to identify with the program and to help make it a success? What's wrong with that?' (Fuller 1966b: 97). This editorial struck a chord with readers, for in the September issue two of the letters to the editor commended them for drawing attention to the planning problems. Yvonne Reid wrote, 'I'm very glad you screamed for all to hear what others of us have been either keeping to ourselves or only whispering in select company' (96), and ended her letter by adding that she hoped coverage would continue 'for a long time to come. From the questions I've been getting, I judge the interest is still there' (96). James Emanuel sounded a similar note, writing:

> you are to be commended for the candor and the objections for which you were criticized by some. It would have been far better for a Negro to have headed the Committee and to have attracted more Negro participation and pride [...] I hope that you will continue to sound the note of self-respect and self-trust. (Fuller 1966b: 97)

Such letters make it evident that the magazine's coverage made a sense of participation and an investment in the symbolic stakes of the festival accessible to a broad range of readers.

While not the focus of this chapter, it is important to note that the festival was also covered widely in more intellectual and political publications, the most prominent being festival-organizer Alioune Diop's *Présence Africaine* as well as magazines like *The Crisis*, whose coverage was provided by the filmmaker William Greaves, who attended the festival to shoot material that eventually became one of the two most celebrated documentaries of the event, *The First World Festival of Negro Arts*. Sponsored by the US Information

Agency, and used widely as a propaganda film in Africa during the decades when it was inaccessible to the general public in the USA, it offers a live version of many of the photographs featured in the glossy pictorial magazines, and matches the visual digest format that these magazines favoured by concentrating on images in their coverage. Another significant documentary covering the festival, *African Rhythmus*, produced by the Soviet state media, remains even more difficult to access, but in contrast to Greaves' film it is in full colour, bringing a vividness to its representations where the Greaves film's black-and-white footage highlights the historic nature of the event.[2] *African Rhythmus* also includes footage of private audiences between Senghor and noted Soviet poet Yevgeny Yevtushenko, thus offering a more intimate portrait of the festival's primary mover.

Another set of impressions never circulated in the popular press appeared in Duke Ellington's widely disseminated autobiography *Music is My Mistress*. The entry 'Dakar Journal, 1966' captures his delight in hearing not only formal performances but the outdoor rehearsals of traditional troupes: 'I wondered whether it was really a rehearsal, or was it a soul brothers' ceremonial gathering with all of its mystical authenticity. Anyway, I wish I could have seen or recorded it. Too much, baby!' (Ellington 1973: 337). Ellington was one of the few to note that ambassador Mercer Cook (who was both a poet and translator of some of Senghor's works) came from distinguished artistic stock of his own, as the son of Maestro William Marion Cook (a composer and Ellington's one-time mentor). And Ellington fully identified with Negritude's claim to unity: 'After writing African music for thirty-five years, here I am at last in Africa! I can only hope and wish that our performance of "La Plus Belle Africaine", which I have written in anticipation of the occasion, will mean something to the people gathered here' (337).

The encounters with fellow artists at the festival were not limited to other musicians (although the coverage of Gana M'Bow's jam session with Ellington's orchestra in the US press indicates that this was indeed an important dimension). Ellington writes about Papa Tall, one of the leading visual artists in Senegal, from whom he purchased eight works, and was delighted that another, then a work in progress, was shipped to him when Tall had completed it. That such vivid and idiosyncratic artists' perspectives were not more prominently featured in the magazines covering the festival suggests that, like the organizers, the magazines saw the event as primarily a top-down process of synthesis (substituting their editorial voices and a select set of intellectuals for the government and designated spokespersons in the official state publications and programmes) rather than a mosaic of contrasting, and sometimes noisy, voices of artists and *audiences* themselves.

2 As David Murphy notes in the introduction to this volume, there is some evidence that this may have been a typographical error, as the French version of the title, *Rythmes d'Afrique*, would suggest the original title in Russian should have been rendered in English as *African Rhythms*.

The Legacies of Dakar 1966

Since the 1966 festival, there have been several other large-scale events that have both laid claim to its legacy and highlighted their departures from it. The First Pan-African Cultural Festival was held in Algiers, Algeria in 1969. In official documents the 1969 festival *also* laid claim to primacy—the official name of the festival claimed to be the first truly pan-African cultural gathering, perhaps reinforced by the fact that it enjoyed the support of the Organization for African Unity (OAU). The name also implicitly underscored criticisms of the 1966 festival's obscuring of the North African presence in Africa. Popular coverage made less of this contrast and, indeed, *Bingo* magazine's articles, in its two issues featuring the festival, emphasized continuity with the culturally oriented pan-Africanism of the 1966 festival. What they did highlight was the attention the festival would draw to the wave of independence that had swept through Africa in the previous decade.

Officially, only participants from the member states of the OAU, along with the freedom fighters from the Portuguese colonies, were invited. However, the invited artists included Miriam Makeba, a representative of the African National Congress (ANC), still fighting for the liberation of South Africa/Azania, and the African American gospel singer, Mahalia Jackson. The pan-Africanist boundaries envisioned were not strictly limited to those nation states belonging to the OAU. Rather than focusing on the valorization of African contributions to world culture, Algiers sought to position culture as central to economic growth/development. The official Pan-African cultural manifesto published for the festival emphasized the role of the masses in developing systems of thought, philosophies, sciences, beliefs, arts and languages, but also defined culture as essentially dynamic, simultaneously rooted in 'the people' and turned towards the future (Organization of African Unity 1970).

Bingo's pre-festival coverage emphasized a shift from a focus on the arts to a broader attention to education and culture that encompassed the sciences and locally grounded uses of technology. Here one line of continuity between the two festivals was emphasized through a detailed description of the work of the planning committee, which included representatives from Cameroon, Ethiopia, Guinea, Mali, Nigeria, Tanzania, Algeria *and* Senegal (with Cameroon, Ethiopia and Tanzania later taking a back seat). Remarkably, the location was only decided upon in 1967, and Algeria's challenge was to prepare for the thousands of participants originally envisaged for a festival in 1968. The rush to prepare lead first to postponing the festival to 1969 before, as *Bingo* described it, a subsequent shift in leadership from this international committee to an Algerian director (Joachim 1969a: 17). *Bingo*'s detailed descriptions of the preparations reveal just how complex it was to organize a large-scale festival, and why the diplomatic stakes in such planning were so high. As with the Dakar festival, the construction of venues for the performances fascinated the reporters; these physical preparations allowed *Bingo* to highlight this one-time event as an example of post-independence industrial

development and architectural modernism. Coverage emphasized the state-of-the-art nature of the sound system, electronics and the air-conditioning, while the festival budget—apparently funded out of the Algerian government's coffers—further demonstrated the modern state's bureaucratic efficiency.

In Algiers, the venues were more democratic than in Dakar, with ten temporary stages in public squares constructed across the capital. In William Klein's documentary of the festival, the spontaneity and close contact between working-class Algerians and visiting performers in such spaces is remarkable. As with the black American coverage of the 1966 festival, *Bingo* devoted considerable space to describing lodgings and other resources available for attendees. In both instances, few readers were likely actually to travel to the festivals, but including such details displayed the organizational prowess of the host countries and gave readers an intimate imagined access to the everyday dimensions of an otherwise overwhelming event. The article closed by reiterating the festival's claim to Africa's modernity: 'À Alger, en 1969, l'Afrique montrera que sa culture, sans défigurer son propre génie, est capable d'allier le passé au présent pour prendre la place qui lui revient dans le monde moderne' [In Algiers, in 1969, Africa will show, without betraying its own genius, that its culture is capable of allying the past and the present so as to occupy its rightful place in the modern world] (Joachim 1969a: 18). It was not the past that was being reclaimed, but the future.

By November, the tone of *Bingo*'s coverage had shifted markedly, as Paulin Joachim's title, 'Absurdes combats de gosier autour de la Négritude à Alger' [Absurd verbal struggles around Negritude in Algiers], indicates. Joachim begins by critiquing the petty quarrels and lack of faith in African unity displayed at the festival, taking particular exception to Stanislav Adotevi's dismissal of Senghor's Negritude. Joachim found Adotevi's critique of Negritude out of date, addressing its origins rather than its evolution as a cultural philosophy: 'Il est fort regrettable que M. Adotevi n'ait pas suivi, d'année en année, de manifestation en manifestation, l'évolution de cette Négritude qu'il pourfend avec une ardeur sauvage' [It is deeply regrettable that Mr Adotevi has not followed, year in year out, from one event to another, the evolution of this Negritude that he assails with a savage ardour] (Joachim 1969b: 12). Joachim cited Césaire's recent characterization of Negritude as a passion, thus aligning the magazine with an elder statesman-poet who enjoyed a similar status to Senghor. The magazine's founding editor, Ousmane Socé Diop, had been a close political ally of Senghor's (and later his ambassador to the USA), and the magazine remained sympathetic to the Senegalese government.

However, Joachim's real lament was that such arguments suggested that Africa was not yet 'mature' enough to aspire to unity. He published an eyewitness account by the writer and politician Lamine Diakhaté as an alternative take. Diakhaté noted that the goal of the festival was to realize African unity on the basis of culture, but from the very beginning the challenge was to 'aussi partir du préalable de la *diversité*, sinon de la *différence*' [also work from the prerequisite of *diversity* and not of *difference*] an occasion to uncover a political

will towards unity. Diakhaté offered a Fanonian diagnosis of the postco-
lonial inferiority complex and tendency to assume that national development
required a *tabula rasa* in order to efface the humiliations of domination and
to 'catch up' with more 'advanced' nations. The value he saw in the Algerian
festival was its opportunity for diverse African civilizations to converge,
meeting and translating each other's heritages and using such differences as
resources to counter centuries of European ideologies that minimized African
cultural production. In fact, the most urgent task, he writes, was 'd'éviter de
transformer en opposition, en antagonisme, les différents aspects de la civili-
sation de leur continent. Cette différence [...] est source d'enrichissement.
L'essentiel est de chercher à être ensemble, parce que différents' [to avoid the
transformation of the different aspects of the civilization of their continent
into opposition and antagonism. This difference [...] is a source of enrichment.
The key is to strive to be together because we are different] (Joachim 1969b:
13). A postmodernist *avant-la-lettre*, Diakhaté cautioned against the dangers of
a dichotomous mode of thinking, one he associated with imperialist thought.

The only Johnson magazine that covered the festival was the *Negro Digest*,
suggesting that the event's overt anti-colonial stance risked alienating the
advertisers that sustained *Ebony* and *Jet*, or that without stars like Ellington
and Hughes its interest was more limited than the Dakar festival. The cover of
the October 1969 issue, devoted to the festival, featured a portrait of Frantz
Fanon, whose work and legacy were analysed in the cover article. In contrast
to the traditional reportage style and highly pictorial format of the coverage
in 1966 across all three Johnson publications, *Negro Digest*'s editor Hoyt Fuller
treated readers to a highly personal set of journal entries.

Fuller's account highlighted the festival's support for the US Black Power
movement and freedom struggles across the continent noting that Stokely
Carmichael and Eldridge and Kathleen Cleaver were among the invited guests.
He began with a reflection on his first trip to Algeria during the liberation
war in 1959, and then tracked his itinerary to the festival, before turning to
his interactions with the festival's writers, visual artists, political activists and
intellectuals, and spontaneous encounters with Algerians in the streets. The
accompanying photographs were highly personal snapshots, quite unlike the
press coverage one might expect of an international diplomatic occasion: they
capture Stokely Carmichael and Eldridge Cleaver in conversation on a hotel
balcony; Miriam Makeba and Stokely in the Mediterranean during a swim
with Nathan Hare; the Afro-American Center from across a crowded street.
These contrasted with the stark geometries of Dakar's architecture in earlier
coverage.

Fuller was less interested in the official events, writing that 'the real talk, the
meaningful dialogue is being held—where it is being held at all—in the hotel
rooms, over dinner at the Hotel Allité and the St. George, in the two or three
posh restaurants around the city' (Fuller 1969: 83). These animated exchanges
constituted the moments when solidarity's rugged contours could be hashed
out and savoured in direct encounters. In detailing topical conversations, he

allowed readers a window into the contradictions of pan-Africanism. In one entry, for example, he reports on the unease expressed by Nigerian sculptor Ben Enwonwu (himself in his 50s) as he witnessed a generation of figures like Hughes, Robeson and Abrahams recede, while newly independent national governments were persecuting the very artists and activists honoured by events such as the festival. Their conversation about Soyinka's imprisonment emphasized the 'precariousness of political power in Africa' and the critical risks posed by the repression of freedom for the broader project of 'true liberation in Africa' (86). However, conversations still primarily took place in the most luxurious, 'posh' venues: in these international festivals, local non-elites repeatedly found themselves marginalized and unlikely to have access to the most dynamic elements of the events unfolding around them.

Similar divergences in the coverage of the 1977 FESTAC gathering in Lagos emerge from a review of the articles in *Bingo* and *Ebony*. The *Negro Digest* (by then known as *Black World*) had gone out of print only the year before and *Jet* limited its coverage to advertising the May 1977 issue of *Ebony* as 'the next best thing' to having been at FESTAC. *Ebony*'s May issue featured an 11-page photo-editorial in which full-colour images took up far more page space than the text that functioned rather as caption than analysis.

While neither the 1966 nor 1969 festival had been covered in any depth by the leading popular magazine in Africa, *Drum* (founded in South Africa and later distributed throughout the continent), it is hardly surprising that its Nigerian edition devoted space in several issues to FESTAC. However, what is striking is that this coverage lagged significantly behind the actual events of the festival, which began in January; it was not until the March issue that it was mentioned, with a cover article that asked, 'Did you see FESTAC?' In their letters to the editor and in interviews, readers lamented the limited coverage. A reader from Port Harcourt, for example, wrote in March 1977 that 'DRUM magazine is one of the most popular journals in Africa. This is more the reason why some of us who could not afford to watch events of FESTAC ask you to put in book form all the events at the FESTAC' ('Did you see FESTAC?' 1977: 3). The same issue ran interviews with 12 Nigerians about their reactions to the festival, and their responses were quite divergent. At their most dire, Nigerians like Sunday James Apeh, a typist, complained: 'I consider FESTAC a waste of money and time. What does the average man gain from it[?]' (3). At the opposite end of the spectrum, Augustine Akpelu voiced the aims of the festival in terms similar to its organizers: 'FESTAC [...] enables us to see our brothers and sisters in other parts of the world and their true colour. It made us see we are one people, regardless of whatever part of the globe we come from' (3). Several interviewees complained about the festival's costs given that the general economy was failing to meet the needs of the average worker. As Andrew Apter shows in *The Pan-African Nation: Oil and the Spectacle of Culture in Nigeria*, the economic and military situation in Nigeria shaped the logistics and meaning-making at the festival in complex ways that even these impromptu readers' commentaries gesture towards.

Drum's coverage highlighted the festival's expected dividends for tourism. The reviews of two general book introductions to Nigeria by European authors in the March 1977 issue certainly reflected this agenda, for what need did a Nigerian magazine reader have for a coffee-table book about their home nation? Curiously, one of the few text articles that covered a performance during FESTAC, Alistair Abrahams' feature on Stevie Wonder, 'Super Star's Songs Rule the World', which ran in the June 1977 issue, noted only in passing that Wonder was in town for the arts festival, and ran a photograph of an impromptu performance with the British Afro-pop group Osibisa and Miriam Makeba. While FESTAC itself was incidental to the article (which focused far more on the author's interview with and impressions of Wonder), the image reiterated a recurring theme, that the most rewarding part of the experience for artist participants was the opportunity to improvise and converse in the sometimes precarious lodgings at the Artists' Village. Oumar Ly's official report on the Senegalese delegation's experiences similarly indicates that such exchanges made FESTAC a success in the view of the artists despite significant tensions over the displacement of Alioune Diop and other Senegalese figures from the planning process.[3]

Conclusion

The magazines examined here addressed greatly diverse audiences and the political contexts in which each was published was unique. However, the coverage in these magazines is strikingly congruent with documentation published elsewhere: in the memoirs of attendees like Duke Ellington in 1966 and Hoyt Fuller in 1969, or in the official reports of Oumar Ly in 1977. Whether from the perspective of elite artists and government appointees or from the standpoint of non-elite audiences surveyed by the magazines, judgements on the value of the large-scale pan-African festivals, and thus the measure of their success, did not depend on performances of modernity such as the smooth functioning of tickets and programming, the construction of impressive venues, the sophistication of ideas at symposia or even the range and quality of art works and performances assembled. Rather, these accounts stress the indelible impression left on the artists by face-to-face live exchanges with peers from other parts of the pan-African world and the spectacle of live expressions of international black cultural resonance. The popular magazines most vividly conveyed these elements in the candid shots of conversations and other interactions and in the informal voices of eyewitnesses whether on staff or in the letters and gossip sections of the magazines. At these festivals what George Shepperson (1962) has called 'little p pan-Africanism' emerged

3 Archives Nationales du Sénégal. Rapport sur la vie de la délégation sénégalaise installée au Village du Festival, Lagos: 10 janvier–16 février 1977, OL/AD République du Sénégal/Ministère de la Culture.

from the interactions of both artists and the little people whom we glimpse through the accounts in these popular black magazines. For while African American artists who travelled to the festivals received a warm welcome at first hand, one important fruit of the coverage in *Ebony, Jet* and *Negro Digest/ Black World* and others was to extend to a broader public the opportunity to participate in emerging diasporic and pan-Africanist modes of identification.

II
Legacies

'Negritude is Dead':
Performing the African Revolution
at the First Pan-African Cultural
Festival (Algiers, 1969)

Samuel D. Anderson

Over the course of 12 days in the summer of 1969, African revolutionaries converged on the city of Algiers for the First Pan-African Cultural Festival (*Festival panafricain d'Alger* or PANAF). PANAF provided a forum for newly independent African nations, as well as the movements still struggling for liberation, to articulate their anti-imperialist vision. In particular, the festival's participants emphasized the central and multiple roles that African culture would play in the formation of the new, postcolonial world. Attendees sought to enact this revolutionary reality through popular artistic performances on the streets of Algiers and in an elite intellectuals' symposium.

In emphasizing the revolutionary potential of African culture, many participants in the Algiers festival challenged the famous ideology of Negritude, especially as championed by Léopold Sédar Senghor of Senegal. Negritude, long a dominant stream in pan-African thought, held that black Africans could use indigenous cultural forms to foster modern identities free from European racist and colonial models. Senghor, a poet and the president of Senegal from independence in 1960 until 1980, had celebrated Negritude's role in independent Africa three years prior to the Algiers festival. At the First World Festival of Negro Arts (*Premier Festival mondial des arts nègres*), held in the Senegalese capital of Dakar in 1966, Senghor and his peers had sought to demonstrate the power of Negritude through various forms of artistic and cultural expression. In the following years, facing criticism from other African intellectuals over the limits of their ideological framework, Senghor and others had by the late 1960s sought to expand the concept of Negritude to the larger-scale level of 'Africanity', or *africanité*. This question of what constituted such a continental cultural identity would prove central to discussions during the Algiers festival.

The Pan-African Cultural Festival of 1969 served as a platform for Africa's cultural and political leaders to debate the major currents in Africanist thought

and to put them into practice in cultural performances. As the records of the symposium make clear, by that time Negritude had lost its power as a guiding ideology. Some of its critics went so far as to declare it 'dead'. In its stead, the festival's participants, especially those from Francophone countries, articulated a new vision of Africanity as radical cultural practice rooted in Frantz Fanon's interpretation of the role of African intellectuals and artists in the anti-colonial struggle. The Pan-African Cultural Manifesto issued at the end of the festival was the outcome of this discussion, and in it African cultural leaders sought to lead their continent to a radical postcolonial future. In this future, African culture took on new meaning as the central force propelling the continent and its inhabitants forward into a more just position on the world stage.

Senghor's *Africanité*

Before delving into the events of the summer of 1969 in Algiers, Senghor's notions of Negritude and Africanity—a central focus of the festival's discussions—deserve some attention. Negritude as developed by Senghor had constituted a major line of cultural and political thought in Africa and the African diaspora in the Americas since the 1930s. In essence, the ideology of Negritude reinterpreted blackness as a positive trait in its Manichaean opposition to whiteness. For example, European colonial thought held that Africans were lazy and Europeans industrious, while Senghor and his allies (especially Aimé Césaire and Léon-Gontran Damas) argued that Africans were creative and Europeans motivated by greed. From its origins in the Parisian diaspora student community, Negritude developed into a highly influential literary and political movement. Jean-Paul Sartre described Negritude as 'racisme antiraciste' [anti-racist racism] in his landmark essay, 'Orphée noir' [Black Orpheus] (1948) because, although it challenged the meanings of black and white racial categories, it did not challenge the validity of those categories as such. Though Negritude was in its time a revolutionary interpretation of black culture, its advocates, Senghor in particular, accepted the notion of a single essential blackness.

In advocating for Negritude as a cultural–political position, Senghor sought a 'civilization of the universal'. This idea entailed a form of socialism steeped in African traditions. Culture was central to the creation of this new political order because it enabled a deeper sort of association between different groups (Senghor 1979b). To Senghor, an ongoing association between France and Africa (especially Senegal) was also necessary. He emphasized the role of the French language and the international French-speaking community—*la Francophonie*—as an important step in the evolution from colonial ideas of assimilation to postcolonial cooperation (Senghor 1979a). In his political career, Senghor deployed Negritude as a way to foster a better relationship between France and its former colonies in West Africa. This new and improved

relationship would, to Senghor's mind, positively adapt the links formed by colonial rule rather than constitute a break with them.

Though Senghor maintained the centrality of Negritude in his vision of world affairs, in the latter half of the 1960s he engaged in an expansion of the concept in such a way as to encompass the whole of the African continent in his project. In doing so, he engaged with the criticisms of other intellectuals who had criticized Negritude for reifying false racial boundaries. *Africanité*, Senghor explained, was an identity comprised of black sub-Saharan Negritude as well as North African *arabité* (Senghor 1969b). Despite real divisions—cultural, linguistic, racial—across the Sahara, Senghor argued, peoples living anywhere on the African continent shared a specific Africanity that contributed to 'l'équilibre de l'Humanisme du XXᵉ siècle [qui] plane sur le destin de l'Afrique' [the equilibrium of twentieth century Humanism [that] looms large over the destiny of Africa] (Senghor 1969b: 119–20). Racial divisions remained central to his thinking, but within the framework of Africanity they would not prevent broader anti-imperial solidarities.

Senghor referred to the deep African past when explaining his expanded notion of Africanity. In this framework, he saw Negritude and *arabité* as evidence of the fact that Africa was the 'cradle of humanity', the source of common roots in all mankind. In a speech at Cairo University in 1967, he explained that the division between black and white races arose in the Neolithic period. At the same time, during the period of human development when these different groups were appearing, African populations, including those in the north, underwent a period of *métissage* and mixing. In linguistics, Senghor saw evidence of relationships between Arabic and the Khoi-San languages of southern Africa, linked like a chain by Kushitic, Nilotic, Bantu and other language groups (Senghor 1967: 45). He focused a good deal of attention on the Arabic language and differentiated between Arabic and other Semitic languages by stating—without a clear justification—that Arabic alone possesses Africanity. According to Senghor, Arabic and its multiple dialects, in their deep structures, possess a sort of ontology that resembles black thought (through a series of 'convergences') much more closely than it does European rationalism. He made this argument while also admitting his ignorance of Arabic and drew his evidence from European orientalist scholars.

In the conclusion to his Cairo speech Senghor grappled with his own intellectual progress as he developed the idea of Negritude. He admitted:

> J'ai, souvent, pensé que l'Indo-européen et le Négro-africain étaient situés aux antipodes, c'est-à-dire aux extrêmes de l'objectivité et de la subjec-tivité, de la raison discursive et de la raison intuitive [...] Et j'ai prôné, comme idéal de l'humanisme du XXᵉ siècle, la symbiose de ces éléments différents, mais complémentaires. (Senghor 1967: 100)

> [I have often thought that the Indo-European and the Negro-African were antipodal, that is at the extremes of objectivity and subjectivity, of discursive reason and intuitive reason [...] I have taken, as the ideal of

humanism in the twentieth century, the symbiosis of these different but complementary elements.]

In his reading of great Arab writers and thinkers, he saw this same interest in combining distinct intellectual approaches. That said, Senghor's humanistic symbiosis required 'que nous restions nous-mêmes d'une part, que, d'autre part, nous allions vers l'Autre' [that we remain ourselves on the one hand but, on the other, we approach the Other] (Senghor 1967: 103). The Arabs in his Egyptian audience should abandon the idea of Arabism, 'qui est *projet*, volonté d'action' [which is a *theory*, a will to action], and instead embrace *arabité*, 'qui est le foyer irradiant des vertus de l'éternel Bédouin' [that which is the source radiating the virtues of the eternal Bedouin] (103; emphasis in original). Egypt, the first human civilization, and one of the strongest nations in modern Africa, should, Senghor concluded, 'regarder vers le Sud comme nous regardons vers le Nord, pour que l'équilibre de l'Humanisme du XXᵉ siècle plane sur le destin de l'Afrique' [look to the South as we [black Africans] look to the North, so that the equilibrium of Humanism in the twentieth century can achieve its destiny in Africa] (105).

With these reflections in the late 1960s, Senghor expanded his vision of Negritude to the scale of the African continent. However, while this did to some extent answer the calls for a pan-African unity, it also demonstrates a refusal on Senghor's part to change his essentialist interpretation of African cultures, be they black or Arab. The idea of *arabité*—specifically divorced from political Arabism—fits into the mould of Negritude and its role in the 'civilization of the universal'. While it incorporated a new understanding of African culture on a continental level, it also retained the older, racially defined vision of black Africa as a distinct cultural unit. Africanity was meant as a foundation for African unity that could be more solid and long term than simple anti-colonialism, but his articulation of this new 'symbiose complémentaire' [complementary symbiosis] of *arabité* and Negritude (10) did not move beyond these older definitions of racial, rather than continental, identities.

Senghor did not himself attend the festival in Algiers, sending instead a Senegalese delegation composed of diplomats, professors and artists. But he sent an address that was read in his name, as part of a series of statements from African leaders both present at and absent from the festival. In it, he summarized the ideas he had been developing in recent years about the importance of the association between Negritude and *arabité* while also referring to the importance of the First World Festival of Negro Arts he had hosted in Dakar three years previously:

> Aujourd'hui, c'est l'Afrique entière, malgré les obstacles que l'on ne cesse de dresser sur son chemin, qui apporte la preuve que Négritude et arabité sont complémentaires [...] En vérité, l'Africanité, c'est le dialogue millénaire entre Arabo-berbères et Négro-africains, c'est la symbiose des deux ethnies complémentaires. (Senghor 1969a: 38)

[Today, it is Africa in its entirety, despite the obstacles that have never ceased to be placed in its path, which proves that Negritude and *arabité* are complementary [...] In truth, Africanity is the age-old dialogue between Arabo-Berbers and Negro-Africans; it is the symbiosis of two complementary ethnicities.]

He hoped that the festival, 'une réflexion sur notre propre identité' [a reflection on our own identity], would help in 'notre contribution à la Civilisation de l'universel' [our contribution to the Civilization of the Universal] (Senghor 1969a: 39). While demonstrating a diplomatic openness to the Algiers festival, Senghor remained dedicated to his notions of Negritude and the newer, less fully developed *arabité* and Africanity. His decision not to attend the festival may have signalled dissatisfaction with the organizers' politics; his absence was certainly felt by those who discussed his ideas in Algiers.

The Festival

The First Pan-African Cultural Festival was far from the first gathering of its kind. From the Pan-African Congresses of the early twentieth century to the Bandung Conference of 1955, anti-colonial and pan-Africanist groups had long held international meetings to promote their political and cultural agendas. These gatherings included artistic exchanges as well, such as the Congresses of Black Writers and Artists, held in Paris in 1956 and in Rome in 1959. Indeed, the Algiers festival was a direct response to the First World Festival of Negro Arts, held in Dakar in 1966 under Senghor's patronage. That festival celebrated global black culture through a series of artistic performances and exhibitions. Though the Algiers festival featured a similar series of performances, its agenda differed from that of its predecessor in Dakar. That the Algiers event was christened the First Pan-African Cultural Festival suggests the distinction between 'negro arts' and 'Pan-African culture' was crucial. That Algiers was presented as the 'first' festival of its kind also indicates its effort to distinguish itself from its antecedents.

The Algiers festival was officially organized by the Organization of African Unity (OAU), based in Addis Ababa. Founded in 1963, the OAU sought the promotion of a unified and prominent African voice in all realms of international affairs, including culture. In 1967, during a meeting in Kinshasa, the Organization decided to organize a pan-African festival. Algeria's representative at that meeting, Abdelaziz Bouteflika, then the minister for foreign affairs (and since 1999 the president of his country), proposed that Algiers would act as host. The organizing committee accepted that suggestion unanimously. Though the OAU lent its name to the sponsorship of the festival, it was for the most part funded by the Algerian state, especially through the revenues of recently nationalized energy companies (Khellas 2014: 39–43). Algeria's leaders welcomed the festival as part of its post-independence policy

that sought to position the newly independent nation as a leader in African affairs (Mortimer 1970).

The festival opened on 20 July 1969, coincidentally the same day that the Apollo 11 mission landed on the moon. In Algiers, attention was focused less on that American scientific achievement and more on the grand opening ceremony. Houari Boumediène, the Algerian president, officially inaugurated the festival with a speech at the conference centre, on the edge of the city, where the symposium took place. In the afternoon, a grand parade wound through central Algiers, from Place Audin near the University of Algiers to Place Port-Saïd, near the famed Casbah. It was led by a fantasia, a Maghrebi equestrian troupe comprised of riders from across Algeria. Delegations from other countries followed behind, dressed for the most part in traditional attire. This initial performance was not purely traditional, however: the delegation from Guinea, by all accounts one of the largest and most politically vocal at the festival, 'brandissant des portraits gigantesques' [was brandishing gigantic portraits] of Guinea's president, Sékou Touré, as they made their way through Algiers (Mahjoub 1969). The parade was the first physical embodiment of the radical pan-African vision of a continent united through its diversity of cultures and through its commitment to a just future (Khellas 2014: 53–59). As residents of Algiers filled the streets to mark the beginning of the festival, they celebrated their place in the vanguard of the anti-colonial revolution in Africa.

For the next 12 days, until 1 August, performances and exhibitions were held across Algiers. These performances were divided into several different categories, including dance, drama, music and plastic arts (such as sculpture and painting). Prizes were awarded for the best participants in each category. Cultural institutions, including the National Library, the National Museum of Art, and the National Theatre, hosted many events, but others were held in the streets to encourage wider participation and to provide a public spectacle.

Thirty-six African nations and liberation movements (largely from Lusophone southern Africa, still fighting for their independence) sent official delegations to Algiers, but Africans were not the only participants in the festival. Official delegations from radical movements were invited from across the world. Revolutionary Brazilian, Indian and Vietnamese artists attended the festival and symposium. Likewise, a delegation from the Fatah party represented the Palestinian cause in Algiers (Pace 1969c). The Black Panther Party from the USA was the most visible revolutionary presence during the festival. Eldridge Cleaver and Stokely Carmichael, among other Party members, opened an office to distribute Panther literature on the rue Didouche Mourad, one of Algiers' main thoroughfares (Pace 1969a; Meghelli 2014).

Many cultural luminaries attended as invited guests and as observers, or as members of their national delegation. These participants included a number of famous writers, such as Ama Ata Aidoo of Ghana, Maya Angelou of the USA, Assia Djebar of Algeria, Dennis Brutus of South Africa and Yambo Ouologuem of Mali. Filmmakers were represented by, among others,

Ousmane Sembene and Djibril Diop Mambéty of Senegal and Youssef Chahine from Egypt. International musical stars were there as well, from Americans Nina Simone and Archie Shepp to the South African Miriam Makeba. Several Africanist scholars attended including both Americans and Soviets, as well as those from as far away as Japan. Even Bernard Lewis, the Orientalist who would later become a prominent and controversial public intellectual, was an official attendee from the University of London. With over 150 of these cultural commentators present in addition to the national delegations, the Pan-African Cultural Festival succeeded in gathering Africa's leading artists and intellectuals in one place to discuss and celebrate their role in global affairs. The most notable absence by far would have been that of Senghor, the chief proponent of the ideology of Negritude that would come to be the focus of discussion throughout the rest of the festival.

The Symposium

The discussions at the symposium eventually coalesced around a strident critique of Senghorian Negritude, though that was not necessarily a preordained conclusion. From the initial pronouncements, however, it is clear that the Algerian organizers, and to some extent the OAU representatives from across the continent, saw the PANAF festival as a distinct and unprecedented event rather than a sequel to the Dakar festival of 1966. More than a simple celebration of African culture, PANAF and, more directly, the symposium were meant to articulate in a new and forceful way the role of African culture in the ongoing anti-colonial revolution and the struggle for development. As Boumediène stated in his opening address, the festival was 'à la fois l'affirmation première d'une unité africaine au niveau de la pensée, de l'âme et du cœur et de la reconnaissance du rôle que cette africanité a joué dans la sauvegarde des personnalités nationales et dans les combats libérateurs' [at the same time a primary affirmation both of African unity on the levels of thought, soul, and heart and of the recognition of the role that this Africanity has played in the preservation of national identities and in the liberation struggle] (Boumediène 1969: 17). African culture was, to these participants, the crucial mode of recovering pre-colonial identities, shedding the weight of colonial domination, and forging newer and stronger national characters. At the same time, as Boumediène stressed in his opening remarks, the festival 'ne peut être qu'un hommage collectif de l'Afrique à ses assises culturelles et artistiques [...] [N]ous ne voulons pas que ce Festival repose sur un ethnocentrisme exacerbé, xénophobe et stérile' [cannot only be a collective homage to Africa's cultural and artistic foundations [...] [W]e do not want this Festival to rest on an exacerbated, xenophobic and sterile ethnocentrism] (18). This sentiment, as well as Boumediène's repeated emphasis on the 'continental scale' of the festival, articulates the Algerian hosts' coded critique of Negritude. What united Africans, Boumediène and his fellow North Africans

139

argued, were the shared traumas of colonial rule and the immense potential of cultural action. Negritude, and its insistence on black particularism, was harmful to the continental solidarities required to overcome the traumatic legacies of colonial misrule.

In his opening remarks, Diallo Telli, the Secretary-General of the OAU and a Guinean diplomat, repeated Boumediène's insistence on geographical, rather than racial, unity as the goal of a pan-African movement. Summarizing the planning of the festival, dating from the 1967 meeting in Kinshasa, Telli described it as the first of many to come, part of the OAU's permanent policy of promoting continental unity and mutual understanding through cultural celebrations (Telli 1969: 20). He emphasized the importance of the OAU to the eventual realization of the pan-African vision, putting it on an equal footing with Algeria's role as host of the festival and as a safe harbour for revolutionary movements from across the continent (21).

The Algerian delegation to the symposium included prominent journalists, scholars and writers. In their joint statement to the symposium, the Algerians emphasized the damage done to colonized societies by European imperialism. They argued that '[d]ès l'instant où l'Europe a déferlé sur l'Afrique [...] elle s'attaqua en premier lieu à notre personnalité fondamentale' [from the very instant when Europe surged into Africa [...] it began by attacking our fundamental personality], including 'nos mœurs, nos coutumes, nos croyances—et jusqu'à nos langues' [our manners, our customs, our beliefs— even our languages] (Délégation de la République Algérienne 1969: 61). The experience of colonial rule 'a freiné considérablement, sinon arrêté, la culture nationale' [had considerably slowed, if not stopped, national culture] from developing productively.

In its statement, the Algerian delegation echoed Frantz Fanon's call for colonized intellectuals and artists to take up the revolutionary cause. Fanon, the Martinican psychiatrist turned Algerian revolutionary, died in 1961, well before the Pan-African Cultural Festival (and tragically before Algeria gained its independence in 1962). His writings were immensely important in the articulation of Algeria's liberation struggle as well as to global anti-colonial movements. His essay 'On National Culture', published in 1961 in *The Wretched of the Earth*, argues that intellectuals and artists must take up a greater role in the fight for liberation by contributing, both physically and intellectually, to the struggle. He certainly hewed to this model, promoting the agenda of the FLN (*Front de Libération Nationale*) while at the same time publishing his influential writings on the conflict and participating in international conferences such as the earlier Congresses of Black Writers and Artists held in Paris and Rome. It is clear from the speeches prepared by many of Fanon's colleagues and comrades in the festival's Algerian delegation that his ideas retained a major influence over African intellectuals in the years after his death and into the independence period.

Fanon offered, in *The Wretched of the Earth*, a damning evaluation of Senghorian Negritude. In his view, advocates of that stance merely reiterated

colonial terms. Reinterpreting these categories in a newly positive light did little, in Fanon's view, to change the colonial situation: as he wrote, Senghor and his allies 'should realize that they can do little more than compare coins and sarcophagi' (Fanon 2004: 168). In other words, Negritude was an intellectual dead end because it did not sufficiently challenge colonial ideas. Even if Africans felt empowered by their essential creativity, as Senghor argued, for Fanon, they could not contribute meaningfully to the 'new humanism' required to create a postcolonial society.

Fanon's alternative took the development of national culture to be a more universally helpful goal than the reimagining of global blackness. Intellectuals and other cultural leaders had to be committed 'body and soul to the national struggle', and had to express that conviction through cultural production as well as through physical sacrifice (Fanon 2004: 176). This arrangement would place the development of a national culture at the core of the anti-colonial revolution, and transform the revolution into a cultural event as well as a political one. As such, he wrote, 'national consciousness is the highest form of culture' (177–78).

In Fanon's formulation, the development of a national culture took on an international dimension through the 'dual emergence' of national and international forms of consciousness (180). Prior to Senghor's *arabité*, Fanon had looked to the Arab world as a model, citing the Arab League as an international organization uniting multiple national cultures to act together. This organization recalled the pre-colonial past, when Muslim communities were united across vast spaces. Though his work was not specifically cited in the festival's official documents, the influence of Fanon's work is clear as organizers sought to encourage the development of these solidarities through culture.

During the 1969 symposium, the Algerian delegation praised 'des intellectuels africains d'avoir su [...] cristalliser l'opinion mondiale sur la situation intolérable qui était faite à leur continent' [African intellectuals for having known how [...] to crystalize world opinion around the intolerable situation of their continent], and made clear that 'la culture africaine ne pouvait se situer qu'au centre même du mouvement de libération [...] [et] elle doit tout à la fois promouvoir l'économie, accéder au progrès et adapter l'héritage culturel à ce cadre nouveau' [African culture can only be situated at the very centre of the movement for liberation [...] [and] it must at the same time promote the economy, be open to progress, and adapt cultural heritage to this new framework] of the postcolonial period (Délégation de la République Algérienne 1969: 62–64). Emphasizing the role of intellectuals and artists in this new era, the Algerians concluded: 'leur combat rejoint celui de leur peuple, celui des autres peuples pour plus de dignité, pour plus de justice, pour la libération globale, totale et réelle de l'être humain' [their combat is the same as that of their people [and] that of other peoples for more dignity, for more justice, for global, total and real liberation of the human being] (68). In other words, Fanon's arguments were powerful but more work needed to be done to achieve the ultimate goals of liberation.

141

Many of the delegations at the symposium were more explicit in their rejection of Negritude, none more so than the delegation from Guinea. At the time, the President of Guinea was the firebrand Sékou Touré, who did not attend the festival personally, but sent a long message that was presented to the symposium. In it, he celebrated the radical politics underpinning the festival as well as the choice of Algiers as its host, describing the city as a 'foyer de rayonnement de la pensée révolutionnaire de notre continent en butte aux agressions multiformes de l'impérialisme' [site from which the revolutionary thought of our continent radiates forth against the multiple threats of imperialism] (Touré 1969: 31). He went on to argue for the importance of a 'révolution culturelle [...] au niveau des masses populaires' [cultural revolution [...] at the level of the masses] that would lead to 'la justice, la solidarité, la promotion et la paix sociales' [justice, solidarity, social advancement and peace] (32). Negritude, however, could not be a part of that cultural revolution: 'La négritude est donc un concept faux, une arme irrationnelle favorisant l'irrationnel, un concept fondé sur la discrimination raciale arbitrairement exercée sur les peuples d'Afrique, d'Asie et sur les hommes de couleur en Amérique et en Europe' [Negritude is a false concept, an irrational weapon favouring the irrational, a concept founded on racial discrimination arbitrarily exercised against the people of Africa, Asia and people of colour in America and in Europe] (33). Rather, the African revolution depended on a more broadly defined African culture:

> La culture historique, la culture politique, la culture économique, la culture sociale, la culture scientifique et technique, la culture humaine, la culture spirituelle, tout cet ensemble constitue une seule et même force, celle par laquelle l'Afrique, de façon rigoureuse, arrivera à briser définitivement les chaînes de l'impérialisme, le carcan du colonialisme et du néocolonialisme perfides, la ruse ou la mystification religieuse, pour pouvoir, et sous sa seule responsabilité, réussir à vivre libre, unie et prospère. (Touré 1969: 36)

> [Historical culture, political culture, economic culture, social culture, scientific and technical culture, human culture, spiritual culture, when taken together constitute a single force, that through which Africa will, in rigorous fashion, definitively break the chains of imperialism, the yoke of perfidious colonialism and neo-colonialism, religious trickery or mystification, in order to be able, under its own guidance, to succeed in living freely, united and prosperous.]

Negritude was too weak, too similar to other forms of racial thought, to bring about the new forms of politics and culture that all Africans needed to overcome their history of colonial domination.

The delegation from the Republic of the Congo (Congo-Brazzaville), led by the novelist and education minister Henri Lopes, cited Fanon frequently and explicitly in its statement to the symposium. The figure of Fanon himself, the Congolese argued, called into question the racially centred ideology

of Negritude. As an Afro-Caribbean Martinican, Fanon was able to join the Algerian liberation struggle 'sans lui demander des comptes sur son degré d'arabisme, qui en a fait simplement un Africain' [without being asked to justify his Arabness, but simply as an African] (Délégation de la République du Congo-Brazzaville 1969: 79). The goal of African artists was to promote a shared culture across the continent, such that 'le jeune Africain d'Alger comprenne celui de Bujumbura et que la jeune femme de Bulawayo se sente solidaire de celle du Caire' [a young African from Algiers understands one from Bujumbura, and a young woman from Bulawayo feels solidarity with another from Cairo] (79). The Algiers festival was different from the earlier conferences—including the Congresses of Black Writers and Artists of 1956 and 1959, as well as the Dakar festival of 1966—because 'nous ne saurions plus nous définir par la race ou par tout autre élément d'ordre somatique, mais par la géographie, et surtout, par cette communauté de choix' [we would no longer define ourselves by race or any other bodily characteristic, but rather by geography and most of all by choice] in their effort to support national and international unity (78). Without criticizing Negritude or Senghor specifically, the Congolese nevertheless made clear that their sympathies differed from the earlier status quo. They sought to further Fanon's idea of strong artistic engagement with revolutionary action by broadening the scope of the revolution to the continental, rather than the racial, level. Taking Fanon as a philosophical as well as a personal model for achieving that goal, Lopes and his compatriots contributed to the reorientation of the pan-African cultural movement for strategic and practical purposes.

The statement from the Republic of Dahomey (today Benin) provided yet another fierce critique of Negritude. Stanislas Adotevi, the head of the delegation and a philosopher, agreed with the basic principle of the festival that culture had to be the basis of African unity but simultaneously emphasized that affirmations of that fact were not enough: intellectuals and artists had to find the means to render that unity concrete. In his reading, Negritude was a purely literary concept: 'c'était, hier, une des formes possibles de la lutte d'émancipation' [it was, in the past, one of the possibilities in the struggle for emancipation] (Délégation de la République de Dahomey 1969: 86). For the purposes of the festival's participants and other revolutionaries, though, it was merely 'une mystification politique' [a political mystification] (84). When used for political purposes in the construction of a pan-African reality, Negritude only reinforced the exoticism of Africans. In Adotevi's words, 'La Négritude creuse, vague, inefficace, est une idéologie. Il n'y a plus en Afrique de place pour une littérature dehors du combat révolutionnaire' [Negritude—hollow, vague, inefficient—is an ideology. There is no more place in Africa for a literature situated outside of revolutionary combat]. He concluded, 'La Négritude est morte' [Negritude is dead] (85). To create modern African states, built on socialist principles, Africans had first to recover their authentic selves, Adotevi claimed. Negritude would not help them to do that given its compromising exoticism and colonial resonances.

The tactics Africans adopted to achieve their goals had to change, Adotevi argued, and to resemble more closely those of Fanon.

René Depestre, a Haitian poet and radical, launched yet another blistering attack on Negritude during his contribution to the symposium. Concerned with the 'mouvement historique de recherche de l'identité' [historical movement organized around the search for identity], combining 'le fait colonial avec la société nationale et avec la société révolutionnaire' [colonial reality with national society and with revolutionary society], Depestre proposed an understanding of black cultures in Africa and the diaspora as having undergone a 'processus de zombification' [process of zombification] during the period of colonization (Depestre 1969: 250). Assimilation, the idea of the 'civilizing mission' and cultural transformation through colonial guidance, was obviously a false promise enacted after the abolition of slavery. In fact, Depestre argued, the idea of assimilation relied on a diametrical opposition between colonizer and colonized. This in turn was reflected in several of the early ethnocentric opposition movements, including Negritude, pan-Arabism and the idea of an 'African personality' (250–51). These ideas all relied on the same colonizer–colonized dialectic and thus could not move beyond it. In practice, this could have disastrous effects. Describing the situation in his home nation, Depestre claimed that under François Duvalier, popularly known as 'Papa Doc', Haiti had become 'une république zombifiée' [a zombified republic] through Duvalier's deployment of 'une négritude totalitaire' [a totalitarian Negritude] that had been transformed into 'une mythologie sinistre' [a sinister mythology] (252–53). For Haitians, Depestre suggested, Negritude was worse than an empty formulation; rather, it was a dangerous tool that could be used by deranged leaders in a neo-colonial, rather than a postcolonial, situation. Just as the system of slavery had given way to assimilationism, the colonial period could be followed by a similarly false and dangerous framework, in the guise of Negritude, without revolutionary action to recover and recreate black identities. In pursuing this revolution, Depestre argued, formerly colonized peoples would need to '[fonder] notre être individuel et social sur des bases historiques que nulle tempête néocoloniale ne pourra plus jamais ébranler' [build a foundation for our individual and social being on historical bases that no neo-colonial tempest can ever undermine] (254). Over the course of the festival, Africanity replaced Negritude as that foundation.

However, the symposium's contributors did not accept radical Africanity uncritically. Several participants sought to explore the idea and its development in their speeches. One such sceptic was Jacques Maquet, a French anthropologist, who spoke on the nature of African culture in a very Senghorian manner. He described culture as a multiply layered idea, one that developed out of a people's natural surroundings and their relationship with nature, saying 'la nature est le donné, la culture est l'acquis' [nature is a given, culture is acquired] (Maquet 1969: 210). He went on to challenge the notion of a unified African culture, or of any united monolithic cultural unit, arguing that Islamic culture, Western culture and African culture were all

similarly divided into smaller cultural units with certain shared character-istics. He described Africanity as an extension of the Negritude of Senghor, Césaire and Damas and as a shared set of developments between human cultures and their environment. This led, Maquet argued, to certain similar cultural forms (211–12). But he disputed the inherent unity of the whole of the African continent: despite the links between pharaonic Egypt and Ethiopia, the Saharan 'sea' and its trade networks and the shared faith of Islam, the physical environments and subsequent cultural developments still separated 'les deux Afriques' [the two Africas] (213). However, Maquet concluded, 'si les Africains des deux rives du Sahara le veulent, les germes d'une nouvelle communauté culturelle continentale croîtront vite' [if the Africans of both sides of the Sahara want it, a new continental cultural community will grow quickly]. The success of the Algiers festival, to him, was evidence enough that this was possible (213).

The Senegalese delegation was likewise reluctant to abandon Negritude as a model and to embrace Africanity as a replacement. Amar Samb, for example, referred several times in his statement to the symposium to the importance of the Dakar festival of 1966 as a foundational event in the history of African culture. Even while praising the Algiers festival as an important next step in Africa's cultural development, Samb used Senghorian terms, describing the event as a way for Africa (notably, not 'black Africa') to '[prendre] conscience de sa personnalité réelle' [become conscious of its real personality] (Samb 1969: 329). In this way, Samb argued, through the festival, African culture, 'éternellement belle' [eternally beautiful], became 'temporairement utilitaire' [temporarily utilitarian] as a way to contribute to world art (330). In other words, the Algiers festival could be a step to achieving Senghor's idealized 'civilization of the universal'. In contrast to most of the other contributors to the festival symposium, Samb perceived African culture and the pan-African festivals as depoliticized and for the most part apolitical. He was less concerned with the anti-colonial revolution than with the development of literature and other arts that could serve as tools; less interested in the immediate emanci-pation of African societies than in the development of vague 'solutions' to Africa's problems. Samb also echoed Senghor's recent thinking on the subject, emphasizing the union of Negritude and *arabité* as crucial in the achievement of these goals. Nevertheless, he never referred to a single pan-African, continental Africanity except as a loose union of distinct identities.

Another Senegalese delegate, poet Lamine Niang, focused more explicitly on Senghor's concept of Negritude in his speech concerning 'Negro-African' poetry. Citing Senghor frequently, Niang described the place of poetry in the preservation and transmission of African culture. He argued that Africans ought to 'recréer et placer notre culture dans la culture de l'Universel' [recreate and to situate our culture within the culture of the Universal], because 'notre culture négro-africaine [...] l'une des dernières à émerger de l'oubli' [our Negro-African culture [...] one of the last to emerge from oblivion], deserved more emphasis 'que toutes autres cultures' [than all other cultures] (1969:

297–98). Citing Senghor, Niang stated that 'l'émotion est nègre, la raison hellène' [emotion is black, reason is Hellenic], and that 'le corps noir meurt. La pensée nègre demeure' [although the black body dies, Negro thought remains], transmitting the content of the past across generations (1969: 298–300). Unlike many other delegates, Niang connected the work of the Algiers festival to that of the Dakar festival of 1966. Niang claimed, for example, that the pan-African moment, 'né hier au Festival Mondial des Arts Nègres et qui fait son chemin à ce symposium d'Alger, s'éclaire [...] des erreurs passées' [born earlier at the World Festival of Negro Arts and having made its way to this symposium in Algiers, clarifies [...] the errors of the past] and would lead to a new way forward (297). Niang, like Samb and other Senegalese delegates, continued to promote the older vision of Negritude, with its metaphysical valorization of blackness, as a viable way forward in the struggle to push Africa and Africans into a new and more positive global position.

In the end, the bulk of the discussion surrounding the role of African culture in the new Africa weighed against Senghor and Negritude. Joseph Ki-Zerbo, a prominent historian from Burkina Faso, summarized the consensus in his statement to the symposium. He enumerated the challenges facing those who sought to transform African culture, including tribalism, 'micro-nationalism' and inter-class struggles; to him Negritude did not contribute to the overcoming of those challenges. It was 'en son temps un concept de résistance. Le contexte ayant disparu, la Négritude est aujourd'hui sans fondement et ne peut servir comme théorie générale du "Risorgimento" africain' [in its time a concept of resistance. That context having disappeared, Negritude is today without foundation and cannot serve as a general theory of the African 'Risorgimento'], a reference to the long and difficult, but ultimately successful, unification of the Italian peninsula in the nineteenth century (Ki-Zerbo 1969: 342). Rather, citing Fanon, Ki-Zerbo called on Africans to 'musculairement collaborer' [muscularly collaborate] in bringing a new, modern Africa into being. For that effort, he argued, 'le panafricanisme (ou la panafricanité) est sans conteste [...] le concept moteur qui peut animer la renaissance culturelle du continent' [Pan-Africanism (or *panafricanité*) is without a doubt [...] the guiding force that can animate the cultural renaissance of the continent] (343–44). Journalistic accounts echoed this assessment. Eric Pace, who covered the festival for the *New York Times*, summarized the symposium's consensus by describing Negritude as 'outmoded' (Pace 1969b).

Outcomes

PANAF was an ephemeral experience. It was partially recorded on film— most famously in *Festival panafricain d'Alger*, by the French–American director William Klein (Hadouchi 2011). Nevertheless, the physical embodiment of pan-Africanism faded from the streets of Algiers after the end of the festival

on 1 August. The organizers sought to ensure PANAF's legacy by adopting new cultural policies to guide continent-wide politics, development and culture. The Pan-African Cultural Manifesto adopted by the symposium's participants and promulgated by the OAU articulated the organization's vision of the role of culture in African development with both general and specific policy recommendations.

The manifesto specified three realms in which African culture contributed to the OAU's mission: the ongoing struggles for national liberation, the consolidation of African unity and the progress of economic and social development across the continent. In each of these categories, the writers of the manifesto made clear that the radical cultural nationalism on display in the festival served as a model for future developments on the continent. Though the idea of Negritude was never specifically rejected, the manifesto codified the consensus of the symposium that it no longer served as a guiding principle in promoting continental unity. Rather, for the OAU, cultural nationalism as defined by Fanon pointed the way forward.

The central tenet of the manifesto is that African culture must serve as the basis for the development of a strong, modern and new Africa in the postcolonial period. In an implicit critique of Negritude, the writers of the manifesto stated, 'we must go back to the sources of our values, not to confine ourselves to them, but rather to draw up a critical inventory in order to get rid of archaic and stultifying elements [...] to bring them into line with what is modern and universal' (Organization of African Unity 1970: 25). Culture was understood to be a necessary tool, intimately linked to technological development, in the promotion of economic growth and the overcoming of colonial hurdles.

Evoking Fanon, the manifesto stated that 'the African man of culture, the artist, the intellectual in general must integrate himself into his people and shoulder the particularly decisive responsibilities incumbent upon him', defined as serving as an inspiration to the masses (25). Artists and intellectuals were responsible for rediscovering African culture and translating it to contemporary situations. The idea of Africanity provided a specifically African way to achieve these goals: 'Africanity obeys the law of a dialectic of the particular, the general and the future, of specificity and universality, in other words of variety at the origin and starting point and unity at the destination' (25). Cultural production was a way to prove Africans' presence in the world, despite imperialist efforts to deny African history and culture.

The manifesto emphasized the importance of continental unity, to be achieved through the realm of culture. Though colonial rule had divided Africans into assimilated elites and exploited masses, the continental vision of Africanity cleared a path to joining Africans together as 'men born of the same land and living in the same continent, bound to share the same destiny by the inevitable process of decolonization [...] notwithstanding regional or national specificities' (27). Citing Fanon almost verbatim, this acknowledgement of a common Africanity on the part of intellectuals and artists meant that 'armed struggle for liberation was and is a pre-eminently cultural

act' (27). For the continent to move forward, 'today's cultural act should be at the center of today's strivings for authenticity and for the development of African values' (27).

The manifesto also elaborated the role of Africanity in the effort to develop the continent economically and socially. More than a vague celebration of the African or black self, African culture when deployed authentically would 'become an instrument in the service of the people in the liberation of Africa from all forms of alienation, an instrument of a synchronized economic and social development' (28). To achieve this goal, the manifesto concluded, 'Africanity should be apparent in a concrete and tangible manner [...] to promote a harmonious and accelerated economic and social development throughout the continent' (28). The manifesto thus articulated a radical vision of the role of culture in the future of African development. Whereas Negritude looked to the past to reclaim a positive interpretation of African creativity and culture, at the Algiers festival and symposium African leaders began to look for ways to use African culture to shape the future.

The manifesto also included 40 propositions for specific ways to realize this vision of Africanity. Many of these were focused on spreading the pan-African ideal through education and media. For example, festival partic-ipants encouraged the founding of a pan-African cinematic institute and several publishing houses to print books in multiple African languages. They sought also to codify African cultural traditions by writing an encyclopedia of African arts and by contributing to the UNESCO project, already underway, to write a general history of Africa. Prizes were to be created 'à récompenser les productions les plus authentiques et les plus utiles' [to reward the most authentic and useful works] of African artists and writers (Organization of African Unity 1969: 186). The 'Panafricanization' of universities would contribute to the broader mission of imbuing African youth, African women and other groups with the ideals of Africanity; these would also serve to reduce the scope of social alienation among the non-elite masses. Finally, the organizers urged member states to continue 'organiser des séminaires culturels inter-régionaux [...] en vue d'encourager le développement économique et social de notre continent' [to organize inter-regional seminars and exhibitions [...] by way of encouraging the economic and social development of our continent] (187). In other words, future pan-African cultural festivals would carry on the Algerians' mission of uniting the continent through a radical interpretation and deployment of African cultural traditions.

Even in its immediate aftermath, the impact of PANAF was somewhat ambiguous, as was outlined by Bernth Lindfors, an Africanist scholar from the University of Texas who attended the festival. The structure of the symposium, he wrote, 'seemed deliberately designed to minimize friction and maximize opportunities for agreement. There were no confrontations, no heated discussions, no spontaneous dialogue' (Lindfors 1970: 5). Although the conflict over the status of Negritude, especially between the Guinean and Senegalese delegations, was clear from the official and individual statements,

Lindfors concluded that 'it would be difficult to say whether the Negritudinists or the anti-Negritudinists came out best in this exchange [...] nobody really won or lost at the Symposium' (7). This was, no doubt, because the format was designed to foster at least the impression of African unity.

In some ways the philosophical debate over the usefulness of Negritude was resolved after the festival concluded. Stanislas Adotevi, the Dahomean delegate who announced the 'death' of Negritude at the symposium, published a fuller critique of Senghor in a book entitled *Négritude et négrologues* (1972). In it, he develops the idea that Senghorian Negritude was defined according to European racist terms and, echoing Marx, concludes that the idea can only serve as 'the opium of the exploited'. Other scholars joined in this critique after the festival. Marcien Towa of Cameroon, for example, in the early 1970s published a volume entitled *Léopold Sédar Senghor: négritude ou servitude* that specifically criticized Senghor's devotion to France as an idealized cultural model. These two examples alone demonstrate that the younger generation of African scholars working in the 1970s continued to develop their criticism of Senghor and sought to move beyond Negritude in productive ways (Ischinger 1974; Jules-Rosette 1998). Whether or not Negritude was dead and buried, the Algiers festival signalled that it had certainly lost its status as the dominant strand of pan-Africanist thought.

In the years following the festival, the revolutionary spirit of Algiers proved difficult to maintain. In Algeria itself, a series of economic, religious and social crises meant that the state more or less abandoned its effort to position itself at the heart of the international revolutionary vanguard. Other African countries committed to the radical goals of the festival faced different challenges: Guinea, for example, suffered the loss of many of its intellectual leaders—including Diallo Telli, of the OAU—when Sékou Touré conducted a sustained purge of his real or imagined political opponents over the course of the 1970s. Though other African cultural festivals were organized in the years that followed, most notably the Zaïre '74 Festival in Kinshasa in 1974 and the Second World Festival of Black Arts and Culture (FESTAC) in Lagos in 1977, the dedication to Africanity demonstrated in Algiers quickly faded. In 2009, Algiers hosted a Second Pan-African Cultural Festival meant to celebrate the twenty-first century's 'African Renaissance', but, like the first festival 40 years prior, it does not seem to have produced a long-lasting, tangible shift in Africa's cultural or political position.

Even if the First Pan-African Cultural Festival of Algiers in 1969 did not produce an enduring radical Africanity, as its sponsors had hoped, the festival remains an important marker in the history of pan-African movements. Similar meetings and festivals had for many years provided ways for Africans and others to articulate their vision for a more just world. The Algiers festival was no different. Its participants sought to articulate a new kind of continental and indeed global African identity, based on the idea of Africanity defined as a shared experience of colonial domination and liberation. In so doing, the festival's participants marked a new era in pan-African intellectual history.

The 'death' of Negritude may have been overstated by some of Senghor's critics at the symposium, but the festival did nevertheless demonstrate a stark shift in pan-Africanist thought from an older racially based model to one that reflected a more radical cultural-political stance. The festival and symposium performed and articulated that change.

Beyond Negritude:
Black Cultural Citizenship and
the Arab Question in FESTAC '77

Andrew Apter

At the core of the analytic apparatus on which black cultural
citizenship gains its force is the reality that there are spaces of
cultural production that are not dependent on the regulatory role
of the state.

Kamari M. Clarke, 'Notes on Cultural Citizenship in the Black
Atlantic World' (2013): 470

When Nigeria hosted FESTAC '77 to celebrate the cultural foundations of the
'Black and African World', it was fashioned after Senghor's *Festival mondial des
arts nègres* (FESMAN '66) held in Dakar 11 years earlier. Like its predecessor,
FESTAC featured the dance, drama, music, arts and philosophical legacies
of a 'traditional' Africa all of which were regimented by opening and closing
ceremonies and exalted as a framework for black nationhood and development.
And if FESTAC was planned on a far grander scale, funded by the windfalls of a
rising petrostate, its kinship with FESMAN was further solidified between both
heads of state, who would serve together as co-patrons of Nigeria's cultural
extravaganza.[1] What began as a diarchic alliance, however, soon devolved
into a divisive debate over the meanings and horizons of black cultural
citizenship. At issue were competing Afrocentric frameworks that clashed over
the North African or 'Arab' question. Should North Africans fully participate,
as Lieutenant-General Olusegun Obasanjo maintained, or should they merely
observe as second-class citizens, as Léopold Sédar Senghor resolutely insisted?
If Nigeria's expansive and inclusive vision of blackness was motivated and
underwritten by its enormous oil wealth, Senghor refused to compromise his
position, precipitating a face-off that ultimately lowered Senegal's prestige.

1 Recent innovative work on FESMAN includes McMahon (2014) and Wofford
(2009).

To understand why North Africa became the focus of these competing definitions of blackness, I turn to the 1969 Pan-African Cultural Festival in Algiers, where Negritude was disclaimed as counter-revolutionary. Placed within a *genealogy* of postcolonial Afrocentric festivals, the struggle over North Africa in FESTAC '77 shows that the political stakes of black cultural citizenship were neither trivial nor ephemeral, but emerged within a transnational festival field of cultural spectacle, racial politics and symbolic capital accumulation.[2] As we shall see, our focus on postcolonial festivals in Africa as primary objects of study 'in themselves' rather than as secondary reflections of 'external' realities de-centres the state as the locus of citizenship while foregrounding the performative and embodied conditions of its genesis.

Le Divorce

I first encountered the ideological fracas between Senghor and Obasanjo over 'the Arab question' during my archival research for *The Pan-African Nation: Oil and the Spectacle of Culture in Nigeria*, a study of the paradoxes of oil prosperity through FESTAC's mirror of cultural production (Apter 2005).[3] Interested in how oil capitalism generated the illusion of development by masking an inverted system of deficit production, I understood the conflict between both leaders in geopolitical terms when an oil-rich Nigeria displaced Senegal as West Africa's regional powerhouse by assuming leadership of the Economic Organization of West African States (ECOWAS) and by remodelling the global horizons of blackness.[4] Bolstered by oil and its global commodity

2 These interconnected dimensions of festivals as linked transnational communities of cultural production overlap with similar frameworks in film studies such as 'a parliament of national cinemas' discussed by Elsaesser (2005: 88). See also Dovey (2015) for the dynamic networks and global communities of African film festivals on the continent and beyond, including the influences of the Dakar and Algiers festivals on FESPACO, the international film festival in Ouagadougou, Burkina Faso. The status of film at the Dakar, Algiers and Lagos festivals raises important issues I have been unable to pursue—particularly in Algiers, where a distinctive style of 'Third' and 'Third World' cinema achieved its 'combative phase' (Gabriel 1982) in the service of socialist revolution. For a discussion of film in the local press during the Algiers festival, see an article in *El Moudjahid* on 21 July 1969 ('Le Cinéma africain' 1969: 5).

3 Developed as a case study of FESTAC, I document the production of black cultural tradition in a variety of festival events and displays to illuminate two related historical trajectories: the nationalization of colonial culture under the sign of precolonial tradition and the commodification of cultural value by the oil boom of the 1970s. Both trajectories, and their concomitant forms of erasure, highlight the symbolic foundations of an oil economy—and its mystifying forms of commodity fetishism—that masked deficit production beneath the illusory signs of development and prosperity.

4 Comparative approaches to 'global blackness' include Thomas (2004), Clarke

flows, if FESTAC was for 'black people', it was also 'for everybody', as proclaimed on the airways by the jùjú musician and superstar King Sunny Adé. As far as Nigeria was concerned, Negritude, like its founding father, was falling out of touch with the changing fortunes and tempos of the times.

Housed in the Centre for Black and African Arts and Civilization (CBAAC) within Nigeria's National Theatre (built specifically for FESTAC), the International Festival Committee (IFC) papers run from the first planning meeting in October 1972 until the concluding session in February 1977, documenting a fascinating trajectory of changing plans and committee debates among FESTAC's zonal representatives. Problems with 'Arab' festival participation first appear in the minutes of the seventh IFC meeting of 29 November to 3 December 1975:

> At the current meeting of the International Festival Committee, one of the 16 zones, which is the West African Francophone Zone (1) headed by Senegal, has been spear-heading a move to exclude the North African countries from fully participating in the Festival, contrary to the decisions of the International Festival Committee. The Zonal Vice-President, Mr. Alioune Sène, the Senegalese Minister of Culture, has gone as far as to threaten that Senegal will not participate in the festival, if the Colloquium, which is the heart of the Festival, is not restricted to Black countries and communities. This in effect means that Senegal is trying to exclude North Africa from fully participating in the Festival.[5]

Thus Senegal initiated the opening challenge to the 'Arab countries' of the North Africa Zone, whose presence at the FESTAC Colloquium—on the theme of Black Civilization and Education—it would only authorize as 'non-partici-pating observers' who could listen but not speak, and who would be barred from submitting papers. The Nigerian response was swift and decisive, issued from the then Head of State, Brigadier Murtala Muhammed (before his assassi-nation three months later), stating that such discriminatory nonsense would not be tolerated:

> While the Federal Military Government would not like any African country or Black community to withdraw from the Festival, it wishes to affirm unequivocally the basis on which it originally accepted to host the festival; that is, full participation by all member states of the Organization of African Unity, Black Governments and Communities Outside Africa and Liberation Movements recognized by the OAU [Organization of African Unity].[6]

and Thomas (2006), who frame a 'macroanalytics of racialization', and, most recently, Pierre (2013). See also Thomas (2011) for an extended explication of 'embodied citizenship' in relation to race, gender and sexuality; and Castor (2013) for a discussion of a 'differentiated' black cultural citizenship in relation to multiculturalism.

5 IFC VII/127/press release, CBAAC.
6 IFC VII/127item 10, CBAAC.

Speaking for the festival at large, and the international community of participating states and communities, Nigeria asserted sovereign authority over an emerging body of black and African zones which both included and cut across independent nation states according to their membership of FESTAC itself; not only the member states of the OAU, but also its recognized liberation movements such as South West Africa People's Organization (SWAPO) in what is now Namibia and the African National Congress (ANC) under apartheid South Africa; as well as those black communities in North America, Europe and even Papua New Guinea which comprised 'nations within nations'.[7] Within such expansive black cultural horizons, North Africans would enjoy full citizenship rights.

Indeed, hosted by Nigeria and remapping the African diaspora, FESTAC had the trappings of a Pan-African nation, with its own emblem, flag, stamps, secretariat and identity cards for registered participants that served as passports for entry into FESTAC Village. Breaking from the strictures of Negritude and its 'Negro-African' sub-Saharan focus, a new definition of black cultural citizenship accompanied a new black world order animated by oil. For participating black communities and liberation movements, black cultural citizenship in FESTAC trumped national citizenship. Senegal's call for limited North African participation was not merely seen as divisive and discriminatory but as a form of second-class citizenship, ironically reproducing the very form of disenfranchisement that Senghor and his black confrères experienced in interwar Paris (Wilder 2005). Vilifications of Senegal and its doctrinal leadership soon erupted in Nigeria's press. Commander O.P. Fingesi, the Nigerian president of the IFC, was widely quoted as saying that 'if the North African countries should be barred from the colloquium on the ground of the colour of their skin, it would amount to racial bigotry in the most nauseating sense' ('FESTAC: Fingesi Clears the Air' 1976: 1). Andrew Aba wrote in the *Sunday Standard*, 'Today I want to hammer down the nail on the lid of the dead orphan called Négritude', adding that its 'masks, rivers, tam-tams, erect breasts, bamboo huts, black Madonnas and swinging buttocks are no use in present-day Africa, if we are to survive the world's technological culture' (Aba 1976). One editorial diatribe against 'the black Frenchman' exclaimed that 'Négritude is the whiteman's Trojan horse to African culture; Senghor and his French masters should be ignored' ('The Black Frenchman' 1976: 5). More sober protestations against Senegal's position appealed to North African linguistic and cultural inroads into so much of Sub-Saharan Africa, manifest in Islam, Swahili, the Tuaregs of Mauritania and Mali, the Fulbe/Peul/Fulani societies across the Northern Sahel, and all manner of historico-cultural crossings, inspiring one editorial call for 'our intellectuals [to] take up the challenge posed by the bluffing Senegal' ('FESTAC and the Senegalese Boycott Threat' 1975: 6).

7 North America Zone Report for the Seventh Meeting of the IFC. IFC/VII, CBAAC.

Senegal had a few allies in its dogmatic stand against non-black participation in the Colloquium, such as Ivory Coast, but support hardly followed along Francophone lines. Adding to the developing fault line, Guinean president Sékou Touré promised a counter-boycott 'if Senegal was allowed to have its way' ('Massive Boycott Threatens FESTAC' 1975: 3).

By 27 May 1976, with Olusegun Obasanjo newly installed as Nigeria's Head of State, the crisis reached a breaking point when Senegal announced its withdrawal from FESTAC, invoking the 'cultural' boundaries of blackness in opposing 'Arab' participation in the Colloquium. In the words of Alioune Sène, who as Senegal's Minister of Culture also doubled as vice-president of FESTAC's Francophone Zone, 'Arab culture is different from that of the black community and they would have nothing to offer us in that aspect' ('Massive Boycott' 1975: 3). Nigeria responded by reaffirming its commitment to full participation for all OAU member states, and retaliated by removing Alioune Diop from his position as Secretary General of the IFC, stating conflicts of interest that shed further light on the lineaments of black cultural citizenship. Addressing the ninth official meeting of the IFC, Commander O.P. Fingesi explained:

> The Secretary-General, in the person of Alioune Diop, had to be relieved of his duties following the confirmation that the Senegalese Government had taken the definitive decision to boycott the Festival [...] That decision of the Senegalese Government [...] did consequently compromise the position of Dr. Alioune Diop, *who is a Senegalese citizen*, as well as the Secretary General of the International Festival Committee. It must be emphasized that the move to relieve Dr. Alioune Diop of his responsibility as the Secretary General of the IFC was in no way a direct personal affront to him. It was a decision that had to be made purely on issues of principles as well as pragmatic realities.[8]

What stands out in this measured proclamation is how Diop's Senegalese citizenship became a political liability jeapordizing the greater good of FESTAC's sovereignty, necessitating his removal by a higher authority within an emerging Pan-African nation.[9] For Diop, FESTAC's black cultural citizenship trumped Senegalese citizenship and the political community to which it was wedded. Diop was replaced by Cameroon's more compliant Ambroise Mbia as the new IFC Secretary General, after the entire

8 'Opening Remarks by Commander O.P. Fingesi, Federal Commissioner for Special Duties of the Federal Republic of Nigeria and President of the 2nd World Black and African Festival of Arts and Culture to the Ninth meeting of the IFC, held in Lagos on 6–9 July, 1976'. Doc 1X/148 CBAAC (my emphasis).

9 Nigeria's removal of Alioune Diop was no small decision. Diop was a central figure of the Negritude movement, having founded its flagship journal, *Présence africaine*, in 1947 and thereafter co-organized FESMAN with Senghor. For a critical analysis of *Présence africaine* and its productive literary, political and philosophical engagements, see Mudimbe (1992).

Colloquium committee was reorganized to gain further control over its Francophone planners.[10]

By 26 August 1976, a peace was brokered, and Senegal rejoined FESTAC, albeit with diminished responsibilities and wounded pride as Senghor's co-patronage was permanently rescinded. Wole Soyinka played an important role in establishing a 'compromis dynamique' [dynamic compromise] between what the press described as Senegal's philosophical principles and FESTAC's political and practical imperatives, heralding the rapprochement as a victory in African diplomacy 'in keeping with the true spirit of African brotherhood and unity'.[11] Although too late to recall Alioune Diop as Secretary-General of the IFC since his successor was already installed, Senegal re-entered the community of black nations with its FESTAC citizenship fully restored. But the question remains, why all the *Sturm und Drang*? Why did Senegal put so much on the line when it marginalized North Africans and waged its boycott? What was at stake over 'Arab' participation in the Colloquium, and why was Senegal so adamant in its racialist refusals? It was Dr Garba Ashiwaju, chairman of FESTAC's National Participation Committee, who identified the root cause of Senghor's animus in the First Pan-African Cultural Festival hosted by Algiers from 21 July to 1 August 1969.[12] The festival is worth revisiting not only for the Fanonian model of revolutionary culture which it promoted (Fanon 1965), contrasting with Negritude's cultural conservatism, but also for the more militant contours of black cultural citizenship that it brought into focus.

The Battle of Algiers

When the OAU hosted the First Pan-African Cultural Festival from 21 July to 1 August 1969, liberation movements in Angola, Mozambique and Rhodesia were in full swing, while the SWAPO-led Namibia was still occupied by South Africa, representing struggles for national self-determination further fuelled by the Cold War superpowers vying for influence throughout the continent. A related shift in African socialist paradigms was also occurring—in many ways articulated by the Algiers festival itself—whereby the first wave of populist

10 The Minutes of the Eighth IFC meeting reveal some sneaky manoeuvres by the Nigerians in control of the IFC. The Cameroonian Engelbert Mveng, who had virtually been appointed as Colloquium chair by the Francophone Zone, was never given a plane ticket to the eighth IFC meeting, resulting in lack of a quorum. Nonetheless, Mbia proposed an ad hoc vote to approve a new East African chair, Dr Katoke, which went through unanimously, just as the delegates' salaries were doubled by Nigeria's Udoji reforms. 'Session of Jan. 29th', IFC/VIII, CBAAC.

11 Gomis (1976). See also 'Late News Release No. 1050, Federal Ministry of Information, Lagos, August 25, 1976, Senegal Now to Take Part in FESTAC'. Nigerian Institute of International Affairs, Clip File 'World Black and African Festival of Arts and Culture'.

12 Personal interview with Dr Garba Ashiwaju in Lagos, 12 October 1993.

socialism of the late 1950s and 1960s, modelled on the socialist communalism of 'traditional' African societies, was followed by a second wave of more militant regimes that would seize control in the 1970s, embracing scientific socialism with its vanguard party while renouncing the false consciousness of traditional culture (Apter 2008). It is hardly surprising that a more revolutionary definition of African culture was on the Algiers agenda, with its Symposium theme addressing 'The Role of African Culture in the Struggle of Liberation and African Unity'.[13] Nor is it surprising that it was in this venue, evoking the Algerian revolution and the critical spirit of Frantz Fanon, that Senghor's philosophy of Negritude was so militantly denounced.

Tensions began with the discursive restrictions that insulated official representatives from popular critique. Presentations during the plenary sessions were limited to the heads of national delegations, none of which 'could be answered from the floor' (Lindfors 1970: 5). During the breakout sessions on substantive themes, journalists and 'uninvited foreign observers' were kept out of the conference rooms, sequestering dissenting views from public dissemination. It was under such conditions of 'systematically distorted communication', appropriate for the monopoly of a vanguard party line, that the assault against Negritude gained declamatory momentum.[14] Guinea opened the charge at the first plenary session with a 40-minute recorded message by Sékou Touré, stating that:

> there is no black culture, nor white culture, nor yellow culture [...] Négritude is thus a false concept, an irrational weapon encouraging the irrationality based on racial discrimination, arbitrarily exercised upon the peoples of Africa, Asia, and upon men of color in America and Europe. (Lindfors 1970: 5)

This was a theme amplified by Mamadi Keita, the head of the Guinean delegation:

> Holy Négritude, be it Arab-Berber or Ethiopian-Bantu is an ideology auxiliary to the general imperialist ideology. The Master transforms his slave into a Negro whom he defines as being without reason, subhuman, and the embittered slave then protests: As you are Reason, I am Emotion and I take this upon myself [...] The Master assumes his preeminence, and the Slave his servitude, but the latter claims his right to weep, a right that the Master grants him [...] One easily understands why the imperialist propaganda system goes to such trouble to spread the comforting concept of Négritude. Négritude is actually a good mystifying anaesthetic for Negroes who have been whipped too long and too severely to a point where they lost all reason and become purely emotional. (Lindfors 1970: 5)

13 This was one of two themes, the other addressing 'The Role of African Culture in the Economic and Social Development of Africa'.
14 For a clarification of Habermas' theory of systematically distorted communication as an index of political domination, see Gross (2006: 337–42).

Negritude had long been criticized for reproducing the formal oppositions of colonial discourse if revaluing their meanings to celebrate African cultural agency, but in Algiers the progressive dimensions of the movement and its contributions to black nationalist politics were given short shrift if acknowledged at all.[15] Henri Lopes of Congo-Brazzaville decried 'the pigmentary belt' imposed by Negritude across the African continent, while Paul Zanga of what was then Congo-Kinshasa found the doctrine 'out of date as an historic movement', recognizing its former importance and 'the need to transcend it' (Lindfors 1970: 6). Wabu Baker Osman of Sudan joined the fray, voicing his criticism in Arabic of a racial philosophy that could only 'serve the interests of the colonialists who have worked for two centuries to characterize people of different continents according to racial criteria' (6). But Dahomey's Stanislas Adotevi delivered the final of coup de grâce in his concluding remarks of the final plenary session. Denouncing Negritude as a reactionary 'mysticism' that impeded the progress of African development, Adotevi identified a fundamental flaw in its recuperative approach to African socialism, one that looked back to a traditional past rather than forward towards the African revolution: 'Négritude, by pretending that socialism already existed in traditional communities and that it would be sufficient to follow African traditions to arrive at an authentic socialism, deliberately camouflaged the truth and thus became ripe for destruction' (6).[16] Thus Adotevi's attack went beyond the 'spirit' of Negritude to negate the central proposition of its socialist humanism.[17]

Needless to say, the battle over Negritude was not just one of words, but of spaces from which to speak. Responding to Adotevi, Senegal's Minister of Culture, Youth and Sport, Amadou Mahtar M'Bow attempted to defend Negritude in more nuanced and dialectical terms—emphasizing the 'symbiosis' and shared cultural base between 'Arab-Berbers and Black Africans' while quoting Lenin on the necessity of recognizing cultural specificity in the USSR—but the damage was done ('Les Interventions du Débat de Samedi—communication du Sénégal' 1969: 7).[18] Lindfors (1970: 6–7) reported that other Senegalese delegates such as Alassane N'Daw and Lamine Niang contributed papers quoting liberally from Senghor, which were distributed but not read. In effect, the discursive deck was stacked from the

15 One of the best discussions (in English) of Negritude as a literary and ideological movement remains Irele (1990: 67–116).

16 See also Hare (1969) and Shepherd (1969) for similar reportage.

17 For an insightful discussion of Adotevi's Algiers statement in relation to ideas he developed further in *Négritude et négrologues* (Adotevi 1972), a book which he dedicated to Angela Davis, see Jules-Rosette (1998: 92–93). See also Meghelli (2014: 175). For Senghor's key ideas about Negritude and socialist humanism, see Senghor (1964a; 1964b).

18 M'Bow was referring to a regional 'symbiosis' argument elaborated at length in Senghor (1967), a book based on a lecture that Senghor delivered at the University of Cairo.

start. The *négritudistes* were largely excluded from the discussion, present more as observers than fully fledged participants.[19] Placed in the broader festival contexts of FESMAN '66 and Algiers 1969, Senghor's opposition to 'Arabs' in the FESTAC '77 Colloquium was a form of retaliation and revenge, giving the North Africans a taste of their own medicine while restoring his doctrine to the Pan-African stage.[20]

It would be a mistake, however, to reduce 'the Arab Question' to a bruised ego and vindictive personality. Such motivating factors may help explain why Senghor put his reputation on the line at FESTAC '77, but do little to illuminate the contours and characteristics of a *transnational form* of black cultural citizenship that was emerging not only within these festivals but also between them, over space and time. One characteristic clearly apparent in the doctrinal debates over Negritude's purview, as they contested the limits of the 'Negro-African' world, highlights an important semantic slippage between race and culture in which the diagnostics of phenotype were never fully eliminated. Both the critics in Algiers and in Nigeria's FESTAC assailed the race-based exclusions of Negritude's blackness, declaimed (as we have seen above) as 'a pigmentary belt', a colonialist delusion, and after Senghor's attempted ban of North Africans from the FESTAC Colloquium, 'racial bigotry in the most nauseating sense'. To be fair, Senghor's doctrine is far more complex and humanistic than such dismissive attacks suggest, emplotting a dialectical movement of opposition and synthesis that sought nothing less than the 'civilization of the universal' in its politico-philosophical telos (Senghor 1977). And yet it was precisely such 'racisme antiraciste', so termed by Jean-Paul Sartre (1948: xiv) in his preface to Senghor's edited *Anthologie de la nouvelle poésie nègre et malgache*, glossing a self-negating racism destined to achieve its own transcendence, that nonetheless persists and lingers despite the most adamant culturalist disavowals, a theme rigorously pursued by Gilroy (2000) and reworked more recently by Mbembe (2013).[21]

19 The North African participants, including the Algerian delegation, led less of a frontal attack against Negritude than an alternative vision of a 'new Africa' that embraced the very scientific rationality that Senghor dismissed as paradigmatically European. The Algerians' 'man of African culture' was 'le technicien, l'ingénieur agronome, l'ingénieur de conception, le planificateur des économies nationales, le pédagogue, le médecin' [the technician, the agricultural engineer, the structural engineer, the planner of national economies, the pedagogue, the doctor], working in the service of a modernizing state (see 'Le texte de l'intervention du porte-parole de la délégation algérienne' 1969: 6–7).

20 For perhaps the richest account of the Negritude debates at the Algiers festival, see Hare (1969). He also clarifies the tensions between Eldridge Cleaver and Stokely Carmichael at the festival, with reference to doctrine and ideology. See also Fuller (1969) and Shepherd (1969). For extraordinary daily coverage of the festival events and debates as they unfolded in Algiers, see *El Moudjahid*, 20 July–5 August 1969.

21 Thus Mbembe (2013: 263) concludes his critique of 'raison nègre' [black reason] and its historical logics of differentiation and desire with the appeal for 'un monde

The lurking racial essentialism within Negritude's blackness, and its associated forms of black cultural citizenship, can be philosophically negated, officially rejected, but never fully eliminated or transcended because it persists, not as a relic of racism, but as the historical condition of its possibility. Such finer distinctions, however, fell on deaf ears at the more militant Algiers festival, which forged a high-profile alliance with the Black Panther Party and a cultural politics of what Meghelli (2009) has called 'transnational solidarity'.

'All Power to the People'

Not that Algiers subordinated cultural spectacle to *realpolitik*. Cultural affinities uniting Africans and their overseas descendants were celebrated and elevated in dance, music and drama, as when jazz legend Archie Shepp invited some Tuareg musicians to jam during one of his sets, providing 'living proof' for poet Ted Joans 'of jazz still being an African music', while reaffirming Miriam Makeba's pronouncement that 'We are all Africans, some are scattered around the world living in different environments, but we all remain black inside' (Joans 1970: 5).[22] But black culture in Algiers was forward-looking and revolutionary, unified and motivated by the shared struggle against Euro-American racism and imperialism—bringing French colonialism and American segregation (with its associated prison–industrial complex) within the same oppositional battlefield.[23] And it was here, within the festival's transnational community that a distinctive form of black citizenship emerged, based not only *contra* hegemonic racial orders, but also 'positively', on inclusive rights of political recognition that took precedence over the sovereign authority of western nation states. In this context the presence of the Panthers in Algiers posed more than an embarrassment for the US government, but ramped up their struggle to international proportions. The Algerians built a new, two-storey Afro-American Information Center which

débarrassé du fardeau de la race, et du ressentiment et du désir de vengeance qu'appelle toute situation de racisme' [a world rid of the burden of race, and of resentment and the desire for revenge called for by any racist situation]. For an illuminating discussion of this point, and other critical strategies in Mbembe's complex genealogy of blackness, see Coburn (2014).

22 For the LP recording of his live performance, see (and hear!) Shepp (1971).

23 Samir Meghelli identifies an important discussion, held in October 1962, between Ahmed Ben Bella—then Algeria's first president-elect—and Martin Luther King Jr, at the time of Ben Bella's United Nations swearing-in ceremony. As King reported, 'the significance of our conversation was Ben Bella's complete familiarity with the progression of events in *the Negro struggle for full citizenship* [...] The battle of the Algerians against colonialism and the battle of the Negro against segregation is a common struggle' (cited in Meghelli 2009: 103; my emphasis). For explications of the prison-industrial complex, see Davis (1971; 2000).

was lavishly stocked with Black Panther pamphlets and posters, where the invited Panther delegation held court (Figure 15). These included none other than Information Minister Eldridge Cleaver, arriving after eight months of exile from the USA via Cuba, together with his wife Kathleen Cleaver, who was the party's Communications and Press Secretary; Emory Douglas, who served as Cultural Minister; and the party's Chief of Staff, David Hilliard.

Articles in the party's newspaper the *Black Panther* illuminate the multiple meanings and dimensions of black citizenship as it intersected with conflicts in the USA and the Middle East, and with liberation struggles throughout Africa.[24] Eldridge Cleaver was initially welcomed in Algiers by supportive crowds shouting 'Power to the People' and 'Al Fatah will win', explicitly identifying the black struggle in America with the plight of Palestinians after the Six Day War of 1967, together with Yasser Arafat's Palestine National Liberation Front, the insurgent wing of the PLO. Standing next to an unnamed Al Fatah official, Cleaver proclaimed that, although 'we recognize that the Jewish people have suffered', nonetheless 'the United States uses the Zionist regime that usurped the land of the Palestinian people as a puppet and pawn' ('Eldridge Warmly Received by the People of Algiers' 1969: 3).[25] The Panthers' solidarity with Palestinian refugees expressed a shared experience of discrimination and disenfranchisement, a denial of full citizenship within the USA and Israel that brought both struggles together. Indeed, the *Black Panther* featured full articles on Al Fatah and its calls for armed resistance and radical change, honouring heroes of the revolution like Ribhi Mohammad and William Najib Nassar, who made the ultimate sacrifice. But if Cleaver's solidarity with liberation movements in Africa and the Middle East resonated with the radicalizing directives of the OAU, it was the latter's recognition of the Black Panther Party as the revolutionary vanguard in the USA which empowered Cleaver and his comrades.

In a press conference called by Panther Chairman Bobby Seale and David Hilliard, who had recently returned from Algiers, the focus was entirely upon Eldridge Cleaver. When asked about the festival, Hilliard replied:

> The only report that I have to bring back to Black people in particular and to the American people in general is Eldridge's wish to return to America [...] Eldridge has stated that he would return today, if he could have his day in court. So that I am here, along with Bobby and the Black Panther Party nationally to create some machinery in order to bring Eldridge back to America, because this is where he prefers to struggle. ('Press Conference' 1969: 7)

24 Meghelli (2009: 106–07) shows how the Algiers festival also resonated with the Nation of Islam, which ran several anticipatory articles in its newspaper, *Muhammad Speaks*. See, for example, Kenneth C. Landry, 'Algerian Festival to Spotlight Africa's Vast Cultural Heritage', *Muhammad Speaks*, 13 July 1969, p. 31 (cited in Meghelli 2009: 117 n. 38).

25 The article quotes from a *New York Times* article without full citation.

Emerging out of a flurry of questions as to whether they were working on a deal ('No'), whether Eldridge trusted the courts and when in fact he might be expected to return, were the Panthers' concerns with due process and citizenship. On the question of Cleaver's imminent return, Hilliard explained:

> Well, that's dependent upon the actions of the mayor of San Francisco in offering Eldridge protection, *as he would any other citizen*, and also the actions and attitudes of the governor of California,—if they're willing to cooperate in terms of letting Eldridge return and have his regular appearances in court, then he'll return today. ('Press Conference' 1969: 7; my emphasis)

Cleaver would be expelled from the Party in 1971, and would not return to the USA until 1975, where he did serve an eight-month prison sentence. But the Algiers festival revealed the vulnerabilities of his citizenship, both at home and abroad, bringing significant political calculations into play. The Party framed the need for adequate city and state protection as the right of any ordinary citizen, not only for an exiled fugitive of justice, but for all black people who were taking up arms to protect themselves against the police, or 'fascist pigs'.[26] Moreover, Eldridge's vulnerable citizenship at home was balanced against different ambiguities in Algeria. When asked if Eldridge would remain in Algeria, Hilliard replied: 'That's not clear, you know. I don't know how permanent it is. We were only offered that center in Algeria and that we were invited there only for the cultural festival and when that's ended, I don't know what's going to happen. I'm not sure' ('Press Conference' 1969: 7). Hilliard's uncertainty reflects the ephemeral character of Cleaver's cultural citizenship in Algeria, circumscribed in space and time by the parameters of the festival itself. The Panthers did not know if Cleaver would be allowed to remain in the country after the celebration ended and the guests went home. But if Cleaver's black (cultural) citizenship was activated throughout the festival, would his political welcome extend post festum?[27]

The question is bigger than Cleaver himself because it addresses the shifting and permeable boundaries between ideology, rhetoric and *realpolitik*. If, as I have argued, black cultural citizenship was a significant political

26 The growing momentum of the 'Black Lives Matter' movement in the USA today shows how the struggle to decriminalize blackness and protect unarmed African Americans against excessive force and murder by white police is far from over.

27 The turbulent complexities of Cleaver's citizenship in exile, from accredited envoy of the International Section of the Black Panther Party to expelled revolutionary on the run, lacking passport and papers, follows a tortuous itinerary from Cuba and Algiers—with visits to Vietnam, China, North Korea and Congo-Brazzaville—to the USA via a safe house in Paris. For the high point of Cleaver's political clout in Algeria, where he outranked the US Chargé d'Affaires, see Gramont (1970). For an extraordinary account of his travels, travails and expulsion from Algeria, written by his ex-wife, who provided key support during those years, see Cleaver (1998).

status worth fighting over in the festivals of Dakar, Algiers and Lagos, then how did it resonate beyond the festivals themselves, with broader struggles for liberation and recognition? To address this concluding question, we reframe conventional distinctions between transnational festivals and nation states; between the performance and institutionalization of what is called citizenship.

Conclusion

We have seen how Senghor's humiliation in Algiers struck a serious blow, not to be easily forgiven in FESTAC '77, even if it was French West and Central Africans rather than North Africans as such who had voiced the most vicious criticisms of Negritude. But beyond the politics of Afrocentric principles and doctrines are the forms and modalities of black cultural citizenship which these discourses of Africanity framed, generated and promoted. Returning to 'le divorce' between Senghor and Obasanjo, how are we to understand the meaning of black and African citizenship in the context of FESTAC '77 and the problematic question of North African ('Arab') participation?

First, we have located FESTAC's black citizenship within the Pan-African nation that Nigeria produced from 15 January to 12 February 1977; replete with its secretariat, employees, security forces, FESTAC village, food distribution system, transportation system, identity cards and sovereign territories based in Lagos and Kaduna, as represented by the FESTAC logo and flag. Hosted, administered and financed by Nigeria, FESTAC's 'Black and African World' was national in form, imperial in scope and self-actualizing in its capacity to become a transnational sovereign entity. Clearly for Senghor, the North African delegation at FESTAC was at best entitled to a form of second-class citizenship, as observers but not participants in the FESTAC Colloquium. From this restriction—had Senghor succeeded—they would have been barred from negotiating the ideological horizons of the black and African World. That Senghor failed, and suffered a loss of both personal and national prestige, proves that *within the context of FESTAC itself,* black cultural citizenship was a highly valued form of political capital—not a secondary representation of national citizenship but a recognized form of entitlement sui generis. Indeed, it was within FESTAC's political community that Senegalese citizenship became a political liability for Alioune Diop, who was relieved of his post as Secretary General of the International Festival Committee (IFC).

Second, we have located FESTAC '77 within a genealogy of Afrocentric festivals that developed institutional frameworks and networks of participation over time, even as these shifted, conjoined and sometimes split apart. Senghor's initial status as FESTAC co-patron derived from his inaugural role in hosting the Dakar *Festival mondial des arts nègres* in 1966, establishing something of a blueprint for postcolonial celebrations to follow, but one that

was derailed by the 1969 Pan-African Festival in Algiers and its more revolutionary model of national culture. It is highly significant that Senghor's campaign against the North Africans in FESTAC revisited the attacks against Negritude in Algiers, and therefore only makes sense in relation to prior festival colloquia and participatory frameworks. In this sense, the cultural battle of Algiers carried over to the Senegalese fracas in Lagos, revealing how FESTAC's black cultural citizenship was partially embedded in prior festivals.

Third, we have related the citizenship of festivals to its cognate forms within the states, communities and liberation movements of its participants. By recognizing black cultural citizens within non-black states like the USA, Canada and apartheid South Africa, *without recognizing the states themselves*, FESTAC constituted a de facto black empire that cut across the global colonial and neo-colonial order. This aspect of what Holston (2008) calls 'insurgent citizenship'—establishing transnational solidarity between the racially disenfranchised and dispossessed—was epitomized by the prominence of the Black Panthers in Algiers, whose militant fight against white power at home resonated with the Palestinian struggle, the liberation movements in Africa and a new wave of revolutionary socialist regimes embraced by the OAU. For Eldridge Cleaver, living in exile, black cultural citizenship was eminently personal, a matter of freedom and incarceration if not life and death. Granted 'festival' citizenship and sanctuary in Algiers, where his longer-term prospects remained uncertain, his negotiations to return to America focused, as we saw above, on the concrete protections of full citizenship at home.

Finally, the manifold dimensions of black cultural citizenship exposed by 'le divorce' and 'the battle of Algiers' reveal complex pathways and fluid boundaries between the politics of festivals and nation states.[28] Conventional approaches to world fairs and cultural festivals cast them as dramatic forms of colonial and postcolonial theatre, representing 'real' countries, cultures and political projects in 'secondary' symbolic performances and displays. From this perspective, delegations represent actual states and communities in symbolic terms, as simulations or artistic expressions of the larger world beyond. The lessons of FESTAC suggest an alternative approach which destabilizes the ontological distinction between real world and staged representation, according to what Bennett (1996) has called the 'exhibitionary complex', a primary status in structuring political entities and projects. If from the first perspective, cultural citizenship within a black world fair is a secondary representation of 'real' national citizenship, from the second perspective, treating the festival as a sociopolitical entity sui generis, its endogenous forms of citizenship and recognition are real unto themselves. Black cultural citizenship within Afrocentric festivals is not a

28 For an analytical framing of these dynamic spaces of cultural production, beyond the regulatory machinery of the nation state, see Clarke (2013).

simulacrum of an external reality but occupies a place within that reality—not only of recognized rights and duties, but also of violence and utopian possibilities. If such an approach seems far-fetched and counter-intuitive, perhaps we should return to the French Revolution, and—as Mona Ozouf (1988) has so brilliantly revealed—the birth of modern European citizenship through its choreographed festivals.

Cultural Festivals in Senegal: Archives of Tradition, Mediations of Modernity

Ferdinand de Jong

Cultural festivals in Senegal draw upon a wide variety of cultural traditions that are staged for an array of local, national and international audiences.[1] Staging masquerades from sacred forests, dances from initiation rites, the skills of sheep-herding, the acrobatics of *capoeira* and gigs by world music stars, cultural festivals are said to promote peace, development and cultural *métissage*. The range of rationales proffered for these festivals is as wide-ranging as that of the cultural performances staged at them. Presented as a panacea against the ills of modernity, culture is framed as both source and resource in its staging in festivals, which in fact function as mediations of modernity. While many disciplines recognize the polyvalence of the term 'culture', it should be acknowledged that the colonial and postcolonial trajectories of its use in the French imperial nation state and independent Senegal are particularly complex and controversial. Appropriating cultural performances for his politics of Negritude, President Léopold Sédar Senghor turned 'culture' into a political instrument. As a result, says Senegalese philosopher Souleymane Bachir Diagne, the very concept of 'culture' constitutes a controversial legacy of Senghor's cultural policy (Diagne 2002).

Cultural performances staged at cultural festivals are usually presented as rooted in 'tradition', although these performances often owe their format to the spectacles staged at colonial exhibitions (Apter 2005). Senegalese cultural festivals can therefore be seen as repositories of a long history of cultural policy, starting with French colonization. While this well-established origin

1 The research for this article was conducted during a year of fieldwork in 2004–05. I would like to thank the inhabitants of Thilogne for their hospitality and Idrissa Kane in particular for his assistance with the research in Thilogne. I am grateful to the Economic and Social Research Council for funding this research and the University of East Anglia for granting me research leave.

in colonial relations is usually disavowed, organizers of cultural festivals make uninhibited use of cultural repertoires and deploy them while using a range of modernizing discourses to rationalise their postcolonial iterations. Acknowledging the colonial genealogy of cultural performances, this chapter demonstrates that the independent Senegalese state and its subjects have reclaimed the format of the colonial exhibit for a modernist agenda by deliberately forgetting the colonial origins of its cultural archive. The cultural performances presented at cultural festivals are, in fact, masquerades of modernity (De Jong 2007).

This argument should be situated within a wider debate on the transformation of cultural formats in postcolonial contexts. Cultural performances are increasingly commoditized by ethnic brokers in an attempt to access resources and achieve international recognition (Comaroff and Comaroff 2009; cf. Peutz 2011). While such a transformation of cultural sources into commodity resources is often deplored as a regrettable loss of authenticity, cultural performers regularly incorporate trajectories of commodification to create new, innovative forms of performance (De Jong 2013). In order to reach global audiences and achieve recognition, traditions are transformed into new, hybrid forms of cultural performance (De Jong 2009a). In this process the cultural repertoire is transformed into an archive that cultural groups can mine for a range of modernizing strategies. Cultural performers reclaim their heritage for a cultural politics of recognition (De Jong and Rowlands 2007).

Although there is a view that archives comprise buildings and the materials contained within them (Zeitlyn 2012: 462), it has long been recognized that the body itself is the object of the archive (Sekula 1986). In her study on the archive and the repertoire, Diana Taylor defines the archive as consisting of supposedly enduring materials, and distinguishes it from the repertoire as consisting of embodied practice/knowledge (2003: 19). But she recognizes that the two do not constitute a binary and this opens up the possibility of thinking about the embodied legacy as archive. In this chapter, I suggest that the cultural performances represented in Senegal's cultural festivals constitute an archive of postcolonial modernity (see also Basu and De Jong 2016).

Colonial Roots of Restorative Nostalgia

In an important article, Michael Rowlands (2007) argues that French colonial policies of heritage conservation had their origins in the nineteenth-century French 'crisis of memory'. In a context of widespread social upheavals as a result of industrialization, urbanization and demographic growth, French literature expressed a yearning for an ideal past and a nostalgic view of pre-industrial society (Terdiman 1993). Charged with a profound and disquieting sense of loss, nostalgia informed nineteenth-century social theory itself. When the German theorist Ferdinand Tönnies made his famous distinction between *Gemeinschaft*

and *Gesellschaft*, he differentiated two forms of memory: while habit memory was transmitted in the close-knit communities of the provinces, modern memory was represented through monuments and ceremonies in Paris, the centre of modernity. Significantly, habit memory was believed to provide an antidote to the modern memory of the metropolis, incurably infatuated with an overdose of history. It is not hard to see how this distinction still informs our current debate on memory. Pierre Nora's (1989) distinction between *lieux de mémoire* and *milieux de mémoire* literally reproduces the distinction made by Tönnies. Nora, too, has emphasized that realms of memory are increasingly undermined by history. Informed by a sense of loss, modernity engendered nostalgia for a lost communitarian society.

The restorative nostalgia that emerged in nineteenth-century Europe informed the colonial project of heritage restoration. Presumed to inhabit pristine *milieux de mémoire*, the colonized were to be saved from modernity and its onslaught on communitarian life. Indeed, as Rowlands (2007) argues, nostalgia for a lost African civilization informed French initiatives to restore the mud architecture of Djenné in 1907. Such nostalgia was not restricted to forms of architecture, but also included civilizations and customs. Although *assimilation* was the official aim of French colonial policy, among colonial administrators and anthropologists many advocated protecting local cultures and mentalities (Wilder 2005: 71). In the African colony, this nostalgic longing for a pure, putatively authentic civilization informed a colonial policy that reified presumed pristine mentalities through regimes of belonging (Mamdani 1996).

In the fashionable negrophilia that ruled Paris in the interwar period, African civilization was imagined as a panacea for Europe's decadent civilization. Marcel Griaule—who led the ethnographic expedition, the Mission Dakar–Djibouti—imagined Africa 'as a pure state of humanity from which modern civilisation has deviated' (Jules-Rosette 1998: 11). This nostalgic longing for the vanishing primitive was adopted in unexpected circles in metropolitan France. Engaged in close conversations with anthropologists, African *évolués* adopted the nostalgic view of Africa as the land of primeval civilization (Clifford 1988; Jules-Rosette 1998). Students from the colonies who sought to articulate their difference within the Empire studied their native societies through the colonial library (Mudimbe 1988). Intrigued by French ethnography's recognition of African civilizations, Léopold Senghor incorporated the nostalgia of French anthropology into his utopian vision of a *Civilisation de l'universel*. Given that Senghor's Negritude philosophy shaped Senegalese cultural politics, it is not hard to see why the imperialist nostalgia that informed Senghor's vision was widely disseminated in Senegal.

However, the discursive decolonial reclamation of African civilization was preceded by its practical appropriation in the colonial context of world exhibitions. The paradoxes of patrimonialization had their origins in the racist appreciation of exotic performances in a nineteenth-century imperialist context. In a transnational public sphere of nationalist rivalry,

cultural performances from the colonies were staged for national publics and provided the format for representations of the other. In his study of FESTAC '77, Apter (2005) suggests that the format of postcolonial festivals can be traced to performances of 'indigenous' dance at colonial exhibitions. European empires demonstrated the fruits of their *mission civilisatrice* to the wider world at such exhibitions at which 'natives' were invited to present their arts and crafts (Mitchell 1991; Bennett 2004). Even though the cultural production of the 'natives' at colonial exhibitions was transformed into spectacle, it was nonetheless deemed to have an educational benefit. In fact, the successful popularization of anthropology relied on these performances at colonial exhibitions (Coombes 1994). Straddling the boundaries between education and entertainment, colonial exhibitions staged African dances to disseminate anthropological knowledge. These entangled histories of anthropology, cultural performance and the 'exhibitionary complex' were not suddenly disentangled at the dawn of independence, but remained intimately intertwined, especially in Senghor's Senegal.

Colonial Education and Cultural Production

This entanglement of citizen discipline and dissemination of knowledge through education and entertainment was not restricted to a metropolitan milieu. In its formation of an indigenous class of government clerks in colonial Africa, the colonial administration saw a purpose in instructing the colonized in their 'native' culture in order to prevent their uprooting. At the prestigious William Ponty School, which provided the highest level of education available in French West Africa, education aimed ambivalently at both *assimilation* and instruction in 'native culture' (De Jong and Quinn 2014). The educational policy of the school included programmes to inculcate 'traditional' values in order to prevent alienation and political dissonance among the students, at risk of becoming *déraciné*. In the 1930s and 1940s the school programme required that students spend considerable time on research papers describing some aspect of African culture. For these so-called *cahiers* (or *devoirs de vacances*), students had to research an aspect of their culture when visiting their home village. This research was subsequently used in the production of plays based on indigenous traditions, histories, legends and folktales (Sabatier 1978; Cohen 2012). Auto-ethnography provided a moral mooring for students at risk of being 'uprooted' (*déracinement*). These exercises probably contributed significantly to the formation of a colonial subjectivity. After graduating, many *Pontins* became teachers or low-ranking clerks in the colonial administration. As *évolués*, they wholeheartedly embraced the task of civilizing the colonial subjects. Since a majority of them were employed in the education of 'natives', auto-ethnography became a form of colonial *subjectivation* (subjectification) shared by the African elite and the indigenous population. As some *Pontins* assumed pivotal functions in the government and administration of

169

independent Senegal, the *cahiers* programme also informed the cultural policy of independent Senegal.

But the training programmes at Ponty also influenced cultural production for the entertainment industry in the metropolis itself. After completing his studies at the William Ponty School in 1943, the Guinean student Fodéba Keita went on to have a successful career as a choreographer in metropolitan Paris. The choreographies of his Ballets Africains drew on innovative combinations of African dance and European theatrical techniques. This was a time of real experimentation, but also an important moment in the codification of traditional performance and in that respect the importance of the Ballets Africains can hardly be overestimated. In the 1950s, the Ballets Africains toured North America, South America, the Middle East and Europe. In their choreographies a performance genre emerged that was celebrated from Paris to New York and Dakar (Cohen 2012: 12). Cohen draws our attention to the fact that its influence was not limited to the metropolis, but included French West Africa. For instance, when the Ballets Africains performed in Dakar in 1956 and 1957, future President Senghor was delighted, and when Senegal acquired its independence, Senghor drew upon the expertise of Ballets Africains dancers in his professionalization of Senegal's National Ballet. In imitation of the successful shows staged by the Ballets Africains in 1950s' Paris, the National Ballet's performances were made up of theatrical *tableaux vivants* of rural life. Senegal's National Ballet thus committed itself to representing African tradition in the 'ethnographic present' (Castaldi 2006: 64). This commitment can be seen in the repertoire of Senegal's National Ballet, which was often inspired by dances and rhythms from Casamance, and frequently incorporated masquerade traditions from this region. In drawing upon the masquerades from a region considered backwards in comparison to cosmopolitan Dakar, the National Ballet continued an established format of exoticizing performances for cosmopolitan audiences (Neveu Kringelbach 2013a).

When Senegal achieved its political independence and Senghor became its first President, the poet-president lavished a large proportion of the national budget on the arts (Snipe 1998). Supporting the École nationale des beaux arts, the Manufactures sénégalaises des arts décoratifs and the Ballet national du Sénégal, the cultural policy of the new nation sustained a wide range of arts in order to disseminate Senghor's ideals of Negritude. In search of *l'âme nègre* [the black soul], the new arts sought to express an African essence Senghor thought characteristic of *l'homme noir* [the black man]. For example, in the context of the artistic production of the École de Dakar many artists sought inspiration in African traditions and abundantly represented practices they identified as tradition. Senegalese artists drew upon the continent's canonical sculptural traditions to develop a new, modernist African aesthetic (Harney 2004: 156). And, just like the early twentieth-century *arts primitifs* that had been celebrated as major African achievements, this work was now exhibited at the *Festival mondial des arts nègres* (1966). Thus Senegal's modern

cultural production revolved around a paradox in the conception of Negritude and its application in Senegal's cultural politics: reproducing a 'primitive' essence as the apogee of African civilization in its quest for global recognition Senegal's cultural production always referenced 'the primitive'.[2]

Cultural production in post-independence Senegal was a showcase for Senghor's philosophy of Negritude. The utopian vision of Negritude imagined that African civilization should develop and open itself to the world (*la Francophonie* in particular) while remaining rooted in an African spirit. African culture should contribute to an evolving *Civilisation de l'universel* through a cultural dialogue aptly captured by the adage *ouverture et enracinement* [openness and rootedness]. Since alienation was to be prevented—reminiscent of the colonial fear of *déracinement* [uprooting]—Senghor's philosophy was often associated with a *retour aux sources* [return to the source]. Today this motto is often embraced during the so-called *semaines culturelles* [cultural weeks] or *journées culturelles* [cultural days] as they are often staged in Senegalese villages. Meant to motivate urban migrants to return to their village of origin, these cultural festivals provide entertainment for the migrants while they spend their summer holiday *au village*. After a supposedly alienating sojourn in the city, the migrants return to the village to quench themselves at the sources of tradition. The programmes of such festivals include the performance of cultural traditions by way of affirmation of the cultural identity of the villagers and as panacea for the cultural alienation of the migrants. In this sense, the *semaines culturelles* are remarkably reminiscent of the *cahiers* programme of the William Ponty School. As we noted above, during the summer holidays students based at this colonial institution were sent home to their native villages in order to record native traditions. The sojourns in the village were meant to restore the students' rootedness in traditional culture (Conteh-Morgan 1994: 51). Today, this logic seems to be repeated in the *semaine culturelle* when the village stages its traditions for the uprooted migrants. Because this colonial notion of culture was deeply indebted to a nostalgic vision of African civilization, Senegal's national culture credits 'tradition' with restorative potential. Ever since Senghor invoked tradition as the essence of *l'homme noir*, an immersion in 'tradition' has been held to have a healing effect on the alienating aspects of modern life (De Jong 1999).

Although necessarily sketchy, this genealogy has, I hope, convincingly demonstrated that Senegal's cultural policy has roots in the education and entertainment of metropolitan audiences at colonial exhibitions and other venues for the communication of imperialist achievements. Spanning the French imperial nation state, the performance of tradition was from its

2 Scholarship on Senegal's cultural policy has appreciated Senghor's tremendous effort in the production of a national culture, but also reflects the earlier criticism of Negritude voiced by Frantz Fanon. According to Castaldi, Negritude reproduced a nostalgic view of African culture by privileging the representation of a primitivizing 'tradition' (Castaldi 2006).

inception aimed at remuneration and recognition, combining pecuniary motives with a search for *l'âme nègre*. In the transnational context of the French imperial nation-state, the performance of culture amounted to an 'extraversion' of tradition in colonial forms of display (Bayart 2000). The mimesis of such colonial forms of display took on dramatic proportions in the first decades after Independence: Senghor's *Festival mondial des arts nègres* (1966) and Nigeria's Second World Black and African Festival of Arts and Culture (FESTAC '77) celebrated African independence. Even though these Pan-African festivals may have been indebted for their format to imperial spectacle, Apter signals that they 'inverted the conventions of imperial expositions by transforming the gaze of othering into one of collective self-apprehension' (Apter 2005: 4). Today, Senegal's national culture still seeks remuneration and recognition for the performance of its 'traditions' in cultural festivals. Even though the cultural traditions performed during cultural festivals are presented in a format fit for both home and foreign audiences (Mark 1994), the 'original' traditions are represented in formats developed in a history of imperialist spectacle. Because the French imperial nation state attributed a moral purpose to cultural traditions by rooting subjects in their 'native' culture, it should not surprise us that such 'traditions' are still credited with moral value today.

Mediations of Modernity

One of the consequences of urbanization is that Senegal's social life has, since the 1950s, seen a dramatic increase in the number of civic associations focused on the village of birth of migrants. While some of these associations emerged in the neighbourhoods of rapidly growing cities like Dakar and incorporated the migrants in their cities of destination, others were established in villages in order to mitigate the effects of migration. In her study of the social organization of football, Susann Baller (2010) has demonstrated how such associations were founded to serve various social purposes. Gradually the number of activities covered by these associations expanded, including the organization of sport, the foundation of libraries, theatre groups, summer schools and the cleaning of the neighbourhood. As such organizations of youth had the potential to channel protest, the Senegalese state sought to control them, and by the early 1970s registered these organizations as *Associations sportives et culturelles* (ASCs). Their primary purpose was to facilitate the participation of the neighbourhood's football team in the local, regional and national soccer competitions (*Navétanes*) organized by national structures that the state also tried to control. Partly as a result of the state's intervention, ASCs started to support theatre groups that performed a genre of popular theatre which had its origins in the theatrical tradition initiated by the William Ponty School (Baller 2010: 289–314; Jézéquel 1999; Mbaye 2006). As Baller demonstrates, the theatrical

plays performed by the ASCs sometimes aired local concerns as they were conceived by the players as an *éducation populaire* (Baller 2010: 291). In addition to these theatrical expressions of political concerns, ASCs often channelled civic concerns, for instance, when they took a leading role in the well-known *Set Setal* movement (Diouf 1992; 1996).

While urban ASCs offer residents a sense of belonging to an urban neighbourhood and a channel for a political engagement 'from below', the rural equivalents of these associations take it upon themselves to offer migrants the possibility to quench themselves at the roots of their culture. Cultural festivals organized by ASCs have proliferated since the 1980s as occasions to cement relations between the village and its migrants.[3] Scheduled during the summer holidays when migrants have the opportunity to return to their village of origin, cultural festivals offer platforms for the mediation of modernity for both migrants and the inhabitants of the village.

That cultural festivals are platforms for the articulation of modern subjectivities became clear to me when I attended the fourth *Festival international de culture et développement de Thilogne* in 2004. Thilogne, a town of around 5,000 inhabitants in the region of Matam, is mostly inhabited by Haalpulaar. The festival was held for the first time in 1998 and has since been celebrated on a biennial basis. The festival is organized by the Thilogne association développement (TAD) (Thilogne Development Association), an international association of migrants (*ressortissants*) from Thilogne, founded in 1978. With branches in France, Italy, Ivory Coast, Gabon and the USA, it connects migrants living abroad and the national capital Dakar with the branch of the home town in Thilogne. From the start, TAD's main aims were to offer its members assistance during their stay abroad and to further the development of Thilogne. With contributions from the various branches, TAD has facilitated the construction of primary schools and drinking water infrastructure in the home town (Kane 2001).[4] In 1998, TAD decided to launch a biennial festival as another channel for its development initiatives (Kane 2010). The festival was also meant to facilitate the communication and communion of migrants by coordinating their return at a particular moment in the year so that the children born in diaspora can visit their parents' home village and learn about its ancestral traditions. While ostensibly serving the economic development of the village, the festival therefore also functions as a channel for the incorporation of its diasporic youth into the worldwide community of Thilogne *ressortissants*. As an initiative of older generations of Thilogne's inhabitants and migrants, the cultural festival has as its aim to incorporate the younger members of its diaspora. Kane notes that this youth

3 On the role of migrant associations in the management of relations between villagers and migrants amongst the Jola, see also Foucher (2002b) and Lambert (2002).

4 Abdoulaye Kane, a sociologist from Thilogne, has studied the social organization of this transnational association in detail. See Kane (2001; 2010).

often has little interest in being incorporated in this transnational community focused on its village of origin in Senegal (2001: 106). Thus the cultural festival faces a complex, even contradictory, challenge of transmitting Thilogne's cultural heritage to an unwilling audience of international migrants while simultaneously serving a 'development' agenda.

Some of the contradictions inherent in the cultural festival as a mediation of modernity emerged starkly on the first day of the festival, which was attended by both local and national politicians. During the official opening, each of the politicians took the opportunity to enhance their profile and emphasize their achievements for the community of Thilogne. It was remarkable that all politicians, save one, did so in French, a language spoken by many inhabitants, but not all, and certainly not by most women. Nonetheless, it was a woman politician from Thilogne who voiced a call for more infrastructural support from the national government for the town. This clearly corroborated what sociologist Kane has already observed: Thilogne Development Association has replaced the state in providing local infrastructural development and apparently also provides a platform for the articulation of local concerns. As the festival was reported in most national newspapers, some of the issues raised were indeed conveyed to a national public. However, since the discussion was held in French and attended by men only, as a mediation of politics the festival excluded a large part of the TAD membership. While the cultural festival mediates political matters of wider concern, it does so within the confines of a male-dominated public sphere.

The exclusion of women became even more obvious during the debates about themes selected for the 2004 festival: the primary education of girls and the literacy programmes for women. The theme was topical as it had recently been established that the educational level of girls in Thilogne was well below the national average. But, to my surprise, speakers were all male and they all spoke in French. While some of them raised pertinent questions and clearly favoured higher levels of education for their daughters and wives, the most popular speaker was a local Muslim cleric who spoke in Pulaar and conveyed the most conservative stance on women's education. His point of view was that higher levels of teenage pregnancy were best prevented by marrying off girls at an early age, irrespective of the consequences for their education. Few women and hardly any girls attended this meeting, as they were busy with domestic chores. As an occasion to promote development policies for local women and girls, the festival was clearly not very inclusive. Nonetheless, even if the development of Thilogne was the principal aim of the cultural festival, it was clear that TAD did not restrict itself to local agendas. For instance, at the 2014 festival, local youth was organized in order to stage a march for peace in Casamance, Senegal's southernmost region, where a separatist movement wages an armed struggle for political independence. By taking such an open stance on such a controversial issue the festival firmly inserts Thilogne into the national public sphere, but in various respects it does so at the expense of excluding part of its population.

Interestingly, within the context of the festival the process of mediation promoted by the organizers very much depends on modern means of communication. For instance, the organization had hired the Senegalese Radio and Television service (RTS) to record the festival in order to produce a video for dissemination in the Thilogne diaspora. The resulting video was to be sold to the members of TAD abroad. Those migrants who could not attend could thus be provided with highlights of the festival. In this video, the newly built stadium in which the festival was staged figured prominently, communicating to the migrants that Thilogne has its own state-of-the-art stadium, complete with electric lighting. Thus the festival mediated professional images of Thilogne's modernity via national television to the home audience and through video to Thilogne's *ressortissants* abroad. The festival thereby sustains the sociality and solidarity of a transnational community by communicating and asserting its modernity.

It is important to emphasize that the conception of modernity performed at this cultural festival was undeniably a local one. This was conveyed very clearly in terms of the musical programme staged at the local stadium, which included Haalpulaar icons such as the late Demba Dia, a national star with local roots, alongside local rappers copying global hip-hop stars. But even if many bands mimicked a global genre of rap music, some played distinctly Senegalese genres using acoustic instruments that celebrated a sense of locality (and were referred to in the national newspapers as 'groupes folkloriques'). It seems justified to suggest that the programme staged bands that played distinctly local genres of music alongside local rappers in a deliberate attempt to present local genres as equivalent in value to global rap music. But, the most important star at the festival did not require any more global recognition than he had already obtained: Baaba Maal's performance sealed the significance of the Thilogne cultural festival. On the last night of the event, the songs of this Haalpulaar artist could be heard for miles across the plains of the Senegal River, asserting the global reach of Thilogne's modernity to a local audience.

Repertoires of Tradition

If the festival promotes an image of Thilogne's modernity by emphasizing its development achievements, individual youth use the festival as a platform to convey their own modern subjectivities. Dressed in T-shirts with pictures of Tupac or NME, Thilogne's youth demonstrated its global musical tastes. Alternatively, they conveyed admiration for international football players like David Beckham, or national players like El Hadj Diouf and Henri Camara, displaying their preferences on their sleeves. Some communicated controversial political affiliations by wearing T-shirts with the effigy of Osama Bin Laden (at the time not yet eliminated by US special forces) against a backdrop of the World Trade Center towers on fire. Although some wore suits,

US black popular culture provided more inspiration than the formal dress codes associated with French civilization. Although some girls could be seen wearing trousers at night, during the daytime they invariably wore *boubous* or *ensembles* (a hand-tailored skirt and top made of the same *bassin* or *wax*). Conveying a sense of a plural African modernity, dress choices also conformed to local standards of female modesty in keeping with local, Muslim standards.

Alongside proclamations of Thilogne's modernity, the festival also staged cultural performances to articulate the town's traditional, hierarchical structure. This section will explore how the cultural festival as a genre of cultural performance has been appropriated to claim global membership by serving as both channel of modernity as well as 'archive' of tradition. To demonstrate this, a brief sketch of Thilogne's social organization is required. Populated almost exclusively by Haalpulaar speakers, Thilogne's social structure is complex and notably hierarchical. Polities of Fuuta Toro, the region in which Thilogne is situated, have their origins in an Islamic revolution whereby a class of Muslim clerics (*toroobe*) assumed hegemony, ending the rule of pagan Fulbe. Although their hegemonic position was curtailed by French colonization, the social structure of a tripartite hierarchical system of different estates in which the *toroobe* dominated has remained in place even after decolonization. In this system the *toroobe*, alongside other land owners, constitute the freeborn, while slaves attach themselves to families of the freeborn in positions of inferiority. The second estate, or intermediate category of men of skills (*nyeenybe*), comprises various kinds of artisans who offer their skills to *toroobe* in exchange for rewards (Dilley 2004). While none of these distinctions is today recognized by the national government, they continue to be observed in day-to-day interactions in Fuuta Toro (as well as among its migrants wherever they live in diaspora). Interestingly, although cultural festivals are mediations of modernity, they also seem to articulate the hierarchical distinctions typical of society in Fuuta Toro.

During the festival in Thilogne, performances of tradition were staged on several occasions: there was a display of traditional wrestling, a performance of circumcised boys singing circumcision songs, a dance by Lawbe women, a performance of a traditional rite of passage by young women and a performance of sheep-herding by Fulbe herders. An entire repertoire of embodied performances was thus enacted for the audience to admire. It is significant that each of these performances was staged by children, women or members of specialist skill groups or 'castes'. The Lawbe, for instance, constitute a social category of which the men are expected to exercise the skill of woodworking, while the women are attributed special knowledge of the domains of sexual reproduction and erotic know-how. This is one reason why Lawbe women are expected to excel in dance, an activity considered 'un-Islamic' and befitting lower-status categories. Their performance at the festival thus reinforced notions about their (dis)reputed mastery of their bodies. This embodied performance conveyed the sense of a social structure, whereby the subordinate social groups are invited to perform social roles that

dominant social groups condemn as not in keeping with Muslim standards. But the public performance of morally hazardous roles was not confined to this particular status group, as Thilogne's young women were allowed to perform the traditional rite of passage of Thiayde. Although certain forms of courtship would today certainly be condemned as not in line with Islamic standards, the performance of the Thiayde by young women was certainly highly appreciated. Historically, the Thiayde was a competition between young women from different neighbourhoods who would compose 'praise songs' to honour themselves and sing diatribes to shame their competitors with the aim of attracting as many husbands from their own neighbourhood, and possibly from others, while also preventing young men from their neighbourhood from marrying elsewhere. At the festival of Thilogne women re-enacted this competition within the stadium for a mixed audience. As Kane argues, this carefully choreographed re-enactment of ritual competition for husbands is a tradition reinvented for the purpose of the festival. Moreover, he suggests, 'It is striking to observe that the cultural practices being performed during the festivals tend to be of little relevance to contemporary village life' (2010: 14). He is correct, of course, that the Thiayde is no longer performed in its current format. Kane also suggests that Thiayde has evolved into a form of ritual competition between girls for future husbands that is today performed around matches played by youths at the football pitch. It is clear, then, that the cultural festival provides an occasion for the staging of a local repertoire of embodied performances as they have been enacted in the past—without acknowledgement of their contemporary iterations.

In her study on the archive and the repertoire, Diana Taylor defines the archive as consisting of supposedly enduring materials, and distinguishes it from the repertoire as consisting of embodied practice/knowledge (2003: 19). In that sense, I would like to suggest, it is possible to conceive of the cultural festival of Thilogne as the representation of a local repertoire of embodied performances. But we should also acknowledge that the repertoire is selective and clearly attributed to categories of the local population that are seen as not bearing responsibility for the transmission of values associated with the Qur'an. In fact, I would suggest that at the festival the repertoire is defined as that which is opposed to Islam, but can nonetheless be transmitted within the context of the festival as constituting the 'roots' that migrants have come to learn about. As the repertoire is framed by the festival as 'tradition' or 'roots', it enables the festival participants to conceptualize these traditions as *not* contemporary. As Taylor astutely observes, 'the tendency has been to banish the repertoire to the past' (2003: 21).

The cultural performances staged at many cultural festivals are framed as 'traditions' that define a dehistoricized cultural essence, which in the context of the festival is attributed to the performers. For instance, sheep-herding by Fulbe herders was one of the most spectacular performances at the cultural festival of Thilogne that enabled the audience to understand itself as 'developed' by distancing itself from the alleged timelessness of 'tradition'.

Performing one at a time, four Fulbe herdsmen ran at high speed across the pitch, circumventing the public sitting there. Every herd of sheep faithfully followed its herdsman. This was a spectacular sight and the public responded enthusiastically to the spectacle of running sheep. The excitement reached its climax when one of the herds stormed into a row of seated women, who took to their feet in fear, and, shouting loudly, dragged their plastic chairs with them in search of security. Here, the distinction between the 'uncivilized', pagan Fulbe and the 'civilized', Muslim toroobe was graphically drawn into relief, as a contamination of these categories dramatically unfolded on the football pitch. The public laughed, in a way Bakhtin would have understood as a carnivalesque 'inversion' of the status hierarchy. After the show, the MC, who gave a running commentary on the performance, concluded, with pomp: 'La culture Peul est magnifique! C'est la seule culture qui ne s'est pas transformée. C'est à dire qu'elle est authentique, qu'elle est vraie!' [Fulani culture is magnificent. It is the only culture that has not been transformed. That means it is authentic, it is true!]. The comments suggest that in the context of the festival the Fulani herdsmen embodied a cultural essence for a public whose return to Thilogne had served their initiation into local culture and, through the distancing of spectacle, had yet been able to affirm its modern subjectivity. The cultural festival of Thilogne archives cultural performances associated with an archaic social structure to enable a nostalgic longing for lost cultural essences.

Conclusion

In his critical analysis of the spectacle, Guy Debord (1983) states that a spectacle is not an image but a series of social relationships mediated by images. Mediating social relations, a cultural festival inevitably transforms the relationship between performers and spectators (Barber 1997; De Jong 2014). At the cultural festival of Thilogne all the performances were staged by children, women or the members of specialist skill groups. The staging of the repertoire was thus attributed to subordinate social categories. The festival re-enacted the hierarchical social structure of estates for a public that embodied a modern subjectivity. Re-enacting the order of estates in a contemporary spectacle, the festival of Thilogne thus resembles other festivals at which the social structure is celebrated in a form that re-enacts historical hierarchies (De Jong 2009b).

The cultural festival of Thilogne constitutes a representation of a cultural repertoire that is transmitted through embodied performance. Situating itself in national and transnational public spheres, the festival mediates modernity through the transmission of performed embodiment. But this mediation has never been a one-way process only, whereby the modern originates in the metropolis and is gratefully received in the colony. In fact, it is due to the appropriation of the colonial format that the festival works so successfully

for the community of Thilogne. For instance, as mentioned above, the RTS produced a video of the festival which was distributed among the members of Thilogne's diaspora. For migrants who were unable to travel to Thilogne, this video demonstrated that Thilogne, too, like other cities and towns around the world, had successfully staged a festival. The migrants were thus assured that their financial and moral contributions to TAD had been used appropriately as the video testified to the town's modern development. The mediations that the cultural festival enabled were directed towards its own, transnational public sphere.

In the postcolonial festivals of Pan-African self-assertion, the performance format adopted for the representation of venerated African traditions owed much to formats established at the colonial exhibitions. Cultural production in the Third World emerged in an economy of the sign in which tradition stood for 'authenticity' and this has not fundamentally changed (Murphy 2012a). Cultural festivals in Senegal follow Negritude's logic of framing traditions in a modernist format to demand recognition for the contribution that African culture has made to the history of humankind. Appropriating this format of imperialist cultural production, Negritude has valued the transformation and translation of culture through cultural exchange as epitomized in Senghor's adage *ouverture et enracinement*. The concept of culture employed in today's festivals is the same and is constituted by a repertoire of embodied performances. Like so many communities in Senegal, Thilogne's transnational association has appropriated the festival as a platform for staging an 'African' self to an audience of villagers and international migrants. Tapping a repertoire of embodied performances, the town has successfully appropriated the colonial format as a technology for archiving itself.

FESMAN at 50: Pan-Africanism, Visual Modernism and the Archive of the Global Contemporary

Elizabeth Harney

In the spring of 1966, the eyes and ears of the black world focused on the *Premier Festival mondial des arts nègres* (FESMAN). In the wake of decolonization, artists and intellectuals convened for almost a month of discussions, performances and festivities in Dakar. The official rhetoric of the host nation focused on the event as a celebration of a shared black condition, advancing a belief in Negritude as a viable tool for the expression and reconciliation of blackness and modernity. Most historians cite the 1956 and 1959 Black Artists and Writers Congresses held in Paris and Rome respectively as precedents. In fact, these were part of a much broader set of cultural proceedings in the immediate post-war era that took as their remit the task of reclaiming denigrated heritages, seeking viable political alliances, envisioning liberated futures and imagining new humanisms. Each of these gatherings, aimed at addressing the pressing political shifts of the day, did so with a steadfast belief in the central role culture could play in the process of nation-building and the fashioning of postcolonial subjectivities. Recognizing the profound imbrication of modernist vanguardism and the colonial project, these events also invested deeply in modes of exhibitionism to foster transparency, accountability and dialogue.

In 1955, in the hopeful early days of Nasser's pan-Arabism, Alexandria hosted the 'Biennale de la Méditerranée', one of the first visual arts biennales on the continent. Like other events of its kind, it 'sought to use the display of recent art as the means to loop back to a glorious era of local art production so as to resurrect the city's international and cultural status' (Gardner and Green 2013: 444). In that same year, the heady declarations of the Bandung Conference set the tone for Third World solidarity and dialogue. Against the growing divisions of the Cold War, in 1958, the Soviets hosted creative and political exchanges at the Afro-Asian Writers' Conference in Tashkent. In 1962,

Frank McEwen organized The *First International Congress of African Art and Culture* at the Salisbury National Gallery in what was then colonial Rhodesia. This cultural arts festival anticipated both the form and feel of FESMAN, attracting notable international attendees such as the first director of the Museum of Modern Art (MoMA), Alfred Barr, artists Tristan Tzara and Roland Penrose and scholars William Fagg and Michel Leiris. It also featured the first exhibition of Shona sculpture, showcased works by pioneering African modernists Ben Enwonwu and Vincent Kofi, amongst others, and included a symposium, dance and musical performances (Njami 2005: 227).

Belief in the efficacy and allure of international gatherings to foster commonality certainly owed much to the legacy of early twentieth-century DuBoisian pan-African congresses in Europe and America. But the performative and visual format of FESMAN also recalled the weighty imperial spectacle of metropolitan world fairs, wherein cultural and racial 'difference' was enacted and embodied as visual fetish and visceral fantasy, all for the delight of the European viewer. With this history in mind, FESMAN '66 surely marked a counter-discursive occasion in which Africans dictated the terms of representation, even if that presentation, as many have claimed, rested upon a mix of reordered fictitious histories and naive imagined futures.

The visual arts constituted a key platform upon which Léopold Sédar Senghor advanced his vision for a shared black consciousness and a universal civilization. As president of his new nation, Senghor put in place a robust patronage for artistic production, establishing a state-of-the-art museum, art academies, annual salons, prizes and bursaries and touring international exhibitions. Senghor's fledgling government claimed to devote 25 per cent of the annual budget to the promotion of culture and consequently positioned the festival as a showcase for this burgeoning art scene, a space of international intellectual exchange and an expression of pan-Africanist cultural pride (Harney 2004). The events of 1966 included two substantial exhibitions, one showcasing the works of contemporary artists from across the continent and diaspora and the other featuring 'traditional' arts gathered through large, unprecedented loans from Western museums. An international symposium on the 'Function and Significance of Negro-African Art in the Life of the People and for the People' augmented these displays (Ficquet and Gallimardet 2009). The commitment to building a receptive and engaged 'public' and crafting a key role for the artist in modern African society was unprecedented, as was the concerted effort to marry discussions of aesthetic heritage with modernization plans.

The multifaceted festival in Dakar proved a lightning rod for numerous debates. Some focused on the tone and terms of post-independence nationalist and supra-nationalist politics—asking what the most effective way forward would be—armed conflict, conciliatory accommodation or some combination thereof. Others challenged the thinking around cultural and racial particularism as it related to assertions of revamped, post-war universalism. Still others questioned the cultural elite's use of spectacle as a mystifying tool

in what they saw to be the continuing disenfranchisement of the masses (Adotevi 1972; Armah 1967; Mphahlele 1962).

Though the philosophical premises and political underpinnings of FESMAN incurred sustained criticism, the festival format would hold lasting appeal, particularly in 'that grey time between decolonization and absorption back into the tectonic undertow of North Atlantic modernity' (Gardner and Green 2013: 447). Indeed, in the decade following FESMAN, other emerging African nations mounted similarly ambitious cultural gatherings, most of which included exhibitions, dance and musical performances and intellectual congresses. These included Algiers in 1969, Kinshasa in 1974 and Lagos in 1977. Others in this volume discuss the archive and import of these occasions in depth. In this chapter, I will focus primarily on the second wave of festivalization that emerged rapidly after the end of the Cold War in the early 1990s, and particularly on the fate of pan-African agendas in a globalizing art world (Bennett, Taylor and Woodward 2014).

How is the imagined and literal archive around FESMAN, and its visual arts components in particular, continually revisited, revalued and repositioned in the literature and politics of the contemporary art world, and increasingly in the spirit of works of artists themselves, many of whom are eager to make sense of the forsaken utopian visions of their parents and the promises of the liberation struggles? Now generally credited as the precursor to the African art biennales and triennials of today, particularly *Dak'Art* which began in the early 1990s, FESMAN's far-reaching aims seem to belong to a lost, squandered modernist moment, in which the winds of decolonization made discussions of 'new universalisms' possible despite the hardening of Cold War tensions and the constant threat of neo-colonial exploitation. In the intervening years, the study of African arts has shifted dramatically from one informed by primitivist, ethnographic understandings of tribal traditions (largely in the hands of European specialists) to a lively discussion of local modernist histories and an ascendant taste for contemporary African artists (through the concerted efforts of a critical community of African and diasporic curators).

A little over a decade ago, art critic and artist Rasheed Araeen assessed the conditions for contemporary African arts (in the wake of biennialization), asserting:

> African art has come a long way; it has now reached a position where there seems no longer to be conflict or struggle with the dominant centre. But can this really be true? If the social, economic, and political conditions of Africa are still struggling against global hegemony of the West, how can its art be free from this hegemony? The present generation of African artists—those we see at the Dakar Biennale as well as those in international exhibitions—may not feel that there is any need to confront the dominant system, but are they not then abandoning the very principle of modernism or the avant-garde (dissent from or challenge to the established order) from which they derive their formal strategies? (Araeen 2003: 100)

In this and many other writings, Araeen urges active and reflexive artistic practice, pointedly exposing the deliberate apolitical nature of the 'global' art world—one controlled by ever-increasing networks of capital and invested in dismissing, playing down or normalizing continuing hegemonies.

Nowadays 'Contemporary African Art' is a hot commodity in the global art world, prompting scholars to rethink the parameters of an art historical canon that had always dismissed African modernist art practices as derivative. Established modern art museums in multicultural metropolitan centres now seek out and promote pluralist histories. Many of these institutions are looking not just to diversify their narratives of modernity but, more so, to reposition modernism as global and multiple—as a set of interconnected phenomena that begat global contemporary practices. For example, the Tate Modern recently launched a two-year initiative to collect and focus public programmes on modern and contemporary African arts, featuring a solo exhibition of Sudanese pioneer El Salahi. In 2013, the Pompidou installed a re-hang of its permanent collections with an eye towards complicating western readings of modernism in the exhibition, 'Modernités plurielles 1905–1970'. In the realm of international festivals and art fairs, curator Okwui Enwezor included a sizeable and unprecedented number of African artists first when he curated 'Documenta 11' (2002) and did so again at the 2015 Venice Biennale. At the same venue, in 2013, Angola won the country award. Notably, 'Art Dubai' (2013) featured the 'Marker' exhibition, a showcase for contemporary artists from five African countries. Meanwhile, in London, independent African curators caused a buzz with their launch of a successful pan-African art fair '1:54' at Somerset House.

What then, one must ask, is the lasting relevance of Dakar 1966 in a contemporary art world that is deeply informed by new models of self-awareness but subject to increasingly aggressive forms of commodification and spectacularization? What expectations do we bring to these histories and their archives? The official archive and its controversial rhetoric of Negritude still have much to contribute to our understandings of the choices made by artists and intellectuals at the time. This archival legacy, however, is now usefully tempered and supplemented by formal and informal conversations with those who participated in or inherited its mantle. For example, in Senegal in the 1990s many first-generation modernists who had participated in 1966 sought to distance themselves from its stultifying shadow. The younger generations spoke adamantly of attaining status as international artists rather than as black or African artists (Harney 2004). Thus FESMAN seemed to operate as both a burden and a blessing—a spectre always available as a local lineage, an anachronism open to quick dismissal or nostalgia, a remembrance of a time when the world seemed to come to Dakar and the horizon of possible futures was visible.

Nostalgia and the Archival Impulse

> I was born to an Africanist, an Ethiopian, and an American who's a
> Montessorian, both modernists, both in certain ways utopianists [...]
> Two thirds of the world being decolonized, this shift to being your own
> individual nation—that's the history that I am coming from. We were the
> children of the people who were making this new world, who believed in
> this new possible world. That informs not only who I am but also those
> socialist and Utopian ideas and theories—they almost haunt me. Not
> necessarily as things that I can believe in, but you can believe in parts of
> them. But they're there—it is the desire—it haunts my thinking. (cited in
> Erikson 2009: 67)

The above reflection of Ethiopian-American artist Julie Mehretu is not unique,
as she and many others of her generation (Zarina Bhimji, Zineb Sedira or
Sammy Baloji, to name but a few of the most visible) evoke in their poignant
and pained work the 'post-memories' of decolonization. For Mehretu, this
haunting signals a critical and useful 'inter-chronic pause', revealing a moment
in which the work of culture seemed urgent and charged with imagining
better futures; an era of mindful assessment (Kubler 1962: 17). While a number
of postcolonial theorists have critiqued the generation of anti-colonialists as
naive nationalists or, worse still, in the case of Senghor, cultural accommoda-
tionists, now the sincerity and utopianism of these thwarted dreams holds
deep appeal—not just for a simpler time and more straightforward answers,
but also for a set of imaginable futures. Jennifer Wenzel has described current
'nostalgia for the Cold War and the weight of the Third World within it, [as a]
nostalgia for a time when the Third World mattered'. 'Unlike other kinds of
nostalgia', she continues, 'anti-imperialist nostalgia is a desire not for a past
moment in and of itself but rather for the past's promise of an alternative
present: the past's future' (Wenzel 2006: 17). For many, then, the bankruptcy of
progressive ideologies (Marxism, indigenous socialisms, Fanon's liberationist
ideals, pan-Africanism) has led to the deep and disconcerting sense of living
in 'tragic times' (Scott 2004: 2). In his masterful text, *Conscripts of Modernity*,
David Scott attempts to remap 'the problematic in which the relation between
colonial pasts and the postcolonial present is conceived' (9). Borrowing from
the work of historian Reinhart Koselleck, he asks what happens when the
'horizon of possible futures' (29) becomes our 'futures past' (42)? Our main
challenge in understanding the linkages between past, present and future, he
insists, is to retain a reflexive approach about the kinds of questions we 'ask'
about the past. In other words, from our contemporary vantage point, how do
we reconcile what Stuart Hall identified as 'the collapse of social and political
hopes that went into the anticolonial imagining and postcolonial making of
national sovereignties?' (Hall 2005).

Mehretu and her family fled Ethiopia soon after the Socialist Derg regime
assumed power in the 1970s, first for Senegal and then for a suburban life
in Michigan. It would be many years before she returned to Ethiopia and yet

her artistic sensibilities had long gravitated towards the archaeological—unearthing histories big and small, lost, silenced or misplaced. Her highly detailed, gestural abstract 'paintings' or murals can be disorienting in their compression of time, space, and place. They speak to the grand points of history—wars, mass migrations and displacements, and the spread of global capital. In translucent vellum and acrylics, she layers archivally sourced architectural drawings, colonial-modern city plans and maps of empire to give a sense of the shared human condition. These structured forms are always complicated by detailed hatch-marks in pencil and ink, said to represent equally important micro-histories and populist action, to remember the power of the individual to contribute to the welfare of the common. In Mehretu's realm, these hatch-marks are fists, raised in revolution, defiance or victory. There is a purposeful opacity to these works, with their illusions of depth, mass, and the cacophonous multiplicity of mankind.

Curators and critics have written extensively of the 'archival impulse' that characterizes much artistic practice in our globalizing world (Foster 2004). Engagement with the archive takes on various forms, from unearthing forgotten materials or silenced voices to questioning the very disciplinary structure that conserves and values these fragments of the past. This practice of archaeology among visual artists subverts or at the very least challenges the global art world's frequent claims of post-historicity, cosmopolitanism and globalization (in the form of biennialization), all of which threaten to submerge and flatten the diverse lived experiences of colonialism and lessen the gains of decolonization and postcolonial politics.

Wary of how the details of history can be obscured, muddied or rewritten to serve the aims of the powerful, Mehretu's pieces insist on vigilance in our attempts to inscribe details of the past and visions of the future onto our present. In this sense, they embody the challenge of remembering historical events like FESMAN and the complicated era in which they flourished. Nostalgia and taste for the retro, seen most vividly in the art world's explosive market for mid-century studio portraits from all over the African continent, severely limit the capacity to understand the *longue durée* of modernity in Africa, situating it only as an easily consumable post-war phenomenon and in the form of European style nationalisms or vanguardist actions (Mercer 2001). Most notably, Okwui Enwezor's impressive exhibition *The Short Century: Independence and Liberation Movements in Africa, 1945–1994* (2001) singlehandedly changed how the larger art world viewed the modernity of Africa, siting it as a purely postcolonial phenomenon. The 1966 festival, presented as a pinnacle of African modern expression, slots perfectly into these timelines, recently plotted by curatorial and scholarly forays alike. As Mercer suggests, the act of recollection can quickly become one of 'redemptive reading', running the 'risk of narcissistic entrapment' in which the use of archival material is 'fixed merely as fashionable iconography in retro-chic' (Mercer 2012).

But of course events such as the 1966 festival were characteristically messy affairs, containing within them, and on their fringes, deep divisions,

contradictions, and misunderstandings emerging out of lively exchange. The attendees brought with them comparable but varying experiences of colonial oppression and diverse visions of black modernity. This diversity has allowed curators, critics and artists to sample and quote generously from this precursor to make sense of and, at times, legitimize their contemporary efforts.

Dialectics and Disillusionments

According to Senghor, the 1966 festival was 'the defence and illustration of Negritude [...] the elaboration of a new humanism, which this time will include all of humanity on the whole of our planet earth' (cited in Vaillant 1990: 332–33). Described variously as a sense of belonging, pride, a way forward in the decolonizing world, and the sum of the values of black civilization, Negritude certainly served as the framing rhetoric of the festival, and the script behind Senghor's cultural patronage more broadly. But this reading has also served to discourage further analysis of the impact of these events. Senghor spoke of creating a 'black ontology'—one that acknowledged the 'vital life forces' and rhythmic dimensions of African heritage. In vocabulary that mirrored European scholars of the time, such as Leo Frobenius, Marcel Griaule and Placide Tempels—the crowd that Simon Gikandi has called the 'surrogate informants'—and drew from Black American writings, Senghor shaped what he saw to be a viable way forward (Gikandi 2003: 475). This agenda is evident in so much of his writing, where he noted: 'The vocabulary of the ethnologists who were just beginning to unveil black Africa's secrets was adopted: like them one spoke of life forces. This was all the young Negro elite was asking for. We had regained our pride' (Senghor as quoted in Dathorne and Feuser 1969: 341). Though unsatisfying to the politics of today, his vision was counter-discursive, nativist and useful for young students in the interwar period—and certainly a less violent means of reckoning the imbrication of colonial culture and local ways of life than that of other anti-colonialist campaigns that called for armed resistance.

As noted by many scholars, his fellow poet and politician Aimé Césaire held a different vision of Negritude, describing it over the years as a shared heritage of displacement, movement, bricolage or creolité. Much of his description can be read within the abstracted language of Mehretu's tumultuous history paintings:

> Negritude, in my eyes, is not a philosophy. Negritude is not a metaphysics. Negritude is not a pretentious conception of the universe. It is a way of living history within history: the history of a community whose experience appears to be [...] unique, with its deportation of populations, its transfer of people from one continent to another, its distant memories of old beliefs, its fragments of murdered cultures. How can we not believe that all this, which has its own coherence, constitutes a heritage? (Césaire 1955: 82)

Nonetheless, for its critics, both then and now, Negritude represented 'a messy and untimely insurrection of particularism' (Diagne 2010: 244) into liberation struggles and the cultural politics of decolonization. Scholars today continue to focus our attention on the festival's shortcomings—particularly Senghor's avoidance of any kind of radical politics required for serious anti-imperialist action and the disenfranchisement of the populace (by sanitizing the streets of the poor and homeless, imprisoning and silencing leftist political opposition). Wole Soyinka and Stanislas Adotevi represented just two of Negritude's best-known detractors. At a time where the gains of independence were still fragile and uncertain, Senghor's version of Negritude was instead largely focused on cultural and psychological liberation. The first years of decolonization were politically acrimonious and tumultuous throughout the continent. In February 1966 (two months before the opening of FESMAN), Kwame Nkrumah, first president of Ghana, was overthrown in a military coup, and the Casablanca–Monrovia split exemplified deep divisions over how best to proceed—armed struggle, various Marxist–Leninist or gradualist approaches (Ratcliff 2014: 173–74).

As Anthony Ratcliff argues: 'To believe that the years of colonial rule would somehow be wiped away simply by returning to pre-colonial cultural practices was highly ahistorical and impolitic' (177). Moreover, Senghor's concept of universal civilization seemed to 'not take into account the continued economic and political exploitation of Africa by Europe and the United States aided by corrupt African elites allied with the West' (176–77). To many it seemed that Senghor was too invested in dialogue. Ratcliff has recently dismissed FESMAN as an occasion that 'mainly revolved around defending Negritude' (175), but I would argue that it set the stage for important discussions that continue to animate the visual art world today—in Senegal in particular, and within many African intellectual circles, not necessarily as direct legacies but rather as resonances.

Resonances

In order to identify some of the connective tissues that join modernist narratives of blackness with their contemporary resonances, one has to set aside the disappointments of Negritude to consider its relevance in our post-racial moment. As Diagne argues, Negritude 'continues to live as an aesthetic category which advocates mixture, hybridity, demultiplication of identities, interactionality' (Diagne 2010: 242). Likewise, key questions that animated the 1966 festival remain not only relevant but pressing issues in today's art world, a few of which I will discuss below: notably, the role of the artist in modern society, the nature of his or her public, the choices between engaging rather than simply commodifying heritage, and the desire to craft a unique and viable modern or contemporary aesthetic practice out of the push and pull of the local and the global.

There are many physical legacies of the 1966 festival and the Senghorian patronage structure that supported it. For example, the Musée Dynamique built to house the grand exhibition of traditional African arts at FESMAN was positioned in a commanding site overlooking Soumbedioune Bay to the west of downtown Dakar and assumed the austere form of Greek temple architecture. Before its closure in 1977 the museum represented a grounded *site* of Senghorian patronage, and in its years of functioning hosted annual artists' salons, individual exhibitions by select Senegalese artists and travelling exhibitions of works by Messanier, Da Vinci and Picasso, amongst others. It reopened in 1985 and was used the following year by the local artists' association to mount the national art salon. However, amidst a storm of protest and lobbying by artists the government closed it again in 1988, first converting it to a school of dance and subsequently making it available for use by the Supreme Court (Sylla 2007). It opened briefly once more for visual arts in the 1990s. The fate of the national collection once stored within its walls remains unknown and controversial. Public and private pleas for the museum's reopening have continued to no effect (Huchard 1992: 7). The most obvious infrastructural 'legacy' of the 1966 festival is *Dak'Art*, the contemporary visual arts biennale that began in 1992 and continues today. But it has never been a direct heir and its appearance in the last decade of the twentieth century came after many false starts, significant upheaval in the political and cultural realms in Dakar, and in concert with a growing desire for new contemporary prospects in the larger art world. Yet it is impossible to deny that Senegal has one of the most active art scenes on the continent.

While I have written extensively about these changes elsewhere, what remains key to this discussion is surely that the efforts of the 1966 festival (the centrepiece of Senghor's administration) created a broader culture of expectation in the country's intellectual circles and, to a large extent, among circles within the culture industry—craft and tourist arts centres, artisanal communities and so on (Harney 2004: 323). FESMAN advanced 'culture' and, by extension, the arts and the artist, as prime operators in the making of a well-functioning postcolonial society, identifying them as instrumental to the more-difficult process of decolonizing the mind and rebuilding bankrupt forms of humanism. Believing in the 'inherently reformative power of culture' (Jachec 2010: 196) in forging a new humanism, Senghor drew upon the philosophical writings of French scientist and Jesuit Pierre Teilhard de Chardin to propose the concept of *Civilisation de l'universel,* to which each culture could contribute to form the Great Civilization.

Harnessing the ideas developed in his Negritude writings, the poet-president set about promoting the nourishing essence of Africa as the common cultural basis upon which to build a shared, globally relevant culture (Senghor 1977). In his conciliatory opening remarks to the festivities of 1966, Senghor asserted boldly that Africa was poised to contribute to an emergent humanism desperately needed after the war, noting:

To whatever God, whatever language they belong, the Nations are invited to the colloquy of Dakar, to bridge the gaps, to clear up the misunderstandings, to settle the differences. Partaking [...] in the building of the universal civilization, united, reunited Africa offers the waiting world [...] the sense of her artistic creation. (Senghor 1966a: 14)

We are deeply honoured on the occasion of this Premier Festival Mondial des Arts Nègres to welcome so many talented people from the four continents: the four horizons of the mind. But what is an even greater honour for us, and one which does you the greatest credit, is the fact that you will have participated in a much more revolutionary undertaking than the exploration of outer space: the development of a new brand of Humanism which, this time round, will include everyone on the planet. (Senghor, cited in Deliss 1995: 224)

A Public Art if Not Quite a Public Sphere

The size and scope of the traditional arts exhibition at the 1966 festival was quite remarkable for the time. It brought art works from 52 museums around the world and was, as of that date, the largest collection of traditional art works for an exhibition on the African continent. It had been in the planning since 1963, not long after Senghor took the helm of his newly independent nation. This exhibition was fully subsidized by the French government, enabling the exhibition to then travel on to the Grand Palais in Paris in August 1966. In contrast, the exhibition of contemporary arts was a modest affair; organized by Senegalese painter Iba N'Diaye—an artist who did not, in the end, want to adhere to Negritude inspired teachings or curating. This exhibition, entitled 'Tendances et Confrontations' featured many of the pioneers of Africa's burgeoning modern art scenes: Christian Lattier, Ibou Diouf, Papa Ibra Tall, Ben Enwonwu as well as key artists of the diaspora such as Frank Bowling. Its legacy is as much visual as intellectual, as it gave many of these young artists a remarkable chance to test their own understanding of their craft in relation to their identity, in an international spotlight. Reflecting on his engagements with Senghor's promotion of Negritude-inspired aesthetics years later, Papa Ibra Tall explained his choices to me as follows:

At the time it was a question of creating, for myself, an artistic language, which seemed to me to belong to Africa and to Senegal. I concluded that art is universal but that it was necessary for there to be particularities that one had to transcend to achieve this universality. So I thought that I couldn't imitate what the French were doing. I was completely outside of that tradition. Therefore, I thought that it was necessary for me to construct a completely new language. I was inspired by the theory of Negritude, which, back then, you must recall, was unique. Wole Soyinka didn't yet exist and the other theoreticians of the day were economic theoreticians—Nkrumah

had an economic theory, not cultural. So, those of us who wanted to create something autonomous, belonging to and reflecting just us, had little to inspire us but Negritude. What interested me in finding a kind of authenticity was not to create pure decoration but to create a language of visual forms, which defined me for myself. (cited in Harney 2004: 59)

Senghor spoke often and with passion of the importance of the artist in the decolonization process, his attentions threatening to strangle creativity:

> However paradoxical as this may seem, writers and artists must play and are playing a leading role in the struggle for decolonization. It is their place to remind politicians that politics, the administration of the Polity, is only one aspect of culture, which, starting from cultural colonialism, in the form of assimilation, is the worst of all. It is their part to analyse the *overall situation* of their respective peoples, and in relation to it, to say what must be retained out of their traditional civilization—values and institutions— and above all to say how they are to be given re-birth thanks to the leaven of external contributions. (Senghor 1959: 293)

But at the 1966 symposium it was Alioune Diop, director of Présence Africaine and head of the Société Africaine de Culture, a key sponsor of the event, who engaged directly with the critical space of the modern artist and his public, arguing:

> There is a regrettable paradox: on the one hand the western public (the only to have appreciated negro art) does not understand the message of the traditional sculptor, and on the other hand the artist of today (like the modern poet) is better appreciated by the west than by his own fellow countrymen. It remains for us, therefore to help the artist and his people to understand each other, and to bring the African people up to date with the modern world [...] Such an understanding between artists and their African public presupposes, it is true, that the people have knowledge and understanding of themselves, that is of their tradition and that the stocktaking as it were of their heritage brings them face to face with the major problems of modern art. (Diop 1966: 17–19)

The fraught linkage between traditions, modernization and modernism was key to these discussions. Is the society modern enough to appreciate and understand the work of its artists? Is it the role of the artist to help (his) public understand itself and its place in a modern society?

Senghor's theories of a 'negro-african aesthetic' remain a controversial feature of his patronage, and yet many of the questions they sought to address, about the power of heritage (real or imagined) and its linkages to race or culture, remain central to debates at *Dak'Art* and within broader black intellectual circles that discuss the merits of Afropolitanism or African Renaissance (Vincent 2014). Moreover, they feature prominently in the ethos of the global art world in which curators seek to nurture authentic localism

and speak of 'multiple temporalities', while adhering to a largely homogenized post-conceptual 'biennale' aesthetic. Fifty years ago, Alioune Diop signalled the challenges of thinking through the 'time' of the modern, noting:

> Modern art fires our enthusiasm, inciting us to write the splendid history of humanity [...] This is all very well, but has the African world reached this stage? Moreover, do we need to go through the same succession of experiences as the western world? Nothing is less sure. (Diop 1966: 19)

Pan-Africanism and Festivalism

From the 1980s onwards, the African continent witnessed an explosion of visual arts festivals: the Bantu Biennale (Gabon, 1985), the Johannesburg Biennale in 1995 and 1997 (now defunct), Bamako Encounters (a pan-African Photography Biennale, beginning 1994), the Cairo Biennale (first mounted in 1984), the Cape Africa Platform (2003), the Amnesia Project (Kenya, 2007), Addis Photofest (2010), the Luanda Triennial (2007), the Lumumbashi Biennale (2008) and many others. Most were funded by a combination of global capital and local governments. Most championed the importance of strengthening intra-continental ties, thereby circumventing or trumping the workings of the Euro-American art machine.

Critic Thomas McEvilley (1993) was one of the first to alert a mainstream Euro-American art world comfortable with its own centrality and primacy to seismic shifts occurring in the global contemporary art scene with the proliferation of non-Western or so-called 'alternative' biennials in many former colonies. As the model of the biennial began to expand in geography and in frequency, Peter Schjeldahl of the *New Yorker*, along with *New York Times* art critic Roberta Smith, chronicled a new phenomenon of 'festivalism' (Schjeldahl 1999: 85–86). I am less interested here in questions of biennalogy than in what Okwui Enwezor has called 'the numbing logic of spectacular capitalism' and the manner in which festivalization builds upon or draws on a deeply felt nostalgia for counter-hegemonic projects (Enwezor 2008: 160). Could festivalism represent a new promise, delivering fresh forms of civic address and participation, missing from the 1966 festival? Or are these theatrical exhibitions threatening, instead, to transform Dakar and other world cities into marketplaces of postcolonial vanguardism within easy reach of neoliberal capital? Is the new emphasis on the global a more equitable form of universalism?

Echoing the questions of 50 years before, Yacouba Konaté, professor, art critic and former jury member of *Dak'Art* questioned who 'the publics for contemporary African art' were (Konaté 2009: 22). The fact remains that the market and the critical discourse on contemporary arts from Africa is strongest outside the continent. Much debate surrounding *Dak'Art* since its inception has focused on defining its scope (local, regional, continental or global) and, in particular, its relationship to histories of pan-Africanist unity.

Should *Dak'Art* or any other visual arts festival in Africa take as its mission the 'launching' of continental artists onto a global platform? Should it develop local infrastructure and culture for contemporary art, or can and should it do both? One result of the 'festivalization' of contemporary practice is the obfuscation of infrastructural challenges in local art scenes and the continued reliance upon foreign sources of funding. Since the first instalment of *Dak'Art* and the rise of biennales dotted through the continent, the public arena for contemporary arts has remained small, although independent projects and local critical discourse are slowly increasing (Kouoh 2012). Some important initiatives include the Centre for Contemporary Arts (Lagos), Raw Material Company (Dakar), L'Appartement 22 (Rabat), Spark (Johannesburg), African Space Station (Cape Town) and many others. Though numerous art world insiders are quick to cite these initiatives as 'new' and therefore evidence of the maturation of local, contemporary art publics and patronage, collaborative, collective or independent spaces and groupings had important precedents in the years following independence in many places across the continent: the Oshogbo School, Nigeria, Vohou Vohou in Ivory Coast, the Laboratoire Agit-Art in Senegal, and well-known multiracial workshops in South Africa such as Polly Street, Federated Union of Black Arts and the Johannesburg Art Foundation are all early examples.

Entropic Cycles and Afropolitanism

In 2010, President Abdoulaye Wade engaged in a shameless, widely criticized campaign to harness the glories of Senghorian Senegal, erecting the African Renaissance Monument, an enormous 'postcolonial fetish' and sponsoring a new FESMAN meant to link, in no uncertain terms, Dakar 1966 and its promises of African renewal with the declarations of an African Renaissance by then South African president Thabo Mbeki (De Jong and Foucher 2010: 188). Any underlying politics of anti-imperialism for the twenty-first century was absent from its borrowings (Konaté 2009). Could the early decades of the twenty-first century, with the passing of the Cold War, the increasing multi-polarity of global capital (Hardt and Negri 2001) and ever-increasing presence of biennale culture bring about a golden age of marketable pan-Africanism? And where, in all of this, do we put recent claims and considerations of the Afropolitan? *Afropolitanism*, as described by Simon Gikandi, is a 'new phenomenology of Africanness' and 'a way of being African in the world', language with striking similarities to Senghorian Negritude and his explanations of the Civilization of the Universal (Hassan 2012). It is not surprising then that one of the key hallmarks of self-proclaimed Afropolitan literature and art is a retro-mania for African modernisms and the era of decolonization. At its most effective as a concept and a discourse, Afropolitanism is about métissage, open-endedness and entanglement, not essentialism. As Gikandi further explains, Afropolitanism is a way of 'rethinking African identities as

rooted in certain locales but transcendental of them. It is to embrace and celebrate a state of cultural hybridity—to be of Africa and of other worlds at the same time' (Gikandi 2011: 9). As if in direct response to Rasheed Araeen's pleas of 2003 when he called for 'a new universal philosophy that recognises the equality of all races and cultures and their equal roles in the dynamic of emanicipatory modernity that can lead us to a better future' (Araeen 2003: 104), *Dak'Art* in 2014 took pan-Africanism as a point of departure. Seeing the exhibition as an opportunity to reassess Senghor's ideas and plea for a 'universal civilization', its theme was 'the Commons' (Libsekal 2014).

As a means of balancing globalism and localism, the curatorial team placed the work of Édouard Glissant on the poetics of relation in dialogue with that of Michael Hardt, and his conception of the 'common'. As its curators claimed:

> Producing the Common is another way of considering the merits or demerits, if you like, of Universal Civilization in light of contemporary cultural production and globalization. We are more interested in the notion of the common as a unifying, edifying, unselfish process, actively generated in the context of cultural production but taking into account what one may refer to as the politics and the economics of sociability. (Nwezi 2014)

Mehretu, in an extension of her comments on the nature of history and its place in her work added:

> history goes in fits and starts. There's this tension and contradiction, this weird entropic cycle of utopian ideals and the impossibility of that. That's what I'm interested in: the space in between, the moment of imagining what is possible and yet not knowing what that is. (Mehretu 2013)

Though she is addressing the motives that drive her own practice, she could very well be referring to the persistent engagement with and appeal of refashioning African modernist and vanguardist discourses of FESMAN '66 to suit the workings of the local and global art worlds of today.

PANAFEST:
A Festival Complex Revisited

Dominique Malaquais and Cédric Vincent

Introduction

The goal of this chapter is to present succinctly an archive in the making: the PANAFEST Archive.[1] Born of exchanges between scholars hailing from several disciplines (anthropology, history, history of art, political science), the Archive focuses on four Pan-African festivals of arts and culture that took place in the 1960s and 1970s. Three of these festivals are well known and while the fourth has attracted considerable attention, prior to the PANAFEST project it had not been considered as a Pan-African festival in its own right. The four festivals are: the First World Festival of Negro Arts (FESMAN, held in Dakar in 1966); the First Pan-African Cultural Festival (PANAF, Algiers 1969); the Second World Festival of Black Art and Culture (FESTAC, Lagos 1977); and Zaïre '74 (Kinshasa, 1974).

These four festivals tend to be addressed today by scholars and cultural actors according to a narrative scheme that sees in them a relatively clear and linear progression of events. FESMAN is perceived as the starting point of this teleology, followed by PANAF, which is read almost exclusively as a counter-FESMAN. Then comes FESTAC, understood as a synthesis of the two prior festivals. Zaïre '74 is not mentioned, though there exist undeniable links between this event and the other three.

A reading that privileges linearity is certainly seductive. It constitutes, however, but one of many possible takes—one way among numerous others

1 Members of the PANAFEST Archive team are researchers at Centre national de la recherche scientifique (CNRS), École des hautes études en sciences sociales (EHESS) and University of Stirling. Key phases of the PANAFEST Archive project have been made possible through generous funding from Fondation de France and Université Paris 1–Sorbonne.

of understanding the relationship(s) between the four festivals. Other articulations can be proposed, which help excavate a more complex and far richer history of the events in question. The PANAFEST project seeks to highlight such complexity. Rather than a smooth narration, it offers a portrait of the four festivals that underscores their mutual entanglement.

From this focus on entanglement a picture emerges less of a series of festivals that followed one another than of a single, evolving event: one vast and shape-shifting festival that travelled across time and space. Considered from this vantage point, what looks initially like a simple progression leading from Dakar to Lagos comes to be seen instead as a sort of Mobius strip, folding over itself to produce multiple forms and meanings. Ideas, symbols and processes recur as the strip unfolds, taking on new appearances and significations.

Of Entanglement

Clearly, there were differences between the Dakar, Algiers, Lagos and Kinshasa festivals. Still, the similarities between the four are striking. A first and critical observation is that three of the festivals (Dakar, Algiers, Lagos) were structured in precisely the same manner and that the fourth (Kinshasa) sought explicitly, if not always successfully, to follow this structure. All four centred around a core set of events: one or several colloquia; a vast, interdisciplinary palette of highly publicized performances (theatre, dance, music, cinema, sport); several exhibitions; and, linking all of the above, a highly centralized message from a head of state celebrating culture as a powerful tool in the construction of Pan-Africanism.

Further, if less often recognized, similarities are worthy of note. Consider the Dakar and Algiers festivals. At both, a grand exhibition of masks and statuary from across the continent was mounted. Given the focus that has often been placed on differences between FESMAN and PANAF, one could perhaps expect that the works shown would have been quite different. In fact, many of the same objects were exhibited in both contexts, suggesting a strong sense of continuity. The same is true of performances. At both festivals (as at FESTAC), national delegations were invited to participate and present highlights of their countries' culture. In many instances, the same troupes appeared in both settings. This is noteworthy because, in theory at least, the political intents of the two festivals were quite different. Dakar, in Senghor's image, was—or, rather, sought to present itself as—a staid, a seamless and, in many respects, a patriarchal event, whereas Algiers cast itself as a revolutionary moment of effervescence. Still, in both cases, an official delegation was present from Cameroon, which at the time was ruled with an iron fist by Ahmadou Ahidjo, a staunch ally of the ex-colonizer, France. Félix Houphouët-Boigny's Ivory Coast, equally close to France, was present as well and represented, in both cases, by the same playwright, Bernard Dadié.

Such ties between the two festivals help explain a striking image from the Algiers festival, one that is easy to overlook but that, on closer examination, seems particularly telling. The moment has stayed with every person who witnessed it: the father of Free Jazz, Archie Shepp, improvising live on the street, surrounded by hundreds of onlookers in a trance to his otherworldly beats. The place: Algiers; the occasion: PANAF. Théo Robichet, a Guevarist filmmaker based in Paris, recorded the scene. In his viewfinder, Shepp appears in a shirt made of printed cloth bearing the FESMAN logo. For those who know the widely recounted story of these two great Pan-African events, the jazzman's choice of outfit comes as a surprise. As previously noted, much has been made of the fact that PANAF was a rebuke to FESMAN, a rejection of everything for which the Dakar festival stood: Léopold Senghor's philosophy of Negritude and his admiration for French culture and politics, most notably.[2] And, indeed, the Algiers event was attended by many for whom Senghor's vision was anathema. The philosopher Stanislas Adotevi and the writer Henri Lopes are cases in point. Still, Shepp's shirt suggests there was significantly more to the story.

Much the same is true of ties linking the Kinshasa festival to its Dakar and Algiers predecessors: there is more at play than initially meets the eye. The 1974 event, remembered above all for the 'Rumble in the Jungle', a stunning upset boxing match between heavyweight champion George Foreman and contender Muhammad Ali, was not a festival per se, but nonetheless was presented as such by the leader of Zaïre at the time, Mobutu Sese Seko. In order to market the event as a festival in the lineage of FESMAN and PANAF, Mobutu borrowed liberally, and quite explicitly, from the roster of symbols and ideas deployed in Dakar and Algiers. Performers who had been invited to Dakar and Algiers, and who were slated to appear in Lagos, were brought to Kinshasa in great pomp. A case in point was Miriam Makeba, whose performance on a Kinshasa stage on the occasion of the festival is immortalized in Leon Gast's famous film *When We Were Kings* (1996).[3] A mask highlighted in the first two festivals, notably on stamps and pamphlet covers, found its way into furniture designed for the luxury lounge at the heart of the Rumble stadium, where VIPs mingled before the match. Massive construction was undertaken to transform the centre of the city, precisely as was done in Dakar and, later, Lagos, the goal being to present Kinshasa as the core of a modern Africa facing toward the future. Like Senghor, who built his entire festival around a celebration of himself and his philosophy of Negritude, Mobutu dreamed the

2 This reading of the relationship between the Dakar and Algiers festivals initially served as a template for the PANAFEST team as well.

3 Makeba was invited to take part in FESMAN and appears on the Dakar festival's programme, but, in fact, was a no-show. Some scholars explain the absence of the star, a staunch supporter of Sékou Touré, by a last-minute decision on her part to boycott Senghor's festival (Arndt 2015: 32). Her memoirs suggest otherwise, pointing instead to a scheduling conflict (Makeba and Mwamuka 2004: 160).

Kinshasa festival as an incarnation of *Authenticité*, the cultural and political banner under which he ruled. And, patterning himself on Algeria, which held the first Pan-African festival at the behest of the Organisation of African Unity (OAU), Mobutu dispatched key aides to Addis Ababa to request (and receive) the OAU's permission to hold the second PANAF in Kinshasa.[4]

Between the Lagos festival and its Dakar and Algiers predecessors there were close, but less-than-linear (and, for this reason, often overlooked) links as well. In the Nigerian capital again, Miriam Makeba was on the guest list— indeed, she was the festival's star—and, as in Algiers, Mobutu's Zaïre was on hand as one of the official country delegations. Ahidjo's Cameroon and Houphouët's Ivory Coast were there as well. In Algiers, several anti-colonial and revolutionary movements (Mozambique's FRELIMO and Angola's MPLA, among others) were present. In Lagos, this was the case too. Most strikingly, the FESTAC logo, a depiction of the world famous Idia mask pillaged in the Benin kingdom by British troops in 1897, was also Nigeria's official logo when it took part in the Dakar festival—this despite the fact that the later Lagos event sought to present itself as a distinct departure from both the Dakar and the Algiers festivals.

Underscoring the Mobius-like imbrications between the festivals—the fact that, as much as distinct events, they constituted a single, morphable entity—all four events appear in retrospect to have been staging grounds for CIA activity. In 1967, the magazine *Ramparts* published an exposé showing that the CIA had for years covertly funded, and thereby infiltrated, key USA-based cultural organizations, notably the American Society of African Culture (AMSAC) ('A Short Account' 1967; see also Fuller 1971). This came as an unpleasant surprise to many rank and file AMSAC members.[5] Among the latter was an important contingent of African American members whose participation in FESMAN had been facilitated by AMSAC sponsorship. The plane that had brought them to Dakar, it turned out, had been chartered with CIA funds[6]—this in the broader context of the Cold War—in order to present a picture of the USA as a country open to the voices of its black minority.[7] Several participants in the 1969 festival interviewed by the PANAFEST Archive team state their certainty (as well as rumours rife on the streets of the

4 Though officially planned, the event never in fact materialized. Highlighting still further entanglements between the various festivals, the OAU report documenting Zaire's quest to hold a second PANAF in Kinshasa includes a request by Senegal that such an event should avoid anti-Negritude sentiment of the kind expressed during the 1969 festival in Algiers. See Organization of African Unity DC/CULT/20/88.71 (1 March 1971).

5 Certain leading members of AMSAC, it appears, were aware of the society's ties with the CIA (see Wilford 2014).

6 Harold Weaver, personal communication, November 2013.

7 For an analysis of the CIA's exploitation of African American artists in the larger context of the Cold War, see, among others, Saunders (2001), Von Eschen (2004) and Wilford (2008). See also Ratcliff (2014).

Algerian capital at the time) that, among the international journalists on-site for the event, there were a number of CIA, or more broadly US government, infiltrators. The same holds true for participants in the Kinshasa and Lagos festivals. Freedom of Information Act (FOIA) requests currently in progress in the USA, led by the PANAFEST team, will hopefully help shed light on this state of affairs.

The matter of CIA meddling points to further complications, which tend to disturb official narratives of the festivals. While FESMAN, PANAF, FESTAC and Zaïre '74, Pan-African in intent though they were, are often thought of as associated with specific nations (their organizing countries), in fact it is equally clear that they had a powerful effect on, and were themselves actively shaped by, the internal politics of third party nations. Reflecting this, startlingly different takes on the four festivals emerge when one shifts one's gaze from the organizers' standpoint(s) to those of invited delegations and, within these, to the takes of individual participants.

On the Nature of Archives

The tendency of scholars and cultural actors today to think of the Dakar, Algiers and Lagos festivals in teleological terms, and their failure to consider the Kinshasa festival in relation to the other three events, are intimately linked to available archival sources. To date, researchers have focused their attention primarily on official accounts—that is, on archives collected by the organizing countries. This makes for a narrow, or in any event a partial, point of view.

The PANAFEST project seeks a broader stance. It calls for a cross-pollination of official archives with a range of other types of archives: institutional, private and constituted by the project itself. The last, in particular, have drawn the team's attention. A key goal for its members is to make available—via filmed and recorded interviews, as well as via the collection of as yet unpublished (or unpublicized) documents, such as photographs, notes and sketches, souvenir albums and diaries—the memories of participants and spectators in the four festivals. Key among these witnesses are persons whom a focus on organizers and official guests tends to elide from view: individuals who, for a variety of reasons, remained out of the limelight (advisers, consultants, sponsors, diplomats); helpers (cameramen and women, electricians, hotel personnel, members of secretarial pools); French *coopérants*, expatriates, local and foreign businesspeople, journalists …

Exchanges with such interlocutors allow a gaze on the four festivals that no official archive, considered alone, can offer. In the documentation conserved by an organizing country, researchers can mine precious data on preparatory phases, that is, on key steps leading up to a given festival. However, in terms of what actually came to pass during the event, they are unlikely to find much information. For official archives mostly end where the festivals they

concern begin. They document what was planned, but provide little insight into how the plan unfolded. They cannot account for the unexpected—for such last-minute changes in content or form as might have been decided on by troupes, individual artists or even organizers and for the impact of these on the public's experience. The ephemeral, in other words, escapes them. Recollections by witnesses—and in particular by witnesses who were not there to cast an official gaze on the proceedings—help fill this gap. Such recollections shed light also on steps in the lead-up to individual festivals that official archives tend to underplay: false starts, failures and reorientations resulting from these.

In the case of FESMAN, moving beyond the official accounts of the organizing country proves very productive. Conserved in the National Archives of Senegal, the festival's institutional archive tends to be seen by scholars as constituting the primary source on the lead-up to and the unfolding of the event. Its contents cover the years 1963 to 1966. While these contents are very rich, this renders the archive incomplete. Preparation began far earlier. As is well known, the project of a festival of black culture to be staged at regular intervals on the African continent was first launched in 1959, at the Second Congress of Black Writers and Artists held that year in Rome. Initially, the first festival was slated to take place in January 1961, in Bamako rather than Dakar. At the helm at the time in Bamako was Modibo Keïta. Keïta, a committed Pan-Africanist and Third-worldist, would in all likelihood have hosted a far different kind of event than took place in 1966 on Senghor's watch. For reasons that remain to be clarified, a few months into the preparation process, the decision was made to move the festival from Bamako to Dakar.[8] The plan was to maintain the 1961 date, but this did not come to pass. Instead there followed three years of back and forth between various actors, focusing, notably on possible programing. Traces of these exchanges can be found in documents conserved at UNESCO and in the Michel Leiris archives (Laboratoire d'Anthropologie Sociale, École des hautes études en sciences sociales, Paris). Concerning the 1963–66 period addressed in the documents conserved in Dakar, complementary archival research is also necessary. A few examples are worth mentioning. Among these are archival holdings of the Schomburg Center for Research in Black Culture in New York and of the Smithsonian Institution in Washington, DC. In both settings key documents are conserved detailing preparations by the US delegation (see Blake 2011). Preparations by other country delegations require close attention as well. In the lead-up to its participation in the Dakar festival, Cameroon, to cite but one example, launched a reflection process focusing on cultural conservation policies; an issue of the journal *Abbia* published in 1966 attests to this. Rich sources concerning preparations for FESMAN are found also at the Musée d'ethnographie de Neuchâtel in Switzerland; they concern a key

8 The change in location may have been related to the implosion of the Mali Federation in August 1960.

exhibition which took place at the Musée Dynamique in Dakar, a structure that was built specifically for the festival, and shed important light on the design of the Musée itself.[9] To these few examples, many others might be added, both of institutional archives and archives such as the PANAFEST project itself aims to collect. Looking to and bringing together such diverse holdings casts a distinctly transnational light on the festival, which complexifies its understanding.

The process of studying PANAF raises significant source questions as well. Concerning preparatory phases leading up to the event, unlike in Dakar and Lagos, we cannot look to official archives conserved in the organizing country, for such archives are not available. (A similar situation obtains for Zaïre '74.) Regarding the festival's unfolding, the situation is equally complex. The many performances held in Algiers were by nature evanescent. Forty years after the fact, this shapes our understanding of the collective experience they represented. Of course, we have access to accounts of the performances in the Algerian, French and US press. In order to grasp the sheer wealth and complexity of the event, however, it is necessary to explore other, less obvious sources of information. It proves useful, for instance, to look in the direction of jazz culture, for which the Algiers festival constitutes a critical marker: that of the official birth of Free Jazz. In this context, a certain after-the-fact production requires close attention: recordings that only became available later on the French label BYG, highlighting a number of musical performances recorded immediately after the festival, notably by Archie Shepp (on his album *Jasmina, A Black Woman*) and Clifford Thornton (on his album *Ketchaoua*, which grew out of Thornton's experience during PANAF as a member of Shepp's quintet); a short, *cinéma direct* film by Théo Robichet, mentioned briefly above, centred on an improvised concert by Shepp during the festival on the streets of Algiers; a new version of the documentary that William Klein dedicated to PANAF, filmed on-site during the festival but long left dormant and, in the interim, re-edited by Klein; recollections of the festival by Shepp, Klein, Robichet and people who both worked with and associated with them during the event.

Focusing on official archives, which, as we have noted, is often done, is problematic in still another respect. It makes little or no room for ways of doing and saying that might express forms of contestation. This is striking in the case of FESMAN. Drawing primarily on documentation conserved in the Senegalese National Archives, many accounts of the festival allow for a reading of it in terms only of normative discourses predominant at the time in Dakar. Yet, clearly, the voice of officialdom was not the only one heard. Partisans of Cheikh Anta Diop, a key intellectual and political opponent of the Senegalese president, it is widely known, objected to the festival,[10] and

9 See Chapter 1 for close engagement with archival sources on the construction of the Musée Dynamique and the exhibition held there.

10 These opponents to Senghor led the Senegalese delegation in attendance at the

Wole Soyinka, though an official guest at the event, was overtly critical of it. This in turn begs a question: what of less visible (or audible) opponents, both of the festival itself and, more broadly, of Senghor's policies? And what of criticism in Algiers, where, as the city officially celebrated the Non-Aligned Movement, torture ran rampant in the jails of the Boumediène regime? Or in Kinshasa, where rumour offered one of the sole means of expressing discontent with Mobutu Sese Seko's violent repression?[11] In Lagos, it is clear that a counter-discourse emerged in reaction to the festival, resulting in the creation of isolated but significant spaces of contestation, a key example of which was a series of concerts organized by the father of Afrobeat, Fela Kuti, a vocal opponent of the military government in power at the time. Despite a relatively important number of references to these concerts in the literature,[12] few details about them are known or have been rendered public. One of the goals of the PANAFEST project is to collect archival data allowing for a better understanding of such counter-discourses as are pointed to by the foregoing examples.

One might object that such data, while they constitute a potential goldmine for thinking against the grain of official history, do not, strictly speaking, constitute archival material. For this reason, precisely, they pose the underlying question of what, in the final analysis, an archive for the type of event we are concerned with here might look like. As materials whose status remains to be determined, they can be seen as a warning against a priori definitions of the term 'archive'. In doing so they prompt reflection around processes that shape and encode archival materials—processes that derive from the tendency to think of archives as entities whose content and location are relatively fixed.[13] Allowing for the foregrounding of voices that express an alternative to official narratives of the festivals, interviews with participants in the four events are, in this context, paramount. By decentring the primacy of official documentation, they allow for empirical consideration of how archives come into being—that is, of the processes, the devices and the manipulations that result in a given source being considered worthy of inclusion in a dedicated archive. For this reason, as previously noted, they are central to the work of the PANAFEST team.

Algiers festival. On this subject, see notably Balogun *et al.* (1977; see section by Pathé Diagne). On Soyinka, see, notably, Ogbechie (2008).

11 See Nlandu-Tsasa (1997).

12 See Collins (2003: 69–70, 73); Dele (2003: 86); Goldman (2003: 107); Hayes Edwards (2007); Kayode Idowu (2003: 16–19); Schoonmaker (2003b: 3).

13 Needless to say, such reflection relates intimately to writings on the nature of archives as historically and culturally constituted artefacts and, thereby, as loci for the (re)production of power.

Conclusion

The PANAFEST project is built on a dual approach. First is a move away from reading FESMAN, PANAF, Zaïre '74 and FESTAC as distinct, individually circum-scribed entities, in favour of focusing on their intimate links to one another. Considering any one of these key Pan-African festivals on its own—that is, as an internally coherent, homogenous whole—we argue, is problematic. Far more productive is a stance that foregrounds the complexity—one might even say the messiness—of their entanglement. Thinking of the Dakar, Algiers, Kinshasa and Lagos events in these terms in turn requires a shift in perspective as regards sources one might mine fully to comprehend this entanglement. Such a shift hinges on three, related propositions undergirding the work of the PANAFEST team: (1) long seen as the de facto place to start for a proper understanding of the events in question, official organizing country archives are, in reality, just one of several possible sites that require the attention of researchers and need not at all be the latter's first port of call; (2) to address the four festivals in all of their complexity, it is critical not only to consider other, extant bodies of documentation, but also to recognize that the archive-building process, as regards the four events, is an ongoing one, in many respects still in its infancy and likely to result in multiple twists and turns; (3) this process must be grounded in a definition of archives as labile entities fixed neither in space nor time—a definition that accords with the complex, multifaceted and changing nature of Pan-Africanism itself.

Books and Films
about the 1966 Festival

Official publications of the 1966 festival

1ᵉʳ Festival mondial des arts nègres, Dakar 1ᵉʳ–24 avril 1966. Colloque Fonction et signification de l'art nègre dans la vie du peuple et pour le peuple, 30 mars–8 avril, 1966. 1967. Paris: Présence Africaine.

L'Art nègre: sources, évolution, expansion. 1966. Paris: Réunion des musées nationaux.

Premier Festival mondial des arts nègres [festival programme]. 1966. Paris: Impressions André Rousseau.

Premier Festival mondial des arts nègres ['livre d'or du festival']. 1967. Paris: Imprimerie Bouchet-Lakara.

Spectacle féerique de Gorée. 1966. Paris: Impressions André Rousseau.

Official music albums of the 1966 festival

1ᵉʳ Festival mondial des arts nègres, Dakar 1966 (Philips 1966)

Ensemble Instrumental Traditionnel du Sénégal, *1ᵉʳ Festival mondial des arts nègres, Dakar 1966* (Barclay 1966)

Premier Festival Mondial des Arts Nègres: Contributions Musicales des Nations Africaines (Philips 1966)

Documentary films about the 1966 festival

Borelli, Sergio. 1966. *Il Festival di Dakar*, Italy.

Calotescu, V., and C. Ionescu-Tonciu. 1968. *Rythmes et Images: Impressions du Premier Festival mondial des arts nègres*, Romania.

Greaves, William. 1966. *The First World Festival of Negro Arts*, USA.

Venzher, Irina, and Leonid Makhnatch. 1966. *African Rhythms* [aka *African Rhythmus*], USSR.

Vieyra, Paulin Soumanou. 1966. *Le Sénégal au Festival mondial des arts nègres*, Senegal.

Bibliography

'21 troupes artistiques sénégalaises se produiront pendant le Festival et feront vivre à nos hôtes notre folklore'. 1966. *Dakar-Matin* (21 February): 3.

Aba, Andrew. 1976. 'FESTAC 77 and Senghor's Negritude'. *Sunday Standard* (11 July): 5–6.

Abbia. 1966. Special issue. 'Festival mondial des arts nègres': 12–13.

Abrahams, Alistair. 1977. 'Super Star's Songs Rule the World'. *Drum Magazine* [Nigeria edition] (June): 26–27.

Adotevi, Stanislas. 1972. *Négritude et négrologues*. Paris: Union Générale d'Éditions.

Amirou, Rachid. 2000. *Imaginaire du tourisme culturel*. Paris: Presses universitaires de France.

Andrieu, Sarah. 2013. 'Une forme globalisée, des enjeux localisés: Les festivals culturels régionaux au Burkina Faso des années 1990 à aujourd'hui'. In Fléchet et al. (eds), *Une histoire des festivals XXᵉ–XXIᵉ siècle*: 123–38.

Apter, Andrew. 2005. *The Pan-African Nation: Oil and the Spectacle of Culture in Nigeria*. Berkeley: University of Chicago Press.

—. 2008. 'Socialism, African'. In *International Encyclopedia of the Social Sciences*, 2nd edn, ed. William A. Darity, Jr, vol. 7. Detroit: Macmillan Reference USA: 638–42.

Araeen, Rasheed. 2003. 'Dak'Art 1992–2002: The Problems of Representation, Contextualization, and Critical Evaluation in Contemporary African Art as Presented by the Dakar Biennale'. *Third Text*, 17.1: 93–106.

Armah, Ayi Kwei. 1967. 'African Socialism: Utopian or Scientific?'. *Présence Africaine*, 67.4: 6–30.

—. 2010 [1985]. 'The Festival Syndrome'. In Armah, *Remembering the Dismembered Continent: Seedtime Essays*. Popenguine (Senegal): Per Ankh: 133–38.

Arndt, Lotte. 2015. 'Decolonization in Adversity: Cultural Constellations through the Prism of Présence Africaine'. *Qalqalah: A Reader*: 18–34 <http://betonsalon.net/PDF/Qalqalah_EN> (consulted 14 December 2015).

L'Art nègre: Sources, évolution, expansion. 1966. Paris: Réunion des musées nationaux.

Aschenbrenner, Joyce. 2002. *Katherine Dunham: Dancing a Life*. Urbana: University of Illinois Press.

Askew, Kelly. 2002. *Performing the Nation: Swahili Music and Cultural Politics in Tanzania*. Chicago: University of Chicago Press.

Bâ, Thierno. 1995. *Lat Dior, le chemin de l'honneur: Drame historique en huit tableaux*. Dakar: Nouvelles éditions africaines.

Babou, Cheikh Anta. 2007. *Fighting the Greater Jihad: Amadu Bamba and the Founding of the Muridiyya of Senegal, 1853–1913*. Athens: Ohio University Press.

Baller, Susann. 2010. Spielfelder der Stadt: Fussball and Jugendpolitik im Senegal seit 1950. Cologne: Böhlau Verlag.

'Les Ballets guinéens sont passés à Dakar'. 1961. *Paris-Dakar* (14 March): 3.

'Les Ballets sénégalais préparent leur tournée européenne'. 1961. *Paris-Dakar* (20 February): 3.

Balogun, Ola, Honorat Aguessy and Pathé Diagne. 1977. *Introduction à la culture africaine*. Paris: 10/18-UNESCO.

Bancel, Nicolas. 2009. 'Les Centres culturels en AOF (1953–1960): Un projet de contrôle sociopolitique des jeunes élites'. In *Lieux de sociabilité urbaine en Afrique*, ed. Laurent Fourchard, Odile Goerg and Muriel Gomez-Perez. Paris: L'Harmattan: 109–34.

Barber, Karin. 1991. *I Could Speak Until Tomorrow: Oriki, Women and the Past in a Yoruba Town*. Edinburgh: Edinburgh University Press.

—. 1997. 'Preliminary Notes on Audiences in Africa'. *Africa: Journal of the International African Institute*, 67.3: 347–62.

Basu, Paul, and Ferdinand de Jong. 2016. 'Utopian Archives: Decolonial Affordances'. *Social Anthropology*, 24.1: 5–19.

Bathily, Abdoulaye. 1992. *Mai 68 à Dakar: ou la révolte universitaire et la démocratie*. Paris: Chaka.

Bayart, Jean-François 1999. 'L'Afrique dans le monde: une histoire d'extraversion'. *Critique Internationale*, 5: 97–120.

—. 2000. 'Africa in the World: A History of Extraversion'. *African Affairs*, 99.395: 217–67.

Béart, Charles. 1937. 'Le théâtre indigène et la culture franco-africaine'. *L'Education Africaine*, numéro spécial: 3–14.

Benga, Ndiouga. 2008. 'Mise en scène de la culture et espace public au Sénégal, 1960–2000'. CODESRIA 12th General Assembly <http://www.codesria.rg/spip.php?article625> (consulted 4 September 2015).

Bennett, Andy, Jodie Taylor and Ian Woodward (eds). 2014. *The Festivalization of Culture*. Aldershot: Ashgate.

Bennett, Tony. 1996. 'The Exhibitionary Complex'. In *Thinking about Exhibitions*, ed. Reesa Greenberg, Bruce W. Ferguson and Sandy Nairne. London: Routledge: 81–112.

—. 2004. *Pasts beyond Memory: Evolution, Museums, Colonialism*. London and New York: Routledge.

Biasini, Emile. 1999. *Sur Malraux: Celui qui aimait les chats*. Paris: Odile Jacob.

Biebuyck, Daniel P. 1969. *Tradition and Creativity in Tribal Art*. Berkeley and Los Angeles: University of California Press.

'The Black Frenchman'. 1976. *New Nigerian* (3 June): 5.

Blake, Jody. 2011. 'Cold War Diplomacy and Civil Rights Activism'. In *Romare Bearden, American Modernist*, ed. Ruth Fine and Jacqueline Francis. Washington, DC and New Haven, CT: National Gallery of Art/Yale University Press: 43–58.

Boukari-Yabara, Amzat. 2014. *Africa Unite! Une histoire du panafricanisme*. Paris: La Découverte.

Boukman, Daniel. 1966. 'A propos du Festival des Arts Nègres de Dakar'. *Partisans*, 29–30.

Boumediène, Houari. 1969. 'Discours d'inauguration de S.E. Monsieur Houari Boumediène'. In *La Culture africaine*: 13–19.

Casanova, Marie. 1976. *Lat Dior: Le Dernier Souverain du Cayor*. Paris: ABC; Dakar and Abidjan: NEA.

Castaldi, Francesca. 2006. *Choreographies of African Identities: Négritude, Dance, and the National Ballet of Senegal*. Urbana and Chicago: University of Illinois Press.

Castor, N. Fadeke. 2013. 'Shifting Multicultural Citizenship: Trinidad Orisha Opens the Road'. *Cultural Anthropology*, 28.3: 475–89.

Césaire, Aimé. 1955. *Discours sur le colonialisme*. Paris: Présence Africaine.

—. 1963. *La Tragédie du roi Christophe*. Paris: Présence Africaine.

—. 2009. 'Discours prononcé par Aimé Césaire à Dakar le 6 avril 1966'. *Gradhiva*, 10: 208–13.

Charry, Eric. 2000. *Mande Music: Traditional and Modern Music of the Maninka and Mandinka of Western Africa*. Chicago and London: University of Chicago Press.

'Le Cinéma africain sur le chemin de sa liberté'. 1969. *El Moudjahid* (21 July): 5.

Clark, VèVè, and Sara E. Johnson (eds). 2005. *Kaiso! Writings by and about Katherine Dunham*. Madison: University of Wisconsin Press.

Clarke, Kamari M. 2013. 'Notes on Cultural Citizenship in the Black Atlantic World'. *Cultural Anthropology*, 28.3: 464–74.

Clarke, Kamari M., and Deborah A. Thomas. 2006. 'Introduction: Globalization and the Transformations of Race'. In *Globalization and Race: Transformations in the Cultural Production of Blackness*, ed. Kamari M. Clarke and Deborah A. Thomas. Durham, NC: Duke University Press: 1–34.

Cleaver, Kathleen N. 1998. 'Back to Africa: The Evolution of the International Section of the Black Panther Party (1969–1972)'. In *The Black Panther Party (Reconsidered)*, ed. Charles E. Jones. Baltimore, MD: Black Classic Press: 211–54.

Clifford, James. 1988. *The Predicament of Culture: Twentieth-Century Ethnography, Literature, and Art*. Cambridge, MA: Harvard University Press.

Coburn, Elaine. 2014. '*Critique de la raison nègre*: A Review'. *Decolonization: Indigeneity, Education & Society*, 3.2: 176–86.

Cohen, Harvey G. 2010. *Duke Ellington's America*. Chicago and London: University of Chicago Press.

Cohen, Joshua. 2012. 'Stages in Transition: Les Ballets Africains and Independence, 1959 to 1960'. *Journal of Black Studies*, 43.1: 11–48.

Collins, John. 2003. 'Fela and the Black President Film: A Diary'. In *Fela*, ed. Schoonmaker 2003a: 55–77.

Comaroff, John L., and Jean Comaroff. 2009. *Ethnicity, Inc.* Chicago and London: University of Chicago Press.

'La Communauté libanaise du Sénégal a remis au président Senghor un chèque de 15 millions de francs'. 1966. *Dakar-Matin* (31 March): 7.

Conteh-Morgan, John. 1994. *Theatre and Drama in Francophone Africa*. Cambridge: Cambridge University Press.

—. 2004. 'Francophone Africa South of the Sahara'. In *A History of Theatre in Africa*, ed. Martin Banham. Cambridge: Cambridge University Press: 86–137.

Cook, Mercer. 1966. 'President Senghor's Visit: A Tale of Five Cities'. *African Forum*, 2.3: 74–86.

Coombes, Annie E. 1994. *Reinventing Africa: Museums, Material Culture and Popular Imagination*. New Haven, CT: Yale University Press.

Coquery-Vidrovitch, Catherine. 2013. 'Festan, Festac, Panaf'. In *Une histoire des festivals XXᵉ–XXIᵉ siècle*, ed. Fléchet et al.: 317–30.

Coquio, Catherine. 2012. 'Un intellectuel "accompagné": Malraux, De Gaulle, Foccart et le réveil de la "décolonisation"'. In *Malraux et l'Afrique*, ed. Lambal: 169–201.

Coutelet, Nathalie. 2012. 'Féral Benga: De la danse nègre à la chorégraphie africaine', *Cahiers d'Etudes Africaines*, 1 (205): 199–215.

Culot, Maurice, and Jean-Marie Thiveaud (eds). 1992. *Architectures françaises outre-mer*. Liège: Mardaga.

La Culture africaine: Le Symposium d'Alger, 21 juillet–1ᵉʳ août 1969. 1969. Algiers: Société nationale d'édition et de diffusion.

D.B. 1965: '"Les Derniers Jours de Lat Dior" par Cissé Dia'. *Dakar-Matin* (1 April).

'Dans le monde'. 1954. *Bingo* (June): 18.

Dathorne, O.R., and Willfried Feuser (eds). 1969. *Africa in Prose*. Harmondsworth: Penguin.

Davis, Angela. 1971. 'Political Prisoners, Prisons, and Black Liberation'. In *If They Come in the Morning: Voices of Resistance*, ed. Angela Davis et al. London: Orbach and Chambers, with the Angela Davis Defence Committee: 27–42.

—. 2000. 'The Prison Industrial Complex and its Impact on Communities of Color'. Videocassette. Madison: University of Wisconsin Press.

Davis, John A. 1965. 'Editorial Statement', *African Forum*, 1.1: 3–6.

de Benoist, Joseph Roger. 1998. *Léopold Sédar Senghor*. Paris: Beauchesne.

De Jong, Ferdinand. 1999. 'Trajectories of a Mask Performance: The Case of the Senegalese *Kumpo*'. *Cahiers d'études africaines*, 153: 49–71.

—. 2007. *Masquerades of Modernity: Power and Secrecy in Casamance, Senegal*. Edinburgh: Edinburgh University Press for the International African Institute.

—. 2009a. 'First Word: Hybrid Heritage'. *African Arts*, 42.4: 1, 4–5.

—. 2009b. 'Shining Lights: Self-fashioning in the Lantern Festival of Saint Louis, Senegal'. *African Arts*, 42.4: 38–53.

—. 2013. 'Le Secret Exposé: Révélation et reconnaissance d'un patrimoine immatériel'. *Gradhiva: Revue d'anthropologie et d'histoire des arts*, 18: 98–123.

—. 2014. 'Archiving after Empire: Saint-Louis and its Sufi Counter-Memory'. *Francosphères*, 3.1: 25–41.

De Jong, Ferdinand, and Brian Quinn. 2014. 'Ruines d'Utopies: L'École William Ponty et L'Université du Futur africain'. *Politique africaine*, 135: 71–94.

De Jong, Ferdinand, and Michael Rowlands (eds). 2007. *Reclaiming Heritage: Alternative Imaginaries of Memory in West Africa*. Walnut Creek, CA: Left Coast Press.

De Jong, Ferdinand, and Vincent Foucher. 2010. 'La Tragédie du roi Abdoulaye? Néomodernisme et Renaissance africaine dans le Sénégal contemporain'. *Politique Africaine*, 118.2: 187–204.

De Suremain, Marie-Albane. 2007. 'L'IFAN et la "mise en musée" des cultures africaines (1936–1961)'. *Outre-mers*, 94.356–57: 151–72.

'De Ziguinchor à la scène et à l'écran. Bachir Touré—Qui êtes-vous?'. 1965. *Bingo* (January): 23–25.

Debord, Guy. 1983. *Society of the Spectacle*. London: Rebel Press.

Delavignette, Robert. 1937. 'Le Théâtre de Gorée et la culture franco-africaine'. *Afrique française*, 10: 471–72.

Dele, Jegede. 2003. 'Dis Fela Sef!–Fela in Lagos.' In *Fela*, ed. Schoonmaker 2003a: 78–102.

Délégation de la République Algérienne Démocratique et Populaire. 1969. 'Discours de la Délégation de la République Algérienne Démocratique et Populaire'. In *La Culture africaine*: 61–68.

Délégation de la République de Dahomey. 1969. 'Discours de la Délégation de la République de Dahomey'. In *La Culture africaine*: 83–88.

Délégation de la République du Congo-Brazzaville. 1969. 'Discours de la Délégation de la République du Congo-Brazzaville'. In *La Culture africaine*: 76–79.

Deliss, Clémentine. 1995. *Seven Stories about Modern Art in Africa*. London: Whitechapel Gallery.

Depestre, René. 1969. 'Les Fondements socio-culturels de notre identité'. In *La Culture africaine*: 250–54.

'Les Derniers Jours de Lat Dior'. 1966. *Dakar-Matin* (11–12 April): 1.

Dia, Amadou Cissé. 1978. *Les Derniers Jours de Lat Dior: drame en 5 actes; La Mort du Damel: pièce en 3 actes*. Paris: Présence Africaine.

Diagne, Souleymane Bachir. 2002. 'La Leçon de musique: Réflexions sur une politique de la culture'. In *Le Sénégal contemporain*, ed. Momar-Coumba Diop. Paris: Karthala: 243–59.

—. 2010. 'In Praise of the Post-Racial: Negritude beyond Negritude'. *Third Text*, 24.2 (March): 241–48.

—. 2013. *L'Encre des savants: Réflexions sur la philosophie en Afrique*. Paris: Présence Africaine; Dakar: CODESRIA.

Diakhaté, Lamine. 1969. 'Le Festival d'Alger et le problème de l'unité par la culture'. *Bingo* (November): 13.

'Did you see FESTAC?'. 1977. *Drum Magazine* [Nigeria edition] (March): 15–17.

Dieye, Yatma. 2012. 'The Dakar Festivals of 1966 and 2010.' In *African Theatre: Festivals*, 11, ed. James Gibbs. Woodbridge: James Currey: 28–29.

Dilley, R.M. 2004. *Islamic and Caste Knowledge Practices among Haalpulaar'en in Senegal: Between Mosque and Termite Mound*. London: Edinburgh University Press for the International African Institute.

Diop, Alioune. 1966. 'Art and Peace'. In *Premier festival mondial des arts nègres* [Festival Programme]: 18–19.

Diop, Alioune Oumy. 1990. *Le Théâtre traditionnel au Sénégal*. Dakar: Nouvelles éditions africaines du Sénégal.

Diop, Boubacar Boris. 2010. 'Faire palabrer nos imaginaires'. *Courrier international* (9 December) <http://www.buala.org/fr/mukanda/faire-palabrer-nos-imaginaires> (consulted 5 June 2015).

Diop, Cheikh Anta. 1948. 'Quand pourra-t-on parler d'une renaissance africaine?'. *Le Musée vivant*, 36–37: 57–65.

—. 1987. *L'Afrique noire précoloniale*, 2nd edn. Paris: Présence Africaine.

—. 2000 [1954]. *Nations nègres et culture: De l'antiquité nègre égyptienne aux problèmes culturels de l'Afrique noire d'aujourd'hui*. Paris: Présence Africaine.

Diouf, Mamadou. 1992. 'Fresques murales et écriture de l'histoire: Le set/setal à Dakar'. *Politique Africaine*, 46: 41–54.

—. 1996. 'Urban Youth and Senegalese Politics: Dakar 1988–1994'. *Public Culture*, 8.2: 225–49.

—. 2001. *Histoire du Sénégal: Le modèle islamo-wolof et ses périphéries*. Paris: Maisonneuve & Larose.

—. 2014. *Le Kajoor au XIX^e siècle: Pouvoir ceddo et conquête coloniale.* 2nd edn. Paris: Karthala.

Djebbari, Elina. 2011. 'Musique, patrimoine, identité: Le Ballet national du Mali'. In *Territoires musicaux mis en scène,* ed. M. Desroches, M.H. Pichette, C. Dauphin and G.E. Smith. Montreal: Presses de l'Université de Montréal: 195–208.

—. 2013. 'La Biennale artistique et culturelle du Mali: la mise en scène d'une culture nationale de l'indépendance à aujourd'hui'. In *Une histoire des festivals XX^e–XXI^e siècle,* ed. Fléchet et al.: 291–301.

Doquet, Anne. 2008. 'Festivals touristiques et expressions identitaires au Mali'. Special issue. 'Festivals et biennales d'Afrique: machine ou utopie?' *Africultures,* 73: 60–67.

Douxami, Christine. 2008. 'Le Festival International de Théâtre et de Marionnettes de Ouagdougou sous le regard de son fondateur: entretien avec Jean-Pierre Guingué'. Special issue. 'Festivals et biennales d'Afrique: machine ou utopie?' *Africultures,* 73: 72–82.

Dovey, Lindiwe. 2015. *Curating Africa in the Age of Film Festivals.* New York: Palgrave Macmillan.

Duerden, Dennis. 1966. 'Dakar Report: A Triumph for Wole Soyinka'. *New Society,* 7 (28 April): 21–22.

Edmonson, Laura. 2007. *Performance and Politics in Tanzania.* Bloomington: Indiana University Press.

'Eldridge Warmly Received by the People of Algiers'. 1969. *Black Panther* (9 August): 3.

'Elles ont dansé et chanté au Festival de Dakar'. 1966. *Bingo* (June): 16–17.

Ellington, Edward Kennedy [Duke]. 1973. *Music is My Mistress.* Garden City, NY: Doubleday.

Elsaesser, Thomas. 2005. *European Cinema: Face to Face with Hollywood.* Amsterdam: Amsterdam University Press.

Enwezor, Okwui. 2008. 'Mega-Exhibitions: The Antinomies of a Transnational Global Form'. In *Other Cities, Other Worlds: Urban Imaginaries in a Globalizing Age,* ed. Andreas Huyssen. Durham, NC: Duke University Press: 147–78.

Erikson, Peter. 2009. 'The Black Atlantic in the 21st Century: Artistic Passages, Circulations, Revisions'. *NkA: Journal of Contemporary African Art,* 24: 56–71.

Fanon, Frantz. 1965 [1961]. 'On National Culture'. In *The Wretched of the Earth.* Trans. Constance Farrington. London: MacGibbon & Kee: 165–200.

—. 2004. *The Wretched of the Earth.* Trans. Richard Philcox. New York: Grove Press [First published as *Les Damnés de la terre,* 1961].

Faye, Birame. 2010. 'Le Folklore ne peut pas régler la crise casamançaise'. *Le Quotidien* (31 December): 4.

'FESTAC and the Senegalese Boycott Threat'. 1975. *Nigerian Observer* (12 December): 6.

'FESTAC: Fingesi Clears the Air'. 1976. *Daily Times* (4 January): 1.

Ficquet, Eloi. 2008: 'L'impact durable d'une action artistique: le Festival Mondial des Arts Nègres de Dakar en 1966', in Vincent, 2008a: 18–25.

— and Lorraine Gallimardet. 2009. '"On ne peut nier longtemps l'art nègre": Enjeux du colloque et de l'exposition du Premier Festival mondial des arts nègres de Dakar en 1966'. *Gradhiva,* 10: 134–55.

Flather, Newell. 1966. 'Impressions of the Dakar Festival'. *Africa Report* (May): 57–60.

Fléchet, Anaïs, et al. (eds). 2013. *Une histoire des festivals XX^e–XXI^e siècle.* Paris: Publications de la Sorbonne.

'Fodéba Keita, ambassadeur itinérant de la culture africaine'. 1957. *Bingo* (April): 10–15, 20–21.

Forsdick, Charles. 2015. 'Cette île n'est pas une île: Locating Gorée'. In *At the Limits of Memory: Legacies of Slavery in the Francophone World*, ed. Nicola Frith and Kate Hodgson. Liverpool: Liverpool University Press: 131–53.

Foster, Hal. 2004. 'The Archival Impulse'. *October*, 110 (Fall): 3–22.

Foucher, Vincent 2002a. 'Cheated Pilgrims: Education, Migration and the Birth of Casamançais Nationalism (Senegal)'. Unpublished PhD thesis. London: SOAS.

—. 2002b. 'Les "Évolués", la migration, l'école: pour une nouvelle interprétation de la naissance du nationalisme casamançais'. In *Le Sénégal contemporain*, ed. Momar-Coumba Diop. Paris: Karthala: 375–425.

Frioux-Salgas, Sarah (ed.). 2009. Special issue. 'Présence Africaine. Les conditions noires: Une généalogie des discours'. *Gradhiva*, 10.

Fuller, Hoyt. 1966a. 'Special: Festival Time in Dakar'. *Negro Digest* (April): 68–82.

—. 1966b. 'Editorial'. *Negro Digest* (June): 97–98.

—. 1966c. 'Festival Postscripts'. *Negro Digest* (June): 82–92.

—. 1966d. 'World Festival of Negro Arts'. *Ebony* (July): 90–106.

—. 1969. 'First Pan-African Cultural Festival: Algiers Journal'. *Negro Digest* (October): 72–87.

—. 1971. *Journey to Africa*. Chicago: Third World Press.

Fumaroli, Marc. 1991. *L'État culturel: Une religion moderne*. Paris: Éditions de Fallois.

Gabriel, Teshome. 1982. *Third Cinema in the Third World: The Aesthetics of Liberation*. Ann Arbor, MI: UMI Research Press.

Gabus, Jean. 1965. 'Aesthetic Principles and General Planning of Educational Exhibitions'. *Museum*, 18.1: 1–59.

—. 1967. *Art nègre: Recherche de ses fonctions et dimensions*. Neuchâtel: A la Baconnière.

Gardner, Anthony, and Charles Green. 2013. 'Biennals of the South on the Edges of Empire'. *Third Text*, 27.4: 442–45.

Garrison, Lloyd. 1966a. 'The Duke, and those Fabulous Dancers'. *New York Times* (24 April): E3.

—. 1966b. 'Debate on "Negritude" Splits Festival in Dakar'. *New York Times* (24 April): 17.

—. 1966c. 'Real Bursts through the Unreal at Dakar Festival'. *New York Times* (26 April).

Gaye, Abdou Khadre. 2011. 'L'Afrique n'a pas parlé'. *Le Quotidien* (8 January): 14.

Gibbs, James. 1986. *Wole Soyinka*. London: Macmillan.

— (ed.). 2012. *African Theatre 11: Festivals*. Woodbridge: James Currey.

Giebelheusen, Michaela. 2006. 'Museum Architecture: A Brief History'. In *A Companion to Museum Studies*, ed. Sharon MacDonald. Oxford: Wiley Blackwell: 223–44.

Gikandi, Simon. 2003. 'Picasso, Modernism and the Schemata of Difference'. *Modernism/Modernity*, 10.3: 445–80.

—. 2011. 'Foreword'. In *Negotiating Afropolitanism: Essays on Borders and Spaces in Contemporary African Literature and Folklore*, ed. Jennifer Wawrzinek and J.K.S. Makokha. Amsterdam and New York: Rodopi: 9–11.

Gilroy, Paul. 2000. *Against Race: Imagining Political Culture Beyond the Color Line*. Cambridge, MA: Harvard University Press.

Giorgi, Liana, Monica Sasatelli and Gerard Delanty (eds). 2011. *Festivals and the Cultural Public Sphere*. Abingdon: Routledge.

Goldman, Vivien. 2003. 'Thinking Africa: Afrobeat Aesthetic and the Dancing Queens'. In *Fela*, ed. Schoonmaker 2003a: 103–10.

Gomis, Gabriel J. 1976. Untitled Editorial. *Le Soleil* (Dakar) (26 August): 5.

Grah Mel, Frédéric. 1995. *Alioune Diop, le bâtisseur inconnu du monde noir*. Abidjan: Presses universitaires de Côte d'Ivoire; Paris: ACCT.

Gramont, Sanche de. 1970. 'Our Other Man in Algiers'. *New York Times Magazine* (1 November).

Gross, Alan D. 2006. 'Systematically Distorted Communication: An Impediment to Social and Political Change'. *Informal Logic*, 30.4: 335–60.

Gugler, Josef. 1997. 'Wole Soyinka's *Kongi's Harvest* from Stage to Screen: Four Endings to Tyranny'. *Canadian Journal of African Studies*, 31.1: 32–49.

Hadouchi, Olivier. 2011. '"African Culture Will Be Revolutionary or Will Not Be": William Klein's Film of the First Pan-African Festival of Algiers (1969)'. *Third Text*, 25.1: 117–28.

Hall, Stuart. 2005. 'David Scott'. *Bomb*, 90 <http://bombmagazine.org/article/2711/david-scott> (consulted 1 March 2015).

Hardt, Michael, and Antonio Negri. 2001. *Empire*. Cambridge, MA: Harvard University Press.

Hare, Nathan. 1969. 'Algiers 1969: A Report on the Pan-African Culture Festival'. *Black Scholar*, 1 (1 November): 2–10.

Harnan, Terry. 1974. *African Rhythm, American Dance: A Biography of Katherine Dunham*. New York: Alfred A. Knopf.

Harney, Elizabeth. 2004. *In Senghor's Shadow: Art, Politics and the Avant-Garde in Senegal 1960–1995*. Durham, NC: Duke University Press.

Hassan, Salah M. 2012. 'Rethinking Cosmopolitanism: Is "Afropolitan" the Answer?' *Reflections*, 5: 2–32.

Hayes Edwards, Brent. 2003. *The Practice of Diaspora: Literature, Translation, and the Rise of Black Internationalism*. Cambridge, MA; Harvard University Press.

—. 2007. 'Crossroads Republic'. *Transition*, 97: 94–119.

Holston, James. 2008. *Insurgent Citizens: Disjunctions of Democracy and Modernity in Brazil*. Princeton, NJ: Princeton University Press.

Huchard, Ousmane Sow. 1989. 'Le Musée Dynamique'. In *Anthologie des arts plastiques contemporains au Sénégal*, ed. Friedrich Axt and El Hadji Moussa Boubacar Sy. Frankfurt: Museum für Völkerkunde: 54–56.

—. 1992. 'Plaidoyer pour le musée'. *Le Soleil* (16 December): 7

—. 2001. 'Le 1er Festival mondial des arts nègres, Dakar 1966'. In *Anthologie de l'art africain du XXe siècle*, ed. N'Goné Fall and Jean-Loup Pivin. Paris: Éditions Revue Noire: 220–29.

—. 2012. 'Le Témoignage d'un muséologue'. In *Malraux et l'Afrique*, ed. Lambal: 119–35.

Hunt, Lynn. 2008. *Measuring Time, Making History*. Budapest: Central European University Press.

Hymans, Jacques Louis. 1971. *Léopold Sédar Senghor: An Intellectual Biography*. Edinburgh: Edinburgh University Press.

'Les Interventions du Débat de Samedi—communication du Sénégal'. 1969. *El Moudjahid* (27–28 July): 7.

'Interview Express'. 1966. *Dakar-Matin* (25–26 April): 6.

Irele, Abiola. 1990 [1981]. *The African Experience in Literature and Ideology*. Bloomington: Indiana University Press.

—. 2001. *The African Imagination: Literature in Africa and the Black Diaspora*. Oxford: Oxford University Press.

Ischinger, Barbara. 1974. 'Négritude: Some Dissident Voices'. *Issue: A Journal of Opinion*, 4:4: 23–25.

Jachec, Nancy. 2010. 'Léopold Sédar Senghor and the *Cultures de l'Afrique noire et l'Occident (1960)*'. *Third Text*, 24.2: 195–204.

Jaji, Tsitsi Ella. 2014. *Africa in Stereo: Modernism, Music, and Pan-African Solidarity*. Oxford: Oxford University Press.

Jamison, Judith. 1993. *Dancing Spirit: An Autobiography*. New York: Anchor Books.

Jeyifo, Biodun. 2003. *Wole Soyinka*. Cambridge: Cambridge University Press.

Jézéquel, Jean-Hervé. 1999. 'Le "Théâtre des instituteurs" en Afrique Occidentale Française (1930–1950): pratique socio-culturelle et vecteur de cristallisation de nouvelles identités urbaines'. In *Fêtes urbaines en Afrique: espaces, identités et pouvoirs*, ed. Odile Goerg. Paris: Karthala: 181–200.

Joachim, Paulin. 1966a. Editorial. 'L'Afrique a rendez-vous avec elle-même'. *Bingo* (April): 5.

—. 1966b. Editorial. 'La Négritude, connais pas'. *Bingo*, 161 (June): 11.

—. 1966c. 'Où va la culture négro-africaine?' *Bingo*, 161 (June): 13–15.

—. 1966d. 'Sembène Ousmane: Les Lettres africaines sont bien parties'. *Bingo*, 161 (June): 47.

—. 1969a. Editorial. *Bingo* (June): 16.

—. 1969b. Editorial. *Bingo* (November): 12.

Joans, Ted. 1970. 'The Pan African Pow Wow'. *Journal of Black Poetry*, 1.13 (Winter/ Spring): 4–5.

Jules-Rosette, Benetta. 1998. *Black Paris: The African Writers' Landscape*. Urbana: University of Illinois Press.

Kaba, Lansiné. 1976. 'The Cultural Revolution, Artistic Creativity, and Freedom of Expression in Guinea'. *Journal of Modern African Studies*, 14.2: 201–18.

Kane, Abdoulaye. 2001. 'Diaspora villageoise et développement local en Afrique: Le Cas de Thilogne Association Développement'. *Hommes & Migrations*, 1229: 96–107.

—. 2010. 'A Cultural Festival in the Senegal River Valley: Reinventing Local Traditions for Returning Migrants'. *Center for African Studies Research Report*: 14. <http://africa.ufl.edu/publications-resources/cas-research-reports> (consulted 13 September 2015).

Kayode Idowu, Mabinuori. 2003. 'African Who Sang and Saw Tomorrow'. In *Fela*, ed. Schoonmaker 2003a: 16–24.

Keita, Fodéba. 1952. *Le Maître d'école—suivi de Minuit*. Paris: Pierre Seghers.

—. 1955. 'Les Hommes de la danse'. *Trait d'Union*, 39: 53–56.

Kelley, Robin G. 2012. *Africa Speaks, America Answers: Modern Jazz in Revolutionary Times*. Cambridge, MA: Harvard University Press.

Khellas, Mériem. 2014. *Le Premier Festival culturel panafricain: Alger, 1969: Une grande messe populaire*. Paris: L'Harmattan.

Ki-Zerbo, Joseph. 1969. 'Positions et propositions pour une néo-culture africaine'. In *La Culture africaine*: 341–45.

Killens, John O. 1966. 'Brotherhood of Blackness'. *Negro Digest* (May): 4–11.

Knee, Adam, and Charles Musser. 1992. 'William Greaves, Documentary Filmmaking and the African-American Experience'. *Film Quarterly*, 45.3 (Spring): 13–25.

Konaté, Yacouba. 2009. *La Biennale de Dakar: Pour une esthétique de la création africaine contemporaine—tête à tête avec Adorno*. Paris: L'Harmattan.

Kouoh, Koyo (ed.). 2012. *État des lieux: Symposium sur la création d'institutions d'art en Afrique*. Dakar: Hantje Cantz and Raw Material Company.

Kubler, George. 1962. *The Shape of Time: Remarks on the History of Things*. New Haven, CT: Yale University Press.

Labouret, H., and M. Travélé. 1928. 'Le Théâtre mandingue (Soudan Français)'. *Africa*, 1.1: 73–97.

Lambal, Raphaël (ed.). 2012. *Malraux et l'Afrique*. Paris: Présence Africaine.

Lambert, Michael. 2002. *Longing for Exile: Migration and the Making of a Translocal Community in Senegal, West Africa*. Portsmouth, NH: Heinemann.

Lassibile, Mahalia. 2004. '"La Danse africaine", une catégorie à déconstruire. Une étude des danses des WoDaaBe du Niger'. *Cahiers d'études africaines*, 3.175: 681–90.

Lebovics, Herman. 1999. *Mona Lisa's Escort: André Malraux and the Reinvention of French Culture*. Ithaca, NY: Cornell University Press.

Libsekal, Missla. 2014. 'Dak'Art 2014 Makes Contemporary African Art Visible'. *Another Africa* (29 May) <http://www.anotherafrica.net/art-culture/dakart-2014-makes-contemporary-african-art-visible> (consulted 5 January 2015).

Lindfors, Bernth. 1970. 'Anti-Négritude in Algiers'. *Africa Today*, 17.1: 5–7.

Ly, Boubacar. 2009. *Les Instituteurs au Sénégal de 1903 à 1945*, vol. 3, *La Formation au métier d'instituteur*. Paris: L'Harmattan.

Mahjoub, Faouzi. 1969. 'Dans Alger en fête'. *Jeune Afrique* (5–11 August).

Makeba, Miriam, and Nomsa Mwamuka. 2004. *The Miriam Makeba Story*. Johannesburg: STE Publishers.

Malaquais, Dominique. 2008. 'Rumble in the Jungle: boxe, festival et politique'. Special issue. 'Festivals et biennales d'Afrique: machine ou utopie?' *Africultures*, 73: 43–59.

Malraux, André. 1959. 'Présentation du budget des affaires culturelles' <http://www.assemblee-nationale.fr/histoire/andre-malraux/discours/Malraux_17nov1959.asp> (consulted 1 March 2015).

—. 1966a: 'Discours prononcé à l'occasion de l'inauguration de la Maison de la Culture d'Amiens, le 19 mars 1966' <http://www.assemblee-nationale.fr/histoire/andre-malraux/discours_politique_culture/maison_culture_amiens.asp> (consulted 3 March 2015).

—. 1966b. 'Discours prononcé à la séance d'ouverture du colloque organisé à l'occasion du premier Festival Mondial des arts nègres, le 30 mars 1966' <http://www.culture.gouv.fr/culture/actualites/dossiers/malraux2006/discours/a.m-dakar.htm> (consulted 1 March 2015). Also available at <http://www.assemblee-nationale.fr/histoire/andre-malraux/discours_politique_culture/discours_Dakar.asp> (consulted 10 June 2015). Speech also reprinted in *Premier Festival mondial des arts nègres* [livre d'or du festival]. 1967: 45–47.

—. 1976. *Le Miroir des Limbes II: La Corde et les souris*. Paris: Gallimard.

Mamdani, Mahmood. 1996. *Citizen and Subject: Contemporary Africa and the Legacy of Late Colonialism*. Princeton, NJ: Princeton University Press.

Maquet, Jacques. 1969. 'En son devenir, l'Africanité'. In *La Culture africaine*: 210–13.

Mark, Peter. 1994. 'Art, Ritual, and Folklore: Dance and Cultural Identity among the Peoples of the Casamance'. *Cahiers d'études africaines*, 34.136: 563–84.

'Massive Boycott Threatens FESTAC'. 1975. *Daily Times* (5 December): 3.

Mazrui, Ali. 1967. *Ancient Greece in African Political Thought*. Nairobi: East African Publishing House.

Mbaye, Alioune. 2004. 'L'autre théâtre historique de l'époque coloniale: Le "Chaka" de Senghor'. *Éthiopiques*, 72. Online edition: <http://ethiopiques.refer.sn/spip.php?page=imprimer-article&id_article=84> (consulted 10 February 2016).

—. 2006. 'Le Théâtre des centres culturels en AOF (1948–1958): "du casque colonial au béret tropical"'. *Éthiopiques*, 76. Online edition: <http://ethiopiques.refer.sn/spip.php?article1494> (consulted 23 February 2016).

Mbembe, Achille. 1992. 'The Banality of Power and the Aesthetics of Vulgarity in the Postcolony'. *Public Culture*, 4.2: 1–30.

—. 2013. *Critique de la raison nègre*. Paris: La Découverte.

Mbengue, Mamadou Seyni. 1970. *Le Procès de Lat Dior: drame sénégalais*. Dakar: Grande Imprimerie Africaine.

—. 1973. *La Politique culturelle au Sénégal*. Paris: UNESCO.

McEvilley, Thomas. 1993. 'Arrivederci Venice: The Third World Biennials'. Artforum International, 32.9 (November): 114–21.

McEwen, Frank. 1967. *The African Workshop School* [s.n.].

McGovern, Mike. 2013. *Unmasking the State: Making Guinea Modern*. Chicago: University of Chicago Press.

McMahon, Christina S. 2014. 'Theater and the Politics of Display: *The Tragedy of King Christophe* at Senegal's First World Festival of Negro Arts'. In *Modernization as Spectacle in Africa*, ed. Peter J. Bloom, Stephan F. Miescher and Takyiwah Manuh. Bloomington: Indiana University Press: 287–306.

Meauzé, Pierre. 1967. *L'Art nègre: Sculpture*. Paris: Hachette.

Meghelli, Samir. 2009. 'From Harlem to Algiers: Transnational Solidarity between the African-American Freedom Movement and Algeria, 1962–1978'. In *Black Routes to Islam*, ed. Manning Marable and Hishaam D. Aidi. New York: Palgrave Macmillan: 99–119.

—. 2014. '"A Weapon in Our Struggle for Liberation": Black Arts, Black Power, and the 1969 Pan-African Cultural Festival'. In *The Global Sixties in Sound and Vision: Media, Counterculture, Revolt*, ed. Timothy Scott Brown and Andrew Lison. New York: Palgrave Macmillan: 167–84.

Mehretu, Julie. 2013. 'Julie Mehretu Paints Chaos with Chaos—from Tahrir Square to Zuccotti Park'. *Guardian* (20 June) <http://www.theguardian.com/artand-design/2013/jun/20/painting-art> (consulted 15 June 2015).

Mensah, Ayoko. 2007. 'Osons le débat!' Special issue. 'Les Cultures africaines sont-elles à vendre? Richesses artistiques et développement économique'. *Africultures*, 69: 6–9.

Mercer, Kobena. 2001. 'African Photography and Contemporary Visual Culture'. *Camera Austria*, 75 (October): 28–37.

—. 2012. 'Photography and the Conditions of Cross-Cultural Modernity'. In *UnFixed: Photography and Postcolonial Perspectives in Contemporary Art*, ed. Sara Blokland and Asmara Pelupessy. Dordrecht: Jap Sam Books and Unfixed Projects: NP.

Mitchell, Timothy. 1991. *Colonising Egypt*. Berkeley: University of California Press.

Monteil, Vincent. 1963. 'Lat Dior, Damel du Kayor, et l'islamisation des Wolofs'. *Archives de sociologie des religions*, 16: 77–104.

Moore, Gerald. 1978. *Wole Soyinka*. London: Evans Brothers.

Mortimer, Robert A. 1970. 'The Algerian Revolution in Search of the African Revolution'. *Journal of Modern African Studies*, 8.3: 363–87.

Mouralis, Bernard. 1986. 'William Ponty Drama'. In *European-Language Writing in Sub-Saharan Africa*, ed. Albert S. Gérard. Budapest: Akadémiai Kiadó: 130–40.

Mphahlele, Ezekiel. 1962. *The African Image*. London: Faber.

Mudimbe, V.Y. 1988. The *Invention of Africa: Gnosis, Philosophy, and the Order of Knowledge*. Bloomington and Indianapolis: Indiana University Press.

— (ed.). 1992. *The Surreptitious Speech: Présence Africaine and the Politics of Otherness, 1947–87*. Chicago: University of Chicago Press.

Murphy, David. 2011. 'Renaissance Men? Behind the Scenes at the *Festival mondial des arts nègres*'. *Bulletin of Francophone Postcolonial Studies*, 2.1: 2–6.

—. 2012a. 'Culture, Empire and the Postcolony: From la Françafrique to *Le Festival mondial des arts nègres* (1966 and 2010)'. *Francosphères*, 1.1: 19–33.

—. 2012b. 'Littérature, culture et développement au Festival Mondial des arts nègres de Dakar (1966 et 2010)'. In *Nos et leurs Afriques: constructions littéraires des identités africaines 50 ans après les décolonisations*, ed. Ana Paula Coutinho, Maria de Fatima Outeirinho and Jose Domingues de Almeida. Brussels: Peter Lang: 29–42.

—. 2014. 'Sport, Culture and the Media at the *Festival mondial des arts nègres de Dakar* (2010): Sport and the Democratization of Culture or Sport as Populism?' *French Cultural Studies*, 25.1: 10–22.

—. 2015. 'Culture, Development, and the African Renaissance: Ousmane Sembene and Léopold Senghor at the World Festival of Negro Arts (Dakar 1966)'. In *Ousmane Sembène and the Politics of Culture*, ed. Amadou T. Fofana and Vetinde Lifongo. Lanham, MD: Lexington: 1–16.

Mveng, Engelbert. 1964. *L'Art d'Afrique noire: Liturgie cosmique et langage religieux*. Tours: Mame.

—. 1967. 'Signification africaine de l'art'. In *1er Festival mondial des arts nègres, Dakar 1er–24 avril 1966. Colloque Fonction et signification de l'art nègre dans la vie du peuple et pour le peuple, 30 mars–8 avril, 1966*. Paris: Présence Africaine: 7–22.

N'Dir, M'Baye. 1966. [Untitled article]. *Sénégal d'Aujourd'hui* (April): 28.

Ndiaye, Jean-Pierre. 1971. *La Jeunesse africaine face à l'impérialisme*. Paris: François Maspero.

Neveu Kringelbach, Hélène. 2013a. *Dance Circles: Movement, Morality and Self-Fashioning in Urban Senegal*. New York and Oxford: Berghahn.

—. 2013b. 'Dance Revival and Elite Nationalism in Senegambia, 1930–2010'. In *The Oxford Handbook of Music Revival*, ed. Caroline Bithell and Juniper Hill. Oxford: Oxford University Press: 226–49.

Ní Loingsigh, Aedín. 2015. 'Tourism Development and the Premier Festival Mondial des Arts Nègres'. *Irish Journal of French Studies*, 15: 77–95.

Niang, Amy. 2012. 'African Renaissance between Rhetoric and the Aesthetics of Extravagance: FESMAN 2010—Entrapped in Textuality'. In *African Theatre: Festivals*, 11, ed. James Gibbs. Woodbridge: James Currey: 30–38.

Niang, Lamine. 1969. 'La Culture et la poésie négro-africaines, éléments de survie de notre civilisation'. In *La Culture africaine*: 297–300.

Niang, Mor Sadio. 1961. 'La Jeunesse de Coki en marche dans la voie du progrès'. *Dakar-Matin* (2 May): 3.

Njami, Simon. 2005. *Africa Remix: Contemporary Art of a Continent*. London: Hayward Gallery Publishing.

Nlandu-Tsasa, Cornelis. 1997. *La Rumeur au Zaïre de Mobutu: Radio-trottoir à Kinshasa*. Paris: L'Harmattan.

Nora, Pierre. 1989. 'Between Memory and History: Les Lieux de mémoire'. *Representations*, 26 (Spring): 7–24.

Nwezi, Ugochukwu-Smooth C. 2014. 'Producing the Common: Dak'Art 2014'. <http://www.goethe.de/ins/za/en/joh/kul/mag/bku/12939789.html> (consulted 1 May 2015).

Nyonda, Vincent de Paul. 1981. *La Mort de Guykafi: Drame en cinq actes; suivi de Deux Albinos à la M'Passa; et Le Soûlard*. Paris: L'Harmattan.

Nzekwu, Onuora. 1966. 'Nigeria, Negritude and the World Festival of Negro Arts'. *Nigeria Magazine*, 89: 80–94.

Ogbechie, Sylvester. 2008. 'Compagnons d'armes: l'avant-garde africaine au Premier Festival mondial des arts nègres de Dakar en 1966'. *Africultures*, 73: 35–42.

Organization of African Unity. 1969. 'Suggestions et propositions'. In *La Culture africaine*: 185–87.

—. 1970: 'Pan-African Cultural Manifesto'. *Africa Today*, 17.1: 25–28.

Ozouf, Mona. 1988. *Festivals and the French Revolution*. Trans. Alan Sheridan. Cambridge, MA: Harvard University Press.

Pace, Eric. 1969a. 'Carmichael Tells of Meeting Cleaver in Algiers'. *New York Times* (25 July).

—. 1969b. 'Africans at Algiers Festival Denounce Concept of "Negritude" as Outmoded'. *New York Times* (28 July).

—. 1969c. 'Al Fatah, at Festival in Algiers, Seeks Black Africans' Support'. *New York Times* (2 August).

Peutz, Nathalie. 2011. 'Bedouin "Abjection": World Heritage, Worldliness, and Worthiness at the Margins of Arabia'. *American Ethnologist*, 38.2: 338–60.

Picard, David, and Mike Robinson (eds). 2006. *Festivals, Tourism and Social Change*. Toronto: Channel View Publications.

Picon, Gaëtan. 2013. 'La Culture et l'État'. In *La Politique culturelle en débat*, ed. Poirrier: 189–94.

Pierre, Jemima. 2013. *The Predicament of Blackness: Postcolonial Ghana and the Politics of Race*. Chicago: University of Chicago Press.

Poirrier, Pierre (ed.). 2013. *La Politique culturelle en débat*. Paris: La Documentation Française.

Pool, Hannah. 2011. 'World Festival of Negro Arts: A Once in A Decade Event'. *Guardian* (3 January).

'Pour une politique de la culture'. 1966. *Présence Africaine*, 4: 3–5.

Povey, John. 1966. 'The First World festival of Negro Arts at Dakar'. *Journal of the New African Literature and the Arts* (Fall): 26.

Premier Festival mondial des arts nègres [livre d'or du festival], 1967. Paris: Imprimerie Bouchet-Lakara.

'La Presse allemande ne tarit pas d'éloges sur les Ballets du Sénégal qui viennent de triompher en Allemagne Fédérale'. 1961. *Paris-Dakar* (17 April): 3.

'Press Conference Chief of Staff's Return from Algiers'. 1969. *Black Panther* (9 August): 7.

'Programme'. 1966: *Dakar-Matin* (23 March): 3.

Rampersad, Arnold. 1988. *The Life and Times of Langston Hughes*, vol. 2, *1941–67: I Dream a World*. New York and Oxford: Oxford University Press.

Ratcliff, Anthony. 2014. 'When Negritude was in Vogue: Critical Reflections of the First World Festival of Negro Arts and Culture 1966'. *Journal of Pan African Studies*, 6.7 (February): 167–86.

Rauch, Marie-Ange. 1998. *Le Bonheur d'entreprendre: les administrateurs de la France d'Outre-mer et la création du Ministère des affaires culturelles*. Paris: Comité d'histoire du Ministère de la Culture.

Roberts, Allen F. 2013. 'Citoyennetés visuelles en compétition dans le Sénégal contemporain'. In *Les Arts de la citoyenneté au Sénégal: espaces contestés et civilités urbaines*, ed. Mamadou Diouf and Rosalind Fredericks. Paris: Karthala: 195–236.

Rous, Jean. 1967. *Léopold Sédar Senghor: la vie d'un président de l'Afrique nouvelle*. Paris: J. Didier.

Rowlands, Michael. 2007. 'Entangled Memories and Parallel Heritages in Mali'. In De Jong and Rowlands (eds), *Reclaiming Heritage*: 127–44.

Sabatier, Peggy R. 1978. '"Elite" Education in French West Africa: The Era of Limits, 1903–1945'. *International Journal of African Historical Studies*, 11.2: 247–66.

—. 1980. 'African Culture and Colonial Education: The William Ponty School Cahiers and Theater'. *Journal of African Studies*, 7.1: 2–10.

Samb, Amar. 1969. 'La Culture africaine'. In *La Culture africaine*: 328–30.

Samb, Assane Marokhaya. 1964. *Cadior Demb*. Dakar: Imprimerie Abdoulaye Diop.

Sanders, Charles L. 1966a. 'Paris Scratchpad'. *Jet* (21 April): 48.

—. 1966b. 'Paris Scratchpad'. *Jet* (28 April): 26.

Sartre, Jean-Paul. 1948. 'Orphée noir'. In *Anthologie de la nouvelle poésie nègre et malgache*, ed. Léopold Sédar Senghor. Paris: Presses universitaires de France: ix–xliv.

—. 1976 [1948]. *Black Orpheus*. Trans. S.W. Allen. Paris: Présence Africaine.

Saunders, Frances Stonor. 2001. *The Cultural Cold War: The CIA and the World of Arts and Letters*. New York: The New Press.

Schjeldahl, Peter. 1999. 'Festivalism: Oceans of Fun at the Venice Biennale'. *New Yorker* (5 July): 85–86.

Schoonmaker, Trevor (ed.). 2003a. *Fela: From West Africa to West Broadway*. New York: Palgrave Macmillan.

—. 2003b. 'Introduction'. In *Fela*, ed. Schoonmaker 2003a: 1–9.

Scott, David. 2004. *Conscripts of Modernity: The Tragedy of Colonial Enlightenment*. Durham, NC: Duke University Press.

Sekula, Allen. 1986. 'The Body and the Archive'. *October*, 39 (Winter): 3–64.

'Le Sénégal ne se laissera pas imposer sa politique par des étrangers'. 1966. *L'Unité africaine* (3 March): 1.

Senghor, Léopold Sédar. 1956. *Chants d'ombre*. Paris: Seuil.

—. 1959. 'Constructive Elements of a Civilization of African Negro Inspiration'. *Présence Africaine*, 24–25.1: 262–94.

—. 1964a. *Liberté 1: Négritude et humanisme*. Paris: Seuil.

—. 1964b. *On African Socialism*. Trans. Mercer Cook. New York: Praeger.

—. 1966a. 'Le Message de l'Afrique'. In *Premier Festival mondial des arts nègres* [Festival Programme]. Paris: Impressions André Rousseau: 11–13.

—. 1966b. 'The Function and Meaning of the First World Festival of Negro Arts'. *African Forum*, 1.4: 5–10.

—. 1967. *Les Fondements de l'africanité; ou, Négritude et arabité*. Paris: Présence Africaine.

—. 1969a. 'Discours du S.E. Monsieur Léopold Sédar Senghor'. In *La Culture africaine*: 38–39.

—. 1969b. *Négritude, arabité et francité: Réflexions sur le problème de la culture*. Beirut: Dar Al-Kitabl Allubnani.

—. 1977. *Liberté 3: Négritude et civilisation de l'universel*. Paris: Seuil.

—. 1979a. 'French—Language of Culture'. In *Ideologies of Liberation in Black Africa, 1856–1970: Documents on Modern African Political Thought from Colonial Times to the Present*, ed. J. Ayo Langley. London: Rex Collings: 378–84. [First published in *Liberté 1: Négritude et humanisme*, 1964.]

—. 1979b. 'Nationhood: Report on the Doctrine and Program of the Party of African Federation'. In *Ideologies of Liberation in Black Africa, 1856–1970: Documents on Modern African Political Thought from Colonial Times to the Present*: 528–45. [First published as 'Report to the Constitutive Congress of the PFA', July 1959.]

—. 1988. *Ce que je crois*. Paris: Grasset & Fasquelle.

Shain, Richard. 2002. 'Roots in Reverse: Cubanismo in Twentieth-Century Senegalese Music'. *International Journal of African Historical Studies*, 35.1: 83–101.

Shepherd, George W. 1969. 'Reflections of the Pan-African Culture Conference in Algiers'. *Africa Today*, 16.4: 1–3.

Shepp, Archie. 1971. *Live at the Panafrican Festival*. BYG Records.

Shepperson, George. 1962. '"Pan-Africanism" and "pan-Africanism": Some Historical Notes'. *Phylon*, 23.4 (Winter): 346–58.

'A Short Account of International Student Politics and the Cold War with Particular Reference to the NSA, CIA, etc.'. 1967. *Ramparts* (March): 29–39.

Snipe, Tracy D. 1998. *Arts and Politics in Senegal, 1960–1996*. Trenton, NJ: Africa World Press.

Soéllé, Ebongué. 1966. 'Lundi, au Stade de l'Amitié. Présentation de "Lat Dior"'. *Dakar-Matin* (1 April): 5.

Sonar Senghor, Maurice. 2004. *Souvenirs de théâtres d'Afrique et d'Outre-Afrique*. Paris: L'Harmattan.

Soyinka, Wole. 1967. 'Le Théâtre moderne négro-africain. La scène nigérienne. Une étude de la tyrannie et de la survivance individuelle'. In *1er Festival mondial des arts nègres, Dakar 1er–24 avril 1966. Colloque Fonction et signification de l'art nègre dans la vie du peuple et pour le peuple, 30 mars–8 avril, 1966*. Paris: Présence Africaine: 539–48.

—. 1968. 'The Writer in a Modern African State'. In *The Writer in Modern Africa: African–Scandinavian Writers' Conference, Stockholm 1967*, ed. Per Wästberg. Uppsala: Nordiska Africainstitutet: 14–20.

—. 1974. *Collected Plays 2*. Oxford: Oxford University Press.

'Le Spectacle féerique de Gorée. Bilan record, 23.500 spectateurs'. 1966. *Dakar-Matin* (26 April): 1.

Spectacle féerique de Gorée. 1966. Paris: Impressions André Rousseau.

Stouky, Abdallah. 1966. 'Le Festival mondial des arts nègres ou les nostalgiques de la négritude'. *Souffles*, 2: 41–45.

Straker, Jay. 2009. *Youth, Nationalism, and the Guinean Revolution*. Bloomington: Indiana University Press.

Sylla Abdou. 2007. 'La Tumultueuse Histoire du Musée Dynamique de Dakar'. *Africultures*, 70: 89.

Taylor, Diana. 2003. *The Archive and the Repertoire: Performing Cultural Memory in the Americas*. Durham, NC and London: Duke University Press.

Telli, Diallo. 1969. 'Discours de S.E. Monsieur Diallo Telli'. In *La Culture africaine*: 20–23.

Terdiman, Richard. 1993. *Present Past: Modernity and the Memory Crisis*. Ithaca, NY: Cornell University Press.

'Le Texte de l'intervention du porte-parole de la délégation algérienne'. 1969. *El Moudjahid* (27–28 July): 6–7.

Thiam, Cheikh. 2014. *Return to the Kingdom of Childhood: Re-envisioning the Legacy and Philosophical Relevance of Negritude*. Columbus: Ohio State University Press.

Thomas, Deborah A. 2004. *Modern Blackness: Nationalism, Globalization, and the Politics of Culture in Jamaica*. Durham, NC: Duke University Press.

—. 2011. *Exceptional Violence: Embodied Citizenship in Transnational Jamaica*. Durham, NC: Duke University Press.

Thomas, Dominic. 2013. *Africa and France: Postcolonial Cultures, Migration and Racism*. Bloomington and Indianapolis: Indiana University Press.

Touré, Ahmed Sékou. 1969. 'Discours de S.E. Ahmed Sékou Touré'. In *La Culture africaine*: 30–37.

Towa, Marcien. 1971. *Léopold Sédar Senghor: négritude ou servitude?* Yaoundé: Éditions CLE.

'Tribal Dance Opens Festival in Dakar'. 1966. *New York Times* (2 April): 16.

Vaillant, Janet G. 1990. *Black, French, and African: A Life of Léopold Sédar Senghor.* Cambridge, MA: Harvard University Press.

—. 2006. *Vie de Léopold Sédar Senghor: Noir, Français et Africain.* Paris: Karthala.

Verdin, Philippe. 2010. *Alioune Diop, le Socrate noir.* Paris: Lethielleux.

Vidal, Henri. 1955. 'Nos victoires dans les compétitions théâtrales'. *Traits d'Union,* 8.

Vincent, Cédric (ed.). 2008a. Special issue. 'Festivals et biennales d'Afrique: machine ou utopie?' *Africultures,* 73.

—. 2008b. 'Une biennale sous le chapeau: une histoire des biennales absentes ou inachevées'. Special issue. 'Festivals et biennales d'Afrique: machine ou utopie?' *Africultures,* 73: 157–60.

—. 2008c. 'Instrumentaliser l'événementiel: entretien avec Simon Njami'. Special issue. 'Festivals et biennales d'Afrique: machine ou utopie?' *Africultures,* 73: 102–09.

—. 2008d. 'Introduction: "Ils construisent pour le futur ...'''. Special issue. 'Festivals et biennales d'Afrique: machine ou utopie?' *Africultures,* 73: 12–17.

—. 2014. 'A Non-Linear History of Dak'Art'. *C&: Contemporary And–Platform for International Art from African Perspectives* <http://www.contemporaryand.com/magazines/a-non-linear-history-of-dakart/> (consulted 1 June 2015).

Vivante Afrique. 1966. Special issue. 'Art nègre'. 246: 14.

von Eschen, Penny. 2004. *Satchmo Blows up the World: Jazz Ambassadors Play the Cold War.* Cambridge, MA: Harvard University Press.

Wenzel, Jennifer. 2006. 'Remembering the Past's Future: Anti-Imperialist Nostalgia and Some Versions of the Third World'. *Cultural Critique,* 62 (Winter): 1–32.

Weston, Randy, and Willard Jenkins. 2010. *African Rhythms: The Autobiography of Randy Weston.* Durham, NC and London: Duke University Press.

White, Bob. 2002. 'Congolese Rumba and Other Cosmopolitanisms'. *Cahiers d'études africaines,* 42.168: 663–86.

—. 2008. *Rumba Rules: The Politics of Dance Music in Mobutu's Zaire.* Durham, NC: Duke University Press.

Wilder, Gary. 2005. *The French Imperial Nation-State: Negritude and Colonial Humanism between the Two World Wars.* Chicago: University of Chicago Press.

—. 2015. *Freedom Time: Negritude, Decolonization and the Future of the World.* Durham, NC: Duke University Press.

Wilford, Hugh. 2008. *The Mighty Wurlitzer: How the CIA Played America.* Cambridge, MA: Harvard University Press.

—. 2014. 'The American Society of African Culture: The CIA and Transnational Networks of African Diaspora Intellectuals in the Cold War'. In *Transnational Anti-Communism and the Cold War: Agents, Activities, and Networks,* ed. Luc van Dongen, Stéphanie Roulin and Giles Scott-Smith. New York: Palgrave Macmillan: 23–34.

Williams, Raymond. 1977. *Marxism and Literature.* Oxford: Oxford University Press.

Wofford, Tobias. 2009. 'Exhibiting a Global Blackness: The First World Festival of Negro Arts'. In *New World Coming: The Sixties and the Shaping of Global Consciousness,* ed. Karen Dubinsky et al. *Toronto: Between the Lines:* 179–86.

Yúdice, George. 2004. *The Expediency of Culture: Uses of Culture in the Global Era.* Durham, NC: Duke University Press.

Zeitlyn, David. 2012. 'Anthropology in and of the Archives: Possible Futures and Contingent Pasts: Archives as Anthropological Surrogates'. *Annual Review of Anthropology,* 41: 461–80.

Index

Printed and bound by CPI Group (UK) Ltd, Croydon, CR0 4YY

09/01/2024

08219666-0001